Flash MX Gar

Thanks to Pam

Flash MX Games
ActionScript for artists

Nik Lever

Focal Press

OXFORD AMSTERDAM BOSTON LONDON NEW YORK PARIS
SAN DIEGO SAN FRANCISCO SINGAPORE SYDNEY TOKYO

Focal Press
An imprint of Elsevier Science
Linacre House, Jordan Hill, Oxford OX2 8DP
200 Wheeler Road, Burlington MA 01803

First published 2003

British Library Cataloguing in Publication Data
A catalogue record for this book is available from the British Library

Library of Congress Cataloguing in Publication Data
A catalogue record for this book is available from the Library of Congress

ISBN 0 240 51903 5

For information on all Focal Press publications visit our website at:
www.focalpress.com

Composition by Genesis Typesetting, Laser Quay, Rochester, Kent
Printed and bound in Great Britain by MPG Books Ltd, Bodmin, Cornwall

Contents at a glance

Flash MX Games

Contents in summary

Flash MX Games

- **Section 4: Flash for boffins 361**
 Sometimes you will need to extend what you can do in Flash using external methods. The last two chapters introduce you to things you should be thinking about.

- **Chapter 19: High score tables 363**
 High score tables encourage users to stay online in order to see their name appear in the high score list. The tables are usually stored in a database and then loaded into Flash when a call to a high score table is required. This chapter explores the options.

- **Chapter 20: Multi-player games using sockets 383**
 Although multi-player games are possible using ASP pages, the best technique is a server-side listening program that exploits the use of sockets. In this chapter we look at creating the server-side program using MFC and then implementing a multi-player game across the Internet.

- **Appendix A: Integrating Flash with C++ 399**
 The final chapter in the book introduced C++. In this chapter we look at how experienced programmers can add Flash to their programs. We also look at communication between the parent program and Flash.

- **Appendix B: Integrating Flash with Director 412**
 Director is starting to make a more significant impact on the Internet with the addition of Shockwave 3D. Here you will find an introduction to controlling a 3D animation using a Flash interface in Director and how to package this for Internet distribution.

- **Appendix C: Creating Flash screensavers 418**
 Having worked through Appendix A, in this section we extend this knowledge to create Flash-based screensavers.

- **Bibliography 429**

- **Index 433**

Introduction:
Learn to write ActionScript
and have fun doing it!

Flash MX provides the perfect platform to create fun games for Internet distribution. This book takes the reader through the entire process from creating the art and animation for these games, through to programming them ready for users across the world to enjoy the results. The book is split into four sections. The first section introduces the new user to the drawing tools in Flash and explains how to create the animation frames that you will need for your games while keeping the files bandwidth friendly. Section 2 takes the reader on a guided tour of using ActionScript. The emphasis is on explaining computer programming to readers from a design background; no previous computer programming is assumed. In Section 3 lots of practical examples are offered of specific games; all the source code is provided in Flash MX format on the included CD. Finally, in Section 4 and the Appendices advanced topics are included about using sockets, databases and integrating with C++ and Director; there is even a section on using Flash to create a screensaver.

Using the CD

You can browse the folders on the CD. Each Chapter and Appendix has a unique folder in the 'Examples' folder. All the projects and source can be found here. To use a project file, open the file directly from the CD in Flash and then save it to your local hard drive if you intend to make changes. The 'Utilities' folder contains a small exe file for Windows machines that can create a MIME-encoded query string from a text file.

Who's the author?

It all started with a ZX81, a hobbyist computer released in Britain in 1981. The ZX81 was soon replaced by a Sinclair Spectrum, an amazing computer from the same company. The Sinclair Spectrum boasted an amazing 48k of memory, and an eight-colour display. From those early days the author was smitten, writing code became something of an obsession. Having graduated as a Graphic Designer in 1980 he had already started work as a professional animator when the interest in computers surfaced. All too soon, his computer hobby merged with professional life. The first example was a computer controlled rostrum stand, a camera for filming 2D animation. Much more recently he has been producing CD-ROMs and web-based multimedia productions for clients including Kelloggs, Coca-Cola, BBC, Sekonda and Polydor. The first interactive web-based work used Java, but the latest work tends to be all Flash or Shockwave 3D based. With compression and streaming abilities that are so web friendly, Flash is set to be a standard for some time to come.

Check out www.catalystpics.co.uk to see the author's handiwork.

Who is this book for?

Designers

If you are a designer who has worked with Flash and wants to go further, you will find lots of interest here. You will learn about applying your creative skills to the many stages of game production. If you have never played with Flash then fear not, you will be guided through the art, animation and programming involved in creating sophisticated games.

Animators

Perhaps you have created the sprites for other people's games and always meant to look into how to create your own; in this book you will learn how. You will see how to use motion tweening in Flash to create smooth animation and then how to add interactive functionality to your game using ActionScript. Even if you have never written a line of code before then you will find the tutorial style easy to follow.

Web developers

If you haven't started writing Flash code then shame on you, start today. Flash offers a sophisticated development environment with good tools for the production of both artwork and code. In this book you will learn how to best use Flash by creating animation and then adding interactivity, producing exciting and dynamic Internet content.

Students

The Internet is rapidly turning into a rich source of employment for visually literate students. If your skills also include adding the code then you will be in demand. In this book you learn all the skills necessary to create highly dynamic web content.

So what are you waiting for?

Boot up your computer, go straight to Flash MX and turn the page where you are going to create your first game in a Flash!

1 Your first game

Rather alarmingly it is now nearly 20 years since I wrote my first bit of code using a Sinclair Spectrum computer and Sinclair Basic.

> In 1980, in the UK, Clive Sinclair, an entrepreneurial inventor, advertised for sale a very simple computer. The ZX80 connected to the TV set and enjoyed 1K of RAM. Each machine came with a simple programming language, BASIC (Beginners All-purpose Symbolic Instruction Code). This early machine started a revolution of young bedroom and garage programmers. Some of these early starters went on to become very successful in the games industry. Sinclair's inexpensive computers, including the Spectrum, are one of the main reasons why the UK has an internationally respected games industry.

Animation had for several years been my main motivation. I still get a buzz from making things move. Although initially unconnected, programming shares many similarities with animation. It is a creative pursuit. If you come to programming from an art background then you may find this doubtful. Surely creative implies the visual, written or musical arts. But programming is not a case of one solution to a problem, there are many solutions and it is the path you take to the solution where the 'art' comes in. I got such a buzz from my first programs working that I now spend rather more of my time writing code than creating animation artwork. In this chapter we are going to rush headlong into creating a game. Not a massively multi-player 3D first person extravaganza, we may have to wait for day two for that! No, the game we will produce will be familiar to anyone who has ever played a computer game. It is a very simple version of 'Pong'. On the way we will discover the Flash interface. You will learn

how to create simple artwork with Flash. Where to find all those panels and what they do. Adding a little code. Testing your work and simple debugging. So without further hesitation let's get going; I strongly advise reading this chapter while using your computer. You will get much more from it if you enter the code and follow the tutorial throughout rather than just dissecting the final program.

Creating simple artwork using Flash

Figure 1.1 shows the basic Flash interface. The biggest area is used for the stage. This is where we put the imagery that the user will see. Above this in the diagram is a grid; this is used as a timeline. In Flash a scene is broken down using time segments and layers. A single column in the upper section represents one time segment and a row represents a layer of graphics. So how long is a time segment? By default a time segment is one twelfth of a second. The user can alter the duration of a time segment by clicking in an empty area of the stage and selecting the Properties window. The window should look like that shown in Figure 1.2.

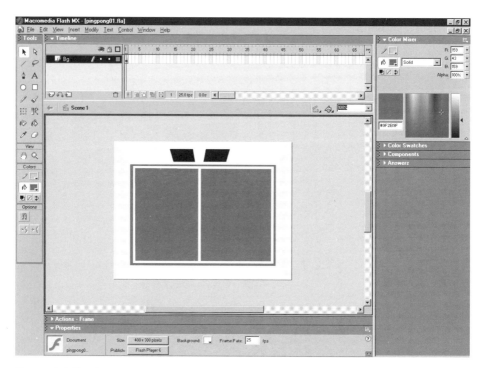

Figure 1.1 The Flash interface.

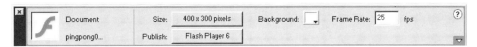

Figure 1.2 Altering Movie Properties.

The first thing to do when following this tutorial is to open the file 'Examples/Chapter01/Pingpong01.fla' from the CD. You must save the project to your local machine if you intend to edit and keep a project. You should be looking at something similar to the view shown in Figure 1.1. Here, in addition to the timeline and main stage area you will see a panel on the left containing the important tools you will use when creating graphics with Flash. The graphics produced using Flash are vector based. That is, you define lines, curves and fills and Flash paints the screen using this information. So let's look at creating our first graphic element. To help you the example already includes the background for the game. The background shows an overhead view of a sports hall. We are going to create a ball and two bats, then add some code to allow the user to move the bats, and finally add some code so that the ball bounces off the bats and walls.

Creating new layers

The first stage of this tutorial chapter is creating the ball. When creating a game in Flash we can sometimes create everything in the same layer, but usually we will use extra layers for different elements. Look at Figure 1.3; here you can see that three layers are involved. To add a layer, click on the icon shown in the lower left corner of the diagram. To delete a layer

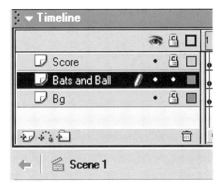

Figure 1.3 Adding and naming layers.

click on the trash can. Try adding a layer and deleting it now. When you have the feel for this add a layer and click on the layer name; it may be 'Layer 2' or another number. When you double-click the name it goes into renaming mode; now you can give the layer a useful name, for this tutorial call it 'Bats and Ball'. When there are only a few layers and you are just creating a game you may be tempted to take the default name. Fight this! Get into the habit of naming everything; if the project gets bigger then you will be glad you did. Also you may come back to a project months after it was completed and find it much easier to find your way around if everything has a useful name. If you are working in a team then you will enjoy working on someone else's project if it is well organized with easily identified names; if everything is poorly structured then the project becomes a nightmare to maintain.

Take a look at the top left corner of Figure 1.3; here you will see that it says 'Scene 1'. In addition to breaking a project down into time segments and layers, Flash also allows you to divide it up using Scenes. When producing a game or any other computer program, structure can make a huge difference to how difficult the project is to produce and maintain. Flash allows the developer to use a very good structure, but equally you can also use a very poor structure. Another aim of this book is to help you understand how to create well-structured projects and to learn how to attack a complex problem so that the task becomes manageable.

Now that we have created a layer to store the ball artwork, make sure that this layer is highlighted before we move on to the next section.

Creating the ball

Take a look at Figure 1.4; here the ring highlights the tool that you should select. Before we do any drawing in Flash let's look briefly at each of the tools in the Tools palette. Starting in the top left is the selection arrow; this tool allows you to select and edit a part of the artwork. The white arrow lets you edit a curve using the control handles that tell Flash how to draw the curve. The next row down has the Line tool for drawing lines and the Lasso tool for more complex selection. Moving down you will find the Pen and Text tools, the Circle and Rectangle tools, the Pencil and Brush tools, the Resize and Edit Fill tools, the Ink and Fill tools, and finally the eye dropper for picking up colours and the eraser for deleting part of the artwork. If you have a tablet for drawing then you will find that some of the tools use the pressure sensitivity of the tablet to adjust line width. Recall that Flash is a vector-based drawing package, it distinguishes between lines and fills. A line has a consistent width that is set using the

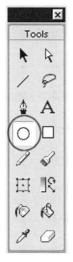

Figure 1.4 *Using the Circle tool.* Figure 1.5 *Selecting the colour.*

'Properties' panel for the Oval tool. When you have selected the Circle tool, take a look at the Colors palette, just below. Notice that there are two colours, a colour for the lines you draw which is to the immediate right of the pencil icon and a colour for the filled areas at the right of the paint bucket. When you create a circle it can include an outline, a fill or any combination of these. Click on the colour square and this brings up a further dialog box. In this box you can select from a pre-defined palette or you can use the mixer panel, 'Windows/Color Mixer', to create a new colour. For the ball we are going to select an outline colour and a fill colour; in the example we use black for the outline and a mid blue for the fill colour.

Before we draw our first element we need to select one further setting, the stroke width. With the Properties box for the Oval Tool visible set the stroke width to '1'. Select 'Windows>Properties' or click the down arrow next to the Properties panel to ensure that the Properties panel is visible. The type of stroke will be 'Solid'. Now we are ready to draw.

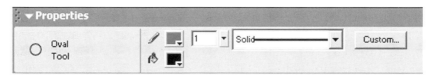

Figure 1.6 *Setting the width of a line.*

Figure 1.7 Stages in drawing the ball.

Figure 1.7 illustrates the four stages in drawing the ball. Stage 1 is to click on the stage area to define the top left extent of the ball, then drag to the bottom right. This sets the size of the ball and creates the ball we see on the left of the diagram. We are going to enhance this simple drawing by adding a shadow to the bottom left. To do this we will use the Line tool.

Using the line tool

Select the Line tool by clicking on the icon highlighted with a ring in Figure 1.8.

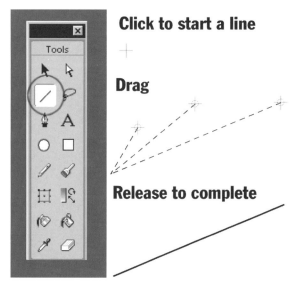

Figure 1.8 Using the Line tool.

A line is initialized using a click. Click on the ball to define the start of the line and drag to the end. If the line is not quite in the right place, then select the 'Arrow' icon and click on the line. The line is highlighted; now press the delete key to remove this line.

By now you should have a ball with a line drawn through it. You can also use the arrow selector as an important editing tool. Move the mouse so that it is near one end of the line. Notice that the mouse cursor includes a corner at the bottom right. Now move the mouse so it is near the middle of the line; the corner changes to a curve. Unlike most vector editing packages, Flash does not show editing handles on a line, unless you use the white arrow. As a user you can determine what will happen when you

Figure 1.9 Using the Selector tool.

edit a line based on the mouse cursor image. If you click and drag when the mouse cursor has a corner showing then you are moving one end of a line segment; if the mouse cursor has a curve then you can stretch the curve by dragging the mouse. Try clicking and dragging near the middle of the line and you will see the curve bend. You may find that it is difficult to see any detail on the ball. If so then try zooming in; remember that Flash is a vector package and as such you can zoom in without any loss of quality. Use the magnifying glass to select the zoom option, or select the level of zoom from the combo box in the bottom left corner of the application. When zoom is selected you can drag a box around your artwork and Flash will resize and centre the artwork to this box.

Figure 1.10 Zooming in. Figure 1.11 Using the Fill tool.

At this stage your ball should look like the third ball from the left in Figure 1.7. To give the illusion of depth to the ball we will add a darker colour to the bottom left of the ball. This area has a bounding shape defined by the circle and the line we have just drawn, so you can use the Fill tool shown highlighted in Figure 1.11. Use the mixer panel to create a darker blue for the bottom left and then click in this area to apply the colour.

At this stage you could choose to remove the outlines. Figure 1.12 shows the completed ball with all the lines and fills selected. The dots over the artwork indicate a selection. If you click on a frame layer in the timeline then everything in that frame layer will be highlighted. To select a section click away from the artwork to deselect, then click on the part you wish to select. To remove the outlines you would click on an outline in the ball; if

Figure 1.12 The ball selected.

you then double-click it selects all the outlines of the same colour and stroke connected to the first selection. Try using the timeline to select and then, using the arrow selection tool, try selecting individual and connected parts. It is important when developing artwork using Flash that you are familiar with the selection tools. Finally highlight the completed ball; the easiest way to do this is by using the timeline selection method. Your selection should look like Figure 1.12.

Using symbols

Flash lets you turn pieces of artwork into symbols. Choose 'Insert/Convert to Symbol . . .' or press F8. This makes a symbol from whatever is currently selected. This brings up the dialog box you can see in Figure 1.13.

Figure 1.13 Creating a symbol.

When creating a symbol you have three choices. The symbol can be a 'Movie Clip', in which case you will have control over it using ActionScript. It can be a 'Button' so that it will respond to a click of the mouse or it can be a 'Graphic'. For now we will choose 'Movie Clip' and give it the name Ball. Having pressed 'OK' the highlighting will change from that shown in Figure 1.12 to a light blue rectangle drawn around the symbol. Although you can still move and resize the symbol you cannot edit it using the

Figure 1.14 Selecting Edit Symbols.

Flash MX Games

drawing tools. To get at the actual artwork you will need to edit the symbol itself. You can get at the symbol one of three ways; either open the 'Library' window using 'Window/Library' or right-click on the symbol and then choose the option to 'Edit in Place'. This will change the timeline so that you are now editing the 'Scene1/Ball' rather than 'Scene 1'. The final option for choosing to edit a symbol is to use the 'Edit Symbols' button at the top right of the stage window.

Adding the bats

At this stage you have an option, you can try to create the bat as shown in Figure 1.15 or you can take the easy way out and open the project from the CD 'Examples/Chapter01/Pingpong03.fla'.

Figure 1.15 The bat.

Each bat uses the same symbol, with the left bat flipped horizontally by using 'Modify/Transform/Flip Horizontal'.

Adding a little code

Now is the time to start to enter a little ActionScript. Right-click on the right-hand bat and select 'Actions'. You should see something similar to Figure 1.16.

```
▼ Actions - Movie Clip                                          ≡,
  Actions for Ball (Ball)                                    ▼  
  + ⌕ ⌗ ⊕ ✓ ≣ ⊡                              ⬧ 80, ⬚.
  onClipEvent(enterFrame){                                       ▲
      //_root.debug = "(" + _x + ", " + (_y - _root.RightBat._y) + ")";
      //_root.debug = "(" + _x + ", " + _y + ")" + chr(13);
      //_root.debug += "(" + moveX + ", " + moveY + ")";
      //Ball limits are (30, 40) - ( 370, 275)
      //LeftBat hits when _x<65 and -18<batY<18
      //RightBat hits when _x>335 and -18<batY<18

      if (moveX==0){
          //Only occurs when ball starts
          if (random(10)>=5){
              moveX = 6;
          }else{                                                 ▼
  ◄                                                          ►
  Line 70 of 70, Col 4
```

Figure 1.16 Entering ActionScript.

Fear not if the sight of all this gibberish fills you with dread, we will examine this code a bit at a time. Firstly, the opening line

```
onClipEvent(enterFrame) {
```

What does this mean? Remember that we created a symbol, and we chose to make this symbol a 'Movie Clip'. Movie clips can have code attached to them and one of the ways you can add this code is by clicking on the symbol, selecting actions then adding an 'onClipEvent'. The curly braces { and } contain a section of code; in this case they contain all the code that occurs for the 'onClipEvent'. An 'onClipEvent' can be passed a little information in the form of a *parameter*. The syntax for Flash is very similar to the syntax for *javascript*, which is often used by pages that you will view in an Internet browser. A parameter is contained within regular brackets, (and). In this example the parameter passed is 'enterFrame'; this occurs as the timer flips on to the next time segment. If you set the movie frame rate to 20, then this section of code will run 20 times a second. If this sounds a lot, bear in mind that many commercial games aim for frame rates of 50 times a second or above. The higher the frame rate the smoother an animation will appear; however, the computer hardware must be able to sustain this level of computation. For now we will leave the frame rate at 20 and hope for the best. If Flash cannot sustain the intended frame rate then it just tries to maintain the highest frame rate it can. As you progress through the book you will learn of different parameters you can pass to the 'onClipEvent'; for now we will limit it to just 'enterFrame'.

Following on from the first line are several lines, each beginning with '//'. The use of // at the beginning of a line indicates that everything following this on the line is a comment. It does not affect the code, its use is as a convenience for the programmer. You are strongly encouraged to comment your code liberally. It has no affect on the performance, yet makes your code easier for yourself or others to understand. A section of code that seems obvious as you write it can often seem like hieroglyphics when you return to it weeks or months later.

The next line we will consider is

```
keypressed = false;
```

All computer programming uses variables. A variable is a slot where you can store information and return to it later. You may want to store a number, a word, a sentence or just whether something is true or not. Flash lets you store all this information. A variable takes a name. It can be any name that you find useful; in this instance I chose the name 'keypressed' and I have set this to false. So at this stage in this section of code the variable 'keypressed' is false.

Then we move on to use a most important tool in the programmer's armoury, the 'if' statement. The syntax of an 'if' statement is

```
if (test){
   //Do this if test is true
}else{
   //Do this if test is false
}
```

The standard brackets contain the test. What could we use here? It can be anything that evaluates to *true* or *false*. In Chapter 7, we will look in detail at how to use the 'if' statement but for now just remember *true* or *false*. If something is *true* then do whatever is in the first set of curly braces. If it is *false* then do whatever is in curly braces following the optional 'else' statement.

We are using the clip event to move the bat up or down. It will move up if the 'K' key is pressed and down if the 'M' key is pressed. In Flash we can test whether a key is pressed using

```
Key.isDown(keycode)
```

The number in the brackets selects which key to test; you will learn how to find out a key's number later in the section on debugging. If the key is down then the result is *true*; if the key is not down then the result is *false*.

In the 'if' statement test we look for two things: one is the whether a key is down and the other is the value of '_y'. This value stores the position up and down the screen of the movie clip itself. To avoid it going too high we want to make sure that this value is always greater than 50. We can combine these two tests by using the operator '&&'. Now both the tests must be true for the combination of the tests to evaluate to true. This is called logical 'And'. Again, later we will look into combining logical operations; for now just accept that the test decides whether the K key is pressed and the movie clip is not too high up the screen. If all this is true then we move on to the code within the curly braces.

```
if (moveY>=0) {
   moveY = -1;
}else if (moveY>-15) {
   moveY *= 1.2;
}
keypressed = true;
_y += moveY;
```

What, another 'if' statement? Yes, programming often involves the use of many conditions. Here we know that the user is pressing the K key and that the bat is not yet in the top position. But we want the bat to speed up as it moves. So we use another variable; this time we have called the variable 'moveY' it could have been called 'threeBlindMice' but 'moveY' describes what the variable is used for and this is very useful when examining yours and other developers code. So what are we testing? If 'moveY' is greater than or equal to 0 then we do the bit in the first curly braces. The symbol '>' means greater than and obviously the symbol '=' means equals. So '>=' means greater than or equal to. If 'moveY' was equal to 0 then the bat was previously stationary, if 'moveY' was greater than 0 then previously the bat was moving down the screen. In either case we need to set the movement of the clip so that it is going to start moving up, which we will do by setting 'moveY' to −1.

A movie clip's location is set using the attributes _x and _y. If _x = 100 and _y = 100. Then moving the clip to (25, 80) would involve setting _x to 25 and _y to 80. This would have the effect of moving the clip to the left (by reducing the _x value) and moving the clip up (by reducing the _y value). Similarly if the clip is moved right and down then the _x and _y values would both increase.

If 'moveY' is already less than 0, then it must already be moving up so we want to speed up its motion as long as it is not already going too fast. In this instance we test the speed by using, yes, you guessed it, an 'if' statement. If 'moveY' is greater than −15 then we can speed up the motion by multiplying the existing motion by 1.2. If the speed was initially −1, then the speed after multiplying by 1.2 will be 1.2. Don't worry, the maths doesn't get much harder than that!! After we've done all that we can set 'keypressed' to true, because we know that the K key is pressed and we can move the bat by adding the moveY value onto the '_y' attribute for this clip. When you are adding, subtracting, multiplying or dividing in Flash, you can use one of two methods.

$x = x + 3$; or $x += 3$;

If x was initially 6, for example, then after either of the above x would be set to 9. I prefer the second option, simply because if x does equal 6 then it patently doesn't equal 9, so the use of the equals symbol can be confusing; what it means is assign the new value of x to be the old value plus 3. The symbol '+=' does not have a simple arithmetic alternative and so there is no confusion. If you prefer the first method then by all means use it, code is like that, you will get into ways of doing things that you will feel comfortable with and if it works for you and the method works then use it. But remember to comment any code; I cannot stress this too highly.

The next section of the code repeats all the same tests with the 'M' key. This time we test for a limit of movement down the screen by ensuring that '_y' is less than 270. When setting 'moveY' we initially set it to 1 rather than −1, because we are moving the bat down the screen and '_y' increases in value down. After testing for the 'M' key we finally check whether the variable 'keypressed', which was initially set to false, has been set to true. The '!' symbol in front of a true or false variable reverses the value of the variable. In English

```
if (!keypressed) moveY = 0;
```

would translate to 'if keypressed is not true then set moveY equal to 0'. So if neither the K nor the M key is pressed then 'moveY' is set to 0. That's all that is needed to move the bats up and down without them going off screen. Here's all the code for the right bat.

```
onClipEvent(enterFrame) {
    //Bat moves up when K(75) is pressed
    //and moves down when M(77) is pressed
    //Speed of the move is governed by moveY
```

```
//moveY is set to zero when neither move
//key is pressed. If there is a change in
//direction then moveY is initialised to 1
//for down or -1 for up. moveY is incremented
//by multiplying by 1.2 for each frame until
//the bat reaches maximum speed.

keypressed = false;

if (Key.isDown(75) && _y>50) {
   if (moveY>=0) {
     moveY = -1;
   }else if (moveY>-15) {
     moveY *= 1.2;
   }
   keypressed = true;
   _y += moveY;
}

if (Key.isDown(77) && _y<270) {
   if (moveY<=0) {
     moveY = 1;
   }else if (moveY<15) {
     moveY *= 1.2;
   }
   keypressed = true;
   _y += moveY;
}

   if (!keypressed) moveY = 0;
}
```

Now try running the program. You can do this by pressing 'Ctrl + Enter'; Flash then enters runtime mode, showing you how the user would see your game. At this stage the only thing happening is the movement of the right bat using the 'K' and 'M' keys.

Testing and debugging

If you have 'Examples/Chapter01/pingpong03.fla' open then you will see that there is a fourth layer, labelled 'Debug'. No developers ever get it all

right first time and when something doesn't work discovering where the errors are can be something of an art. One useful method is to send information to a text box that you can see on screen. You can create a text box by choosing the Text Tool (the A icon) and then placing your mouse on the stage and typing in some text. You can set the text box to operate as a Dynamic Text box using the properties panel for the Text Tool.

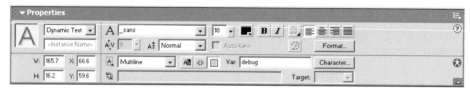

Figure 1.17 Setting up a Dynamic Text box.

In this example the settings are for a Multiline box that tracks the variable 'debug'. Now if you set the variable 'debug' to 'Hello' using ActionScript then that would appear in the box as the program runs. We can use this tool to test lots of useful information about our program. We will look into debugging in detail in Chapter 10.

The movement of the ball is a little more complicated than the movement of the bats. Open 'Examples/Chapter01/pingpong04.fla' and press 'Ctrl + Enter' to test it. Now the ball bounces off the walls and the bats. Stop playing the game and try right-clicking the ball and selecting Actions. Take a look at the code and see if you can work out what is going on. Don't worry if you can't, this chapter is just a quick introduction and although the code in the ball isn't too hard it is much more complicated than the script for the bats. By the time you have worked through the later chapters of this book it will all be second nature.

Adding a scoreboard

One thing that we can do to improve the game is to add a score. Those strange boxes that both have 123 in them will be where we put the score. The LeftBat scores every time the ball goes out of screen right and the RightBat scores every time the ball goes out of screen left. So how do we accomplish this?

Take a look at the section of code in the Ball clip event that follows the comment '//Ball moving right'. See how useful the comment is. Now you know that the Ball is moving right in this section. If it is moving right then the RightBat should hit it, if it doesn't then the LeftBat scores a point.

```
...
//Ball moving right
if (_x > 370) {
    _x = startX;
    _y = startY;
    moveX = 0;
    _root.LeftScore++;
    ...
```

If the Ball's '_x' value is greater than 370 then it is off screen at the right so we can add one to the LeftBat's score. This is achieved by the curious code

```
    _root.LeftScore++;
```

The '++' symbol simply means add one to the variable that comes before it. But, the variable isn't just called 'LeftScore', it is called '_root.LeftScore'. Why? Variables have something called scope. If we are in the clip 'Bat' and want to access a variable that is in a different clip then we can use one of two methods: either relative addressing or direct addressing. Let's look at an example; in the current example we have the hierarchy:

```
_root
    └ Ball
    └ LeftBat
    └ RightBat
```

All Flash movies have as the highest level of the hierarchy, '_root'. The value of 'moveX' in 'LeftBat' can be accessed from the 'Ball' by using '_root.LeftBat.moveX', each layer in the hierarchy being separated by the '.' operator. This method is direct addressing. The alternative approach uses relative addressing '_parent.LeftBat.moveX'; in this method we move up a layer from the current position, before looking in the movie clip 'LeftBat'. Although they seem similar they are actually quite different. A more complex hierarchy can often require several '_parent's before the appropriate clip can be accessed, such as '_parent._parent._parent.LeftPlayer.RightArm.Bat.moveX'; if the clip called 'LeftPlayer' was at the root of the movie then the same variable can be accessed using '_root.LeftBat.RightArm.Bat.moveX'. In the current example the score variables are at the '_root' and so when we are in the 'Ball' clip we need to append '_root' to the name of the variable in order to access them.

Variable scope can be a confusing issue and is covered in much more depth in Chapter 6.

Having inserted in the code to add the score for the 'LeftBat' we repeat by adding the score for the 'RightBat'.

```
...
//Ball moving left
if (_x < 30) {
    _x = startX;
    _y = startY;
    moveX = 0;
    _root.RightScore++;
...
```

The final stage of the game is saved as

'Examples\Chapter01\Pingpong05.fla'.

How to improve it

To finish the game there needs to be a beginning and an end. The beginning would give instructions for keypresses and the end would show the final score. In this simple example we will exclude these details but you are encouraged to develop the game further to include these aspects as your skills progress.

Playing against the computer

It would be nice if the player could compete with the computer. To achieve this one of the bats could be under computer control, the clip event for the bat would judge where the ball would hit the bat and move the bat accordingly. Although this is a little complicated it should be within your abilities after completing Section 3 of this book. When the computer is in control it may be impossible for the player to win. It is your job as a developer to set the skill level so a player is not frustrated, but is challenged. Setting the game play level so that a player is progressively challenged as their skill level develops is one of the hardest aspects of game play development but one of the most important.

Summary

This was a quick look at creating a Flash game; hopefully it gave you an overview. If you found the code confusing then don't worry, we will be going at a much slower pace in the later chapters when looking at ActionScript. In principle, I want you to take away from this chapter an initial awareness of the Flash interface, how to use some of the drawing tools, the use of symbols and where to enter bits of ActionScript. As you progress through the book you will be encouraged to enter your own code and develop on the examples that you will find in later chapters. Nothing improves your skill more than trying it out yourself. Practice really does make, if not perfect, then at least much better.

Section 1
Animation

The first section looks at creating the artwork and animation that will feature in the games we create.

2 Drawing with Flash

Flash provides you with all the tools you will need to create great games. In this chapter we look at the basics of using the package to create artwork. Most games will require animated artwork and later in the chapter we will look at the principles of animation.

The Flash toolbox

Flash includes all the drawing tools you need to create character animation; indeed, some professional studios are now using Flash to produce TV animation. Unlike some drawing applications there are not many tools to learn. Before we start to do any drawing let's look at all the tools and what we can use them for.

The tools in the toolbox let you draw, paint, select, and modify artwork, and change the view of the Stage. The toolbox is divided into four sections:

- The Tools section contains drawing, painting and selection tools.
- The View section contains tools for zooming and panning in the application window.
- The Colors section contains modifiers for stroke and fill colours.
- The Options section displays modifiers for the selected tool, which affect the tool's painting or editing operations.

We will look first at using the drawing and painting tools.

Using the drawing tools

The Line tool

Click and drag to draw a straight line in the currently selected colour and stroke. To select a different colour, choose 'Window/Color Mixer' to open the colour mixer panel. You can select a colour by clicking in the colour

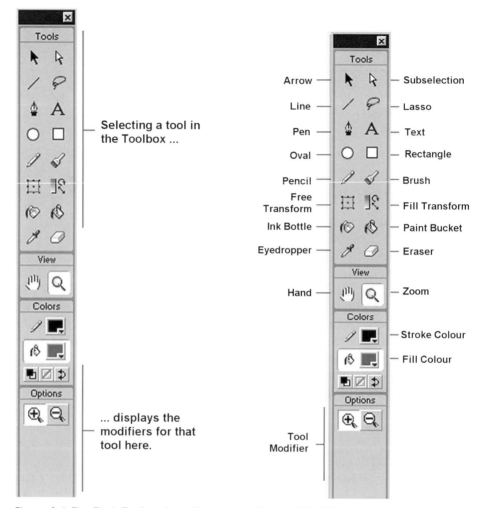

Figure 2.1 The Flash Toolbox in outline. *Figure 2.2 All the tools named.*

spectrum box, use the bar to the right to set the brightness; you can also set the level of opacity using the 'Alpha' setting. The number underneath the box displaying the current colour is the Hexadecimal equivalent. Internet browsers use this number to set the colour of backgrounds and fonts.

To adjust the stroke, that is the line width and style (solid, dotted etc.), use the Arrow tool to select the line. You will find that the Properties window, which is context sensitive, will be similar to that shown in Figure 2.5.

You can adjust the stroke width using the arrow next to the box displaying a '1' in the diagram. You can also choose whether the line is solid or not using the combo box to the right of the stroke width selector.

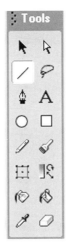

Figure 2.3 Selecting the Line tool.

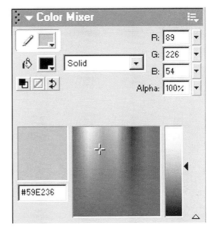

Figure 2.4 Selecting a colour in Flash MX.

Having selected a colour and stroke, try drawing a few lines. If the 'Magnet' button is selected then the lines will jump to horizontal or vertical if they are close to those angles. If 'View/Grid/Snap to Grid' is selected then the ends of the lines will jump to an invisible grid as you draw. You can edit the grid using 'View/Grid/Edit Grid' and you can display the grid using 'View/Grid/Show Grid'.

If you want the line to be curved then select the black 'Arrow' button in the 'Tools' panel. Move your mouse close to the ends of the line. Notice that the cursor shows a corner icon, while away from the ends the cursor shows a curve icon. If the mouse displays a corner then clicking and dragging the mouse will move the corner of a curve. If the mouse cursor image shows a curve then clicking and dragging will bend the curve. If you double-click on the line then you will select the entire curve. The mouse cursor will show the 'Move Object' image. Clicking and dragging will move the whole line.

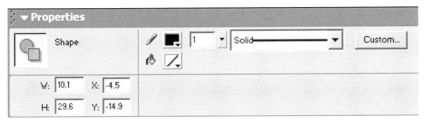

Figure 2.5 Adjusting the stroke characteristics.

Figure 2.6 Arrow tool cursor images.

If you want to get a curve that doubles back on itself then you will need to cut through the line.

1 First draw a simple line by clicking and dragging.
2 Bend the line using the Arrow tool.

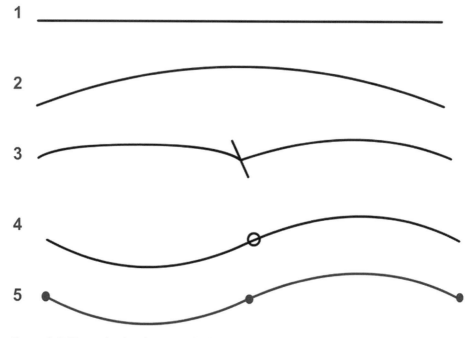

Figure 2.7 Stages in drawing a multiple curve line.

3 Draw a line across the first. Bend one side differently from the other.
4 Delete the short line by clicking on the line segment and pressing the 'Delete' key.
5 With magnet on, move the middle of the line until the circle is displayed.
6 If you select the 'Subselection' (white arrow) tool then you will see that the curve now has three handles.

The 'Subselection' tool can be useful when you want to see how Flash is actually drawing the curves that you create. It highlights the 'handle' in the curve whereas the 'Arrow' tool lets you do the same editing without showing the underlying structure.

The Pen tool

The 'Pen' tool is used for creating precise curved lines. Start by clicking with the mouse, this defines the start of the line; now click for each

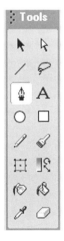

Figure 2.8 Selecting the Pen tool.

connected line segment. The upper curve in Figure 2.9 shows the first stage in creating a curved line with the 'Pen' tool. Having placed the basic 'straight edge' curve, now select the 'Subselection' (white arrow) tool and click on a 'handle', a blue circle or square; by moving the handle, or adjusting the tangents (the short sticks that protrude from a handle), you have total control over the flow of a complex curve. Try doing it now to familiarize yourself with the method.

Figure 2.9 Using the Pen and Subselection tools.

The Oval tool

The 'Oval' and 'Rectangle' tools can use both the stroke and the fill colours. If a stroke is selected then this will form the outline for the oval or rectangle. If a fill colour is selected then this will be the colour for the interior fill. The tools are used simply by clicking and dragging to reshape.

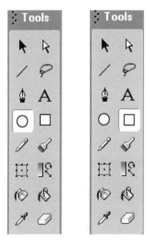

Figure 2.10 The Oval and Rectangle tools.　　　　Figure 2.11 Options for the Arrow tool.

Once you have created an Oval or Rectangle it can be adjusted with the 'Arrow' or 'Subselection' tools. Any vector artwork that you place on the stage is made from lines and fills. So an Oval or Rectangle is just a set of lines and fills.

Figure 2.11 shows the options for the 'Arrow' tool. The first option is 'Magnet'; using this causes dragged artwork to snap to objects. The next two buttons allow you to 'smooth' or 'straighten' the edges of a selection. You can easily bend the edges of a rectangle or adjust the curve of an Oval using the Arrow tool.

The Pencil tool

The Pencil tool uses the current stroke settings. To use the tool, select it in the Toolbox, then select the options you want.

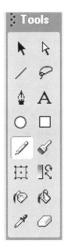

Figure 2.12 Selecting the Pencil tool. Figure 2.13 Options for the Pencil tool.

Straighten causes the lines that you draw to be drawn as straight connected line segments. Smooth creates smooth lines if they are within the boundaries set for your current preferences. You adjust your preferences using 'Edit/Preferences . . .'. The setting to check if you are not happy with the way the line is smoothed is 'Smooth curves:' under the 'Editing' tab.

The final option for the Pencil tool is to set it to Ink mode. In this mode the freehand drawing that you do is not affected by Flash and you see exactly what you draw.

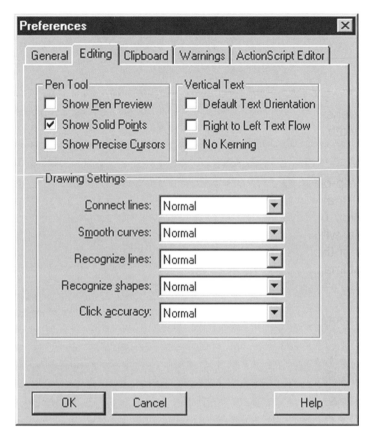

Figure 2.14 Adjusting Drawing Settings using Edit/Preferences . . .

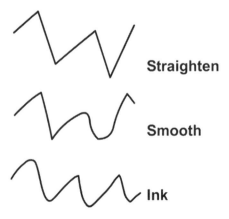

Figure 2.15 The effect of the different options for the Pencil tool.

The Brush tool

The Brush tool, unlike the Pencil tool, does not take the current stroke settings. A Brush uses the fill settings, because you are creating a fill when using the Brush tool.

The options for the Brush include how the Brush is applied, whether pressure sensitivity should be used. If you have a pressure-sensitive tablet then the width of the Brush is affected by the pressure you apply to the pen when you use this option. Without a pressure-sensitive tablet this option will not be available. A drop-down box allows you to select the brush size and a second drop-down allows you to select the brush shape. Finally, you can lock the fill that you are drawing to another fill area.

When you use the Brush it can be applied normally, within fills only, behind fills, within a selection area or inside an object. Figure 2.19 shows the effect of the different modes.

The first image shows the original artwork. The second shows the effect of using 'Paint Normal' here; everything on the current layer is overwritten

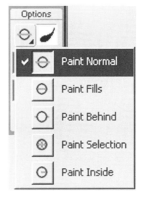

Figure 2.16 Selecting the Brush tool.

Figure 2.17 The options for the Brush tool.

Figure 2.18 The Brush mode option for the Brush tool.

Figure 2.19 Using the different Brush modes.

Figure 2.20 The effect of using pressure and different Brush shapes.

by the application of the brush. Image 3 shows the effect of 'Paint Fills', only fills are overpainted, not lines. Image 4 uses 'Paint Behind'; now any fill or line on the layer is protected and only blank areas are used. To use 'Paint Selection' you obviously need a selection. Finally 'Paint Inside' applies the Brush to the fill that is under the mouse cursor when the mouse is first pressed.

The Free Transform tool

The Free Transform tool allows you to rotate, scale or distort a selection. The tool has four options, shown in Figure 2.22.

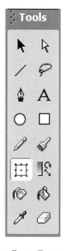

Figure 2.21 The Free Transform tool.

Figure 2.22 Options for the Free Transform tool.

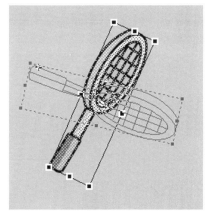

Figure 2.23 Rotating a selection.

Figure 2.24 Skewing a selection.

Option 1, Rotate and Skew, allows you to rotate the current selection. When rotating, placing the mouse cursor over a corner handle changes the mouse cursor into a circular arrow. In this mode a click and drag allows you to rotate the selection.

If the mouse cursor is over the handles at the middle of the edge lines then a click and drag will skew the selection.

The second option is to Scale the selection. When using the Scale option, clicking and dragging in the corners scales the selection, while

Figure 2.25 Scaling a selection.

clicking and dragging the middle handles allow you to stretch a selection in one axis only.

Option 3, Distort, allows you to pick up the corners of the selection and distort them; it is useful for adding perspective into a drawing.

The final option, Envelope, allows you to distort a selection in a very complex way, introducing curves where lines were previously straight.

Figure 2.26 Distorting and applying an envelope to a selection.

The next button on the Tools toolbar is the Fill Transform tool; we will look at that a little later.

The Ink Bottle tool

As you know, Flash distinguishes between lines and fills. If you want to change the characteristics of a line then select the 'Ink Bottle'. By changing the current stroke colour and current stroke width and style you can, by clicking on a line, fill that line with a new line style and colour.

The Paint Bucket tool

If you want to affect the colour of a fill area then use the 'Paint Bucket' tool. The options panel for the 'Paint Bucket' allows you to select how to fill an

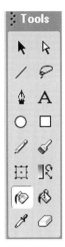

Figure 2.27 Selecting the Ink Bottle tool.

area that is not fully surrounded. A small gap may exist; Flash can still fill the area if you select 'Close Small Gaps' from the 'Gap Size' menu. If this still doesn't work then you can choose either 'Close Medium Gaps' or 'Close Large Gaps'. The lower button on the options panel is 'Lock'.

Filled areas can be a colour, a gradient or a bitmap fill.

To use a gradient select a linear, radial or bitmap fill in the colour mixer panel. You can add as many colour segments to the gradient bar as you need to make the gradient. Now click inside a bounded area, making sure

Figure 2.28 Selecting the Paint Bucket tool.

Figure 2.29 Options for the Paint Bucket tool.

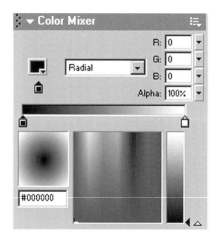

Figure 2.30 Selecting a gradient using the Fill panel.

that 'Lock Fill' is unselected. The area is filled with the gradient. If the positioning of the gradient is not to your liking then you can choose the 'Fill Transform tool' button and click on the gradient. You will get something like the image shown in Figure 2.29, if you have chosen a radial gradient. You can move the centre of the gradient using the central circle handle. The square handle stretches the scale of the gradient. The circle on the outer edge between the two other handles sizes the gradient and the

Figure 2.31 Moving a gradient using the Transform Fill option.

lower circle rotates the gradient. If you selected a 'Linear Gradient' then the handles for adjusting the gradient will be rectangular. The square one is for stretching and the circular one for rotating. Position is adjusted by clicking and dragging the central circular handle.

If you want to fill an area with a bitmap then import a bitmap into Flash using 'File/Import . . .'. Select the bitmap by clicking on it and choose the menu option 'Modify/Break Apart'. The bitmap selection changes from a surrounding rectangle to a patterned area. If you use the 'Eyedropper' tool, then you can pick up the image as a fill. Now click on an area to apply the image. If the area is bigger than the image then the image will be repeated in both the width and height.

The basics of animation

Now that you know the basic drawing tools we are ready to start work on a little animation. Animation on TV uses around 12 drawings to the second, because these still drawings are changed so quickly we perceive the images as showing a moving image. In Flash the pace with which the images are changed is set using the 'Modify/Document . . .' dialog box or by clicking in a blank area of the stage; the context-sensitive Properties panel will show dialog controls that allow you to alter the movie's frame rate. The default Movie frame rate is set to the TV favourite of 12 frames per second. Just to get started let's bounce a ball. Open 'Examples/Chapter02/Ball.fla'. In this project there are three scenes. Take a look at scene one. Choose 'Control/Loop Playback' then press 'Enter' to see the

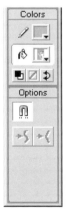

Figure 2.32 Using a bitmap as a fill.

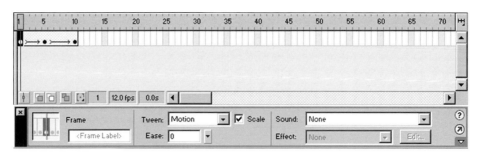

Figure 2.33 Using motion tweening in Flash.

ball move. The ball does move but it is not very 'bouncy'. To stop the animation press 'Enter' again.

The animation has been done using motion tweening. First the 'Ball' was drawn and then this was turned into a graphic symbol by pressing F8, or selecting 'Insert/Convert to Symbol . . .' from the menu. A position was set at frames 1, 6 and 12 by pressing F6 to insert a keyframe then moving the Ball symbol. Finally frames 1–6 were selected and, using the 'Frame' panel, tweening was selected for these frames. The motion produced using this technique is illustrated in Figure 2.32.

The motion produced by Flash, by default, using tweening is a linear interpolation from one key position to the next. That is, the gaps between the positions will be the same for each step. To see how the motion will behave, turn on onion skinning using the button at the second from the left at the bottom of the timeline area. Having selected onion skinning, you

Figure 2.34 First step to a bouncing ball.

Figure 2.35 Selecting onion skinning.

can choose how many frames are displayed using the grey areas to the left and right of the current frame rectangle in the timeline.

To improve the movement we want the action to slow down up to the maximum height then speed up as the ball falls under gravity. To do this we set the 'Easing' for frames 1 to −50 and the 'Easing' for frames 6 to −50, using the properties panel for a frame. This gives a somewhat more realistic action but the motion is still not a curve. There are two ways to achieve this. Either we can put keyframes in throughout the animation and not use motion tweening at all or we can use a curve to control the motion.

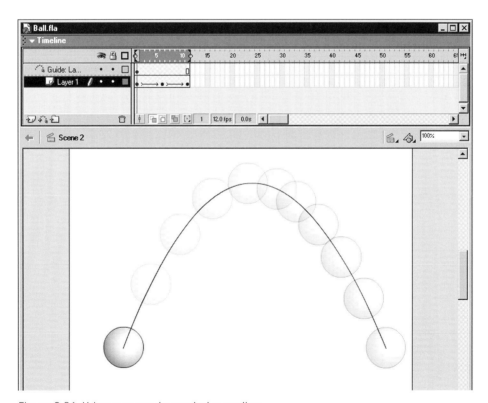

Figure 2.36 Using a curve to control a motion.

The latter option is the best to use for simple actions while keyframes throughout works best for complex actions.

To control an animation with a curve, first put the start and end frames for the ball, then right-click the layer and choose 'Add Motion Guide'. This adds a new layer above the current layer. Draw a curve in this layer and then with the 'Magnet' on snap the ball to the start of the curve on the first frame and the end of the curve on the last frame. The ball will now be centred around the curve.

Figure 2.37 Using keyframes throughout.

Scene 2 from 'Examples/Chapter02/ball.fla' shows how this motion can be set up. The 'Easing' has been set by adding an extra keyframe at frame 6. The 'Easing' for frame 1 is set to 50 and at frame 6 the 'Easing' is set to −50.

Designing a character

Personally I don't think you can beat a real pencil for getting the feel for a character design, but some colleagues prefer to use a tablet and draw directly in Flash. Whichever method you choose you will need to be

Figure 2.38 First scribbles for a character.

Figure 2.39 The final design.

prepared to revisit your design many times before a really good character design develops. Character design is greatly affected by the fashion of the moment. Nevertheless there are a few golden rules.

- Make sure the character is distinctive.
- Be prepared to exaggerate features.
- Keep the design simple.
- Think in colour not black and white.

Dramatic performance in most games is usually very limited. Your character will rarely be called on to be a great actor, but an expressive face is usually going to be an asset to a design; it is better that your character can convey a range of emotions, even if they will not be called on to prove it.

Summary

Flash is a great tool for experimenting with animation. In this chapter we looked at the principal drawing tools and studied some methods for producing simple animation. In the next chapter we will look at creating effective character animation with the minimum of artwork.

3 Simple cut-out animation

Flash is often used to display animation within a web browser. In many parts of the world most web users still access the web using a modem. Their connection speed is around 4 K per second. That means that a 40 K file will take 10 seconds to download, while a 400 K file will take around 100 seconds. As a developer you need to be aware that the patience of your viewers is limited. File size is likely to be a huge issue for Internet developers for the next several years. In this chapter we will look at how you can create animations that look fluid while using a minimum of artwork. This has a dual benefit: it is quicker to produce and it results in smaller file sizes.

Segmenting a character

Cut-out animation is produced by splitting a character into small segments and then animating the segments simply by moving and rotating. If you intend to use motion tweening, a very fast method for moving and rotating symbols in Flash, then you will need to place each segment on a separate layer. In this chapter we will take a very simple cat character and create several walks of increasing sophistication. The character was drawn directly in Flash using the drawing tools discussed in the previous chapter. Then the character was divided into sections by using the Lasso tool. To select the Lasso tool you need to click the 'Tools' button indicated in Figure 3.2.

To use the Lasso tool open the project 'Examples\Chapter03\FatCat.fla' and select the Body symbol from the library. Draw around the character by clicking and holding the left mouse button. The selected area will show an overlaid dot pattern. To convert a selected area into a symbol press F8 or choose 'Insert/Convert to Symbol . . .' from the menu. In the dialog box choose 'Graphic' as the symbol type and enter a descriptive name. The selection will change from the dot pattern to a bounding box. The name

Figure 3.1 The segments in the simple walk.

that you give the symbol will be the name displayed in the Library. You can view the 'Library' at any time by pressing F11 or selecting 'Window/ Library' from the main menu. When the segment is a symbol you can use it as many times as you like either by dragging it out of the Library or by copying an instance of it on the stage and then pasting the instance into

Figure 3.2 Selecting the Lasso tool.

Figure 3.3 *Selected area.*

a new frame or new layer of the current frame. You can even paste a duplicate of the symbol in the current layer, but remember that this will not work with motion tweening. The next step is to ensure that the rotation centre is correct.

If you intend to use motion tweening then it is important that the point about which the segment will rotate is carefully chosen.

To adjust a symbol's pivot point select the Free Transform tool from the Tools palette and move the white circle. The white circle defines the point about which the symbol will rotate. To get an accurate placement it is usually best to use the 'Zoom' tool. Using the 'Zoom' tool you can move

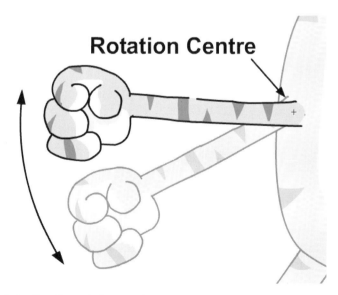

Figure 3.4 *Selecting the rotation centre.*

in and out by selecting either the '+' option or the '−' option and clicking, or you can drag a rectangle and then Flash will resize to suit this rectangle. The amount the artwork moves when using the arrow keys is dependent on the scale of your view of the artwork, because the pixel movement refers to screen size not the original size of the artwork. Move the white circle until the rotation centre is in the most appropriate place. It is important that you understand the difference between the positioning of the artwork inside a symbol in relation to its rotation centre and the positioning of a symbol on the stage. This difference is very important. You can move the rotation centre so that it is a long way from the artwork inside a symbol, but the problem is that when you start to rotate the symbol it will stray away from where you intend it to be; consequently, you will need to add multiple keys to get it back in place. These multiple keys negate the advantage of using motion tweening. If you find you are having to use a great number of keyframes because of problems occurring when you rotate a symbol then it is often best to check the location of the pivot centre using the Free Transform tool.

A first walk with this character

Now is a good time to open the project 'Examples/Chapter03/FatCat.fla'. Take a look at 'Scene 1'. Recall that you can select the current scene using the 'Edit Scene' button at the bottom right of the timeline or by using the 'Windows/Panels/Scene' panel.

Take a look at Figure 3.1 and you can see that the segmenting of this character is very simple. Each segment appears on a new layer inside a new symbol called 'Walk1'; double-click on the character to see it. On the root timeline there are keyframes for the symbol 'Walk1' at 1, 7, 9, 15 and 17. These ensure that the cat goes up and down as he walks. Because all the limbs are inside the symbol 'Walk1' these will go up and down with the body so the arms and legs will not become separated from the body as it goes up and down. Nesting symbols inside other symbols in this way can make your animations easier to prepare. But, before we put in the keys for the main 'Walk1' symbol, we need to prepare the main key positions.

Figure 3.5 shows the extreme positions for the cat. The left leg is fully back at frames 1 and 17, while the right leg is back at frame 9. The arms are opposite to the legs; when the right leg is fully forward the right arm is fully back. Always refer to your segments in relation to the character. The right arm should always be the character's right arm. If the character is facing you then it is tempting to call their right arm the left arm, because it is on the left in the screen view. But at some stage the character will be

Figure 3.5 The principal keys in the simple walk.

side on or from the rear: at what point do you swap? At least if the segments always refer to the character's right side then you can work it out and it becomes less confusing. Make the key positions that you have entered into 'Motion' either by selecting the frame in the timeline and choosing 'Create Motion Tween' from the context menu or by selecting 'Motion' from the 'Tween' combo box in the context-sensitive Properties panel for a frame. The character is now animated. Make sure that 'Control/Loop Playback' is checked in the menu and play the animation using the 'Play' button, 'Control/Play' from the menu or by pressing the 'Enter' key. Because you are inside the symbol the cat's legs and arms swing but the body does not go up and down. Go back to the root timeline either by double-clicking in an empty space or clicking on 'Scene 1' at the upper left corner of the timeline. To complete this animation, adjust the height of the 'Walk1' symbol at frames 1, 7, 9, 15 and 17 so that the feet stay on the floor. Make frames 1, 7, 9 and 15 'Motion' type frames and play the animation. It's very stiff but at least it has started to move in a very basic way. You have a walk this way in very little time and if you do a 'Control/Test Scene' you will see that the file size for this scene is only 6 K, not bad for an animation.

Figure 3.6 Selecting the current scene.

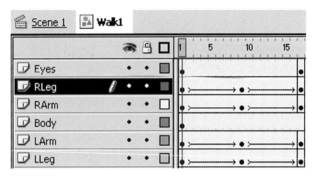

Figure 3.7 Using motion tweening for this animation.

Improving the walk

To improve the walk the arms and legs will need further segmenting. At this stage the benefits of nesting clips inside clips start to be outweighed by the difficulties of actually editing the animation. The segments we are going to use are shown in Figure 3.8. Each of the named segments is a symbol in the library. The layers used have been reduced somewhat because we are not going to use any motion tweening, we are going to add all the keys individually. Take a look now at 'Scene 2'.

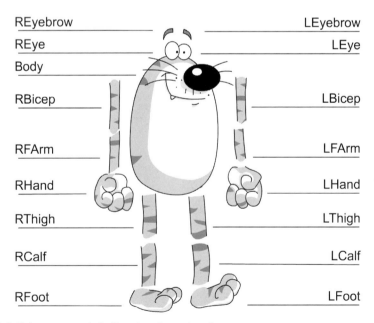

Figure 3.8 Extra segments in the developed walk.

Because all the positions are going to be individually animated this animation will take a little longer to do. First set up the extremes, the stretched leg positions at frames 1 and 9; 17 is simply 1 repeated because we want the animation to loop. Second, put in the passing positions at 5 and 13. The body will be higher at the passing position.

Then add in the down positions at 3 and 11 and the up positions at 7 and 15.

Finally, do all the in-between positions by using the onion skinning technique. To use onion skinning, click on the onion-skinning button in the lower left of the timeline. Select the range of the onion skinning by moving the circle handles in the onion-skinning range indicators. Onion skinning allows you to see the frames that precede the current frame and those that follow it. The fewer preceding and following frames that you view the easier it is to work out what is happening; for these final in-betweens you need only view one preceding and one following frame. To do the in-

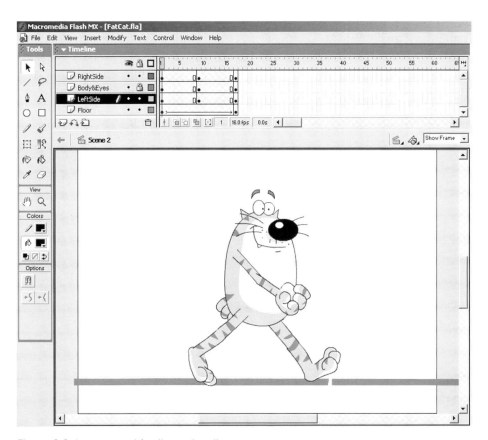

Figure 3.9 Layers used for the animation.

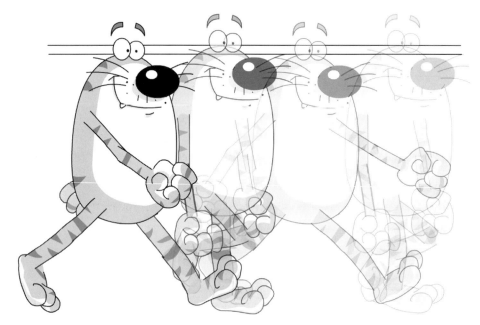

Figure 3.10 The extremes and the passing positions.

Figure 3.11 Adding the up and down positions.

betweens start by just moving the body, feet and hands. If you have difficulty moving a segment because it is behind another, lock the offending layer using the lock button in the timeline options.

Before you move the thighs, calfs, biceps or forearms, switch off onion skinning. You will have a much better view of the artwork by then and the position of the body, feet and arms will dictate where the other segments need to go. 'Scene 2' through to 'Scene 5' show various stages of creating this walk. I hope you agree that it is much looser than the first walk. This is a standard walk but a standard is made to be broken. 'Scene 6' shows how the walk can look by making the passing position a low position. The effect is to create a walk with a double bounce; it is a popular technique for many cartoon characters. Try to adjust the walk to get as much life and vitality as you can.

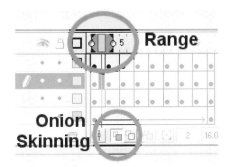

Figure 3.12 Selecting onion skinning.

We have made progress but the character is still rather glazed. We need to add a blink.

Combining cut-out animation and cell animation

The blink is added to the eye symbol. But the eyes are inside the body symbol, so how do we get them to show the correct frame? Now is when we really need to discover the difference between a 'Graphic' and a 'Movie Clip'. A 'Movie Clip' is independent of the main timeline. At design time it will only show frame 1; however, at run time it will show a looping animation unless told differently. Because we are creating animation and do not intend to control the eyes from 'ActionScript' we set the 'Eyes' to be a Graphic. The 'Body' is also a 'Graphic'. 'Graphics' try to keep in step with the timeline. If we place a 'Graphic' on the timeline at frame 11 and

the graphic contains six frames, then at frame 16 the 'Graphic' will be displaying frame 6. If we go on to show frame 17 then by default the 'Graphic' will loop back and show frame 1. This behaviour can be easily adjusted; however, a 'Graphic' can be set to 'Loop', in which case a six-frame graphic will loop four times as the timeline moves on 24 frames. The 'Graphic' can be set to 'Play Once', in which case the size trame 'Graphic' will play once then stop on frame 6 as the timeline moves on 24 frames. The third and final alternative for a 'Graphic' is to display a single frame, in which case a six-frame 'Graphic' will display a static frame as the timeline moves on 24 frames. To create the blink we will add two frames to the 'Body' symbol, simply by clicking in 'Body' layer on frame 3 and pressing F5. The timeline shows a grey bar stretching from frame 1 to frame 3. Now we edit the eyes to include frames 2 and 3, which are edited as shown in Figure 3.13.

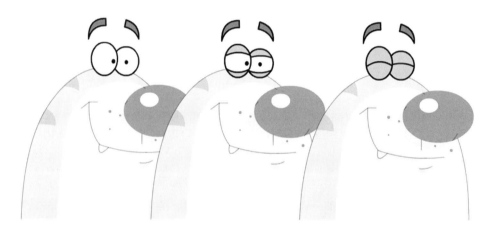

Figure 3.13 Animating a blink.

In the 'Body' clip set frames 2 and 3 to show frames 2 and 3 of the 'Eyes' clip. To do this click on an eye. In the Properties panel you will see that the 'Behaviour' is set to 'Graphic', the method to 'Single Frame' and the 'First' option is set to the frame that you wish to display. Alternatively you could set the first frame to 'Play Once', in which case the eyes would stay in sync with the timeline for their parent. You should find that displaying frame 2 of the 'Body' symbol shows half closed eyes and frame 3 closed eyes. Now switch back to the main timeline. To get the blink to display you will need to set the frame to display for the 'Body' clip. If you look in 'Scene 7' and click on the 'Body' layer frame 4, you will see that the frame to display is set to 2, for frame 5 it is set to 3 and for frame 6 it is

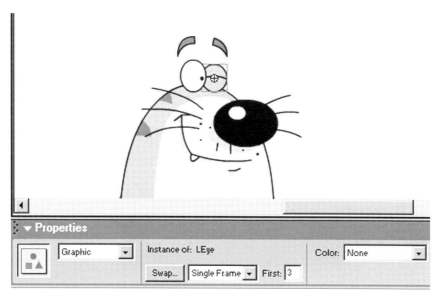

Figure 3.14 Setting the appropriate frame.

set to frame 2. Finally, frame 7 goes back to the default behaviour of displaying frame 1. Controlling the displayed frame by using 'Graphics' and the three display options gives you total control over the behaviour of nested animations and is the preferred method for animation that does not require user intervention. Later in the book we will look in detail at how user input can be used to control the behaviour of 'Movie Clips'. 'Movie Clips' are much more flexible when dealing with interactive behaviour, but because they only display frame 1 at design time they are not very suited to creating animations. You can easily embed 'Graphics' inside a 'Movie Clip' to get the best of both worlds.

Creating a usable sprite

We will finish this chapter by showing how the animations you have created can be combined to create a sprite character and place this under simple user control. What we are going to need is a standing animation, a start walk animation, a stop walk animation and a turn. Then we will need all the animations facing the opposite direction. 'Scene 8' shows all these actions. Each action must link to another for the animation to flow smoothly. We can move between actions using labels.

You can see from Figure 3.16 that the labels in the sprite animation are:

AmbientRight
StopRight
StartRight
WalkRight
AmbientLeft
StopLeft
StartLeft
WalkLeft
TurnLeft
TurnRight

Notice that the labels are all added to a separate layer. Although this is not strictly necessary it is the recommended method. The same layer is used for any code we are going to add. At the end of the 'AmbientLeft' and 'AmbientRight' actions we force the playback head to move back to 'AmbientLeft' or 'AmbientRight' respectively using the following 'Action-Script' statement.

```
gotoAndPlay("AmbientLeft");
```

or

```
gotoAndPlay("AmbientRight");
```

Figure 3.15 Creating a new pose for the turn around.

	5	10	15	20	25	30	35	40	45	50	55	60	65	70	75	80	85	90

AmbientRight StopRight StartR WalkRight AmbientLeft StopLeft StartL WalkLeft Tur Tur

Figure 3.16 The timeline for the cat sprite.

To add 'ActionScript', click on the frame where it is going to go, making sure that you have a keyframe in this position. If no keyframe exists then press F7 to create a blank keyframe. Then select 'Actions' from the context menu or select 'Window/Actions'. This opens the 'Actions' panel. This panel can be used in either 'Normal' or 'Expert' mode. In this book we are going to stick to 'Expert' mode because you will be told exactly what to enter at first and by the end you will all be experts! Select 'Expert' mode using the menu that can be accessed using the forward/right arrow icon at the top right of the Action panel. Make sure the 'Expert Mode' is checked and then type in the command above.

Most of the script simply tells the playback head to move to another label. The only code that is a little more complicated is for the loop back for the walks; in this code the keyboard is tested and if the arrow keys are not down then the playback jumps to the 'StopLeft' or 'StopRight' depending on the current direction. Now that the animation is all prepared we need to place this inside a symbol. Open the project 'Examples/Chapter03/FatCatSprite.fla'. In this project the animations from the earlier project have all been pasted into a symbol called 'Cat'. To paste the frames simply select them all and choose 'Copy Frames' from the context menu or 'Edit/Copy Frames'. Then move to the new location and choose

Press Right arrow to start walking

Figure 3.17 Moving the character using the keyboard.

'Paste Frames' from the context menu or 'Edit/Paste Frames' from the main menu bar.

By pressing the left or right arrow keys the cat will now walk either left or right, turning at the edges of the screen. See if you can work out how the code works, it is very simple and after you have completed Section 3 of this book you will definitely understand exactly how it is done. But that is for a later chapter.

Summary

In this chapter we looked at how to create interesting and dynamic animation that is both quick to produce and small in file size. We looked at creating this using motion tweening and using keyframes. We looked at how to enhance a cut-out animation using additional drawn frames and how the playback of these can be controlled by setting the properties for a 'Graphic'. Finally we looked at connecting several animation loops together so we can put a character under user control. In the next chapter we will look into how we can create animations using computer animation packages and import these into Flash.

4 Using CGI programs to create animation

Although Flash is a great tool for creating and editing drawn animation, another method for creating animations for Flash games is to use a computer animation program. Teaching the techniques required to use all the many computer animation programs is way beyond the scope of this book, but the principles common to all programs are briefly covered in this chapter. Having created your animation you then need to get them into Flash. To do this you can use certain import methods such as swf generators like Vecta3D, Swift3D and Flicker or you can use bitmap images directly from within Flash. We will consider the options, which you can then judge from both a design perspective and the impact on file size. A further option that will lead to the most highly optimized files is to hand trace the images that are created by the CG programs. We will look at how, by tracing the images, you can achieve file sizes one sixth that of using trace bitmaps. Along the way we will create a couple of test animations to highlight the differences between the methods in terms of both design and file size.

Character animation using a computer animation program

Since 1985 I have been the managing director of an animation company in Manchester, UK called Catalyst Pictures. At Catalyst we have been using Lightwave for character animation since 1998. The reason is totally pragmatic; it is the cheapest program to offer all the facilities needed for TV quality character animation. Indeed, as I write the first full feature to use Lightwave throughout is just opening in UK theatres, *Jimmy Neutron*, for which I wrote a little character animation plug-in called 'Bendypoints'. As you no doubt gather I am something of a CG fan. Having spent the best part of 12 years doing drawn animation for clients who seem to like nothing better than changing things for no reason, CG is an absolute

blessing. If the character changes colour or has to move faster or should be viewed from the left, right, top or bottom, then the CG work has the blessing of being constantly editable. This is in marked contrast to drawn animation, where almost all changes mean starting from scratch. The character that you see in this chapter was created from a clean sheet and animated in a morning by one person. There is no way that a drawn character could ever be done in that time. OK, let's look at the process.

Modelling with a CGI program

Computer animation is a three-stage process. First, you create a virtual model of the character that you are going to animate, then you animate and finally you render. When modelling, most CGI programs show four views of the model, as you can see in Figure 4.1. These days, interfaces are all so configurable that you can usually set up the display to show you whatever you like, but the default is to show a top view of the character in the display to the top left, a front view in the bottom left, a 3D view in the top right and a side view in the bottom right. Different programs approach

Figure 4.1 Fatcat in Lightwave 7.

modelling in different ways. A few years ago there was a craze for NURBS (Non-Uniform Rational B-Splines) modellers. This craze has waned because NURBS modelling is extremely hard to do for arbitrary meshes. What is an arbitrary mesh? It is a mesh that has points that sometimes have six lines meeting and sometimes more or less. A totally standard mesh of triangles would have six lines meeting at every point.

Figure 4.2 A 'standard' triangular mesh.

The new craze is for polygon modellers that use subdivision surfaces. A polygon model is the simplest type of model that you can have in CG. Essentially, to create a polygon model you join points in 3D space to create a polygon; usually you will create either three- or four-sided polygons. Having created this mesh, the software uses the polygon mesh as a control cage; each polygon is converted into four polygons for each subdivision. With three or four divisions you have a smooth shape. Take a look at the first of the strip of images in Figure 4.3. Look at the point at the top of the cat's right shoulder. Notice that eight lines meet at this point, while the point immediately above it has just six lines meeting. This is possible for a polygon cage; indeed, any number of lines can meet at a point, but a NURBS cage has to have the same number of lines meeting for every point.

To show how the cat model was developed, we will look at the Lightwave modeller. As a polygon modeller Lightwave is often considered the best there is and after using it you will quickly see why. The tools you use are very simple and easy to use. For the cat model we first start with a basic ball.

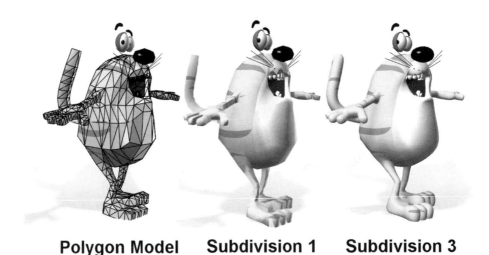

Polygon Model **Subdivision 1** **Subdivision 3**

Figure 4.3 Using subdivision.

All polygon modellers offer a ball creator. In Lightwave you can specify how many segments around the ball there are and how many slices. Having created the ball, certain polygons are pulled around to create the inside of the mouth. If you look closely at the side view you can see how what used to be the cap is now inside and facing in the opposite direction. As you create a polygon model you will constantly be adding and modifying the geometry. In Lightwave a useful tool is the knife, which allows you to cut through a model and so create more geometry. Another useful technique is to smooth shift a polygon. Notice in Figure 4.4 that the top right view shows two sticks pointing out of two polygons. By highlighting the polygons in this way and selecting the 'Smooth Shift' tool we can add geometry. The polygon is moved in the direction of the lines and four new polygons are added to fill in the gap.

We can repeat this method several times to create the geometry that we will use for the arms and legs.

Having added the geometry we then resize the bits to fit the design we are creating. Next we need to create the hands and feet, which we do using Smooth Shift and the knife tool to create more geometry. Again, a little dragging of the points and we have a rather clumsy hand shape. One of the features of subdivision surfaces in Lightwave is that they tend to be slimmer than the control cage. So we often need to create a control cage that looks a little clumsy so that the subdivided result looks good.

Finally, we can add teeth and other features.

When the geometry is complete it is time to set the colouring and surface details. For the cat we use a bitmap that is wrapped around the

Figure 4.4 First step in creating the cat model.

Figure 4.5 Adding the arms and legs.

Figure 4.6 The arms and legs in place.

Figure 4.7 Creating a hand.

cat by the rendering software to create the stripes. This is called texture mapping. The texture map was created in Flash and then exported as a 'bmp' file.

When we have finished we have a model that is starting to look like a very strange cat character. Now we need to set this up so that we can animate the character. Most computer animation programs that can animate a character use some kind of 'Bone' system. Lightwave is no exception. You can create the bones using the modelling tools. The purpose of a bone is to modify the position of the points in a mesh. Lightwave can decide which points a bone modifies on the basis of location. A point will be controlled more by nearby bones than by distant bones. This method works for some meshes but can cause errors in character animation as limbs are so close together that the left thigh bone may influence the right thigh bone. Another technique is to create a definite relationship between a bone and certain points in the mesh. To set up a character to use bones in this way, you create vertex maps; a vertex

Figure 4.8 The texture map that is used for the cat's body.

Figure 4.9 The main body for the cat model.

map is simply a list of vertices with each vertex getting a specified weight. A weight of 100 per cent means total control over the vertex while a weight of 50 per cent means partial control. In this way you can control exactly which bone adjusts which points and errors are eliminated.

Animating the character

Once the character is set up to use bones you have control over each part of the mesh. Another useful feature of most computer animation programs is the use of inverse kinematics (IK). This is just a fancy name that means that you can move the body but the feet will stay put. When animating a character, IK is a very useful feature and well worth setting up. You create a Null object (an object which is used for animating but contains no geometry, so it is invisible to the camera); this will become the target for the feet. Using IK, the feet will move to the target and can be made to rotate towards the target. The cat character uses IK on the feet, tail and eyes. Once set up correctly, you can move and rock the body and the feet stay anchored, while the eye target ensures that the eyes stay locked in a direction even as the body moves.

Figure 4.10 Animating the cat character.

Animating the character uses the principles that have been outlined in the previous chapter. For a walk you put in the extremes, then the passing positions and finally the up and down positions.

As you get experienced using a CG program, you will be able to create a short animation for a Flash game sprite very quickly.

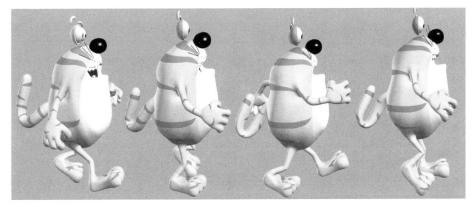

Figure 4.11 The main keys in the cat's walk.

Importing the animation into flash

One method for creating animation that will be suitable to use in Flash is to use one of the specialist exporters. Vecta3D and Swift3D both work well with 3D Studio Max animations, while Flicker is a plug-in for Lightwave. Unfortunately, both these options involve you spending another US $200–500. If you use it regularly then no problem, but if you only use it rarely then here's a couple of techniques that you might like to consider that don't involve extra cost.

The first method is to use bitmaps in Flash. Although Flash is a vector package it does handle bitmaps fairly well. All computer animation programs have an option to save an animation as a sequence of frames. When saving the frames it is important to consider the on-screen size in pixels of the bitmaps. Unlike vector images, bitmaps have a definite size; if you create the bitmaps too big then you can resize them in Flash. Unfortunately this will incur a performance hit and a files size hit. Create them too small and the picture quality will be poor. If the little guy is going to be 200 pixels high then render the animation with the little guy 200 pixels high. Most computer animation packages will allow you to save off an alpha sequence, a silhouette of the animation. You need the alpha to cut out the bitmap so that an irregular-shaped bitmap can be placed over a background. An alternative approach is to render a png sequence which can contain an alpha.

When importing artwork into Flash you choose 'File/Import . . .'. Make sure you are on a clear layer and navigate to the folder where the colour images have been rendered. Select the first in the sequence. Flash prompts you with a dialog box.

Each consecutive file in the sequence of images is placed on a new frame of the current layer. Repeat this action on a new layer for the alpha sequence if your images use a separate alpha. If the alpha images are larger than the colour images then use scale to size them down using 'Window/Transform' or the context menu 'Panels/Transform'.

Make sure that 'Constrain' is checked and type in 50 per cent if the image was rendered at double the size. You will need to repeat this for

Figure 4.12 Multiple bitmaps dialog box.

Figure 4.14 The Edit Multiple Frames button.

Figure 4.13 Resizing a selection.

each image in the sequence. Once the sequence is sized appropriately, make sure it is in exact alignment with the colour image. To do this zoom in so that the bitmaps fill the stage area. Make the stage as big as possible by minimizing 'Actions' and 'Properties' windows. Use the magnifying glass tool by dragging a rectangle around the bitmaps. They will size so the dragged rectangle fills the stage area. If the alpha images need to be moved then use the 'Edit Multiple Frames' button in the lower left of the timeline.

With the button selected, drag the frame range circles in the same way as using onion skinning. Finally, select all the bitmaps using the 'Arrow' tool, by dragging a rectangle around them. Now move the bitmaps together so that they align with the colour bitmaps.

For each alpha bitmap use the 'Modify/Trace Bitmap . . .' menu option. This brings up the dialog box shown in Figure 4.15.

The purpose of Trace Bitmap is to create a vector image from a bitmap. 'Color Threshold' defines the boundaries between colour areas; a low value means there will be lots of small areas of colour, a high

Figure 4.15 The Trace Bitmap options.

value means there will be fewer. The 'Minimum Area' option is the minimum distance between control points on a curve. 'Curve Fit' and 'Corner Threshold' set how curves will appear and when sharp corners will appear. Because we want to convert the alpha image into just black and white we can have a high colour threshold. In this example we set the minimum area to 5 pixels. By clicking OK the bitmap is turned into a vector image. Click in the white area and press the delete key to remove it. You should now be able to see the colour image on the layer below. Remove any remaining white bits and repeat for all the alpha images in the sequence.

Having completed the alpha, hide the alpha layer using the eye button for that layer. On the colour layer choose 'Modify/Break Apart' for each bitmap. The image is turned into a pixel set and can be edited in a limited fashion. Show the alpha sequence once again. For each image in the sequence, cut it out by pressing 'Ctrl + X' or selecting 'Edit/Cut', and then paste it into the colour layer using 'Ctrl + Shift + V' or 'Edit/Paste in Place'. At this stage you should be up to stage 3 in Figure 4.16.

Figure 4.16 Removing transparent areas from a bitmap.

Finally, click on the black area and delete it. You should have a bitmap with an irregular shape. You can achieve a similar result using the magic wand option of the 'Lasso' tool, but in our experience you will get a better result using the alpha image option or a png sequence with an embedded alpha. When you have done this job to each image in the animation sequence you can use the animation on any background. Take a look at 'Examples/Chapter04/FatCatCG.fla' to see how an animation created in this way looks. The file size for this 16-frame animation loop is 44 K.

An alternative approach to using separate alpha sequences is to render off the sequence using the png file format and an embedded alpha. Some CG packages offer this option.

Figure 4.17 The final result from 'Examples/Chapter04/FatCatCG.fla'.

Using Trace Bitmap to get a cartoon effect

Most computer animation software includes options to output the images as a non-photorealistic render. Usually this means a cartoon look. This can be a very effective way of getting animation graphics into Flash. First you set up the renderer to output using outline edges and flat colours. Then you bring this into Flash as a sequence of images. Finally, by using 'Modify/Trace Bitmap . . .' on each image in the sequence they can be converted into vector images. The parameters to set for the Trace Bitmap dialog box will vary from one bitmap sequence to another, the most important being the use of 'Color Threshold'; this needs to be set as high as possible while retaining the colours in the original image. You are aiming at avoiding the Trace Bitmap function retaining the anti-aliasing. Having converted the sequence of images it is usually a good idea to go through the sequence using 'Modify/Optimize . . .'. This brings up the dialog in Figure 4.19.

A higher setting will delete more curves. The curves are all checked and reduced based on a sophisticated algorithm. If the animation is usually shown at a small size then optimizing the frames will make a great

Flash MX Games

Figure 4.18 Using Trace Bitmap.

difference to the size of the file and improve the performance. The final result is shown in Figure 4.20 and can be seen as 'Scene 2' of 'Examples/Chapter04/FatCatCG.fla'. The file size for this version is 184 K, huge by comparison to the bitmap version. Bitmaps traced in this way often result in large file sizes.

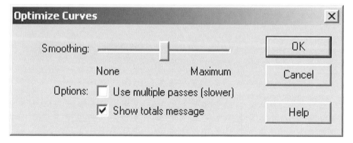

Figure 4.19 The Optimize Curves dialog box.

Hand tracing a computer animation

The slowest method for getting data out of a computer animation program is to import the bitmaps as before, then in a new layer hand trace the images one by one. This is a very slow process but results in easily the smallest files. Once the images have all been traced and coloured, remember to delete the bitmap layer. A single image in the cat animation uses just 2634 bytes when hand traced and 12 274 when Trace Bitmap is

Figure 4.20 Trace Bitmap animation sequence.

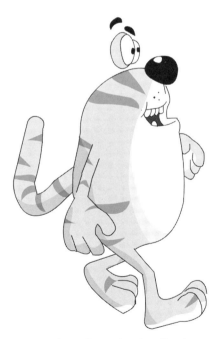

Figure 4.21 Hand-traced image from the cat animation loop.

used. If file size is the most important issue and production time is available, then hand tracing cannot be bettered.

Summary

In this chapter we looked at how an animator can use a computer animation program to create animation that can be imported into Flash. We saw that Flash does not always have to work with vector images but can use bitmap images very effectively. We saw how to best publish and display the file so that bitmap images are seen to the best effect. What we are missing is some great background art to place these animations over. In the next chapter we will look at creating background art for our games.

5 Background art

All your games will require some kind of background artwork. Your animated characters will need to appear in some context. In this chapter we look at creating backgrounds to act as a setting for the action that takes place in your games. There are many options for creating the background artwork; most of these are aesthetic, but some are pragmatic. For example, there is no point creating a fast scrolling game that will not scroll fast because of the complexity of the background artwork. Remember that Flash is essentially a vector-based package. It tries to create beautiful, anti-aliased artwork, but this image quality comes at the expense of speed; it is your job to balance the two competing aspects of game design in Flash. Even if you have no intention of creating background art you will find the tips in this chapter useful.

The benefits of keeping the design simple

Design is such a subjective thing. One person may like something that another finds horrible. Design is connected with fashion; the art and design of 30 years ago differs markedly from the art and design of today. But there is one thing that persistently holds true and that is that simplicity is attractive. Complex imagery can be fascinating but the understated usually wins out. Warner Brothers cartoons often had the barest of background but they were just enough to give context without detracting from the main focus of a scene. All the images in this chapter can be seen in the project file, 'Examples\Chapter05\bgs.fla'. Many of the images look so much better in colour; you are recommended to look at the artwork so that you are better able to judge the comments about each example. The first image we will consider is the simple tree shown in Figure 5.1. This design by Christian Holland is a perfect example of the attractive quality of simplicity. Just simple flat colour and the barest suggestion of leaf structure says tree instantly, but with style and charm.

Figure 5.1 A very simple tree.

Figure 5.2 by Suzie Webb shows the surface of the moon in four colours and again just the hint of detail. The design has just enough form to evoke the place, yet is understated enough so that the Flash engine is not overwhelmed by the detail.

Figure 5.3 shows another design by Suzie that again in just a few bold colours creates a terrifically sunny bedroom, that has a modern yet retro 1950s feel. That is another aspect of design, that a clever designer can take influences from another time and place and create artwork that has a feel of the original while being totally new and modern at the same time.

Creating games is a complex technical challenge, but the user sees the design first before they are captivated by the game play. Most designers assimilate the influences around them. It can be painting and the traditional arts, but it can just as well be a cooker or a chair that catches their attention. Comic book art, children's books, advertising, films, toys, newspapers, photography, the inspiration is out there. If you are interested in design then arm yourself with a camera and capture images that inspire you. This helps you remember and may form the catalyst when faced with a new design project.

Figure 5.2 Moon and stars.

Figure 5.3 A simple bedroom.

Using a keyline

Traditional comic book art uses a keyline. The reason was for convenience rather than design; the artwork was often created with a team of people and an artist, colourist and inker. The colourist could keep to a handful of simple colours and the inker pulled out the detail using a keyline. When creating artwork with Flash the use of a keyline adds to the work that Flash will have to do as each frame of a game is painted. Sometimes you can use a keyline to minimize the amount of colour changes; in such circumstances the use of a keyline reduces the work that Flash has to do. Figure 5.4 shows an image design by John Ashton. The bendy nature of the design is a classic cartoon signature.

Figure 5.4 Incorporating line in the design.

Figure 5.5 takes the use of a keyline to perhaps the ultimate conclusion. This is a very complex graphic and would be totally unsuitable to form the background of a fast moving game. This particular example was used as the menu screen for a graphic adventure. So the speed of screen updates was not vital; nevertheless as artwork becomes more and more complex

Figure 5.5 A complex background.

it may be better to export the image as a bitmap from Flash and then import the bitmap as a replacement for the vector art. A bitmap can be as complex as you want and makes no difference to the speed of updating. A bitmap is still slower than a simple vector graphic, but a bitmap is much faster than complex vector art. If the image is never scaled, then you will not suffer a big reduction in picture quality moving from vector to bitmap. If, however, you intend to use scaling in the game then you will get much better imagery using vector art. Commercial artists have always had to balance the problems of delivery and aesthetic; Flash artists have very similar problems.

When you create your background art make sure that it does not overshadow your characters, make sure they have the space to move around and are not over confided by the design. Also consider using several layers so that your characters can appear from behind a section of the background. Figure 5.6 shows a simple medieval room set; the design allows the central magician character to walk from the room up the stairs, disappearing behind the wall as they climb the spiral steps. The design incorporates the chimney for the magician's cauldron. The character goes behind this element of the set, giving extra depth to the animation.

Flash MX Games

Figure 5.6 Give your characters space.

Importing scanned artwork and artwork created in other paint programs

Remember that you are not limited to creating artwork in Flash alone. Figure 5.7 shows a background that has been hand painted with watercolours. Not a computer in sight! The final result was scanned and imported as a bitmap. This technique has the feel of a children's book illustration and gives a texture to the graphic that is sometimes missing in vector art. Of course, there are numerous paint programs that allow you to create textured graphics directly on your PC if you prefer.

Using very simple designs to ensure when creating a scrolling background

If your game is going to use a scrolling background then you must be very sparing with the detail to maintain a high frame rate. Scrolling backgrounds need a frame rate of at least 30 fps to look smooth and 50 fps would be

Figure 5.7 Using a scanned painted background.

preferable. Getting the frame rate to be maintained at this level requires developers to use all their ingenuity to minimize screen redrawing. Flash will run faster if it is only drawing a small section of the screen as opposed to the whole stage. Sometimes the best technique for achieving a high frame rate is to have a background where most of the design remains static. Figure 5.8 shows an overhead view of a section of road. This background was used for a game with a man running along the pavement. In the black and white illustration, it is difficult to see the image as a road and you are advised to look at the colour version on the CD, which is much easier to understand. The narrow double line forms the edge of the road; two yellow lines indicate a no parking zone in the UK, where this game was first used. The strip to the left is green grass. The stripes reading from left to right are grass, pavement, road markings and road. None of these elements would change if you were flying over the road in a helicopter. To give the illusion of movement we need an item to move down the screen. In the game we used a fence between houses, fire hydrants and postboxes. These moved down as the player stayed in the middle of the screen, suggesting movement along the road. Because only a small area of the screen is changing, the frame rate is maintained even on a slower computer.

Flash MX Games

Figure 5.8 Keeping it simple to allow for scrolling.

Using abstract imagery

Another interesting technique for creating backgrounds is to use abstract imagery or imagery derived from type. Figure 5.9 shows the background of a game that featured the pop group 'Steps'. At first glance you may well have missed that the shapes at the top of the screen form the word steps. A second look makes it easy to see the letters. The graphic that forms the word was used repeatedly with a fading effect to create the remainder of the background design.

The advantage of using a single symbol is that the file size will be reduced and the overall design is strengthened by the lack of complexity. Using type symbolically, you can very quickly create lots of background designs.

Building complex art using symbols

Symbols are very useful when creating a background. Figure 5.10 shows the inside of a student's fridge. Students are notorious for avoiding housework. In this illustration it is years since the fridge was given a

Figure 5.9 Using an abstract background design.

Figure 5.10 Using symbols to add texture.

Figure 5.11 Keeping the file size small using symbols.

healthy spring clean. As a result of years of neglect, the fridge is beginning to have a life of its own. Mould and curry splatters are mixed with spilled bean cans and other monstrosities. Creating this disgusting scene required lots of research! The mould growing at the edges was created from a single symbol. By combining the symbol several times, stretching and altering the alpha, an effect is created that looks impossible using just radial or linear gradients.

Figure 5.11 shows another clever use of symbols; this evocative background uses single cloud and pole graphics that are flipped, squashed and stretched to form the mysterious landscape. The background was used for a fun email game that features two Ninja Warriors facing each other in a deadly game. It is one of many great games to be found at mohsye.com.

Using computer graphic packages to create the background art

Another very effective way to create background art for your games is to use a computer graphic package. The image in Figure 5.12 shows a

simple set created in the Lightwave 3D package. The image is pre-rendered to the correct size for the game then imported as a bitmap file. 3D packages are great for putting together background designs or buttons. You can very quickly create detailed environments using just a few interesting textures and some simple meshes. If you are regularly creating artwork for games then you are advised to spend some time learning a 3D package. After meddling with a few different packages we settled on Lightwave, which provides the best combination of modelling tools, animation and rendering at a reasonable price.

Figure 5.12 Using a computer graphic background.

Using tiled backgrounds

If your background uses repeating elements then consider creating the background as sections, importing each section as a 'png' bitmap. The advantage of the 'png' format is that it is lossless and can incorporate an alpha channel.

Bitmaps come in many different file formats. A Flash developer is likely to use jpegs, bmp, gif and png. The 'eps' format is not a bitmap but a

Table 5.1 Advantages and disadvantages of different file formats used for importing and exporting image data

Format	Advantages	Disadvantages	Flat colour	Half tone
Jpg	Small file size	The compression method loses detail from the image. Can have strange speckled artefacts	Likely to create strange artefacts	Best for photographic images
Bmp	Big files	Only the most basic of compression methods	Reasonable choice; bmp images can have 16, 256, or 16 m colours	Will result in a very big file
Png	Uses a clever compression that loses no information in the image. Can incorporate an alpha channel	Compression method will not create files as small as jpegs	Not the best choice	Good choice for images that need to be maintained at optimum quality
Gif	A relatively small file size can be achieved without losing information in the image	Cannot use 24-bit palette; the maximum number of different colours in a gif file is limited to 256	Best choice for flat colour images that need a high level of compression	Not suitable
Eps	Vector format ensures resolution independence. An eps can contain a bitmap; the bitmap will not be resolution independent	Not suitable for bitmaps	The best choice if the image is in vector format	Not suitable

vector format. An eps image can contain a bitmap, but this is not recommended because the bitmap image is resolution dependent while the eps is regarded as resolution independent. Remember that an eps is only truly resolution independent when it only contains vector elements. A list of advatanges and disadvantages of the different formats is given in Table 5.1.

The image in Figure 5.12 was created by first creating some brick tiles, the horns, the round window and the arch. Each element was imported as a png and combined in Flash. This results in a smaller file size and allows you as a developer to create different backgrounds using a limited number of tiles. Tiled backgrounds were very popular when computers had more limited facilities and are not used as often these days; they do offer flexibility and small file sizes, so they should be considered for some game formats.

Using photography

Sometimes the simplest way to create a great background is to go outside and photograph the real world. For some games this is a quick way to produce an effective result.

Figure 5.13 Using photo compositing to build the background.

Figure 5.14 Using a photograph.

Summary

There are many ways to add a background to your game. You can create the background entirely in Flash or entirely in another package and import it. In this chapter we looked at some of the options available and examined where certain approaches may not be effective for particular games. You are now armed with the graphic skills necessary to start creating your games. Now we will turn our attention to writing the code.

(Thanks to Magnetic North/Kelloggs UK for permission to use some of the images in this chapter.)

Section 2
Action

Having developed the animation, we now look at how to add interactivity to this art using ActionScript.

6 So what's a variable?

After the first blistering introduction to ActionScript in Chapter 1, we now take a more leisurely stroll through the basics of programming, starting with variables. The most fundamental aspect of programming is the ability to store and retrieve data. In essence, all computer programming involves the manipulation of data. If your game uses a moving animated character running, jumping and shooting, you will need to store the position, size and action of the character as the game develops; this information is not static, it varies as the user plays the game. In this chapter we will look at how a variable can be used to store lots of different types of information, including the data you would need for your character. We will look at how to set a variable's value and how to get the value stored in a variable. We will look at using chunks of variables in a structure called an *Array*. Along the way we will examine the options using animated sprites. We will let the user input a code that controls the behaviour of the sprite. Finally, we will let the user replay an animation using information stored in the string variable.

What is ActionScript?

ActionScript is a list of instructions written in a very specific way that is converted into a series of codes; when the Flash Player reads the codes, it performs the instruction in an unambiguous way. For example, if it found the instruction

```
Ball.gotoAndStop(23);
```

Then it would first of all look to see if at this frame on the timeline a Movie Clip instance with the name Ball existed. If it did not then nothing would happen. If it found the clip then it would attempt to move the playback

head within the clip to frame 23. Each Movie Clip has its own timeline. If the Movie Clip did not have a frame 23 then it would move the playback head to the nearest frame to this value. ActionScript can be applied to a frame on the timeline, to a Movie Clip as a clip event or to a Button as an action to take as the mouse button is pressed. You will learn in Chapter 9 about where to place your code. As you experiment with code, you are encouraged to keep one layer of the timeline for frame actions; do not place frame actions in any other layer. To add a frame action follow these simple steps:

1 Create the empty layer that you will use for frame actions. If the layer already exists then skip this step and go on to stage 2.
2 Right-click on the timeline, in the frame action layer at the frame where you want to add, or edit, the action. Select Action from the pop-up menu.
3 This opens the Action panel. Here you can choose between 'Normal' and 'Expert' modes. Normal mode allows you to enter code from a menu of options, then fill in any additional information using enter boxes specific to the command. Expert mode just takes free text entry. In this book we will use Expert mode throughout, but as you are learning you may prefer Normal mode until the syntax of the commands is familiar to you.

To add an action to a Movie Clip, follow these steps:

1 Right-click on the Movie Clip and select Action.
2 In the Action panel, place any code you intend to use in an `onClipEvent(eventName){};` eventName can be `data`, `load`, `keyDown` or `enterFrame`. We will look at using the clip event options in Chapter 9.

To add an action to a Button, follow these steps:

1 Right-click on the Button and select Action.
2 In the Action panel, place any code you intend to use in an `on (eventName){}.` eventName can be `press`, `release`, `rollOver` or `rollOut`. We will look at using mouse events in Chapter 7.

What is a variable?

There are lots of ways to visualize a variable if the concept seems strange. One suggestion is to think of a telephone book. If you have a friend called Jim and his telephone number is 01234 567890 then you would put the number 01234 567890 under the name Jim in your book.

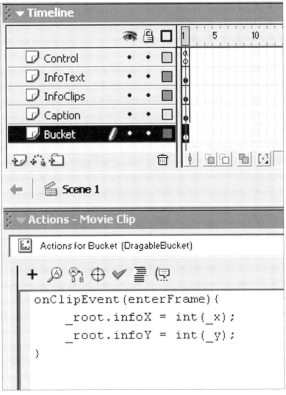

Figure 6.1 Entering ActionScript for a frame action.

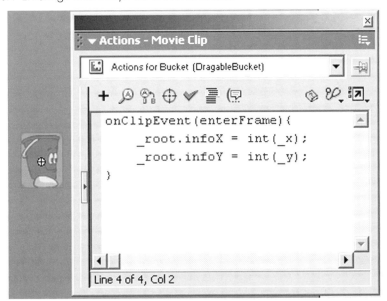

Figure 6.2 Entering ActionScript for a Movie Clip instance.

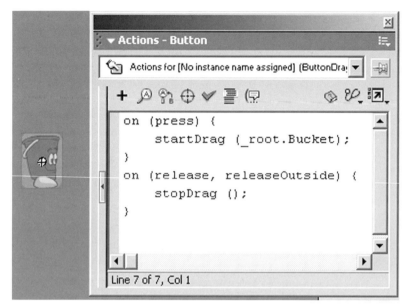

Figure 6.3 Entering ActionScript for a button.

Whenever you want to know what Jim's telephone number is you look at the name Jim in the book and find out the number is 01234 567890. But suppose that Jim changes house and gets a new number. Perhaps the new number is now 09876 543210. You simply cross out the old number and put the new one in its place. Using the name Jim you can check the number; this is how you use a variable in a computer program.

To create a variable in Flash you simply use it for the first time:

```
bigfeet = 14;
```

This would create a variable called 'bigfeet' and set its current value to 14. As a developer you can add ActionScript, that would create, set or access a variable, to a frame in the timeline, to the *ClipEvent* of a *Movie Clip*, or to the *MouseEvent* of a *Button*. Because you can add code in different places this is both very convenient and in some ways confusing, especially when you are writing your first programs.

The scope of a variable

A variable has something called *scope*. If you have read through Chapter 1, then you will realize that Flash can use something called a symbol and

that a symbol can be a *Movie Clip*. You can think of a Movie Clip as literally another Flash movie nested into the current one. If you are working on a Flash movie that uses the symbols 'Clown', 'RingMaster' and 'Elephant', and these are all named Movie Clips, each of the symbols could have its own version of the variable 'bigfeet'. You would have:

```
Clown.bigfeet = 14;
RingMaster.bigfeet = 10;
Elephant.bigfeet = 21;
```

You can access a Movie Clip's variables by using the dot operator. You give the Movie Clip's instance name, a dot and finally the variable name you are after. Scope can be confusing at first. Remember that every Flash movie has a '_root', that is the timeline that you see when you first start to develop a game. Any Movie Clip symbol that you add to this '_root' can be given an instance name. If you already have a Movie Clip then click on it and set the instance name in the Properties panel. If you are creating a symbol for the first time, then choose 'Insert/Convert to Symbol . . .' or press F8. Make sure you choose Movie Clip as the symbol type. If you already have a symbol and it is currently a graphic, then you can change its behaviour to act as a Movie Clip using the Properties panel. If you accidentally created a symbol as a Graphic and you meant to create a Movie Clip then you can change its behaviour in the Library, by choosing 'Window/Library', right-clicking on the symbol and choosing 'Behaviour/ Movie Clip'. This would not change the behaviour of any instance of this symbol that you have put on the timeline but it would mean that the default behaviour whenever you place the symbol on the timeline in future would now be as a Movie Clip. One common problem when learning to use ActionScript is confusing the scope of a variable. You may have a variable that you initially set at the root.

```
bigfeet = 14;
```

Then inside the MovieClip called 'Clown' you have a test

```
if (bigfeet>12){
      //Do this if bigfeet is greater than 12
}
```

Each time you test the movie by pressing 'Ctrl + Enter', the code in the braces does not execute. Why? Because, the test is using the value of the variable 'bigfeet' inside the MovieClip 'Clown'. If this has not been set then

Table 6.1 Variable scope

Variable	Value
bigfeet	14
Clown.bigfeet	0

Flash sets the value of the variable to a default of 0. In this movie there are two variables called 'bigfeet', one at the '_root' level and one inside 'Clown'.

When inside the Movie Clip 'Clown', if you test the value of 'bigfeet' then you are testing the value of the version of bigfeet that is local to the Movie Clip. If you want to access the 'bigfeet' variable at the root, from within a Movie Clip, then you must use:

```
_root.bigfeet = 14;
```

You can add a Movie Clip to the root of a movie, or you can add a Movie Clip to another Movie Clip. Let's consider a movie that has nested Movie Clips in the following hierarchy:

```
_root
  └Hips
      └LeftLeg
          └Foot
      └RightLeg
          └Foot
```

Each level of the hierarchy has a variable called 'power'. The values at a given time for each of these variables are given in Table 6.2.

Table 6.2 Variable access

Variable	Value
_root.power	12
_root.Hips.power	43
_root.Hips.LeftLeg.power	23
_root.Hips.LeftLeg.Foot.power	34
_root.Hips.RightLeg.power	67
_root.Hips.RightLeg.Foot.power	5

To access the 'power' variable of the 'RightLeg', from the 'LeftLeg' you can use one of two methods; *direct* or *relative* addressing. With *direct* addressing you set the route to the variable from '_root'. The 'power' variable in 'RightLeg' can always be accessed using:

```
_root.Hips.RightLeg.power
```

It can also be accessed from 'LeftLeg' using

```
_parent.RightLeg.power
```

Using '_parent' moves the location from 'LeftLeg' to 'Hips'; from here we can move up the hierarchy using 'RightLeg' and then look at the value for 'power' at this level. Think in terms of a family tree; from a child, *Sophie*, to a cousin, *Andrew*, you must go up a generation to a parent, *Alan*, then up another generation to a grandparent, *Doris*, now follow the path to the uncle, *David*, and finally down to the cousin, *Andrew*.

```
Jean m. Peter
  └ Doris m. Norman
      └ Alan m. Margaret
          └ Sophie
      └ David m. Julie
          └ Andrew
```

It is important to understand how to access variables in one part of a hierarchy from another part. But even the most experienced programmers can make mistakes. These mistakes can often be very difficult to track down. Each time you review the code you read the line with a variable listed and keep overlooking that instead of checking, for example, '_root.Hips.power'; from a script that is at '_root' level, you are in fact checking the value of '_root.power'.

What is a program?

When you create an interactive Flash program you are in fact creating a computer program. The simplest way to visualize a computer program is as a list of unambiguous instructions. Flash allows you to add code in many places and although this can lead to well-structured programs, it can also lead to impenetrable spaghetti. There is no more important adage than that old favourite, KISS, 'Keep It Simple, Stupid'. Simple programs are easier to write and easier to maintain. One of the most

common problems arises when a Movie Clip changes a variable that is not within its own level. As a developer you look carefully at the code in a Movie Clip and decide it is doing exactly the right thing, but when you run the program it doesn't do what you planned for. Why? Often this is because one Movie Clip is using ActionScript to alter the value of a variable inside another Movie Clip. Although this is allowed it can lead to problems. OOP (Object Orientated Programming) is fundamental to the Flash structure. Most developers use OOP. In Flash a Movie Clip is an Object; when using OOP in some programming languages you cannot access a variable in another Object by default. There is a good reason for this; it is because of the danger of corrupting the values in the variables. Instead you use a function call to change a variable's value. This has the effect that a variable can only possibly be changed by running one section of code; now all the developer's efforts can be directed at this single section of code to determine where the error is arising. I strongly advise using the same method in all but the simplest of programs.

Here is a simple example using the `power` variables described earlier. First we create a function; a function is a section of code that can be accessed at any time from another section of code by using its name and a set of none, one or more variables, listed in brackets following the function's name. Each variable in a function call is separated from the next using a comma. A function can execute a set of instructions then return to the original script or it can also return a value.

```
function setPower(newvalue) {
  if (newvalue<100) {
    power = newvalue;
    return true;
  }else{
    return false;
  }
}
```

If you placed this bit of code in the ActionScript for the first frame of the Movie Clip 'LeftLeg' then you can set the value of 'power' for 'LeftLeg' by using

```
_root.LeftLeg.setPower(45)
```

Because the function returns a value you can also use this function as a test. In the code we only allow the value of 'power' to be set to a new value if the variable called 'newvalue' is less than 100. If we were to use

```
__root.LeftLeg.setPower(120)
```

Here the value that the function will use as 'newvalue' is going to be 120. Whatever you have in the brackets will be the value that the function uses as 'newvalue'. Because 'newvalue' is greater than 100, the function will not set 'power' and will return false.

```
if (_root.LeftLeg.setPower(newpower)) {
      //newpower less than 100
}else{
      //newpower greater than or equal to 100
}
```

Now by using a function to set the value of 'power', we can check that 'power' is within a certain range and make sure that another part of the program is not setting it incorrectly. We could even use a more sophisticated form of the function to identify which part of the program was trying to set the value incorrectly.

A function can take more than one value in the brackets:

```
_root.LeftLeg.setPower(120, "RightLeg: frame 4")
```

Now we can change the function:

```
function setPower(newvalue, caller) {
  trace(caller);
  if (newvalue<100) {
    power = newvalue;
    return true;
  }else{
    return false;
  }
}
```

The extra line `trace(caller)` sends the value of `caller` to the *Output Window*.

The Output Window is very useful for tracing the way your program proceeds. By using the extra parameter it is easier to find out when something strange happens. Although at this stage all code is an unfamiliar area, if you get into good habits now then these will become second nature. If, on the other hand, you get into bad habits now then they will be difficult to break.

Figure 6.4 Using the Output Window.

Some different types of variable

Although a variable can be thought of as a pigeon-hole in which you store some information, this information may be a number, a word or a sentence. In some programming languages as a developer you need to decide what kind of variable you are going to use and once set it must stay this way for the duration of the program. In Flash you need not declare a variable, it is created the first time it is used and can be changed in its use from a number to a sentence if necessary. Some possible variables and their values are given in Table 6.3.

An alternative list is given in Table 6.4.

Table 6.3 Variable types

Variable	Value
Sword	false
horseHeight	43
horsePower	23
knightName	Lancelot
battleLocation	The Forest of Dean
KnightAge	23.78

Table 6.4 Variable types

Variable	Value
var1	false
var2	43
var3	23
var4	Lancelot
var5	The Forest of Dean
var6	23.78

Although the values are the same the names are not. As a developer you can choose the name that you find most useful. When people speak of a programming language, that is what you need to learn, you need to understand what will happen when you write a section of code, but you don't need to make your life any harder than it needs to be and one of the great benefits of using a programming language is that you usually have the convenience of naming your variables as you think best. Over the years lots of developers have thought about the naming of variables and it is always best if your naming makes sense, and try not to abbreviate the names; always use *carspeed* rather than *cs*. The different names make no difference to the performance of your program, but they do make a great deal of difference to the readability of your code. You may think that you will always understand the way you have written a program, but you won't. Even a week later a complex section of code will seem mystifying. Remember the golden rule, 'Keep It Simple, Stupid'.

How decimal values differ from integers

The first type of variable we will consider in any depth is a number. Numbers come in literally an infinite amount of values. Unfortunately computers, although fast and capable of storing very large and very small values, cannot store an infinite number of values. The way that developers have got around the limitations inherent in computer storage is to use two distinct types of number: *integers* and *floats*. The best thing about integers is they are exact.

 2 * 12 = 24

The '*' symbol is used to represent multiplication on a computer, not the \times symbol. But the range of values that can be stored in an integer is limited; you can use integers to store values into the millions, but not into the trillions. Similarly, integers are not very useful if your numbers all range between zero and one. For the very big and the very small you can use floats. There is a potential problem, however, in that floats are not exact. They seem exact, but they are not. Suppose you multiply 0.01 by itself lots of times. The number will get smaller:

```
0 = 0.0001
1 = 0.00001 or 1e-6
2 = 0.0000001 or 1e-8
3 = 0.000000001 or 1e-10
4 = 0.00000000001 or 1e-12
```

```
...
152 = 1e-308
153 = 9.9999999999998e-311
154 = 9.99999999998466e-313
155 = 9.99999999963881e-315
156 = 9.99999983659715e-317
157 = 9.99998748495601e-319
158 = 9.99988867182684e-321
159 = 9.88131291682494e-323
160 = 0
```

After the 160th iteration, the value becomes zero. This may seem unlikely, but a computer would whiz through the calculation in a blink of an eye. Once the value has diminished to zero the quantity has disappeared. If the intention was to use the result to multiply another variable then this too will become zero. Floating point errors like this are another source of difficult to locate bugs in a program. Always remember that unless you are working with integers within a sensible range, all other values are approximate. You may test two floating point values to see if they are the same using

```
if (number1==number2) {
      //Do something
}
```

Although this would work fine for integers, don't use it for floats, use

```
if (((number1 - number2)*(number1 - number2))<0.0000001) {
      //Do something
}
```

By subtracting the second number from the first you get the difference between two numbers. This could be positive or negative; by multiplying the difference by itself you guarantee it will be positive, any number multiplied by itself is positive. Now you can test to see whether this is a small number. The choice of 0.0000001 is arbitrary and could be smaller if necessary; the important thing is that you use a difference test and not an equality test. Another way to guarantee a positive value is to use:

```
if (Math.abs(number1 - number2)) n{
      //Do something
}
```

Here the *Math* object is used with the operation *abs*, which is short for absolute value. You may prefer this method.

If you are totally new to programming then you will probably be in something of a daze at this time. This feeling is natural. We speak of programming *languages*. If you are new to programming then you will be feeling like a stranger in a strange land, where nothing is what it seems and nobody speaks your language. As you start to pick up a few words, you can at least order a coffee and buy a loaf of bread.

In this chapter we are rather forced to introduce a few words and a little punctuation. Please bear with us, in the end you will no longer be a stranger.

Enough theory, show me an example

If you are starting to glaze over then open up your laptop or power up the PC because now is the time to see variables in action. Open the project 'Examples\Chapter06\DragBucket.fla'.

Figure 6.5 Developing DragBucket.

The timeline contains five layers:

Control Used for frame action scripts.
InfoText Used to store the text boxes that show the *x* and *y* values
 of the Bucket's position.
InfoClips Used as the background to the *x* and *y* values.
Caption The words at the top of screen, describing what to do.
Bucket The layer where the Bucket clip is stored.

So we have three Movie Clips. The boxes at the bottom of the screen with the 'xx' labels are Movie Clips and so too is the Bucket cartoon. Before we look at the Bucket cartoon let's look at the boxes. Each of these is an Instance of the Movie Clip, `SmallInfoPanel`. You can create a new instance of this Movie Clip by opening the Library panel, using 'Windows/ Library' or by pressing F11. Select the item named SmallInfoPanel and then drag this onto the stage.

Inside this clip is a text box. If you double-click on the Movie Clip on the stage or right-click and select 'Edit In Place', then you will move to the

Figure 6.6 The SmallInfoPanel Movie Clip.

Figure 6.7 Using Dynamic Text.

timeline inside the Movie Clip. Now click on the 'xx'. This is a Dynamic Text box. You can make the text in this box follow a variable.

In this example the variable that is used is called `label`. If we change the value of `label` using ActionScript, then the letters in this box will change. Since we want this box to describe what we will show in the white box to the right we need only set the label value once, when we first see the Movie Clip. We can use the load event for the clip for this purpose. The code we use is:

```
onClipEvent(load) {
    label = "x";
}
```

To view this code, go back to the root level timeline. Right-click on the left of the two boxes at the base of the screen, and select 'Action'. You should see the above code has already been entered. By setting label equal to '*x*', the label for the box will be '*x*'. If you right-click on the right-hand box and open the Action panel, you will see that 'label' is set to '*y*'. How are you doing so far? Not too bad is it.

Now click on the white area of the boxes. This switches focus to other text boxes that are stored in the top layer. Each of these is a Dynamic Text box, one using the label 'infoX' and the other 'infoY'. We are nearly there; the final element in this simple program is the Bucket cartoon. This has an invisible button place inside it. That is why the image appears with a blue tint. To look at the code for this; right-click on the Bucket and choose 'Edit In Place', or double-click the Bucket. Inside this Movie Clip you will find the Bucket Movie Clip in the second layer and an invisible button in the top layer. Click on the Bucket and look at the Action panel (right-click and choose Action, or double-click). You should see the following code:

```
on (press) {
  startDrag (_root.Bucket);
}
```

```
on (release, releaseOutside) {
  stopDrag ();
}
```

A button can respond to several events and these can all be placed in this ActionScript. In this simple example we use the `press` event; this occurs when the user clicks on a button, and the `release` and `releaseOutside` events. The `press` event is used to tell Flash to start dragging a Movie Clip when the user moves their mouse. The Movie Clip to drag in this instance is the Bucket itself; `release` and `releaseOutside` occur when the mouse button is released when within the button itself or outside the button, respectively. In this instance we use the release event to stop dragging.

The last thing we will look at is the enterFrame event for the Bucket clip. Go back to the root level timeline and click on the Bucket. If the Action panel is open then you will see the following code. If it is not open then you should know how to open the panel by now (right-click and choose Action).

```
onClipEvent (enterFrame) {
  _root.infoX = int (_x);
  _root.infoY = int (_y);
}
```

This is the place where the variables 'infoX' and 'infoY' are set. The Dynamic Text boxes that follow these values are updated as the values change. The values will change as the user moves the Bucket.

Using strings

Although variables are often used to store numerical values, they can also be used to store letters. You can create a variable that describes someone's name:

```
name = "Steve";
```

Or you can create a variable that can store a sentence:

```
saying = "The early bird catches the worm";
```

Such variables are called strings and Flash lets you manipulate them in several ways:

```
str1 = "Look before you";
str2 = "leap";
str3 = str1 + " " + str2;
len1 = length(str1);
len2 = length(str2);
```

If you run the section of code above then the values of the variables will be:

```
str3 = "look before you leap"
len1 = 15
len2 = 4
```

When using strings in Flash the '+' operator joins two strings together. "Look before you" is added to " " and finally "leap" is placed on the end. The result is assigned to the variable *str3*. The function *length* can be used to find out how many letters, including punctuation, are in a string. You can even extract a part of a string using:

```
substring(str3, 5, 6)
```
will return 'before'

Here *substring* takes three parameters, the string to use and the first letter to use and how many letters from the first to include.

Starting with version 5, Flash introduced a String object. Objects can hold data and ways to manipulate this data. The String object has lots of methods you can use to manipulate letters, words and sentences. We will look at just a few:

```
str = "Look before you leap";
strx = new String(str);
```

The first line creates a standard string (`str`) and the second creates a String object (`strx`) from this string. The names `str` and `strx` can be any names you choose. The important thing is that the name you use in the brackets after *String* is a string variable name, in this case, `str`. Now you can use the methods of the String object. A very useful method is:

```
strx.length;
```

This returns the number of letters or characters in the string, in this case 20. Another useful method is:

```
strx.charAt(10);
```

When using a String object the first character is at position 0, the next at position 1, and similarly to the end of the string. The above line would

return 'e', for the last letter in 'before' is at index 10. If you try using different values in the brackets you will return different letters. Flash thinks of ' ', a space, as a letter, '.', ',', ';' are all letters likewise. Strings are regularly used to store information in a coded form. When you write a program, you arc inputting strings. These strings are used to build the code that the program actually uses when creating the screens that the user will see. We could establish our own simple programming language and then store this in a string.

Table 6.5 A simple code

Code	Description	Usage
Xx	Set the _x value for the Character to x	X123
Yx	Set the _y value for the Character to y	Y56
Lx	Character walks left for x pixels	L107
Rx	Character walks right for x pixels	R12
Cx	Character climbs up or down for x pixels	C-56
L	Character lands softly after a fall	L
H	Character lands heavily after a fall	H
Wx	Character stops for x seconds	W2.4
T	Character turns	J
Fx	Character falls for x pixels	F23
S	Returns the string pointer to the start	S

Now we can use

X350,Y280,L100,W1.2,T,W0.2,R100,C82,R50,F82,T,L50,S

to mean 'set the character's position to (350, 280) then walk 100 pixels to the left, then wait for 1.2 seconds, turn and wait for 0.2 seconds, walk right 100 and then climb up for 82 pixels, walk right for 50 pixels, fall for 82, turn and walk left for 50 pixels. Finally loop back to the start'. We can store all that information in a simple 51-character string.

Implementing the Code reader

Take a look at the project 'Examples\Chapter06\CodeBucket.fla'.

In the project we use the same Bucket clip, a Dynamic Text box to store the code string we are going to read, two Info boxes and a Button. Before

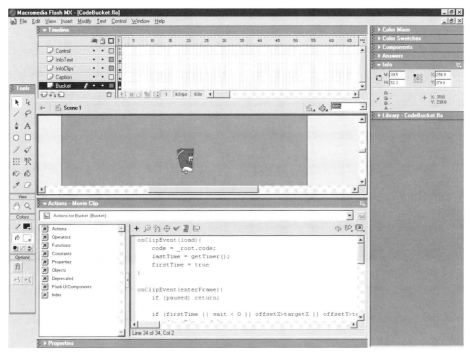

Figure 6.8 Developing the CodeBucket program.

we look at the more complicated string slicing, let's look at the Info boxes. These track the value of the current `token` and `value` from the string we are reading. The `token` variable has a letter such as X, Y or L; this has been read from the code string and stored in a variable inside the Bucket Movie Clip. The Info box on the left tracks the value of Bucket.token. The `value` variable stores a number; this is the numerical component that follows most of the code letters. For example, the string slicing program looks at 'X350,..' and strips off the 'X' and stores it as the variable 'Bucket.token', which we can then see in the Info box in the lower left corner. Then it looks for a number and finds '350'. It stops searching when it finds the comma. This stores in the variable 'Bucket.value' and displays it in the second Info box. The labels for the Info boxes are set in the onClipEvent(load) event, the left label is set to 'token' and the right label is set to 'value'.

In this project we also include a Button. A Button is a special kind of Movie Clip that uses just four frames. Each of these frames has a specific purpose. Frame 1 will be displayed if no event is occurring. Frame 2 is displayed whenever the mouse is over the button, Frame 3 is shown when the user clicks on the Button and finally frame 4 is used to describe the

area to use for the rollover event. A button does not need to have all these frames set. Sometimes you will use just the rollover area in frame 4; this makes an invisible button, very useful when you want to use mouse events to action Movie Clips. We will look in more detail at Buttons in Chapter 9. Having created the artwork for your button, you can then make it respond to the user by adding ActionScript. Here is the code used for the Button on the screen.

```
on(release) {
   if (ButtonLabel=="play") {
        Bucket.paused = false;
        Bucket.gotoAndPlay(Bucket._currentframe);
        ButtonLabel = "stop";
   }else{
        Bucket.paused = true;
        Bucket.gotoAndStop(Bucket._currentframe);
        ButtonLabel = "play";
   }
}
```

A Button has several events that are prompted by the mouse. One of these is release; this occurs when the user releases their mouse button, while over the button. The code here is all inside this event. First we check what the caption is on the Button. The caption is set using a variable called `ButtonLabel`. We test to see if it's set to 'play'; if it is then the code in the curly braces immediately following the test is executed, if not then the code in the curly braces following the else statement is executed. In the code a paused variable inside the Bucket clip is set to true or false. The Bucket clip is then halted or restarted and the label on the Button itself is flipped between 'stop' and 'play'. Notice how we are now using a Button to change the values of variables in the Movie Clip. Although this is certainly possible, a much better method would be to create a function inside the Bucket and call this. On the first frame of the Bucket Movie Clip you could put:

```
function stop() {
  paused = true;
  gotoAndStop(_currentframe);
}
function play() {
  paused = false;
  gotoAndPlay(_currentframe);
}
```

The Button code would then change to:

```
on(release) {
  if (ButtonLabel=="play") {
      Bucket.play();
      ButtonLabel = "stop";
  }else{
      Bucket.stop();
      ButtonLabel = "play";
  }
}
```

Both are tidier and much easier to find a problem if one is occurring, since the function will be the only place where the variable, paused, is set.

Finally, we come to the code necessary to read the string and access the bits. This is all placed in the first frame of the Bucket Movie Clip. Two functions are used, one called getNextCode and another called getNumber. The first of these is used to extract the next usable code letter from the code string. We use a string pointer, which is just a variable called strPos, which is initially set to 0, then it is incremented one at a time. Since code is a string we can access a single letter in this string using

```
token = code.charAt(strPos++);
```

Here strPos must be a number from 0 to the number of characters in the string. We can then test this token variable to see if it is one of the code letters we are using. If it is, then in most instances we must also get the numerical value, which follows. For this purpose we use the function getNumber. This function uses the same principle, this time looking for a comma, which indicates the end of the number entry. The use of '++' simply adds one to the value of the variable that precedes it. In addition to looking for a comma we must also check for the end of the string. At this stage in your programming development you are not expected to be able to write this code yourself, but it is useful to see how strings can be used to store more information than just a simple word or sentence.

```
//=================getNumber========================
//parameters   none
//=================================================
//returns             a number
//=================================================
//purpose
//Reads a number from a formatted code string "code"
```

```
//The current position in the string is stored in the variable
//strPos. This function is called from getNextCode only
//=========================================================
function getNumber(){
  pos = strPos;
  while(code.charAt(strPos++)!=','){
          if (strPos>=length(code)){
                  strPos = length(code) + 1;
                  break;
          }
  }
  val = Number(code.substring(pos, strPos - 1));
  return val;
}
```

Here is the full code for getNextCode. It simply looks for the next character in the code string and then reacts accordingly. For now just be aware of the two variables token and value, which are set in this code; these are tracked by the Info boxes.

```
//==================getNextCode======================
//parameters   none
//=========================================================
//returns              nothing
//=========================================================
//purpose
//Reads the next token from a formatted code string "code"
//The current position in the string is stored in the variable
//strPos. Most tokens then read a number from the string
//using the function getNumber
//=========================================================
function getNextCode() {
  //Must have finished
  if (strPos>length(code)) return;

  wait = 0;
  offsetX = 0;
  targetX = 0;
  offsetY = 0;
  targetY = 0;
  value = "";
```

```
while (strPos<length(code)) {
      token = code.charAt(strPos++);

      if (token=='X'){
            value = getNumber();
            _x = value;
      }else if (token=='Y'){
            value = getNumber();
            _y = value;
      }else if (token=='L'){
            left = true;
            moveY = 0;
            moveX = -3;
            value = getNumber();
            targetX = value;
            offsetX = 0;
            left = true;
            gotoAndPlay("WalkLeft");
            break;
      }else if (token=='R'){
            moveY = 0;
            moveX = 3;
            value = getNumber();
            targetX = value;
            offsetX = 0;
            left = false;
            gotoAndPlay("WalkRight");
            break;
      }else if (token=='W'){
            moveY = 0;
            moveX = 0;
            value = getNumber();
            wait = value;
            gotoAndStop(_currentframe);
            break;
      }else if (token=='C'){
            moveY = -2;
            moveX = 0;
            value = getNumber();
            targetY = value;
            offsetY = 0;
            if (left){
                  gotoAndPlay("IntoClimbLeft");
```

```
                    }else{
                            gotoAndPlay("IntoClimbRight");
                    }
                    break;
            }else if (token=='F'){
                    moveY = 4;
                    moveX = 0;
                    value = getNumber();
                    targetY = value;
                    offsetY = 0;
                    if (left){
                            gotoAndPlay("FallLeft");
                    }else{
                            gotoAndPlay("FallRight");
                    }
                    break;
            }else if (token=='T'){
                    wait = 0.5;
                    moveY = 0;
                    moveX = 0;
                    if (left){
                            left = false;
                            gotoAndPlay("TurnRight");
                    }else{
                            left = true;
                            gotoAndPlay("TurnLeft");
                    }
                    break;
            }else if (token=='S'){
                    strPos = 1;
            }
        }
    }
}
```

To make the program work, the function sets values for the variables wait, moveX, moveY, targetX, targetY, offsetX and offsetY. These variables are all used in the onClipEvent for the Bucket. moveX and moveY are numerical values that are added to the current position of the clip; this has the effect of moving the Bucket around the stage; wait is used as a second countdown to allow the Bucket to stop for a short time. The values for targetX and targetY are used to determine if the Bucket has walked, climbed or fallen sufficiently. The value for offsetX and offsetY is set to 0 and

then it is incremented using the moveX and moveY variables respectively. When the value for offsetX or offsetY exceeds the value for targetX or targetY respectively then the Bucket has arrived at its destination.

Finally, we will look at the onClipEvent code for the Bucket. Return to the main timeline and click on the Bucket; the following code will be displayed in the Action panel.

```
onClipEvent(load) {
        code = _root.code;
        lastTime = getTimer();
        firstTime = true
}

onClipEvent(enterFrame) {
        if (paused) return;

        if (firstTime||wait < 0||offsetX>targetX||
offsetY>targetY) {
                firstTime = false;
                getNextCode();
        }

        _x += moveX;
        _y += moveY;

        if (moveX>0) {
                offsetX += moveX;
        }else if (moveX<0) {
                offsetX -= moveX;
        }

        if (moveY>0) {
                offsetY += moveY;
        }else if (moveY<0) {
                offsetY -= moveY;
        }

        frameTime = (getTimer() - lastTime)/1000.0;
        if (wait>0) wait -= frameTime;

        lastTime = getTimer();
}
```

Although this may seem complicated, it is really quite simple to understand. Look at the line following onClipEvent(enterFrame). This line is a simple test for the value of paused. If the Bucket is paused then there is nothing left to do, so the function returns, in this case nothing after this point is executed. If we get past this line then we check to see if we have finished doing one of the things that will make us read the next code. These conditions are: it is the first time we have used this function, hence firstTime will be set, the value for wait is less than 0 or the offset variables are greater than their targets. The '| |' symbol can be read to mean 'or'. If any of these conditions are met then we must read the next code. Then we go on to adjust the Bucket's position on the stage by adding the value of moveX and moveY to _x and _y respectively. We then increment the offset variables if the values for the move variables are not zero. Finally we adjust the wait variable based on how long this frame took to display. Although you can set the frame rate for a movie, this rate is not guaranteed; a user computer may not be able to sustain the rate that is set. By using the function getTimer we can keep a track of the time taken to display a frame. getTimer uses milliseconds, so we divide this by 1000 to get the seconds taken.

Using Arrays

Another very useful Object is an Array. You create an Array using.

```
myList = new Array();
myList = new Array(10);
myList = new Array("Steve", "Jim", "Nigel", "Andy"; "Mike", "Dave")
```

The first version creates an empty Array, the second version creates an Array with 10 empty entries, the final version creates an Array of six entries that are already set. To access one of the values in an Array use:

```
myList[3];
```

In this instance the value would be 'Andy', an Array's first index is zero. You can find how many entries an Array has using:

```
myList.length;
```

You can add to an Array using:

```
myList.push("Richard";
```

You can remove the top entry in an Array using:

```
myList.pop();
```

You can join all the elements in an Array using:

```
myList.join(" ");
```

The parameter in brackets is added between each item in the Array; if you omit this then Flash uses a comma instead. In this instance the result would be:

```
Steve Jim Nigel Andy Mike Dave
```

You can reverse the order of an Array using:

```
myList.reverse();
```

If you join the list now the result will be

```
Dave Mike Andy Nigel Jim Steve
```

You can join an Array to another Array using:

```
anotherList = new Array("Sheila", "Anne", "Julie");
bigList = myList.concat(anotherList);
```

Now the `bigList` Array will contain nine entries:

```
Steve Jim Nigel Andy Mike Dave Sheila Anne Julie
//bigList[0] contains "Steve"
//bigList[1] contains "Jim"
//bigList[2] contains "Nigel"
//bigList[3] contains "Andy"
//bigList[4] contains "Mike"
//bigList[5] contains "Dave"
//bigList[6] contains "Sheila"
//bigList[7] contains "Anne"
//bigList[8] contains "Julie"
//bigList.length equals 9
```

Building up a variable's name

Sometimes a variable's name will be stored in another variable. For example, if `Arthur` is a Movie Clip instance, and this Movie Clip contains a variable called `power` then you can access the value of `power` using:

```
charPower = Arthur.power;
```

But, what if you do not know the name of the Movie Clip until the player clicks on it? By clicking on the Movie Clip the user can set the value of a variable you have created called `charName`, to 'Arthur'. Now 'Arthur' is a string that is stored in the variable `charName`. So how do you use the `charName` to access the value of power in the Movie Clip instance called `Arthur`? If you use:

```
charName.power;
```

This does not access the Movie Clip, instead it accesses the String called `charName`. This does not have a power setting so Flash would return zero. To access the Movie Clip you use:

```
eval("charName").power;
```

The function `eval` takes a String parameter and returns a Movie Clip instance with that name if it exists. The `eval` function can be very useful for accessing Movie Clip instances when you have many copies of a Movie Clip, all with names that include a number: Ball0, Ball1. .. Ball12. If you want to apply the same code to each instance then you would build up a name using a loop; we will look at using loops in Chapter 8. The format would be:

```
//Start loop with i=0, with each loop add 1 to the variable I
... .
eval("Ball" + I)._x += 12;
... .
```

Summary

We have covered a great deal in this chapter, from creating a basic variable to much more complex string slicing. Along the way the structure

of many of your Flash projects has been introduced. You have learnt how to add ActionScript, to a frame action, a Movie Clip and a Button. Along the way you have come across several elements in ActionScript including the 'if' statement. In the next chapter we will look at using this most useful of commands in greater detail.

7 In tip-top condition

Should I go to Barcelona at Easter? If I have the money, there are flights available and I can get a hotel, then I'll go. Life is full of decisions. Should I take that job? Should I join a gym? Should I make a cup of tea? Whenever you make a decision, you will consider a number of options and in the end you will either decide to do something or you will choose not to. As you embark on your programming career you may be thinking if this doesn't get any easier then I stick to producing artwork. In this chapter we look at making decisions in your programs using the marvellous 'if' statement. An 'if' statement takes a logical argument that resolves to true or false; none of the difficult in-between concepts for a computer, it's either true or it's false and no half measures. Sometimes we need to combine several decisions before we come to our final conclusion. Multiple decisions are handled using Boolean logic, which is introduced in this chapter. We will illustrate some of these concepts using a keyboard controlled walking bucket and some very attractive lights. So without further ado let us set sail on the sea of conditions.

The marvellous 'if' statement

Because it is almost impossible to write any program without making a decision, you have already seen the 'if' statement in action. The introductory chapter used the 'if' statement and so too did the last chapter. You probably had a good idea what was going on, but you were not properly introduced. The marvellous 'if' statement can be used in one of three different ways. The simplest way is like this:

```
if (condition) {
  //Do something if condition is true
}
```

The line starts using 'if', then in brackets we put a condition. This can be anything that evaluates to true. You can even put the key word true in there and then the 'if' statement always evaluates to true, so the code in the curly braces is always executed. Later in this chapter we will look at the different conditions you can use.

The second variant of the 'if' statement takes this form:

```
if (condition) {
  //Do something if condition is true
}else{
  //Do something if condition is false
}
```

This time we cannot only execute code if the condition is true, we can also execute different code if the condition is false.

The third and final form of the 'if' statement takes the form:

```
if (condition1) {
  //Do something if condition1 is true
}else if (condition2) {
  //Do something if condition2 is true
}else{
  //Do something if neither condition1 nor condition2 is true
}
```

Here we have introduced 'else if'. We can have as many 'else if's as necessary for the logic in the program. The final 'else' is optional and is only executed if all the previous 'if's and 'else if's in the block evaluate to false.

Tell me more about conditions

Flash has a form very similar to JavaScript. The logical operators it supports are given in Table 7.1.

All of these operators take a left operand (described as '*a*' in the table) and a right operand ('*b*' in the table). Either operand can be a variable or a fixed numerical value. Suppose you want to know when a character on screen is at a certain position (100, 200), that is 100 pixels to the right and 200 pixels down from the upper left corner. You can test for an actual position using the following code snippet.

```
if (_x == 100) {
   //Movie Clip at _x equals 100
   if (_y == 200) {
         //Movie Clip at (100, 200)
         //Do something
   }
}
```

Notice how, in this example we nest one 'if' statement inside another. You can do this as many times as you choose, but if the nesting is more than three then you are encouraged to find another way to execute the code, since nested 'if' statements are very prone to give difficulty in detecting bugs; sometimes a condition is not met and the code goes screwy.

Table 7.1 Logical operators in Flash 6

Operator	Description	Possible usage
$a == b$	Evaluates to true if a equals b	$x == 23$
$a > b$	Evaluates to true if a is greater than b	$x > 12$
$a < b$	Evaluates to true if a is less than b	$x < -22.3$
$a >= b$	Evaluates to true if a is greater than or equal to b	$x >= y$
$a <= b$	Evaluates to true if a is less than or equal to b	$x <= -y$
$a != b$	Evaluates to true if a is not equal to b	$x != 1$

Testing for a specific position is likely to fail. One reason is because positions in Flash are not integer values and so the character may be at (100.1, 199.8); this is extremely close to the target position yet the condition would fail. One way around this problem is to reduce the exercise to a distance away from the target.

Now you may be thinking 'how can Pythagoras help with this problem?' The answer is that the relationship between the three sides of a right-angled triangle is one of the most useful devices you will find when creating graphical games. Let's start by reviewing the concept. If we have a triangle ABC where side AC has length x and side BC has length y, then side AB must have length, the square root of the sum of the squares of the two other sides. Looking at Figure 7.1, this means that the area of the square attached to the side AC plus the area of the square attached to the side BC is equal to the area of the square attached to the side AB. Oh dear, this sounds unfortunately like a Maths lesson. Fear not, you are not

Figure 7.1 That pesky Pythagoras.

going to have to do any proofs or solve any complex algebra; no, we are just going to use this very useful fact to get the distance between two points on our screen. Suppose we have point A and point B. Then we know from our good friend Pythagoras that the distance from A to B is found by squaring the distance from AB in the *x* direction and squaring the distance from AB in the *y* direction. If we add these two results and find the square root of the sum, then we have the distance from A to B. In Flash code we can turn this into a useful little function.

```
function distanceBetween(x1, y1, x2, y2) {
   x = x1 - x2;
   y = y1 - y2;
   return (Math.sqrt(x * x + y * y));
}
```

If you understand the above, then go to the top of the class; if it all seems a little hazy then let's take it a bit a time. A function can be passed any

number of parameters; they are the variables in the brackets, '()'. If we have a point on the screen (100, 200) and another point (105, 210) then we can pass this information into this function by using:

```
...
dist = distanceBetween(100, 200, 105, 210);
...
```

What happens when Flash sees this code is the player looks for a function, in the current scope, with the name 'distanceBetween'. If it does not find the function then Flash does not report an error, it simply sets the variable 'dist' to zero. If it does find the function, then it runs the code in the function, because of the values we have used in this example:

```
//x1 = 100, y1 = 200, x2 = 105 and y2 = 210
```

The order they appear in the brackets dictates the value assigned to each of the parameter variables in the function. If we change the order then the variables will be assigned different values, for example:

```
...
dist = distanceBetween(200, 100, 210, 105);
...
//Assigns x1 = 200, y1 = 100, x2 = 210 and y2 = 105
```

Within the function we use these values to get the distance between the points along each axis, using

```
x = x1 - x2;
y = y1 - y2;
```

Now if you are being extra smart you will realize that both x and y could take negative values if $x2$ or $y2$ are greater than $x1$ and $y1$ respectively. How do we handle this case? The fact is that in the function we make use of the square of these values and a square can never be negative. If we multiply a positive or negative number by itself then we get a positive value. For example:

```
//-2 * -2 = 4 not -4
```

A function can return a value; to do this we use the key word `return`. In this example we also use the square root function that is part of the Math

object. The square root function takes a single parameter and returns the square root of this parameter. In this instance we are interested in the sum of the two squares.

Now we can make use of this function to test the distance between two points:

```
if (distanceBetween(100, 200, clip._x, clip_y)<2) {
  //Do something
}
```

Because the function returns a value we can use it as one side of a logical operator. In this instance we 'do something' if the distance between the Movie Clip instance `clip` and the screen point (100, 200) is greater than 2. This test is much more robust and unlikely to do strange things. But a square root is quite a complex operation and in this instance not really necessary, so we can use the square of the distance between two points for the test. If we want the distance to be less than 2, then we want the squared distance to be less than 2 squared, or 4. We can change our function to

```
function squaredDistanceBetween(x1, y1, x2, y2) {
  x = x1 – x2;
  y = y1 – y2;
  return (x * x + y * y);
}
```

And use the new test

```
if (squaredDistanceBetween(100, 200, clip._x, clip_y)<4) {
  //Do something
}
```

Computationally this uses much less processing power, for no loss of accuracy. Always look out for times when you can lower the hit on the processor because your games will play more smoothly.

It doesn't seem very logical to me!

We've looked at how we can use the 'if' statement to select which code to run. So far we have used a single condition. But we can combine

conditions using either an 'And' operation or an 'Or' operation. Flash uses the symbol '&&' to represent And and '||' to represent Or. So how do we use these to combine conditions? The 'And' option means that all the conditions must be true for the combined condition to evaluate to true. The 'Or' option just requires a single condition to evaluate to true for the combined result to evaluate to true. Truth tables are often used to show the results of combinations; the truth tables for both 'And' and 'Or' are given in Table 7.2.

Table 7.2 And and Or truth tables

And	true	false
true	true	false
false	false	false
Or	true	false
true	true	true
false	true	false

Let's look at how we can use these options to improve our conditional statements. Suppose we want to run a section of code if our character is inside a rectangle on screen. We will define the rectangle using the upper left corner and the lower right corner. To be within the region the character's _x position must be greater than the value for left of the rectangle and also less than the value for right; in addition, the character's _y position must be greater than the top line of the rectangle but less than the bottom line. So how do we put this into code? Let's consider the rectangle (100, 200, 300, 400). Here the left side is at 100, the top is at 200, the right is at 300 and the bottom is at 400. If we have a Movie Clip called `clip` then the code we would use would be:

```
if (clip._x>100 && clip._y>200 && clip._x<300 && clip._y<400) {
  //Do something
}
```

This reads as 'if the _x position of clip is greater than 100 and the _y position is greater than 200 and the _x position is less than 300 and the _y position is less than 400 then do something'.

But what if we want to 'do something' if the character is in one of two different rectangles. First, let's put the test into a function.

```
function pointInRect(x, y, left, top, right, bottom)
  if (x>left && y>top && x<right && y<bottom) {
    return true;
  }else{
    return false;
  }
}
```

This little function returns true if the point (*x*, *y*) is inside the rectangle (left, top, right, bottom). To use the function in the first example we would use:

```
if (pointInRect(clip._x, clip._y, 100, 200, 300, 400)){
  //Do something
}
```

But if we want to run the code if the character is inside the rectangle (100, 200, 300, 400) or the rectangle (400, 25, 500, 127) then we can combine two calls to the function using:

```
if (pointInRect(clip._x, clip._y, 100, 200, 300, 400) ||
      pointInRect(clip._x, clip._y, 400, 25, 500, 127)) {
  //Do something
}
```

Notice how Flash allows you to put a long line onto two or more lines; Flash ignores what is referred to as 'white space'. This includes spaces and carriage returns, so you can fit the code into a narrower text box.

Let's try out an example

When you are learning about using any sort of programming language, there is no substitute for hands-on experience. We are going to look at a practical example of the 'if' statement in action and you are firmly encouraged to run your copy of Flash and open 'Examples\Chapter-07\OverlapTest.fla'. Take a look at the _root level timeline. There are six layers; each layer has been named with a relevant name. Most of the code we are going to study is in the layer 'Control' on frame 1. When declaring new functions for a Movie Clip or _root level timeline, frame 1 is a good place to put the new function code. In this example we will be using a function that is placed on the first frame.

Figure 7.2 The layers used in the OverlapTest project.

The purpose of the program is to detect when the Bucket overlaps with the Box in the middle of the screen. As well as detecting the overlap, we set the caption that in Figure 7.3 displays 'No overlap' to indicate the current overlap and set the light to be red, amber, bright amber or green, depending on the level of overlap.

Figure 7.3 The stage for the OverlapTest project.

Most of the functionality is in the function `overlapTest`. Let's look at the function now; you will find it in the 'Control' layer of frame 1, scene 1 'Examples\Chapter07\OverlapTest.fla'.

```
//==================overlapTest=====================
//Parameters
//clipA- name of a Movie Clip
//clipB- name of a Movie Clip
//==================================================
//Returns
//1 if no overlap
//2 if at a corner
//3 if at a side
//4 if fully inside
//==================================================
//Description
//Takes the name of two Movie Clips, clipA should be smaller in
//both width and height. The function returns a numeric value
//indicating the level of overlap
//==================================================
function overlapTest(clipA, clipB) {
  if (clipA==clipB) return 4;//Must be fully overlapped
  left1 = eval(clipA)._x;
  left2 = eval(clipB)._x;
  top1 = eval(clipA)._y;
  top2 = eval(clipB)._y;
  right1 = left1 + eval(clipA).width;
  right2 = left2 + eval(clipB)._width;
  bottom1 = top1 + eval(clipA).height;
  bottom2 = top2 + eval(clipB)._height;

  //These conditions indicate no overlap
  if (left1>right2||right1<left2||top1>bottom2||bottom1 < top2){
        overlap = "No overlap";
        return 1;
  }else if (left1<left2 && right1>left2) {
        //Overlap to clipB left
        if (top1 < top2){
                //Overlap at top left corner
                overlap = "Top left";
                return 2;
```

```
        }else if (bottom1 > bottom2) {
                //Overlap at bottom left corner
                overlap = "Bottom left";
                return 2;
        }else{
                //Must be in middle on left
                overlap = "Middle left";
                return 3;
        }
}else if (left1<right2 && right1>right2) {
        //Overlap to clipB right
        if (top1 < top2){
                //Overlap at top right corner
                overlap = "Top right";
                return 2;
        }else if (bottom1 > bottom2) {
                //Overlap at bottom right corner
                overlap = "Bottom right";
                return 2;
}else{
        //Must be in middle on right
                overlap = "Middle right";
                return 3;
        }
}else{
        //Must be in middle column
        if (top1<top2){
                //Middle top of clipB overlap
                overlap = "Top middle";
                return 3;
        }else if (bottom1>bottom2) {
                //Middle bottom of clipB overlap
                overlap = "Bottom middle";
                return 3;
        }else{
                //Must be completely inside clipB
                overlap = "Inside";
                return 4;
        }
    }
 }
```

Figure 7.4 How two Movie Clips can overlap.

Before we study the code let's try to understand the problem. The problem is to identify and classify the overlap of two Movie Clips. Figure 7.4 shows the possible locations of the two clips.

The smaller Movie Clip, in the example the Bucket, can be positioned in one of 10 possible places, in relation to the larger Movie Clip, in this case the Box.

1 No Overlap
2 Top Left
3 Middle Left
4 Bottom Left
5 Top Middle
6 Inside
7 Bottom Middle
8 Top Right
9 Middle Right
10 Bottom Right

If we were totally general and allowed the case where Movie Clip A can be bigger than B, then there would be other cases; for now we only consider the case where both the width and height of clip A is less than clip B.

Table 7.3 gives the conditions that will identify the placement of the smaller Movie Clip in relation to the larger one; we use (left1, top1, right1,

Table 7.3 The conditions necessary to locate Movie Clip A in relation to Movie Clip B

Location	left1	right1	top1	bottom1
No Overlap	left1>right2	Or right1<left2	Or bottom1<top2	Or top1>bottom2
Top Left	left1<left2	And right1>left2	And top1<top2	And bottom1>top2
Middle Left	left1<left2	And right1>left2	And top1>top2	And bottom1<bottom2
Bottom Left	left1<left2	And right1>left2	And top1<bottom2	And bottom1>bottom2
Top Middle	left1>left2	And right1<right2	And top1<top2	And bottom1>top2
Inside	left1>left2	And right1<right2	And top1>top2	And bottom1<bottom2
Bottom Middle	left1>left2	And right1<right2	And top1<bottom2	And bottom1>bottom2
Top Right	left1<right1	And right1>right2	And top1<top2	And bottom1>top2
Middle Right	left1<right1	And right1>right2	And top1>top2	And bottom1<bottom2
Bottom Right	left1<right1	And right1>right2	And top1<bottom2	And bottom1>bottom2

bottom1) to define the rectangle for A and (left2, top2, right2, bottom2) to define the rectangle for B.

Apart from the special case of 'No Overlap' it takes four tests to determine the location; we need to test for the left, top, right and bottom of the first Movie Clip in relation to the second. The location determines which of these tests we need to do. If we first check the 'No Overlap' case and find that this does not apply then we need to identify which of the nine other cases is the current location. To do this we would test first for a column and then for a row in the column. For example, a successful test for (left1<left2 and right1>left2) would place Movie Clip A in the Left column of Figure 7.4. Then we need to work out if we are in the top, middle or bottom row. This is achieved using the code snippet:

```
...
}else if (left1<left2 && right1>left2) {
    //Overlap to clipB left
    if (top1 < top2){
        //Overlap at top left corner
        overlap = "Top left";
        return 2;
    }else if (bottom1 > bottom2) {
        //Overlap at bottom left corner
        overlap = "Bottom left";
        return 2;
```

```
    }else{
        //Must be in middle on left
        overlap = "Middle left";
        return 3;
    }

...
```

In the example the variable 'overlap' is set to a descriptive string for the current context. A Dynamic Text box tracks this variable. The function returns a value of 1 for no overlap, 2 if at a corner, 3 if at an edge and 4 if totally inside. This function is called by the 'Light' Movie Clip in an `onClipEvent(enterFrame)` event. Click on the 'Light' and look at the Action panel to see the script for the event. It is very simple, the frame that the 'Light' is parked on is set using the returned value from the function `overlapTest`.

The movement of the 'Bucket' is controlled using the Arrow keys. You can read the value of a key at any time using the Flash 'Key' object. We will be looking in more detail at the various objects that Flash allows the developer to use in later chapters, but for now we simply use the Key object method `isDown` to find out if one of the arrow keys is down. The 'Key' object contains several constants that define certain important keys. The arrow keys are listed in Table 7.4.

In the example, if an arrow key is pressed then we first check to see if the 'Bucket' is currently executing the appropriate action; the current action is stored in the variable action. The code can be found by double-clicking the Bucket, to enter the 'BucketB' Movie clip then clicking the Bucket again and examining the 'onClipEvent(keyDown)' that you will find displayed in the 'Action' panel. A value of 1 means the 'Bucket' is walking left, 2 the 'Bucket' is climbing up to the left, 3 climbing up to the right, 4 means walking right, 5 and 6 climbing down to left and right respectively, and 7 means the 'Bucket' is stopped. If the 'Bucket' is currently facing to

Table 7.4 Arrow key codes

Key	Symbol	Code
Left Arrow	Key.LEFT	37
Up Arrow	Key.UP	38
Right Arrow	Key.RIGHT	39
Down Arrow	Key.DOWN	40

the right and the Left Arrow Key is pressed, then the 'TurnLeft' animation sequence is executed to rotate the character. Equally, if the 'Bucket' is facing left and the Right Arrow Key is pressed then the 'TurnRight' sequence is run. All this functionality is placed in the `onClipEvent (keyDown)` event. In the example, we are checking the overlap of two clips in relation to their (_x, _y) location. The (_x, _y) location can be set anywhere on a Movie Clip, in the code we need it to be at the top left corner. The 'Bucket' animation, in fact, uses the middle bottom as the locating point. So how do we move this to the top left. The easiest way is to nest the Bucket clip inside a new clip. The 'Bucket' animation can be placed within another Movie Clip by pressing F8 and nesting the animation inside a new parent clip. The Bucket was then moved within this new parent so the cross is at the top left corner.

Figure 7.5 Setting the (_x, _y) location for a Movie Clip.

Here is the full code for the clip event for the Bucket.

```
onClipEvent(keyDown) {
    if (Key.isDown(37)) {
        //Left
        _root.code = "Left";
```

```
        if (action!=1) {
              moveX = -5;
              moveY = 0;
              if (left){
                     this.gotoAndPlay("WalkLeft");
              }else{
                     left = true;
                     this.gotoAndPlay("TurnLeft");
              }
        }
        action = 1;
}else if (Key.isDown(38)) {
        //Up
        _root.code = "Up";
        if (left){
              if (action!=2) {
                     moveX = 0;
                     moveY = -4;
                     this.gotoAndPlay("IntoClimbLeft");
              }
              action = 2;
        }else{
              if (action!=3) {
                     moveX = 0;
                     moveY = -4;
                     this.gotoAndPlay("IntoClimbRight");
              }
              action = 3;
        }
}else if (Key.isDown(39)) {
        //Right
        _root.code = "Right";
        if (action!=4) {
              moveX = 5;
              moveY = 0;
              if (left){
                     left = false;
                     this.gotoAndPlay("TurnRight");
              }else{
                     this.gotoAndPlay("WalkRight");
              }
        }
        action = 4;
```

```
        }else if (Key.isDown(40)) {
            //Down
            _root.code = "Down";
            if (left){
                if (action!=5) {
                    moveX = 0;
                    moveY = 4;
                    this.gotoAndPlay("IntoClimbDownLeft");
                }
                action = 5;
            }else{
                if (action!=6) {
                    moveX = 0;
                    moveY = 4;
                    this.gotoAndPlay("IntoClimbDownRight");
                }
                action = 6;
            }
        }else if (Key.isDown(32)) {
            //Down
            _root.code = "Stop";
            if (action!=7) {
                moveX = 0;
                moveY = 0;
                if (left){
                    this.gotoAndStop("WalkLeft");
                }else{
                    this.gotoAndStop("WalkRight");
                }

            }
            action = 7;
        }
    }
    onClipEvent(enterFrame) {
    _parent._x += moveX;
    _parent._y += moveY;
    }
```

Notice how the onClipEvent(enterFrame) is used to move the parent, not the clip itself. We could move the nested clip; the user would

see the same action. Try it now; change the two lines above so that the clip event is now:

```
onClipEvent(enterFrame) {
  _x += moveX;
  _y += moveY;
}
```

The action of the 'Bucket' is the same but the overlap display always shows 'No Overlap' all the time and the light shows red. Why? Because the function overlapTest is passed the name of two Movie Clips, the root level 'Bucket' and 'Box'. But the root level 'Bucket' clip doesn't move. It is the clip 'Bucket.Bucket' which is moving. So the overlapTest function calculates the same values for (left1, top1, right1, bottom1) all the time. Since the starting position is no overlap, this will be the value for the duration of the program. By moving the parent we are moving 'Bucket' on the stage as well as 'Bucket.Bucket', and so the function call works. You might think, why not pass the name 'Bucket.Bucket' to the function by changing the clip event for the light from:

```
onClipEvent(enterFrame) {
  frame = _root.overlapTest("Bucket", "Box")
  this.gotoAndStop(frame);
}
```

to

```
onClipEvent(enterFrame) {
  frame = _root.overlapTest("Bucket.Bucket", "Box")
  this.gotoAndStop(frame);
}
```

Click on the light to view and edit the code.

Now overlaps are recorded, but they are in relation to a rectangle that is the same width and height as the 'Bucket' but has its top left corner at the middle of the base of the 'Bucket'.

Try the program and get a feel for where the tests are located. An alternative approach would be to include an `offsetX` and `offsetY` value in the Movie Clips that are included in the calculation of the

Figure 7.6 How the overlapTest is dependent on the Movie Clip's original location.

rectangles for the `overlapTest` function. We can initialize these values in the `onClipEvent(load)` event. Or we can make the 'Bucket' or the box a component. To do this, go to the Library panel and right-click on the 'Bucket' symbol, then select 'Component Definition . . .'. You will see the panel shown in Figure 7.7.

By clicking on the '+' button you can add a variable and give it a default value. The '−' button removes a parameter and the 'Description' panel allows you to enter details about the clip. The 'Link to Custom UI' allows you to add a Flash movie that will be used to enter the values for these parameters. The advantage of using a Component is that you can create a complex clip that can easily be modified by designers. They can right-click the clip on the stage and select the Parameters tab in the Properties panel in order to edit the values.

Now we can set the offset from the current origin cross to the top left corner of the clip. In this instance the clip is (39.5, 52.3) and the cross is

in the middle at the base. The `offsetY` value involves moving up to the top, which will be −52.3. The `offsetX` value involves moving left from the middle, which will be −20. Now we can use these values in the `overlapTest` function.

```
left1 = eval(clipA)._x + eval(clipA).offsetX;
left2 = eval(clipB)._x + eval(clipB).offsetX;
top1 = eval(clipA)._y + eval(clipA).offsetY;
top2 = eval(clipB)._y + eval(clipB).offsetY;
right1 = left1 + eval(clipA)._width;
right2 = left2 + eval(clipB)._width;
bottom1 = top1 + eval(clipA)._height;
bottom2 = top2 + eval(clipB)._height;
```

Figure 7.7 Defining parameters for a component.

Figure 7.8 Altering the default values for a component.

If you open the project 'Examples\Chapter07\overlapTestB.fla' then you can see this method being used.

Summary

The 'if' statement is one of the most useful keywords you will find in any programming language; it allows you as developer to select the code that will run based on current conditions. In this chapter we looked at using the 'if' statement in both simple and complex ways. The 'if' statement takes a parameter that must evaluate to either 'true' or 'false'. We looked at using simple conditions and also conditions that are built from several tests using the combining logic of 'And' and 'Or'. In the next chapter we look at how we can execute repetitive tasks easily.

8 Using loops

If there is one thing that computers are good at – but if yours has just crashed on you then you might be forgiven for thinking they are good at precious little – then that is doing boring repetitive jobs. In this chapter we will look at how you can tell your program to repeat and repeat and repeat. No programming language would be complete without the ability to repeat sections of code several times. Games regularly need to run a section of code several times. In this chapter we will look at creating sections of code that repeat and show you how to control the program flow in these situations. We will learn how to jump out of the code if a certain condition is met. We will consider using repeats that run at least once and repeats that may never run at all. One of the most important aspects of using loops is the initializing of the data used in a loop. We will look at the potential pitfalls from initialization errors.

Creating sections of code that repeat

Flash has several options for repeating; the first option is used when you already know how many times you want to repeat a section of code. In this circumstance you use the 'for' statement.

```
sum = 0;
for(i=1; i<=100; i++) {
  //Code that repeats 100 times with i=1, 2, 3.. 100
  sum += i;
}
```

The 'for' statement takes three code lines as a parameter. Because they are lines of code, they are separated by a semi-colon, not a comma. The first line is the starting condition. Most 'for' loops use a counting variable,

in this instance *i*; the first line is usually where you will set the start value for the variable that you use as a counter. The second line dictates the condition that will cause the 'for' loop to be executed; as soon as this condition fails the 'for' loop is exited. In the example above, the exit condition occurs when *i* is no longer less than or equal to 100 (*i*<=100). The final code line in the 'for' statement parameter is the repeat action; this code snippet is executed each time the 'for' loop repeats. In the example above, the English language equivalent would be 'Set *i*=0. Start the loop. If *i* is less than 100 then execute the code within the curly braces. Having executed the code increment (add one to) *i*. Now repeat from start of the loop.' Recall that the symbol '++' means add one to the variable that precedes it.

The 'for' statement is very flexible; the counter variable does not need to be called *i* and the repeat code need not involve simply adding one. Here is an alternative example using the variable *n* and the repeat code takes 0.4 from its value for each loop. The loop continues while *n* is greater than zero.

```
count = 0
for(n=-100; n>0; n-=0.4) {
  count++;
  }
```

You don't need to use a loop variable at all; the following example is perfectly legal.

```
i = 1;
sum = 0;
for(;;) }
  if (i>100) break;
  sum += i++;
}
```

Here we initialize two variables, *i* and 'sum', before entering the 'for' loop. Inside the loop we test to see if *i* is greater than 100; if it is then we use the 'break' statement. This causes the program to jump out of the 'for' loop immediately. If the 'break' condition is not met then the current value of *i* is added to the variable 'sum' and then the variable *i* is incremented. The last line in the loop could have been changed to:

```
sum = sum + i;
i = i + 1;
```

Both code snippets do the same thing. Most people get into a way of writing code that they are happy with; unless you work in a big team you will be able to write the code the way you choose. Personally, unless the case is very obvious I would discourage using multiple code in a single line. I would prefer:

```
sum += i;
i++;
```

In the above example it is pretty clear what is happening, but...

```
if ((code++) < (getCode (i++, n--) + 3) ||
    i++>(23 * getCode(i--, n++))) {
    //Hmm is this going to happen or not?
}
```

... is far from obvious. The code is in fact:

```
code++;
res = getCode(i, n) + 3;
i++;
n--;
testA = code<res;
res = 23 * getCode(i, n);
i--;
n++;
testB = i < res;
i++;
if (testA || testB) {
  //Do something
}
```

Notice how the increments and decrements are only executed after the variable has been used within its current operation. By combining all the operations, no speed increase is achieved, but the sense of the code is completely lost. The later example will be much easier to debug if there is a problem in the operation.

Jumping out of the code if a condition is met

With the 'for' loop there are two exit routes from the loop. The first is the repeat condition entered as the second line in the 'for' loop parameter. The

second possibility is to use a 'break' statement. The 'break' statement can also be used inside the second type of repeat loop, the 'while' statement:

```
i = 1;
sum = 0;
while(i<=100) {
  sum += i;
  i++;
}
```

This will give the same answer as the first of the repeat examples but offers a different construction. In this example two variables '*i*' and 'sum' are initialized, then a loop is entered. The brackets that follow the 'while' statement contain the exit condition. In this instant the loop will repeat until the variable '*i*' is over 100. Although used as above, it is difficult to see why you would want to use this construction. But there is a reason to use the 'for' loop construction and the 'while' loop. Here is another simple problem much better suited to the 'while' loop construction:

```
i = 1;
sum = 0;
while(sum<5000) {
  sum += i;
  i++;
}
```

Now instead of testing for the case where the loop variable *i* reaches a certain value, we look for when the sum gets to a certain value. The 'for' loop is best used with a loop variable that is incremented by a regular amount, usually one, and the test is for the loop variable reaching a certain value. The 'while' loop is best used when the knowledge of the loop condition is not so closely allied to the loop variable. It is possible with both constructions to create a loop that never terminates. In such circumstances your computer will briefly hang until Flash realizes that something untoward is going on and offers a dialog box enabling you to terminate the use of scripts in the existing program. Here are two obvious examples of loops that will never terminate:

```
//Example A
sum = 0;
for (i=0; i<100; n++) {
  sum += i;
}
```

```
//Example B
i = 1;
sum = 0;
while(i<=1)
  sum += i;
}
```

With example A, the repeat code increments the wrong variable; instead of incrementing the loop variable *i*, the variable *n* is used. This might seem an unlikely circumstance, but you will be surprised the number of times you copy and paste a section of code then neglect to update all the variable references. In example B, the loop condition is always met because the loop variable *i* is not varied within the code block. This is the most common error when using 'while' loops. It is essential that the loop condition ultimately fails. A common use of the 'while' loop uses the following construction:

```
i = 1;
sum = 0;
while(true) {
  sum += i;
  i++;
  if (sum>1000) break;
}
```

Here the 'while' loop condition is always going to be true, since true equals true! But within the code block a terminating condition is included, if (sum>1000) then the code block is exited using the break statement.

Repeats that run at least once

The third and final repeat construction to use is one where we ensure that the loop code block is always executed at least once. You can have a 'for' loop where the format is:

```
a = 0;
for (i=min; i<100; i++) {
  a++;
}
```

Here the initialization uses a variable '*i*' being assigned the value of the variable 'min'. When 'min' is greater than 100 this code loop will not execute at all. Similarly, using the 'while' loop we may have:

```
a = 0;
i = min;
while(i<100) {
   a++;
   i++;
}
```

Again, if 'min' is greater than or equal to 100, then the code block will be skipped. In most circumstances this is OK. But you may use the loop to initialize another variable. Because it is skipped the variable is not set to the appropriate value. In the above example, if you assume that '*a*' will have a value other than zero, then this could lead to errors in your program. There is a simple solution to this dilemma; use a construction that ensures that the loop will execute at least once.

```
a = 0;
i = min;
do{
   a++;
   i++;
} while(i<100) {
```

Using this construction the loop is guaranteed to run, so the minimum value that '*a*' can take is at least 1, regardless of the value of the variable 'min'.

Skipping part of the repeating block of code

There may be times in your repeating code block when you will want to speed on to the next loop, skipping the remaining code in the block. To do this you use the continue statement.

```
a = 0;
i = min;
do{
   a++;
   if (a==10) continue;
   //Do things as long as a does not equal 10
   ...

   i++;
} while(i<100) {
```

The effect of the above code is to skip the case where '*a*' is equal to 10. You may have 10 Movie Clips that are being adjusted using the code loop, but Movie Clip 10 is the one under keyboard control and so should be bypassed.

Initializing the data used in a loop and ensuring the exit condition

When using code loops it is essential that you initialize the data for the loop before the loop is entered and that there will be a case when the loop will terminate. It's surprising how often these two important factors are overlooked. If you are using the 'for' loop construction in the standard way with a single variable that is incremented for each repeat of the code block, then the most common cause of problems is accidentally using the loop variable within the code block. Here is an example that is all too common:

```
for(i=0; i<10; i++) {
        name = "Bucket" + i;
        eval(name)._x += 100 * i;
        if (i=9) {
                eval(name)._y = 50;
        }
}
```

This section of code is supposed to repeat 10 times with *i* taking the values 0 through to 9. Instead, it executes just once. Why? There is a classic error in the code block. Flash uses '==' to test for equality and '=' to assign a value to a variable. The line

```
if (i=9) {
```

has the effect of making the variable *i* equal to 9, not testing whether *i* is equal to 9. Make sure you realize the difference; '=' changes the variable on the left, '==' tests whether both sides of the operation are equal. Having, in this instance, assigned 9 to the variable '*i*', the loop operation is executed. This operation adds 1 to the value of the variable '*i*' at which point the variable '*i*' is equal to 10. Since '*i*' is no longer less than 10, the next repeat of the code block is skipped. This is so easy to do and relatively difficult to spot. You may read through the code several times before you spot that you have used a '=' when '==' is intended. This example is even more frustrating because it never exits:

```
for(i=0; i<10; i++) {
       name = "Bucket" + i;
       eval(name)._x += 100 * i;
       if (i=1) {
              eval(name)._y = 50;
       }
}
```

Because '*i*' is constantly set to 1 in the 'if' statement the value of *i* hovers between 1 and 2. When Flash detects an infinite loop after a short time, it realizes the problem and offers the developer the option to abort any further scripts; this returns control and the program can be gracefully exited.

Pitfalls caused by initialization errors

When using the 'while' loop construction, you will find that the most common problem is due to inappropriate initialization. Take the following example:

```
while(i!=20) {
   //Do something
   ...
   i+=2;
}
```

Here we enter the loop with no initialization, blindly assuming that *i* will default to zero. Never assume anything about initialization. You will find that almost all hard to locate errors will be the result of poor initialization. How do I know? Because I have done most of them! Don't be stupid like me, make sure that all variables that are used inside a code loop have a known and predictable value at the start and throughout the code loop. The example above also betrays another common problem with loops using any kind of equality condition. In the above we allow the loop to continue until *i* is equal to 20. But, what if *i* will never equal 20. Maybe it starts equal to 25. Therefore, as '*i*' increases for every iteration of the loop, it will never equal 20. You may find an instance where *i* starts the loop as an odd number. When 2 is added to an odd number the number stays odd, so it will never equal 20, which, as you know, is an even number. Always use greater than or less than as the exit condition; you will eliminate at least half the problems you may encounter with loops by adopting this useful advice.

Two examples to help you understand

As usual examples are the best way to learn. Boot up your machine and open 'Examples\Chapter08\LoopBucket.fla'. Here is a very simple program that uses the now familiar walking Bucket to show how loops can work.

Figure 8.1 shows the 'LoopBucket' project in development. There are just five layers. The usual 'Control' layer is where any frame actions are placed. There is only one frame in this timeline; the action for frame 1 is just to set a global variable 'numBuckets' to the value 1, since we have just one bucket on screen, then the second line is the ActionScript command 'stop()'.

```
numBuckets = 1;
stop ();
```

The code to move and update the Bucket is all inside the Bucket clip or as an 'onClipEvent' action for the clip. If you are interested, then click on the Bucket and view the 'Action' panel. The code we are interested in in this

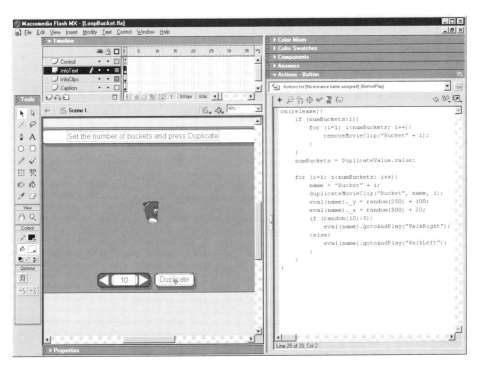

Figure 8.1 The LoopBucket project.

chapter is all inside the 'Action' for the 'Duplicate' Button. Right-click the 'Duplicate' Button and select 'Action' to view the code. The value entered in the number box using the left and right arrow buttons can be between 2 and 10. When you click on the 'Duplicate' Button the following code is run:

```
on(release) {
  if (numBuckets>1) {
        for (i=1; i<numBuckets; i++) {
                removeMovieClip("Bucket" + i);
        }
  }
  numBuckets = DuplicateValue.value;

  for (i=1; i<numBuckets; i++) {
        name = "Bucket" + i;
        duplicateMovieClip("Bucket", name, i);
        eval(name)._y = random(250) + 100;
        eval(name)._x = random(500) + 20;
        if (random(10)>5) {
                eval(name).gotoAndPlay("WalkRight");
        }else {
                eval(name).gotoAndPlay("WalkLeft");
        }
  }
}
```

The effect of this code is to duplicate the number of Buckets; we go from what is seen in Figure 8.2 to the view shown in Figure 8.3.

Let's look at the code a section at a time. Firstly, this is an 'Action' for a Button. Buttons have 'rollOver', 'rollOut', 'release', 'releaseOutside' and 'press' events. All the events are initiated by a mouse action. The event we trap is the 'release' event. This happens whenever the Button is pressed and then the mouse is released within the area defined for the Button, either by using the 'Hit' frame 4 of a Button instance or by using the graphics defined in frames 1–3. The first part of the function checks the current value for 'numBuckets'; recall that this value is initialized using the frame action on frame 1 of the main timeline. If the value is 1 then the only Bucket on the screen is the one that was placed there at design time. To retain the functionality of the program, this Bucket cannot be removed. If the value for 'numBuckets' is greater than 1 then there has already been a duplication, so we remove the duplicated Buckets using a 'for' loop. In the 'for' loop we set a loop variable 'i' to 1 initially and test to see if the

Figure 8.2 The LoopBucket project at run-time.

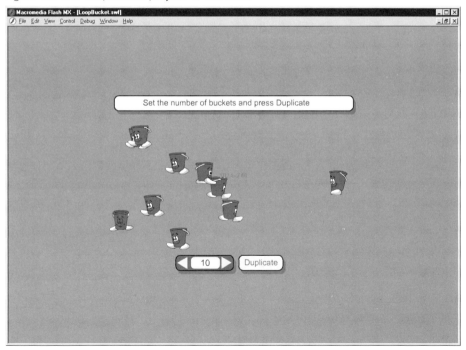

Figure 8.3 The LoopBucket project at run-time after the Duplicate Button is pressed.

value is less than the total for the 'numBuckets'. If it is less then we must remove a Bucket. First we build the name of the Bucket; all duplicated instances on the stage must have a name. To create the name we simply use the code

```
"Bucket" + i
```

This creates the names 'Bucket1', 'Bucket2', etc. as '*i*' takes the values 1, 2 . . . up to one less than 'numBuckets'. The Movie Clip with this name is removed from the stage using the command 'removeMovieClip' with the name passed as a parameter. After this first loop has run through, we set the new value for the number of Buckets using the value that is controlled inside the 'DuplicateValue' clip. This value is set using the left and right arrow buttons inside the clip. We can extract the value in the Dynamic Text box using the code:

```
numBuckets = DuplicateValue.value;
```

Finally, we enter a loop where the new duplication value is used to create new randomly placed Buckets. Again, a 'for' loop is used because we need to do something as a single integer moves up in value between two known quantities. The first value is 1 and the top value is one less than 'numBuckets' because there is always one Bucket on the screen. To duplicate a Movie Clip we use the command 'duplicateMovieClip' with three parameters. The first parameter is the instance name for the existing Movie Clip, the one we are about to duplicate. The second parameter is the name to use for the new Movie Clip and the final parameter is the level to create this on. This must be different from the duplicate's value and must be different from any other duplicated clip. In the example we simply use the value of the loop variable '*i*'.

Having duplicated the original clip we then set up some initial conditions. The value for the Movie Clips _x and _y values is set to a random value using the Flash command 'random'; 'random' takes an integer value. Each call to 'random(*x*)' will return a value between zero and one less than the value passed as parameter '*x*'. The _y value is set between 100 and 349 using this code, since 100 is added to the value returned from the call to 'random(250)'; _x is set similarly. To access the duplicated Movie Clip we use the new value for the instance name and the Flash command 'eval'. Recall that 'eval' takes a single parameter, which is a Movie Clip's instance name; if the instance exists then this clip is returned. In addition to setting the _x and _y values, we also set the current direction; again the choice is dictated by the value returned from

a 'random' call. The effect of the code is to remove all duplicated instances of the initial Bucket, then to duplicate a new or equivalent number of Buckets that are randomly placed, walking either left or right. See how much functionality we get from such a small amount of code.

Creating simple components

Although you are taking the time to learn how to write code, not everyone likes to get their hands dirty. Now you know about variables, condition statements and repeat loops, you are well on your way to being a Flash expert. But suppose you want to let others share your code. They want to use your code in the simplest way possible, ideally just by dragging a Movie Clip out of the library and placing it on the stage. The drag and drop option doesn't give them any control over the behaviour of the Movie Clip, however. They would prefer to set up initial conditions using the minimum of fuss. Take a look at 'Examples\Chapter08\Fireworks.fla'.

If you right-click on the star and select the Parameters tab in the Component Properties panel, you should see the window in Figure 8.4.

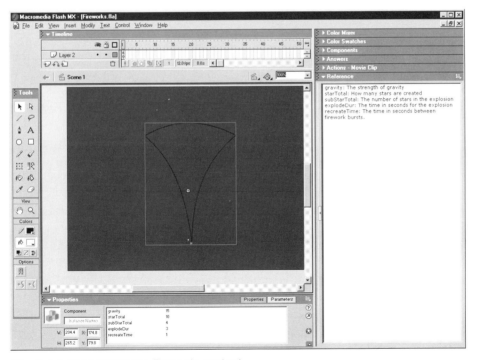

Figure 8.4 Developing the Fireworks project.

This window lets the developer set the initial value for variables in the Movie Clip. In this example the variables are 'gravity', 'starTotal', 'subStarTotal', 'explodeDur' and 'recreateTime'. We will look at how the code works later, but for now try altering the values for 'starTotal' and 'subStarTotal' and then running the code using 'Ctrl + Enter'. As you vary the values the movie runs differently. The movie itself shows a simulation of a firework; the number of stars in the firework is set using the 'starTotal' clip parameter. As the stars pass the maximum height they explode; the number of stars in the explosion is defined using the 'subStarTotal' parameter.

The parameters that appear in the Component's Parameters panel are defined by right-clicking on the Movie Clip in the Library panel and selecting 'Component Definition'. You will see a dialog like the one in

Figure 8.5 Defining Component Parameters.

Figure 8.5. You set the name of the variable, what its default value will be, the value it takes just by a drag and drop without the user setting any specific values, and set the type of variable. It is even possible to use a Flash Movie as the customized user interface for setting the values. By changing the variable values, the code inside the Movie Clip that uses these values is affected. The 'starTotal' and 'subStarTotal' parameters are used by repeat loops inside the clip. Here is an example:

```
for (i=0; i<starTotal; i++) {
  name = "Star" + i;
  eval(name).gotoAndPlay("Fire");
}
```

Creating physical simulations

The firework project uses code in a physical simulation. If you are interested in this sort of thing, then read on. If not, then by all means skip to the next chapter because the main purpose of this chapter, to introduce repeat loops, is complete.

All physical simulations that you will meet when playing with other people's Flash code will be based on Newtonian mechanics. This complex sounding topic is really quite simple to use. The Fireworks example uses the simplest example, projectile motion under gravity with no friction. The classic formula for this is:

$$x = v_0 t \cos \theta$$
$$y = v_0 t \sin \theta - \tfrac{1}{2} g t^2$$

Here v_0 is the initial velocity of the particle, t is the current time in seconds, θ is the start angle measured from the horizontal and g, is the acceleration due to gravity measured in metres per second squared. The operations 'sin' and 'cos' are frequently used in both 2D and 3D games. They relate the length of sides of a right-angled triangle to an angle in the triangle.

Take a look at Figure 8.6. The sides and angles are related using the following formulae:

$$\sin \theta = {}^{\text{opp}}/\text{hyp}$$
$$\cos \theta = {}^{\text{adj}}/\text{hyp}$$
$$\tan \theta = {}^{\text{adj}}/\text{opp}$$

Figure 8.6 A right-angled triangle.

If we know an angle then we can convert this into a length using a sin or cos operation.

A projectile motion is based on the starting angle and the starting velocity measured in metres per second. The final aspect of the equations that govern the motion of the projectile is the use of gravity. The *y* value for the projectile is calculated using two components: a component based on the initial condition and one based on gravity. The initial condition is multiplied by the current time in seconds and the gravity component is multiplied by the current time squared. As time increases in size the gravity component will grow more quickly, because it is multiplied by the value of time squared. Below 1 second, the square will be smaller than the original value; above 1 second it is greater:

Table 8.1 How squared values grow

Time	Time * time
0.5	0.25
1	1
2	4
5	25
10	100

Because of the use of a squared value in the gravity component, at some stage the gravity value will overtake the value based on the starting condition. At this time the projectile will be descending.

So how do we use all this theory? First we need a starting value for the velocity in the *x* and *y* directions. The developer needs to be able to easily relate this to the current scene. For this purpose we include a shape in the clip called 'Area' that gives a guide to the shape the firework will have when moving. In the code for frame 1 of the Movie Clip, 'Fireworks', we take the '_width' and '_height' of this clip and use it to set the width and height values we will use. Then we duplicate the Movie Clip, 'Star0', 'starTotal' times using a 'for' loop. For each of the 'Stars' we set a value for 'spread' and 'speed'; 'spread' will control the '_x' values and 'speed' will control the '_y' values. The value set for 'spread' and 'speed' uses a 'random' value. Finally, in the frame action for frame 1 of the 'Fireworks' Movie Clip, we set the value for the origin and for the point we will use as a centre. The 'Area' Movie Clip is only used by the developer to set the spread and height of the firework. After it has been used for this purpose we set the '_alpha' value to zero to ensure that it is not displayed. Having done all the initializing the Movie Clip playback is sent to the label 'Fire'.

```
//Init frame 1 action
//Create moving stars
width = Area._width * 0.5;
height = Area._height * 0.7;
heightrange = height/4.0;
averageheight = height - heightrange;
for (i=0; i<starTotal; i++) {
  name = "Star" + i;
  if (i>0) {
        duplicateMovieClip("Star0", name, i);
  }
  eval(name).spread = (random(width) - width/2.0)/2.0;
  eval(name).speed = (random(heightrange) + averageheight)/2.0;
}
orgX = _x;
orgY = _y;
centreX = Area._x;
centreY = Area._y;
Area._alpha = 0;
gotoAndPlay("Fire");
```

So what happens when the 'Firework' is launched? The playback position for all the duplicated Movie Clips is also set to 'Fire'. Because these are all Movie Clips inside the current Movie Clip, the 'Fire' referred to is the 'Fire' inside the sub-clips, not the 'Fire' inside the current Movie Clip. Further initialization is done which is specific to the current launch of the fireworks. The 'Firework' Movie Clip launches itself repeatedly using the 'Fire' frame action; each time the launch is different. The initialization variables specific to the current launch are the ones that are set in the action; the initialization values of variables that hold their values throughout the life of the clip are set in the action for frame 1. Because the calculation for the flight of the 'Firework' is dependent on time, we set a 'startTime' variable that will be used while the 'Firework' is in flight to determine the time since launch.

```
//Fire frame action
//Initialise firing
for (i=0; i<starTotal; i++) {
  name = "Star" + i;
  eval(name).gotoAndPlay("Fire");
}

_x = orgX + random(100) - 50;;
_y = orgY;
angle = random(80) - 40;
if (angle<0) angle += 360;
_rotation = angle;

startTime = getTimer ();
gotoAndPlay("Flying");
```

As the 'Firework' flies through the air, the frame action labelled 'Flying' is called repeatedly. Again, we use a 'for' loop and iterate through the different 'Star' clips. For each clip we set the '_x' position based on the 'centreX' value, which is simply the launch location and the value of time in seconds. The value for time is set using the 'getTimer' function. This function returns an elapsed time value in milliseconds. To get the time since launch, we first subtract the value for 'startTime' then divide by 1000, to convert milliseconds into seconds. Since we need to know when the 'Firework' is completely burnt out, we set an initial value for the variable 'exploded'. If 'exploded' ends the loop, being equal to the variable 'starTotal', then every 'Star' in the 'Firework' has burnt out and so the life of the 'Firework' is over.

To calculate the '_y' location we use a combination of a value that is specific to the current 'Star' and a value for the effect of gravity. Since the gravity component is the same for all the 'Stars' we can set this value outside the loop to avoid calculating it repeatedly. We use the simple product of time squared and the value set for 'gravity'. To decide whether or not to explode the 'Star' we use a condition statement:

```
if (curY>eval(name)._y && !eval(name).exploding && random(10)>8) {
```

Let's see how you are doing. What does the above condition statement mean? Can you remember what '&&' means? It means 'And'; when used in a condition statement it can be read in English as 'if condition 1 And condition 2' then do something. Here we have three conditions. The first condition checks the calculated value for the new '_y' position, 'curY'. If 'curY' is greater than the current value of the Movie Clips '_y' value then the 'Star' must be moving down the screen (_y values increase down the screen). Next we test to see if the 'Star' is already exploding, in which case the Movie Clips variable 'exploding' will evaluate to 'true'. Finally, the condition statement uses a 'random' test, otherwise every 'Star' would explode at its peak height. By using a random value we can make some 'Stars' explode at the peak height and others on the descent. So here is the code for the frame action labelled 'Flying'.

```
//Flying frame action
curtime = (getTimer () - startTime)/1000.0;
down = gravity * curtime * curtime;
exploded = 0;

for (i=0; i<starTotal; i++) {
  name = "Star" + i;
  eval(name)._x = centreX + curtime * eval(name).spread;
  up = curtime * eval(name).speed;
  curY = centerY - up + down;
  if (curY>eval(name)._y && !eval(name).exploding && random(10)>8) {
        eval(name).gotoAndPlay("Explode");
  }
  if (eval(name).explodeComplete) exploded++;
  eval(name)._y = curY;
}
```

```
if (exploded==starTotal) {
  startTime = getTimer ();
  gotoAndPlay("Wait");
}else {
  prevFrame ();
}
```

In the 'Flying' frame action there is a jump to 'Wait' when all the 'Fireworks' have erupted. The frame action at the frame labelled 'Wait' is just a simple delay. First we get the current time based on a call to 'getTimer' and then we test this value against the Clip Parameter 'recreateTime'. As soon as the wait delay exceeds this value, the play switches to the 'Fire' label.

```
//Wait frame action
curtime = (getTimer () – startTime)/1000.0;

if (curtime>recreateTime) {
  gotoAndPlay("Fire");
}else {
  prevFrame ();
}
```

Although this embedded clip contains code that is a little more complex than most of the code we have considered so far, there is very little that you haven't already looked at. That is because at the heart of almost all programming we have variables, condition statements and loops.

Summary

In this chapter we looked at the third vital component of all programming languages, loops. With this third important component you are nearly ready to get on and start writing your own code. You might think great I'm ready, or might think how do I move from a game idea to a finished game? Planning and structure are the answer. Forward planning and good structure will make all the difference to the development of your next masterpiece. So before setting you loose, I recommend spending some time reviewing the tips in the next chapter. There we look at how you can structure your programs to make your games easier to write, debug and maintain, and you will see how you can use bits from one game in another.

9 Keep it modular

Firstly, congratulations on your tenacity. If you have worked through the book and got as far as this chapter then you are well on your way to being a fully-fledged Flash developer. In this chapter we are going to introduce the skills you will need to really develop your own games rather than just copying someone else's code. This is an entire chapter with advice on how to structure your code from an idea to a game. Throughout we will consider the example of writing a 'Tetris' game. Unlike most chapters in the book there is not a working example; instead you are encouraged with hints to develop your own version of the game.

Flash can provide you with the programming tools to make your code well structured. Unfortunately, this flexibility can also be used to create very poorly structured code. Game development can be made very hard or very easy. Careful planning and good structure makes development so much easier. In this chapter we look at how to take an idea for a game, turn it into a well-planned project and then develop the code. We will look at using custom functions to make sure that you only have to change your code in one place to have a global effect. We look at using functions to change the value of certain variables. We look at the difference between local and global variables. But most importantly we will look at how to embed complexity into your Movie Clips so that they can look after themselves and better still you will have code that you can reuse.

From an idea to a plan

The starting point for all games is an idea. Your idea is the basis for all subsequent development. Because we are concerned with games let us consider a game that everyone will be familiar with, 'Tetris'. In Tetris we have a board layout that is based on square cells. Each cell can either have a tile in it or not. At its simplest that is the game. But the game play is another matter. The game revolves around a block of four tiles in a line, square block or L shape dropping at a consistent rate from the top. When

any one of the four tiles that make up the set of tiles hits the base of the play area the movement of that set of tiles stops and the set of tiles remains on the screen. At this point we need to create a new block of tiles and start this dropping. This new set of tiles and all subsequent ones stop when either the base is reached by any one of the tiles or any one of the tiles hits a parked tile. Over the course of the game the speed at which the tiles drop increases. The user can remove parked tiles if, as the current dropping set of tiles lands, a complete row of tiles is created. By removing tiles the score increases and if the user simultaneously created more than one row then they get a higher score than a *pro rata* multiple of the value of a single row. The maximum rows that can be removed in a single removal is four, which results in the maximum additional score.

Does that sound like a full description of 'Tetris'? If it does then it only indicates how easy it is to overlook a very important feature. As described above, the user does absolutely nothing! Such a game is unlikely to become a world beater. The input from the user to control the horizontal position of the descending tile set has been overlooked in the summary. When you are writing your plan you need to work extremely hard to ensure that you have considered all the options. But the single most important consideration when writing the spec for a game is to decide what the user actually does when playing your game. If all they do is admire your lovely graphics then go back to the drawing board.

From a plan to a structure

Now we have a plan, but how do you intend to turn this into a working game? A very popular concept in computer science is to use the top-down approach. You start by presenting an overview of the game. Then you break the game down into manageable chunks that can be developed in isolation. This methodology is a very effective technique when computer programming, creating chunks of an application that can be developed in isolation, and debugged separately.

Returning to our Tetris example, let's try to break down the overview into small chunks of functionality.

Initialization:
When the Movie Clips that form the game board are created by duplication.

New Game:
When all the game variables are initialized and the game board is cleared.

User Input:
We are going to need a keyboard reader that moves the playing piece if such a movement is possible.

Next Piece Generator:
We will need to be able to create the next piece that is going to be used in the game that randomly determines the next piece to fall. The game is over when a new tile cannot be added, so if this function returns false then this indicates the end of the game.

Legal Move Confirmation:
We will need to be able to confirm whether the descending tile can move to a certain game board position.

Complete Row Checker:
We will need to be able to confirm when a completed row has occurred.

Complete Row Removal:
This is where the game board will be adjusted to remove a completed row.

Update Game Board:
The game board is controlled using a multi-dimensional array.

Game Over:
This could be a complex animation or a simple text box could be displayed.

Timer Update:
If the score is going to use elapsed time as well as removed rows then we will need to show a timer.

Score Update:
The score should be continuously updated based on the rows removed and the elapsed time.

We are also going to need several variables to track the game's progress:

Score: The current player's score.

curTile: This is a 4 × 4 Multi-dimensional Array that describes the current tile, the possible values for this are illustrated in Table 9.1.

Table 9.1 Values stored in Multi-dimensional Arrays to store the current tile

1	0	0	0		1	1	1	1		1	1	0	0					
1	0	0	0		0	0	0	0		1	1	0	0					
1	0	0	0		0	0	0	0		0	0	0	0					
1	0	0	0		0	0	0	0		0	0	0	0					
1	1	0	0		1	1	1	0		0	1	0	0		1	0	0	0
1	0	0	0		0	0	1	0		0	1	0	0		1	1	1	0
1	0	0	0		0	0	0	0		1	1	0	0		0	0	0	0
0	0	0	0		0	0	0	0		0	0	0	0		0	0	0	0
1	1	1	0		0	1	0	0		0	1	0	0		1	0	0	0
0	1	0	0		1	1	0	0		1	1	1	0		1	1	0	0
0	0	0	0		0	1	0	0		0	0	0	0		1	0	0	0
0	0	0	0		0	0	0	0		0	0	0	0		0	0	0	0

curTileX: The *x*-position within the board where the descending tile is located. This is where the left column of the descending tile maps.

curTileY: The *y*-position within the board where the descending tile is located. This is where the top row of the descending tile maps.

gameBoard: This is a Multi-dimensional Array that stores the current board position. A value of '1' in a cell of the Array indicates a tile is present and a value of '0' means it is empty.

fixedBoard: Same as the 'board' Array, without the current descending tile.

startTime: Useful for generating the time elapsed since the start of the game.

Multi-dimensional Arrays are very useful when a program lends itself to a grid-like structure. We are basing the code for the Tetris example on a grid-like structure; we will use 21 rows and 14 columns. If we find a '1' in the grid then a tile should be displayed in that position; if we find a '0' then the grid is empty and no tile will be shown. To allow for row highlighting when a completed row occurs, '2' is used in the grid to indicate a highlighted tile. Figure 9.1 shows how the grid numbers translate to the displayed game board.

Figure 9.1 How the values in Table 9.1 translate into images in the game.

An Array of Arrays creates a Multi-dimensional Array. For example, the following code:

```
fruits = new Array("oranges", "lemons", "apples");
veg = new Array("potatoes", "cabbages", "carrots");
food = new Array(fruits, veg);
for (i=0; i<food.length; i++) {
  for(j=0; j<food[i].length; j++) {
        trace("food[" + i + "] [" + j + "]=" + food[i][j]);
  }
}
```

generates the following output:

```
food [0] [0]=oranges
food [0] [1]=lemons
food [0] [2]=apples
food [1] [0]=potatoes
food [1] [1]=cabbages
food [1] [2]=carrots
```

Already, by breaking the game concept into a plan and a structure we are much closer to having a working game. It is imperative that new sections of a program do exactly what they are intended to do. They should work like a little black box. We will translate the first of the two lists above into functions. A function should do exactly what it is supposed to do and nothing else. If the function is 'initGame' and the purpose of this function is to reset all the variables needed in the game, then this is what it should do and no more. If a function should return a value then this should be able to take any game condition and return an appropriate value with no exceptions. So let's look at how we can move forward from this specification to a finished game.

From a structure to a project

Each function that you create to build your game should be tested in isolation; this often means you will need to output debugging information or set up a game condition in order to test your function. Each cell in the game board grid can display a blank, a normal tile or a highlighted tile. Figure 9.2 shows how these will appear.

0	0	0	0	0	0	0	0	0	0	0	0	0	0
0	0	0	0	0	0	0	0	0	0	0	0	0	0
0	0	0	0	0	0	0	0	0	0	0	0	0	0
0	0	0	0	0	0	0	0	0	0	0	0	0	0
0	0	0	0	0	0	0	0	0	0	0	0	0	0
0	0	0	0	0	0	0	0	0	0	0	0	0	0
0	0	0	0	0	0	0	0	0	0	0	0	0	0
0	0	0	0	0	1	1	1	0	0	0	0	0	0
0	0	0	0	0	0	1	0	0	0	0	0	0	0
0	0	0	0	0	0	0	0	0	0	0	0	0	0
0	0	0	0	0	0	0	0	0	0	0	0	0	0
0	0	0	0	0	0	0	0	0	0	0	0	0	0
0	0	0	0	0	0	0	0	0	0	0	0	0	0
0	0	0	0	0	0	0	0	0	0	0	0	0	0
0	0	0	0	0	0	0	0	0	0	0	0	0	0
0	0	0	0	0	0	0	0	0	0	0	0	0	0
1	0	0	0	1	1	0	0	0	0	0	0	0	0
1	0	0	0	1	1	1	0	0	0	1	0	0	0
1	0	1	0	1	1	0	0	0	1	1	1	0	1
1	0	1	1	1	1	0	0	0	1	1	1	0	1
1	1	1	0	1	1	1	0	1	1	0	1	0	1

Figure 9.2 How the Multi-dimensional Array is used to store the current game board position.

The purpose of the function 'initBoard' will be to take a single Movie Clip based at the top left corner of the game board, and containing the images shown in Figure 9.2, and duplicating it 21 × 14 times less the original clip. Each new clip will be named so that the array that we will use to set the clip's frame has a similar structure. If the Movie Clip is called tile3_4, then the Multi-dimensional Array that contains the frame number for this clip is called board[3][4]. To duplicate the Movie Clip we need to set up two loops, one nested inside the other. One loop deals with the rows while the other deals with the columns. If we call the original tile 'tile0_0', then we can duplicate all the clips we want using this simple code:

```
count = 0;
for (col = 0; col<14; col++) {
  xpos = tile0_0._x + col * 18;
  for (row=0; row<21; row++) {
        if (count!=0) {
                name = "tile" + row + "_" + col;
                duplicateMovieClip("tile0_0", name, count);
                eval(name)._x = xpos;
                eval(name)._y = tile0_0._y + row * 18;
        }
        count++;
  }
}
```

The command 'duplicateMovieClip' takes as the third parameter the level where the new clip will be created. This needs to be a new level; the easiest way to achieve this is simply to have a variable that is incremented by one as each run through the loop is executed. The other thing to point

Frame 1 Frame 2 Frame 3

Figure 9.3 Possible displayed images for each cell in the game board grid.

out is that the first Movie Clip already exists so if count is equal to zero then the clip does not need duplicating. Having created this function we need to be sure it does the job for which it is intended. By running the movie using 'Ctrl + Enter' you should see the entire board displayed. But it would be useful to set up a connection between the game board Array and the duplicated Movie Clips. For this purpose we can create a function called something like 'testGameBoardArray'. The purpose of the function is to populate the Array and then to call the function 'updateGameBoard'. So the test function is dual purpose: it will check the 'initBoard' function and the 'updateGameBoard' function. The function will look something like this:

```
function testGameBoardArray () {
   for (row=0; row<21; row+=2) {
        for(col=0; col<14; col++) {
                gameBoard[row][col] = 1;
        }
        for(col=0; col<14; col++) {
                gameBoard[row + 1][col] = 0;
        }
    }
}
```

Notice that the incrementing term in a 'for' loop does not have to be just '++'. You can use any statement. In the above example we add 2 to the loop variable using 'row+=2'.

This simple function will set alternate rows in the 'gameBoard' Array to 1 or 0. Then the 'updateGameBoard' function needs to read these data and set the Movie Clips appropriately, something like:

```
function updateGameBoard () {
   for (row=0; row<21; row++) {
        for(col=0; col<14; col++) {
                name = "tile" + row + "_" + col;
                eval(name).gotoAndStop(gameBoard[row][col] + 1);
        }
    }
}
```

By making your program modular using functions you place complex functionality in a black box that you can test and then use elsewhere in your program. In the above example, the function 'updateGameBoard' allows you to update the board at any time simply by calling the function.

To call a function, simply place the name of the function in your script, along with any parameters the function needs. To call 'updateGame-Board' you would use

```
...
updateGameBoard ();
...
```

From a project to a game

Already the project is developing into a game. Remember that a function must do exactly what it is intended to do regardless of the current state of the game or passed parameters. If passed parameters are unsuitable then pass this information on either by using a 'trace' or by using an on-screen text box, that ultimately will be hidden from the player but will make creating the game easier for you as the developer. When you develop new functions you can place them all inside the same script. When developing Flash games we tend to place all functions on the first frame of the first scene. If you are calling the function from a '_root' level frame script, then you just use the function name as indicated above. If, however, you are calling the function from a Movie Clip then you need to indicate a path to the function either by using '_root.myfunction ()' or '_parent.myfunction ()'. If using the '_parent' alternative then make sure that you have moved through the appropriate number of parents. If a Movie Clip is nested three down from the '_root', then you will need to use three '_parent's: '_parent._parent._parent.myfunction ()'.

You will never succeed in creating complex games by writing the whole game and then hoping that it works. It simply doesn't work like that. Modularize the game. Write each individual component and then test the components using test data. When you set out to do the testing, try to break the function using extreme data parameters. In game play the extremes are likely to occur at some stage. Try to keep all the functionality for an aspect of your game in one place. Flash is very flexible; you could have a condition inside a Movie Clip that sets the playback for the '_root'. When you are returning to a project that is set up in this way it is very

difficult to work out why the playback head is moving. An example may illustrate the problem more effectively. Imagine a kids' maths game. There is a cartoon character holding up a board on which you need to enter a value. If you get it wrong then the board is held up again; if you get it wrong a second time then the cartoon character shows you the correct answer. We could put all the functionality into the cartoon character Movie Clip. The Clip could initialize a 'wrongcount' variable at the start of a problem then increment the value if the child gets the sum wrong. That method would be fine. Problems are likely to occur if a '_root' level frame action controls the behaviour of the Clip, but the updating of the 'wrongcount' variable is done inside the Movie Clip. Although this method could certainly be made to work, it is likely to confuse the developer when they return to the game to tweak it, some weeks later. Either control everything at the '_root' frame action level or control everything in the Movie Clip. If everything is controlled inside the Movie Clip, then why not add a 'do nothing' script to the first frame of the scene.

```
//Functionality is control inside the Rhino Movie Clip
//The variable 'wrongcount' is updated everytime the child
//enters an incorrect value. This is handled using the 'enterData'↵
  loop
//When the child presses the return key the Clip jumps to
//'validateData'. A correct answer jumps to 'correct'
//An incorrect answer and the Clip jumps to 'inCorrect'
//where the variable 'wrongcount' is incremented. If 'wrongcount'
//is equal to one then the clip jumps to 'showAnswer'
//where the correct answer is displayed for the child.
//Then the game moves on to the next problem by calling↵
  'nextProblem'.
```

Believe me, if you do that you will feel a warm glow when you return to your own code and other developers who read your code will think just one thing, respect!

One final tip: don't change a variable's value outside the current scope. If you find that you do need to change the value of a variable in several places, then set the variable's value using a function, such as

```
function setMyVariable(newValue, calledFrom) {
  trace ("setMyVariable to " + newValue + " called from " +↵
    calledFrom);
  myVariable = newValue;
}
```

This will make tracking down any errors much easier to find. The 'trace' will show you who attempted to change the value of the variable. Often, you can find that as you develop your programs there may be errant code that is left over from an earlier incarnation of the program and that this errant code is setting the values in a Movie Clip inappropriately. These types of errors are much easier to find if you follow the simple rule: 'don't change the value of a variable directly, outside the current scope. Always use a function call that says who was trying to change the value'.

Creating a new object

Object Orientated Programming involves combining the data and the operations on the data within a single object. Flash allows you to create such an object. In this code snippet, we create a new object by calling the 'point' function. This type of function is sometimes called a constructor. Inside the function variables are created and initialized. The variables 'x' and 'y' are both set to zero, but the variables 'init' and 'sum' are set to point to functions. We can use the functions from within the object. In this example, 'pt1' calls the 'init' method which sets the values of 'x' and 'y' to 3 and 10 respectively and 'pt2' uses the same method to initialize the values. Then the function 'pt2' uses the method 'sum' to add the point 'pt1' to its own internal data. After running the program, the output window will display 23 40.

```
pt1 = new point ();
pt2 = new point ();
pt1.init (3, 10);
pt2.init (20, 30);
pt2.sum (pt1);
trace (pt2.x + " " + pt2.y);

function point () {
        this.x = 0;
        this.y = 0;
        this.init = setPoint;
        this.sum = addPoint;
}

function setPoint (x, y) {
        this.x = x;
        this.y = y;
}
```

Flash MX Games

```
function addPoint(pt) {
        this.x += pt.x;
        this.y += pt.y;
}
```

Summary

In this chapter we looked at how to modularize your code so that you can write small chunks of functionality that can be used from anywhere in your game. We looked at how you can break down the way a game will be coded by splitting the game into small segments and identifying key variables. Functions are such a useful idea that they should form the basis of much of the more complex behaviour of your games. Movie Clip frame actions are perfect for reading user input or navigation, but they should not be used for more complex testing such as a collision detection or data formatting. This should always be put inside a function so that it can be called from different places in your game. Remember, write it once and use it lots of times. You will often find developers who place almost the same code in many places in a program; if the code needs tweaking then they must change all the instances of it, a technique prone to error. When designing your games try to keep all the functionality for a particular aspect of your game in one place. Many of the techniques in this chapter are designed to make your programs easier to write, easier to extend and easier to debug. This last aspect leads on to the next chapter, where we look in detail at debugging techniques.

10 Debugging

No matter how experienced you get at writing code, there will be times when the code you write doesn't work the way you expect. Isolating and fixing the errors is called *debugging* and is a fascinating mental challenge, or a complete headache depending how you are feeling that day! In this chapter we will look at many of the more common errors and look at techniques for isolating the problems and then fixing them.

Strings and numbers

You have created a game that allows the user to input a numerical value using an Input Box. Then you run this code:

```
on (release) {
      newValue = oldValue + userInput;
}
```

You have an *oldValue* of 14 and a *userInput* of 10. You expect the *newValue* to be set to 24, instead it is set to 1410. Why? Simple really, *userInput* is a string, all Input Boxes store data as a string. The operation '+' can be applied to strings, so Flash converts *oldValue*, 14, into the string '14' and 'adds' it to the string '10'. The string operation '+' is concatenation; the string to the left of the operator and the string to the right are joined together. This is not the method that was intended; in your code you wanted the string '14' to be used as a number. The solution is to make sure Flash realizes to use userInput as a number by using the 'Number' method:

```
on (release) {
      newValue = oldValue + Number(userInput);
}
```

The result will now be a number, 24, as you intended. If the combination operation were any other arithmetic operation then Flash would have realized that you intended to use *userInput* as a numerical quantity, because no other arithmetic operation applies to strings. Therefore:

```
on (release) {
        newValue = oldValue - userInput;
}
```

would give the result 4, if oldValue was 14 and userInput was 10, with no requirement to force userInput to be a number. Flash 'knows' that if you are using the '−' operator then the value to the left and right of the operation is a number.

In many languages you are forced to define what type of variable you are using, then when you combine incompatible types you are warned. Flash is not a strongly typed language so you have to be careful that you are combining data types in the way intended.

Declare your variables

Flash does not force you to declare variables. This is both a benefit and a problem. See if you can work out what will happen in the following code:

```
piece = 10;
trace ("The current value of piece is" + getPiece ());

function getPiece () {
        return peice;
}
```

Award yourself a prize if you thought that the value returned will be undefined. Instead of 10 being the return value, the value will be empty because there is a typo error. The function returns the value of the undefined variable 'peice' instead of the variable 'piece'.

Errors like this are quite hard to spot because Flash creates variables as you use them. In a strongly typed language you would get a compilation error because you are returning a value that does not exist.

Here's another one:

```
i=10;
trace(sumUpTo ());
i--;
trace(sumUpTo ());

function sumUpTo () {
        total = 0;
        while (i>0) {
                total += i;
                i--;
        }
        return total;
}
```

The function sumUpTo uses the _root level variable '*i*' and decrements it until it is equal to zero. The aim is to add the numbers up to the value of '*i*'.

The output of this program is shown in Figure 10.1.

Figure 10.1 Output of sumUpTo program.

The sum of 10 + 9 + 8 + 7 + 6 + 5 + 4 + 3 + 2 + 1 + 0 = 55. But looking at the code you would have thought that the second time the function was called, '*i*' would be nine and so the returned value would be 9 + 8 + 7 + 6 + 5 + 4 + 3 + 2 + 1 + 0 = 45. Instead, we get a result of zero. The problem is that the function altered the value of the root level variable '*i*'. After the function was called, '*i*' was equal to zero. Then this value is decremented making '*i*' equal to –1. Because '*i*' is not greater than zero the function returns the initial value of the variable 'total', zero. A much better alternative would be:

```
i=10;
trace(sumUpTo ());
i--;
trace(sumUpTo ());

function sumUpTo () {
        n = i;
        total = 0;
        while (n>0) {
                total += n;
                n--;
        }
        return total;
}
```

Now we get the values we are aiming at, 55 and 45. However, we are still dealing with root level variables. What if the code used was:

```
n = 25;
i = 10;
trace("Sum =" + sumUpTo ());
trace("n = " + n);
function sumUpTo () {
        n = i;
        total = 0;
        while (n>0) {
                total += n;
                n--;
        }
        return total;
}
```

Again, inside the black box function, the root level variable '*n*' has been set to a new value, zero. This can be a very difficult error to correct, because you look through the code and often overlook what is happening inside the function.

```
total = 0;
n = 25;
i = 10;
trace("Sum =" + sumUpTo ());
trace("n =" + n);
trace("total =" + total);
```

```
function sumUpTo () {
        var n = i, total = 0;
        while (n>0) {
                total += n;
                n--;
        }
        return total;
}
```

This shows the simple fix. Declaring the variables '*n*' and 'total' inside the function using 'var' means that we are using local and temporary versions of the variables, not the root level variables with the same name. If you intend to change the value of a variable inside a function then use local variables not root level. There will be no problem reading root level variables, but do not change their value.

Variable scope

Another extremely common problem is illustrated by 'Examples\Chapter10\counter01.fla'.

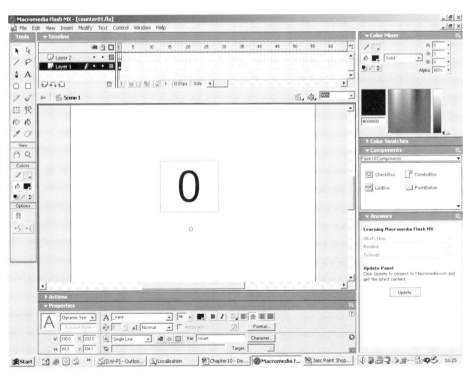

Figure 10.2 Developing the counter01 project.

In this simple project we have a Dynamic Text box tracking the variable 'count' and a Movie Clip with the instance name 'counter'. The 'counter' clip, the small circle under the '0', has the following clip events:

```
onClipEvent (load) {
        count = 0;
}

onClipEvent (enterFrame) {
        count++;
}
```

If you try running the program, however, the number stays stubbornly at zero. Why? Because the text box is tracking the variable 'count', not the variable 'counter.count'. This very simple error is so common that you are advised to check for it as a first step in debugging your code. Always ensure that you are dealing with a variable that has the correct scope.

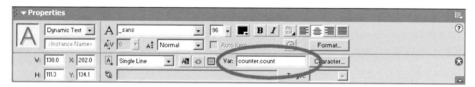

Figure 10.3 Setting a variable for a Dynamic Text box.

Infinite loops

If you experience a long delay in the program and then get the message shown in Figure 10.4, the cause is almost certainly an infinite loop.

```
i = 0;
while (i<10) {
        trace("Hello there");
}
```

The above code snippet is a classic infinite loop. The intention is almost certainly to print 10 'Hello there's' to the output window. But instead of decrementing the variable '*i*' for each run through the loop, there is no change to '*i*'. Consequently, the loop will never terminate. This loop is very easy to spot, but the following example is much more difficult to

Figure 10.4 Error caused by infinite loop.

determine, especially if the function 'setBoxes' is declared on a different frame than the calling script. This gives another example of why it is so important not to alter root level variables inside a function. In this example, the value of 'i' is set to zero and incremented for each loop. In theory, therefore, the loop would terminate after 10 passes. But the variable 'i' is also used inside the function; as the function exits 'i' is set to 5, it is then incremented to 6, but this is less than 10 so the loop is permitted. For every loop after the first the value of i will be 6 and so the program enters an infinite loop. By declaring 'i' local to the function 'setBoxes' this infinite loop can be avoided.

```
i = 0;
while (i<10) {
      setBoxes(i*50);
      i++;
}
trace("Boxes set");

function setBoxes(n) {
      for (i=0; i<5; i++) {
            name = "Box" + i;
            eval(name)._x = n;
            eval(name)._y = 100;
      }
}
```

Program execution

Never assume you know what is going on under the hood. Some of the most stubborn bugs occur because of program execution order. You may be setting something inside a Movie Clip that is being overridden by another clip or a root level loop. Often, the best way to discover the

Figure 10.5 Running 'Examples\Chapter10\order.fla'

error is to trace every function call. The following code snippet from 'Examples\Chapter10\order.fla' illustrates how to track program execution. Each function call is headed by a 'trace'; the trace string is set to give the parameters passed to the function, which can often highlight an error.

```
count = 0;
while(count<10) {
        i = random(3);
        switch(i) {
                case 0:
                red ();
                break;
                case 1:
                green(random(100), random(100));
                break;
                case 2:
                blue(random(7));
                break;
        }
        count++;
}
```

```
function red () {
        trace(count + "red");
}

function green(x, y) {
        trace(count + ":green (" + x + "," + y + ")");
}

function blue(i) {
        trace(count + ":blue " + i);
        if (i>3) {
                trace("Calling red from blue");
                red ();
        }
}
```

Turning your debugging on and off

There will be times when you are tracking down a particularly annoying bug that you will want to dump reams of information to the output window. Once you have tracked down the problem you can go through all the code and comment out the debugging code, or you could precede each debug code section with a condition that can be set globally. By changing one variable assignment you then effectively turn off detailed debugging. The benefit of this approach is that it can be turned on again just as easily.

```
DEBUG = false;
count = 0;
while(count<10) {
        i = random(3);
        switch(i) {
                case 0:
                red ();
                break;
                case 1:
                green(random(100), random(100));
                break;
                case 2:
                blue(random(9));
                break;
        }
        count++;
```

```
}
trace("Finished");

function red () {
        if (DEBUG) trace(count + ":red");
}

function green (x, y) {
        if (DEBUG) trace(count + ":green (" + x + "," + y + ") ");
}

function blue(i) {
        if (DEBUG) trace(count + ":blue " + i);
        if (i>3) {
                if (DEBUG) trace("Calling red from blue");
                red ();
        }
}
```

Using a debug layer

When your code runs, it will execute so fast that it becomes extremely difficult to work out what is happening. A debug layer is often useful for more stubborn run time errors. You create a Dynamic Text Box on its own layer, that tracks the variable 'info', or any other name that you prefer. Then for each Movie Clip create a 'dump' function. The dump function can be used to add some information to the 'info' variable. Open 'Examples\Chapter10\Dump01.fla'.

```
Frame 1 – Main timeline
info = Ball.dump ();
Frame 1 – Ball clip at the bottom of the script
function dump () {
        return "Pos (" + _x + "," + _y + ")" + chr(13) +
                "Target (" + tX + "," + tY + ")";
}
```

By creating the text box on an independent layer you can instantly remove the layer, either by deleting the layer or by setting it to be a guide. Guides do not show at run time.

Figure 10.6 Using an information layer in 'Examples\Chapter10\Dump01.fla'.

Setting data with functions

You will greatly improve your code and minimize debugging if you set the values for a clip inside a function. The benefit of using a function is that you can check the integrity of the data passed to the function. For example, if the value of '*sx*' can vary between 0 and 500, then values outside this range are unsuitable. By using a function call you can test for unacceptable values and track down where in your code the out of range values are being set.

```
function setSX(n) {
    if (n<0 || n>500) {
        trace("Out of range error");
        return;
    }
    sx = n;
}
```

Using the Flash debugger

Flash MX now includes a full breakpoint debugger. This tool can be very useful when tracking down difficult to locate bugs. To activate the

Figure 10.7 The Flash MX debugger.

debugger, either use the menu option 'Control\Debug Movie' or press 'Ctrl + Shift + Enter'. Flash parks at the start of a movie before playing the first frame. To continue press the green arrow.

Take a look at 'Examples\Chapter10\DebugTest.fla'. Right-click on the 'Cat' sprite and choose 'Actions' in the script window; right-click on the fourth line down 'this.gotoAndPlay("StartRight")'. From the context menu choose 'Set Breakpoint'. A red circle appears in the blue band to the left of the script. This red circle indicates a breakpoint. In this example you should find that it is already set. When in debug movie mode, the script will halt whenever this line is executed. Now run the movie in debug mode by pressing 'Ctrl + Shift + Enter'. Press the green arrow to continue and move or resize the debug window so that the 'Cat' is visible. Press the right arrow key. Notice that the break line is within a code block that is only executed when the right arrow key is pressed. Code execution should halt and the debug window will look like the one shown in Figure 10.8.

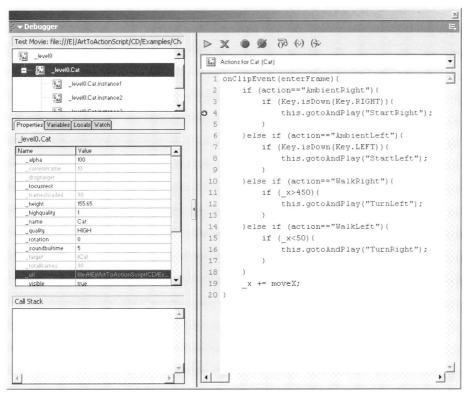

Figure 10.8 Debugging 'Examples\Chapter10\DebugTest.fla'.

Once the code is halted you can use the debug window to examine the state of every variable that is currently available in Flash. Move through the different clips and levels using the list box at the top left of the debugger. Clicking on the '_level0.Cat' level allows you to examine the 'properties' of this clip. Some of the properties can be altered by entering a new value. Try altering the '_x' property as you move the debugger; the Cat will jump to a new location across the screen. Moving the debugger window is necessary in order to force Flash to repaint itself; when halted at a breakpoint Flash is not running any code and so no repainting is occurring. Other properties are read only and cannot be altered by the developer; these properties are greyed out so that the value can be read but not altered.

The variables tab lists the variables that are set in the clip. In this example this is just the 'action' and the value for 'moveX'. A right-click on the variable allows you to add these to the 'Watch' panel. To avoid moving through several Movie Clips and layers, you can add certain variables to

the Watch window, then you can see just how these variables are behaving as you run through the code. There is also a 'locals' tab; this lists the variables that are declared in the current function.

The buttons above the script pane allow the developer to 'Continue', 'Stop Debugging', 'Toggle Breakpoint', 'Remove All Breakpoints', 'Step Over', 'Step In' and 'Step Out'. The last three allow the developer the ability to study at close quarters how the code behaves.

'Step Over' executes a single line of code in the current function.

'Step In' will take the playback head into a user-defined function if there is such a call on the current line of code. Once inside the function you can use Step Over to examine how the code behaves a line at a time.

'Step Out' only applies to a user defined function. If the code pointer is currently inside a user-defined function, then that function is executed until there is a return from the function, then the program halts.

Stepping through the code can be a very effective way of tracking down a persistent problem.

Remote debugging

You can even use the debugger to analyse a remote file. But to do this you will have to ensure that your computer uses the debug version of the Flash plug-in. If, when you right-click on a Flash movie in your browser,

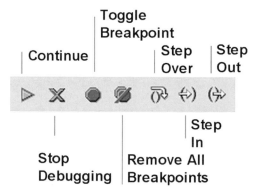

Figure 10.9 Debugger toolbar.

there is an option for 'Debugger' then you have the debug version installed and need do nothing further. If not, then you will need to uninstall Flash and install the debug version. On a PC you will need to remove the ActiveX control that is used by Internet Explorer to display Flash content. Details of how to do this can be found at http://www.macromedia.com/support/flash/ts/documents/control_remove.htm.

To enable remote debugging you must ensure that you have taken two important steps.

Step 1

Enable remote debugging of the movie by selecting 'File/Publish Settings'. The dialog box shown in Figure 10.9 appears. Make sure that you have checked the box that says 'Debugging Permitted'.

If necessary, you can enter a password in the dialog box to make your file more secure. Then publish your movie.

Figure 10.10 Enabling remote debugging.

Figure 10.11 The remote debugging confirmation box.

Step 2

When you publish the movie, Flash creates a file with the extension 'swd'; this file has the same name as the 'swf' file. It is essential that the 'swd' file be in the same location as the 'swf' file for remote debugging to work fully. Without the 'swd' file Flash will not be able to stop at a breakpoint or step through the code a line at a time.

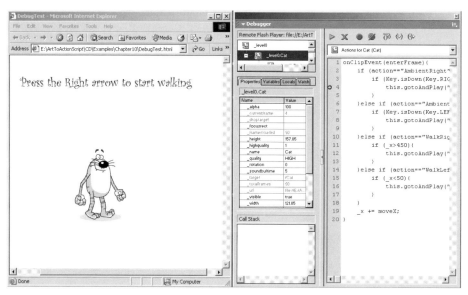

Figure 10.12 Debugging remotely.

Having made sure that you have the debug version of the ActiveX control or plug-in, that you have enabled debugging and that the 'swd' file resides at the same URL as the 'swf' file, you are now ready to use remote debugging. Try running the file 'Examples/Chapter10/Remote.html'.

Before the page launches, you will see the dialog box in Figure 10.10; accept the default of 'Localhost'.

This example is the same as 'DebugTest'; there is a breakpoint set in the clip event for the 'cat' Movie Clip. The breakpoint occurs whenever the right arrow key is pressed. Set the windows on the desktop so that you can see both debug window and the browser. At the breakpoint you can check variables and step through the code as if the file were local. When you have got the project working correctly, deleting the 'swd' and unchecking the 'Debugging Permitted' check box will ensure that your code is secure from prying eyes.

Summary

Debugging is something that is learnt by experience. Each project will require a different technique in order to detect where the code is in error. In this chapter we have looked at some tips and techniques that will help you get started when debugging your code.

11 Using external files

When you are using Flash, the target platform for your game is usually the web. Your game will be seen in a browser. In order for your game to be available on the web it will need to reside on a server that can be accessed from the web. In most cases this will mean that the game is on a computer belonging to an ISP (Internet Service Provider). If you work for a big company then you may well have one or more servers that are accessible from the web, but for home and small business users this accessibility is usual provided by a third party. Once your game is accessible to the world via the Internet you may want your game to have several levels or you may want the ability to easily change the game monthly, weekly or daily. You may want the game to perform slightly differently for different users. To achieve these goals you may have the different versions of the game on the server or the behaviour of the game could be influenced using an external file. In this chapter we will look at using a simple text file containing variable data so that the game you have created behaves differently by using different configuration text files. Another popular method for setting the configuration data is to use ASP (Active Server Pages). ASP is often used to link to databases on the server. Using a link to the database, the game can be easily updated or made to have a unique configuration for the current user.

A brief overview of the web

You probably already know about the web and how to use it, but if not here's the briefest of brief introductions. The web was the brainchild of Tim Berners Lee, who came up with a common standard for hyperlinked documents across a network. He invented the acronym that we have all come to love, HTML (Hyper Text Mark-up Language); we link to an HTML

document using HTTP (Hyper Text Transfer Protocol). Everything on the web has a URL (Uniform Resource Locator). The URL for the home page for this book is

http://www.toon3d.com/flash/index.html

'http' indicates the protocol; 'www.toon3d.com' directs the browser to the appropriate folder on the appropriate server. Basically, the name is just a link into a big look-up table that finds the IP address of the computer. An IP address will have the form XXX.XXX.XXX.XXX, where XXX is a number up to 255. Although interesting, so far none of this is directly relevant to you as a developer. Where it gets more interesting is the document itself, the HTML page. In this example we have 'index.html', although because the server defaults to this file and because HTTP is presumed:

www.toon3d.com/flash

will find the same file.

All HTML documents have the format

```
<HTML>
<HEAD>
<TITLE>A very simple web page</TITLE>
</HEAD>
<BODY>
This is the content of the web page.
</BODY>
</HTML>
```

Most HTML tags have the form <TAG> . . . </TAG>, where 'TAG' is the start of a tag and '/TAG' is the end of that tag. Most tags can be nested inside other tags. You may well have your favourite program for creating HTML pages, 'Frontpage' and 'Dreamweaver' are just two. But it is useful to know what is being created when you author an HTML page. Essentially you just create a text file. Whenever an image is added the image is not part of the document; instead a URL is created. This can be a direct link to the image, such as 'http://www.catalystpics.co.uk/art2actionscript/images/masthead.jpg' or alternatively in the current example we can just use 'images/masthead.jpg', which is a relative link to

Figure 11.1 Setting the Publish Settings in Flash.

the file, relative in respect of the current page, 'http://www.toon3d.com/ flash.' We look in the image folder and find the file 'masthead.jpg'. When you create a Flash game you can choose to 'Publish' the game. Figure 11.1 shows the 'Publish Settings' dialog box that is accessed from 'File/ Publish Settings . . .'.

The check boxes that are checked by default are 'Flash' and 'HTML'. When you create a Flash game the project file is an 'FLA' file. When you publish this file it is in the compressed form of an 'SWF' file. In order to view this file on the Internet, you will link to the HTML file not the SWF file. Linking to the SWF file directly will simply bring up a file download box if you have the rights to download files from the folder. Here is an HTML file produced using a Flash publish.

```
<HTML>
<HEAD>
<TITLE>Publishing</TITLE>
</HEAD>
```

```
<BODY bgcolor="#FFFFFF">
<!-- URL's used in the movie-->
<!-- text used in the movie-->
<OBJECT classid="clsid:D27CDB6E-AE6D-11cf-96B8-444553540000"
 codebase="http://download.macromedia.com/pub/shockwave/⏎
   cabs/flash/swflash.cab#version=5,0,0,0"
 WIDTH=550 HEIGHT=400>
 <PARAM NAME=movie VALUE="Publishing.swf">
 <PARAM NAME=quality VALUE=high>
 <PARAM NAME=bgcolor VALUE=#FFFFFF>
 <EMBED
   src="Publishing.swf"
   quality=high bgcolor=#FFFFFF
   WIDTH=550 HEIGHT=400
   TYPE="application/x-shockwave-flash"
   PLUGINSPAGE="http://www.macromedia.com/shockwave/download/⏎
     index.cgi?P1_Prod_Version=ShockwaveFlash">
 </EMBED>
</OBJECT>
</BODY>
</HTML>
```

The familiar HTML tags are all there, but in addition within the 'BODY' tags are 'OBJECT' tags and within those are 'EMBED' tags. 'OBJECT' is used by Internet Explorer to insert an ActiveX control. When using Flash with IE, the user sees an ActiveX control, usually found in the 'System32' folder of the 'Windows' folder. The strange numbered 'classid' is simply Windows' way of finding the control within Windows' registry. If the control cannot be found then the 'codebase' option tells IE where to find the installation program for Flash on the Internet; this is a URL address. The final parameters for the 'OBJECT' tag define the width and height in pixels. Following the 'OBJECT' tag are several lines beginning with 'PARAM'. ActiveX technology can be passed in parameters via the HTML page. A parameter has a name and a value. The 'movie' parameter defines the name of the 'SWF' file. This is in URL format so it can reside in a different folder if necessary. The 'quality' parameter controls whether anti-aliasing is used on the display. Some slower computers struggle to display a high-quality image and so the frame rate can drop. It is sometimes useful to give the player the option of a higher frame rate at the expense of a poorer display or vice versa. The final parameter in this example is 'bgcolor', which takes a value in hexadecimal notation.

Numbers do not have to use a base of 10. In the familiar place-value decimal notation, when a column reaches 9 and is incremented the next column along has one added and the current column goes to zero:

100, 101, 102, 103, 104, 105, 106, 107, 108, 109, 110

In the binary system, that has only two symbols for numbers, once a column has the value 1 and is incremented the next column along becomes 1 and the current column becomes zero.

100, 101, 110

Translating the symbols into a value involves summing the values of the columns

$1111 = 1 * 10^3 + 1 * 10^2 + 1 * 10 + 1$ in the decimal system (10^3 simply means 10 * 10 * 10)

$1111 = 1 * 2^3 + 1 * 2^2 + 1 * 2 + 1$ in the binary system or 15 as a decimal value.

Hexadecimal uses 16 symbols; after 9 there are A, B, C, D, E and F. F is equivalent to 15 in decimal notation. When specifying colours in an HTML document they take the form '#RRGGBB', where 'RR', 'GG' and 'BB' are two hexadecimal values that specify a number between zero and 255 for red (RR), green (GG) and blue (BB). How is this the case? Take the hexadecimal value '00'; this is simply:

0 * 16 + 0 = 0

At the maximum end we have the value 'FF', which means

15 * 16 + 15 = 255

Since each term; red, green and blue, can take a value between 0 and 255, the maximum number of colours possible is

256 * 256 * 256 = 16777216

A value of 255 in decimal is FF in hexadecimal and 11111111 in binary. That is, it takes eight numbers to define the value in binary; each of these numbers is sometimes called a bit and a cluster of eight is called a byte. Since the colour is defined using three 8-bit values, there are in actual fact 24 bits used to define a colour, hence the term 24-bit colour.

Netscape uses a different method to insert a Flash file. This is where the 'EMBED' tags come in. As usual the tag has a closing '</EMBED>' tag. Within the tag the parameters are specified directly; 'src' gives the Flash movie name, 'quality' and 'bgcolor' are as previously described. Width and height are specified in the same way as used by the 'OBJECT' tag. The main difference is the way the application that will display the content is described. Instead of inserting an ActiveX control, Netscape uses a plug-in. The 'type' is defined, if this is not found on the client's machine then the 'pluginspage' defines where to find the plug-in. Notice how the end of the string defining the location of the plug-in uses a '?'; this means that whatever follows it is a query. Although in this example the data following the question mark are used by a different programming language, CGI (Common Gateway Interface); query strings are also a very useful way of setting data inside Flash.

Tell me about query strings

Suppose inside Flash you want to set the value for the variable 'configfile' to 'config/february.txt'. You can do this very easily by altering the specification for both the 'movie' parameter for IE and the 'src' parameter for Netscape.

```
<OBJECT classid="clsid:D27CDB6E-AE6D-11cf-96B8-444553540000"
  codebase="http://download.macromedia.com/pub/shockwave/cabs↵
    /flash/swflash.cab#version=5,0,0,0"
WIDTH=550 HEIGHT=400>
 <PARAM NAME=movie↵
       VALUE="Publishing.swf?configfile=config/February.txt">
<PARAM NAME=quality VALUE=high>
<PARAM NAME=bgcolor VALUE=#FFFFFF>
 <EMBED
       src="Publishing.swf?configfile=config/February.txt "
 ...
```

When specifiying several variables, they must be separated using the '&' symbol; for example:

```
<PARAM NAME=movie↵
      VALUE="Publishing.swf?configfile=config/February.txt&↵
         audiofile=sounds/February.swf">
```

Figure 11.2 Running 'Examples/Chapter11/QueryString.html' from the CD.

When Flash starts, the value of the variables following the question mark are automatically set. Later in the chapter we will look at using query strings as part of the URL for the page. They are commonly used when using ASP.

Try running 'Examples/Chapter11/QueryString.html' on the CD. Then, open the file in a text editor (Notepad on the PC or Simple Text on the Mac). The file looks like this:

```
<HTML>
<HEAD>
<TITLE>QueryStrings</TITLE>
```

```
</HEAD>
<BODY bgcolor="#CCCC99">
<BR><BR>
<CENTER>
<!-- URL's used in the movie -->
<!- text used in the movie -->
<OBJECT classid="clsid:D27CDB6E-AE6D-11cf-96B8-444553540000"
codebase="http://download.macromedia.com/pub/shockwave/cabs/↵
                flash/swflash.cab#version=5,0,0,0"
 WIDTH=550 HEIGHT=400>
 <PARAM NAME=movie VALUE="QueryStrings.swf?configfile=config/↵
    February.txt&audiofile=sounds/February.swf">
 <PARAM NAME=quality VALUE=high>
 <PARAM NAME=bgcolor VALUE=#CCCC99>
 <EMBED
   src="QueryStrings.swf?configfile=config/February.txt&↵
     audiofile=sounds/February.swf"
   quality=high bgcolor=#CCCC99
   WIDTH=550     HEIGHT=400
   TYPE="application/x-shockwave-flash"
   PLUGINSPAGE="http://www.macromedia.com/shockwave/download/↵
              index.cgi?P1_Prod_Version=ShockwaveFlash">
 </EMBED>
</OBJECT>
</CENTER>
</BODY>
</HTML>
```

Notice how the 'bgcolor' is set to '#CCCC99', that is a red value of 'CC' (12 * 16 + 12 = 204), a green value of 'CC' (204) and a blue value of '99' (9 * 16 + 9 = 153). But the most important aspect of this file is the values for 'configfile' and 'audiofile'; try changing the values and then re-running the HTML file. The display will change to show the new values. If you are running IE on a PC then change the value for the 'PARAM NAME=movie'; if you are running Netscape or on a Mac then change the value for the '<EMBED src..'.

Query strings are very useful for getting information into Flash, but there is a limitation. The symbol that delimits (links together) the variables is '&'; this effectively means you cannot use the '&' symbol within a variable. Another problem with query strings is the structure of the file. Query strings are just a single very long sentence. Creating them can lead to confusion. Compare the clarity of the first list:

```
date=23 February 2002
day=Saturday
time=9am
place=dobcross
temperature=-1C
weather=Snow and high winds
outlook=Winds dying, snow changing to sleet
font=Copperplate
map=UK
symbols=ukweathermap.swf
anim=1
webcam=1
webcamURL=http://www.dobcross.co.uk/webcam/cam1.html
```

With a query string version

```
date=23 February 2002&day=Saturday&time=9am&place=dobcross&↵
temperature=-1C&weather=Snow and high winds&outlook=Winds dying,↵
snow changing to sleet&font=Copperplate&map=UK&symbols=↵
ukweathermap.swf&anim=1&webcam=1&webcamURL=http://www.↵
dobcross.co.uk/webcam/cam1.html
```

On the CD you will find a small program, 'Utilities/MakeQueryString.exe'; this takes a list in the first format and changes it into a query string format. If you have particularly complex query strings, then I recommend using this program (sorry it is PC only).

Using loadVariables

Query strings are useful for a one-off initialization of variables. If at launch you need to collect information from the user before knowing which set of variables to initialize, then you will need to use a slightly different method, 'loadVariables'. The syntax to use is:

```
anyMovieClip.loadVariables(url, variables);
```

where 'url' is the absolute or relative URL for the external text file. It is essential that this file is in the same domain as the Movie Clip. The second parameter, 'variables', defines the method for sending the variables. Despite the name of the function, 'loadVariables' can be used for sending variables. You have one of two options for this, either 'GET',

which appends the variables to the end of the URL, in other words, a query string. Please bear in mind that all variables local to the Movie Clip will be appended, so if you have a lot of variables defined then this string is likely to be too long to work effectively.

```
myMovieClip.loadVariables ("sendvariables.asp", "GET");
```

If the Movie Clip 'myMovieClip' has variables 'tom', 'dick' and 'harry' defined, then the URL will actually be set to:

```
http://currentMoviePath/sendVariables.asp?tom=smart&dick=↵
normal&harry=stupid
```

Notice how the variables have been added to the URL as a query string. The Flash documentation recommends using this method for small numbers of variables. The second method 'POST' sends the variables in a separate HTTP header and is recommended to be used for long strings of variables. But neither method is needed for loading variables from an external file into Flash. So if this is what you are doing then use:

```
myMovieClip.loadVariables("variables.txt");
```

instead.

Try running 'Examples/Chapter11/Weather.html'; this simple program loads data from a static text file into the current Flash Movie. The action on frame 1 starts this happening:

```
loaded = 0;
_root.loadVariables("weather.txt");
```

Here we have set a '_root' level variable 'loaded' to zero. The reason for this is that 'loadVariables' returns immediately after the call; on many connections this does not mean that the variables are now set as expected. You must wait until they have been correctly set, by including a variable in the loading file that when loaded will have a known value you can detect when the loading has completed. Here is the file 'weather.txt'.

```
date=23 February 2002&day=Saturday&time=9am&place=dobcross&↵
temperature=- 1C&weather=Snow and high winds&outlook=Winds ↵
dying, snow changing to sleet&font=Copperplate&mapmode=UK&↵
symbols=ukweathermap.swf&anim=1&webcam=1&w ebcamURL=↵
http://www.dobcross.co.uk/webcam/cam1.html&lastupdate=06:00↵
23/02/02&loaded=1&
```

Notice that the variable 'loaded' is included in the file, it is set to the value 1. The variable does not have to be called 'loaded', any variable will do as long as the file sets it to a known value; it could be 'Batman=Bruce Wayne', as long as before the call to 'loadVariable' the variable 'Batman' is set to some value other than 'Bruce Wayne'. Because we must wait for the external file to load, we have a simple looping script that checks the value of the variable 'loaded' and continues to loop until the value is 1. On some occasions because of server problems the file may never load; because of this it is useful to add a counter. Each loop in the wait script will increment the counter. If the counter exceeds a 30-second wait then you may choose to show a text box that explains that there are problems with the server at present, come back later. If the 'fps' for the current Movie is 25, then 30 seconds will have elapsed when the counter is 25 * 30 = 750. You may decide that 2 minutes is a better waiting time; it is dependent on your server and the traffic on the site. Simultaneous users all trying to access the file will greatly affect the load time.

When using 'loadVariables', the external file can be a static text file, but it can also be a text file generated by a CGI script, Active Server Pages (ASP), or PHP. Before you start reeling with the alternatives, we are only

Figure 11.3 Developing the Weather program.

going to consider one, ASP. In the above example we used a static text file. But in a real application the data will be dynamic. You will be connecting to actual data that are current at the present time. This is where server-side creation of the strings that load into your program becomes vital. Let's consider one of the most commonly used techniques.

So what is ASP?

An ASP page is simply a script page that when you access it from a URL runs as a program on the server, using either 'VBScript' or 'JavaScript'. This program can then generate the variable data that Flash requires, passing this information back to Flash dynamically. You can create an ASP page using any text editor. But to function it needs to be run from a Windows Server. If you are using Win95, Win98, Win2000 or WinXP Professional, then you can set up your own machine to function as a Server by installing Internet Information Services (IIS).

To install Internet Information Services

1 Click **Start**, point to **Settings**, click **Control Panel** and start the **Add/Remove Programs** application.
2 Select **Add/Remove Windows Components** and then follow the on-screen instructions to install, remove, or add components to IIS.

If you are able to install IIS then you must create and run ASP pages in the 'inetpub/wwwroot' folder that IIS creates. If you are not able to install IIS because you are on a Mac platform or your version of Windows doesn't contain IIS, then you will need to run the ASP pages from a remote server, uploading the pages using an FTP program to test them.

Later in the book we will study ASP pages in more detail. Here is a very simple example.

```
<%@ language="Javascript" %>
<%
    var a = Number(Request("A"));
    var b = Number(Request("B"));
    var op = Request("op");
    var output = "answer=error";
```

```
Response.Expires = -1;

if (op == "add") {
        output = "answer=" + (a + b);
}else if (op == "subtract") {
        output = "answer=" + (a - b);
}
Response.Write(output);
%>
```

The first line tells ASP that the scripting language is JavaScript. Then the actual script is contained between the tags '<% %>'. Because the language is JavaScript it is very similar to ActionScript. First we declare a few variables. `Number(Request("A"))` extracts the variable *A* in the query string and turns it into a number rather than the default of a string. If the file is saved as 'calc.asp' in folder 'scripts' of server 'myserver' then we can call the page using

```
http://myserver/scripts/calc.asp?A=13&B=8&op=add
```

In this case the value for the variable *a* will be set to 13, *b* to 8 and op to 'add'. Using 'Response.Expires=−1' tells the browser not to cache the page. Then we test for the appropriate op; if either 'add' or 'subtract' is found then we build a string 'output'. Finally, this is sent to the browser using 'Response.Write(output). If we called this from Flash then the variable 'answer' would be set to one of *a* + *b*, *a* − *b*, or 'error'. The output can contain multiple values if each variable, value pair is connected to the rest using the ampersand character (&).

Using the LoadVars object

A new feature in Flash MX is the LoadVars object. This useful object is designed to make communicating with external data easier for the developer. The object uses callback functions. A callback function is simply a function that is called when a particular event occurs. You tell the object where to find the function and then this function will be called whenever a certain event takes place.

Suppose we have the following code on frame 1 of our main timeline:

```
lv = new LoadVars();
lv.onLoad = loaded;
lv.load("myvariables.txt");
stop();
```

```
function loaded(success) {
        if (success) {
                gotoAndStop("LoadedOK");
        }else {
                gotoAndStop("LoadFailed");
        }
}
```

Firstly, a new LoadVars object is created and called 'lv'. The callback that will be used whenever the object has loaded some variables is set to the function called 'loaded'. A LoadVars object passes a single parameter into the onLoad function that indicates whether the load was successful or not. We can use this parameter to adjust the behaviour of the movie. We do not have to call this parameter 'success', it is simply a Boolean variable (true or false) and can have whatever name we choose.

If the load is successful then the variables are not at the root of the movie; instead they are all inside the LoadVars object. For example, if the file 'myvariables.txt' contained:

Apple=1&Pear=2&Orange=3

then the object lv would contain:

lv.Apples = 1
lv.Pear = 2
lv.Orange = 3

Chapters 14 and 19 give more information about communicating with databases using Flash and ASP pages.

Using JavaScript on the current page

Flash can communicate with the current page using any JavaScript function that is placed on the page using the ActionScript function 'fscommand'. This function takes two parameters; the first is a string that can be used as a command name, the second is used for arguments. Because Internet Explorer uses 'VBScript' as the default scripting language, you need to put a 'VBScript' version on the page and a 'JavaScript' version. In example 'Examples\Chapter11\fscommand.html',

we use a simple Flash movie 'fscommand.swf' that is created with the project file 'fscommand.fla'.

The 'Set' button calls a function 'onSet', which contains the following code:

```
function onSet() {
        fscommand("setSpan", str);
}
```

The variable 'str' is the Input Box that you can see in Figure 11.4 displaying the string 'Flash Calling'. When 'fscommand' is called for

Figure 11.4 Communication between Flash and the html page using 'fscommand'.

Internet Explorer, if the HTML page contains a VBScript Sub 'xxxx_ FSCommand(cmd, args)', where 'xxxx' is the id used for the Flash object, then this subroutine is called. When fscommand is called for Netscape, if the HTML page contains a JavaScript function 'xxxx_DoFSCommand(cmd, args), where 'xxxx' is the name used for a Flash embed, then this function is called. A VBScript can call a JavaScript function on the same page using the form 'call functionname(parameter1, . . .)'. In the example, the VBScript function 'flash_FSCommand' calls the JavaScript function 'flash_DoFSCommand' using the 'call' method.

In this instance, Flash affects the actual page by setting the document object with the ID 'flashStr', which is the SPAN of the one item table, to the value passed in the variable 'args'.

```
...
<SCRIPT LANGUAGE=JavaScript>
function flash_DoFSCommand(command, args) {
        if (command == "setSpan") {
                document.all.flashStr.innerHTML = args;
        }
}
</SCRIPT>

<SCRIPT LANGUAGE="VBScript">
<!-
//  Handle IE.
Sub flash_FSCommand(ByVal command, ByVal args)
    call flash_DoFSCommand(command, args)
end sub
//->
</SCRIPT>

</HEAD>

<BODY bgcolor="#ffffff">
<CENTER><BR><BR>
<TABLE>
<tr bgcolor="#ccccff">
  <td width="450" height="20">
     <P align=center>
    <font face="Verdana, Arial, Helvetica, sans-serif" size="2"
            color="#0000ff"><span id="flashStr"> </span>
    </font></P></td>
```

```
</tr>
</TABLE>
...
<OBJECT
        id=flash
        ...
        <EMBED
            ...
                NAME="flash"
        </EMBED>
</OBJECT>
 ...
```

Summary

As your games get more sophisticated and your program skills develop you will often need to access data in external files. In this chapter we looked at using the 'loadVariables' method and the 'LoadVars' object. Sometimes the data needs to be created dynamically and we introduced the use of ASP pages for this purpose. Finally, we look at how Flash can use JavaScript on the page into which Flash is embedded by using the fscommand method.

12 Tweening in code

The easiest way to tween a graphic or a Movie Clip is to right-click on a frame layer in the timeline and choose 'Create Motion Tween'. Unfortunately, the results are not always fantastic. In this chapter we look at how you can use ActionScript to provide dynamic tweening that gives a much smoother and more flexible result. In the first part of the chapter we will simply look at how ramping (easing) in and out of a move gives a more natural feel. Later in the chapter we will look at how several keyframes can be linked together to create a smooth and curved motion, the same kind of motion you would get in a CG animation package.

A bit of background

Traditional cell animation was, until relatively recently, shot on a camera that was mounted to point vertically down. This set-up was called a rostrum camera or an animation stand. The only movement the camera could do was to move up and down a very rigid column. The artwork was placed on a bench underneath the camera. This bench could move north, south, east and west in relation to the camera. On most animation stands, the bench could also rotate through 360 degrees. By moving the bench the artwork could move in a controlled fashion beneath the camera; by moving the camera up and down the column the camera could be made to zoom in or out of the artwork. In the early days of rostrum cameras the movement of each axis was linked to a manual counter. The counter would often count up in thousandths of an inch. To creating a smooth motion from one position to another on such a camera would require the use of a look-up table for each axis. The cameraman would first calculate the movement for each axis, then find the nearest look-up table to achieve this movement in the desired number of frames. The look-up tables incorporated an acceleration from a stationary position and a deceleration to a stop at the end. If the

cameraman had a move that went through several positions they would have to use some kind of smoothing to make the movement through a middle position seem smooth. Most of the tables that were used to give these camera moves used a sine curve as a ramp in and out. A rostrum cameraman's life was transformed when computers became available to control the motion of each axis. Many years ago I was involved in creating the software to drive the motors for an animation stand. The maths used to control the stands is the same that you will find in this chapter and the curved motion is still used to provide the movement of many motion control stands that are the big brother of an animation stand.

Options for easing in and out

When you move a clip from one location to another over time you have several options over the look of the motion. Each time interval could be used to move the clip exactly the same distance. This is called linear interpolation and it is the default for Flash motion tweening. The result is fine for an object that is already moving, but looks stiff and artificial if the object either starts from stationary or stops while in view. An alternative is to ease in to the motion; the first time interval would move the clip only a small amount and this would be increased for each successive time interval, either until a certain speed is achieved or the ramping could continue throughout the motion. Similarly, at the end of a motion the amount of motion for each successive time interval could be reduced to bring the clip to a smooth stop. When you start to play about with the speed of a clip in this way you will find that accelerating and then abruptly stopping has a dynamic that may be suitable for a particular application. Motion is as important to the success of a game as the look and feel. Controlling the speed of a clip can be done using simple mathematics, the simplest option being linear.

Linear interpolation

If a clip moves from location A to location B in time T, then linear interpolation is simply

```
var dt = time/duration;
_x = offset.x * dt + start.x;
_y = offset.y * dt + start.y;
```

Here we use a point object to store the start position and the total movement that is required. A motion is usually relative to the starting position. In this instance, we simply create a variable *dt* and set it to the current time since the start of the motion divided by the duration of the motion. This number will vary over time between 0 and 1. At the start no time will have elapsed so the value for *dt* will be 0, in which case the *x* and *y* values are simply set to the starting position. As the variable time approaches the duration value, *dt* will get close to 1, so that *x* and *y* will be set to the starting value plus the value for offset.

Quadratic interpolation

The graph of $y = x^2$ is shown in Figure 12.1. As you can see, this is not a straight line, it is a curve. We will let the *x* value represent a number between 0 and 1, being the elapsed time in proportion to the total duration of a move. The *y* parameter will be the total distance moved. As you can see from the shape of the curve, there will be a smaller movement at first, gaining speed throughout the move. This will give an ease in to the motion.

Figure 12.1 The graph of $y = x^2$.

Such a motion is achieved using this code snippet.

```
var dt = time/duration;
_x = offset.x * dt * dt + start.x;
_y = offset.y * dt * dt + start.y;
```

If an ease out is required then we need a different shape to the curve. In fact, we need to flip the curve for both values. Flipping the time value will give a parameter moving by 1 − dt (if dt is a value between 0 and 1 as described above). The quadratic of 1 − dt is simply (1 − dt)(1 − dt), which can be multiplied out to give 1 − 2dt + dt^2. We also want to flip the value parameter, so the result is 1 − (1 − 2dt + dt^2), which simplifies to 2dt − dt^2. So the curve we want is $y = 2x − x^2$, which is shown in Figure 12.2.

Such a curve is created with the code snippet:

```
var dt = time/duration;
_x = offset.x * dt *(2 – dt) + start.x;
_y = offset.y * dt *(2 – dt) + start.y;
```

Value

time

Figure 12.2 The graph of 2x – x².

In all the curves we shall study we are using a delta time parameter *dt* that varies over the range 0–1, to create a curve whose maximum value is also 1. We use the value of the curve multiplied by the offset required for the actual move to place the moving item in the correct place for both the *x* and *y* directions. When we are considering the ease in and out option for a quadratic, we need to join together the two previous curves. We want the ease in curve to be used for the first half of the motion and the ease out curve to be used for the second half. This time, however, we need to scale the result of the ease in calculation by a half; we want the maximum value for this curve to happen when *dt* is 0.5 and for the result to be 0.5 likewise. To do this, we must multiply the time value by 2, but half the final answer. We get

```
var dt = time/duration;
dt *= 2;
if (dt < 1) {
        _x = offset.x/2 * dt * dt + start.x;
        _y = offset.y/2 * dt * dt + start.y;
}
```

If *dt* is past the halfway mark, then we need to apply the second curve with *dt* starting from 0 at the halfway stage and again we must half the final result and add 0.5, because the first part of the curve has already got to this point. We get:

```
var dt = time/duration;
dt *= 2;
if (dt >= 1) {
        dt--;
        _x = offset.x * dt *(2 - dt) + 0.5 + start.x;
        _y = offset.y * dt *(2 - dt) + 0.5 + start.y;
}
```

In this way we can join together the two curves seamlessly at the point (0.5, 0.5) on the curve.

Joining together curves in this way can give very interesting motion. The Excel spreadsheet 'Examples\Chapter12\quadratic tweening.xls' allows you to play about with curves to see the results in the charts.

Quadratic tweening can be extended to cubic or higher polynomials. A cubic curve is simply $y = x^3$. The higher the power, the faster the ramping will be.

Figure 12.3 Joining x^2 and $2x - x^2$.

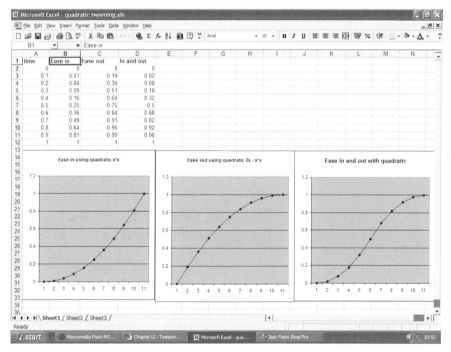

Figure 12.4 Using Excel to chart the curves.

Sinusoidal tweening

A totally different method for generating motion curves is to use the sine curve. Figure 12.5 shows a section of a cosine curve between π and 2π. Trigonometrical functions use radians as the parameter not degrees; 180 degrees is the equivalent of π radians, so the curve shown is actually between 180 and 360 degrees. Notice that the curve ramps up and ramps down between the two values and that the range for the function is ±1.

Figure 12.5 A section of the cosine curve.

The curve is very similar to the joined quadratic curve. To use the curve to ease in, we need the section between π and $3\pi/2$. This will give a result between -1 and 0, so we will need to add 1 to get the values we want, between 0 and 1.

```
var n, dt = time/duration;
n = Math.cos(Math.PI/2 * dt + Math.PI) + 1;
_x = offset.x * n + start.x;
_y = offset.y * n + start.y;
```

For an ease out we will use the curve between $3\pi/2$ and 2π; this section of the curve already gives values between 0 and 1, so we do not need to scale or shift the values.

```
var n, dt = time/duration;
n = Math.cos((Math.PI * (dt + 3))/2);
_x = offset.x * n + start.x;
_y = offset.y * n + start.y;
```

The final option is to use the full curve to give both an ease in and out. For this, we must use the full curve between π and 2π; the returned values will vary between +1 and −1, so we must add 1 then divide by 2 to give returned values between 0 and 1.

```
var n, dt = time/duration;
n = (Math.cos(Math.PI * dt + Math.PI) + 1)/2;
_x = offset.x * n + start.x;
_y = offset.y * n + start.y;
```

Exponential tweening

Another curve that can give a very fast ramp is the curve $y = 2^x$. Any number raised to the power zero is equal to 1. As you know, the value of dt ranges between 0 and 1, but we want the result to start at 0 and ramp up to 1 for an ease in curve. If we used 2^{dt} then the result would start at 1 and ramp up to 2 with very little curve in the motion. In fact, we want the tangent to the curve at time zero to have a zero gradient. This implies that before time zero the curve was flat, indicating a static object. If we use the curve $y = 1/2^x$, then for large values of x, y tends to zero. If we make the starting value for x equal to 10, then $y = {}^1/_{1024}$, which is fairly small. $1/2^x$ is the same as 2^{-x}. So we want the power values to range between −10 and 0.

```
var n, dt = time/duration;
n = Math.pow(2, 10 * (dt - 1) };
_x = offset.x * n + start.x;
_y = offset.y * n + start.y;
```

The ease out curve needs to start fast and decelerate, so we flip the curve and reverse the direction.

```
var n, dt = time/duration;
n = 1 - Math.pow(2, -10 * dt) - 1 ;
_x = offset.x * n + start.x;
_y = offset.y * n + start.y;
```

For an ease in and out we do a piecewise interpolation using the ease in for values up to *dt* = 0.5 and the ease out curve for *dt* >0.5. The curves

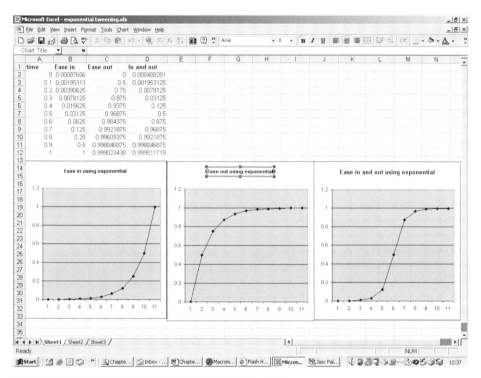

Figure 12.6 Using Excel to chart exponential curves.

need to be scaled in both directions and the ease out curve needs translating so that *dt* = 0.5 gives a result of 0.5.

```
var n, dt = time/duration;
dt *= 2;
if (dt < 1) {
        n = Math.pow(2, 10 * (dt - 1))/2;
        _x = offset.x * n + start.x;
        _y = offset.y * n + start.y;
```

```
}else {
        dt--;
        n = -(Math.pow(2, -10 * dt) - 2)/2;
        _x = offset.x * n + start.x;
        _y - offset.y * n + start_y;
}
```

If you find the maths confusing then just copy the stuff into your project and use it like a black box. It works!

The tweening example project

In addition to the Excel spreadsheets of the curves there is Flash project, 'Examples\Chapter12\tweening.fla,' to help you to understand how this stuff works and what the results look like.

The tweening project consists of a screen that contains two check boxes to select easing in and easing out, and four radio buttons to choose the curve type. If you deselect both the ease in and out options then you

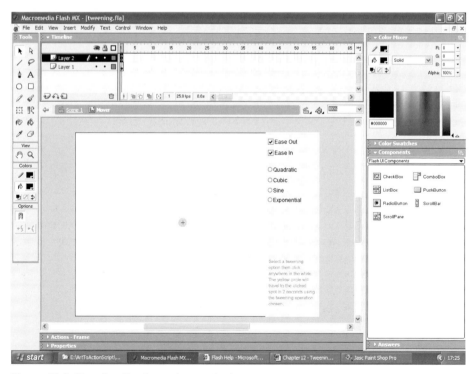

Figure 12.7 Creating the tweening project.

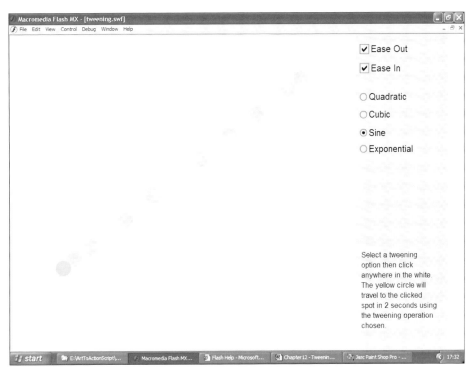

Figure 12.8 Using the tweening example.

will get a linear interpolation. The aim of the application is to allow you to click anywhere in the white area and then the yellow dot will move from its current location to the new location in one second, leaving behind a trail that gives an indication of how the speed of the motion accelerates and decelerates over time. Try running the application now to get a feel for the different curves involved. The code inside the project uses the code snippets already outlined and introduces a *point* class. As you know from Chapter 9, keeping data and the manipulation of data together is a very useful technique, it makes your code more robust and easier to modify, and is highly recommended. To create a new point simply use the 'new' keyword. The function 'point' assigns values to the data and sets up pointers to function calls. Then to set a point you can use the method 'set' to add and subtract you can use the methods 'add' and 'sub'. The results of the code snippet here would be to set 'offset' to the point (2, −18).

```
start = new point ();
end = new point ();
offset = new point ();
```

```
start.set(12, 34);
end.set(10, 52);
offset.copy(start);
offset.sub(end);

function point () {
        this.x = 0;
        this.y = 0;
        this.set = setPoint;
        this.add = addPoint;
        this.sub = subPoint;
        this.copy = copyPoint;
}

function setPoint(nx, ny) {
        this.x = nx;
        this.y = ny;
}

function addPoint(pt) {
        this.x += pt.x;
        this.y += pt.y;
}

function subPoint(pt) {
        this.x -= pt.x;
        this.y -= pt.y;
}

function copyPoint (pt) {
        this.x = pt.x;
        this.y = pt.y;
}
```

Creating keyframes

So far the methods described will take a graphic element from one screen location to another. Suppose we want the element to move through several positions smoothly and with a curved motion. This is the principle behind computer animation programs. The interpolation through the key positions is handled in several different ways; one of the simplest yet

controllable options is to use a variant on a hermite curve. To use such a curve we are going to need a structure that can contain all the information needed to manipulate each key position on the curve. Such a structure needs to contain values for

time, x, y, scale, rotation, tension, continuity and bias

The last three values allow you to control how the curves interpolate through the key positions, should the motion bunch up to a key, be very curved around the key or favour the start of a section rather than the tail. To store all these data we will create a *keyframe* class.

```
//Constructor for a keyframe object
function keyframe(i) {
        //Member variables
        this.x = 0;
        this.y = 0;
        this.rotation = 0;
        this.scale = 100;
        this.ct = 0.0;
        this.bs = 0.0;
        this.tn = 0.0;
        this.millisecs = 0;
        this.linear = false;
        //Function pointers
        this.tween = tween_keyframe;
        this.dump = dump_keyframe;
}
```

Interpolating between keyframes using TCB curves

Suppose we have a series of keyframe values that must change smoothly over time. Figure 12.8 indicates how the values change with respect to time. Notice that there is an abrupt change at $K3$. Here the tangent to the incoming curve does not match the tangent to the outgoing curve. Creating a smooth motion is in reality a curve-fitting exercise. You are creating a curve that smoothly moves between certain defined positions.

The technique we will use is a piecewise fit. We will calculate the move between, for example, $K1$ and $K2$ using a cubic curve while ensuring that the tangent at $K1$ is also used when considering the section $K0$ to $K1$ and

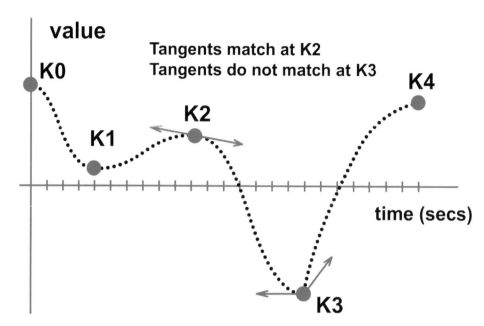

Figure 12.9 Piecewise curve fitting.

the tangent at $K2$ is used when interpolating between $K2$ and $K3$. The curve we will use is:

$$y = h_0 * K1 + h_1 * K2 + h_2 * T1 + h_3 * T2$$

where h_3–h_3 are the Hermite coefficients:

$$h_0 = 2t^3 - 3t^2 + 1$$
$$h_1 = 3t^2 - 2t^3$$
$$h_2 = t^3 - 2t^2 + t$$
$$h_3 = t^3 - t^2$$

and $T1$ and $T2$ are the smoothing parameters. If $S1$ and $S2$ are defined as:

$$S1 = (K2.\text{time} - K1.\text{time})/(K2.\text{time} - K0.\text{time})$$
$$S1 = (K2.\text{time} - K1.\text{time})/(K3.\text{time} - K1.\text{time})$$

Then

$$T1 = S1*((1 - K1.tn)(1 + K1.bs)(1 + K1.ct)(K1.\text{value} - K0.\text{value})$$
$$+ (1 - K1.tn)(1 - K1.bs)(1 - K1.ct)(K2.\text{value} - K1.\text{value}))$$

$$T2 = S2*((1 - K2.tn)(1 + K2.bs)(1 - K1.ct)(K2.\text{value} - K1.\text{value})$$
$$+ (1 - K2.tn)(1 - K2.bs)(1 + K2.ct)(K3.\text{value} - K2.\text{value}))$$

If the curve section is between $K0$ and $K1$, then

$$T1 = 0.5 * (K2.\text{value} - K1.\text{value})* ((1 - K1.tn)(1 + K1.bs)(1 + K1.ct)$$
$$+ (1 - K1.tn)(1 - K1.bs)(1 - K1.ct))$$

and if the curve section is between the penultimate and the final keyframes, then

$$T2 = 0.5 * (K2.\text{value} - K1.\text{value})*(((1 - K2.tn)(1 + K2.bs)(1 - K1.ct)$$
$$+ (1 - K2.tn)(1 - K2.bs)(1 + K2.ct))$$

In the tweening function we first test to see if the time passed as a parameter is within range. If not, then we set the motion to either the first or last keyframe. Then we look through the keyframe list to see which section to interpolate. If the current time is an exact match with a keyframe time, then no interpolation is required and so the position is set directly and the function returns. If interpolation is required then we precalculate the value of tcb coefficients and store them in the variables $a - d$. These are used to derive the values of $T1$ and $T2$. A section of the curve can be set to be linear if required, in which case the interpolation calculation is simplified to starting position plus the product of delta time and the offset value for the curve section. This arithmetic is applied to all the channels in the keyframe.

```
function tween_keyframe(name, channels, millisecs)
{
    if (millisecs<keys[0].millisecs) {
        setDirect(name, 0);
        return;
    }
    if (millisecs>keys[keys.length-1].millisecs) {
        setDirect(name, keys.length - 1);
        return;
    }

    //Must be within range
    var index = 0, i;
```

```
for (i=0; i<keys.length; i++) if (millisecs>keys[i].millisecs)↵
    index = i;

if (millisecs == keys[index].millisecs) {
    setDirect(name, index);
    return;
}

//Interpolation required
var t, tt, ttt, h1, h2, h3, h4, a, b, c, d;
var secDur, s1, s2, dd0, ds1, result, p0, p1, p2, p3, d10;
secDur = keys[index+1].millisecs - keys[index].millisecs;
t = (millisecs - keys[index].millisecs)/secDur;

//Hermite coefficients
tt = t*t; ttt = t*tt;
h1 = 2 * ttt - 3 * tt + 1;
h2 = 3 * tt - 2 * ttt;
h3 = ttt - 2*tt +t;
h4 = ttt - tt;

a = (1 - keys[index].tn) * (1 + keys[index].ct) *
    (1 + keys[index].bs);
b = (1.0 - keys[index].tn) * (1.0 - keys[index].ct) *
    (1.0 - keys[index].bs);
c = (1.0 - keys[index+1].tn) * (1.0 - keys[index+1].ct) *
    (1.0 + keys[index+1].bs);
d = (1.0 - keys[key+1].tn) * (1.0 + keys[key+1].ct) *
    (1.0 - keys[key+1].bs);
if (index!=0)
    s1 = secDur/(keys[index+1].millisecs - keys[index-1].↵
        millisecs);
if (index!=(keys.length - 2))
    s2 = secDur/(keys[index+2].millisecs - keys[index].↵
        millisecs);

//Set the channel values
for (i=0; i<channels; i++) {
    p0 = GetKeyValue(i, index-1);
    p1 = GetKeyValue(i, index);
    p2 = GetKeyValue(i, index+1);
    p3 = GetKeyValue(i, index+2);
```

```
        if (!keys[index+1].linear) {
            if (index==0) {
                t1 = 0.5*(a + b)*(p2 – p1);
            }else {
                t1 = s1*(a*(p1-p0)) + b*(p2 – p1);
            }
            if (index==keys.length-2) {
                t2 = 0.5*(c + d)*(p2 – p1);
            }else {
                t2 = s2*(c*(p2 – p1) + d*(p3 – p2));
            }
            result=h1*p1 + h2*p2 + h3*t1 + h4*t2;
        }else {
            result=p1 +t * (p2 – p1);
        }
        SetChannel(name, i, result);
    }
}

function GetKeyValue(channel, index) {
    if (index<0 || index>=keys.length) return 0;

    switch (channel) {
        case 0:
        return keys[index].x;
        case 1:
        return keys[index].y;
        case 2:
        return keys[index].rotation;
        case 3:
        return keys[index].scale;
    }

    return 0;
}

function SetChannel(name, channel, value) {
    switch(channel) {
        case 0:
        eval(name)._x = value;
        break;
```

```
        case 1:
        eval(name)._y = value;
        break;
        case 2:
        eval(name)._rotation = value;
        break;
        case 3:
        eval(name)._xscale = value;
        eval(name)._yscale = value;
        break;
    }
}
```

The TCB curves example

Figure 12.10 shows 'Examples\Chapter12\tcbcurves.fla' in action. In the example you can move, scale or rotate the key positions using the mouse.

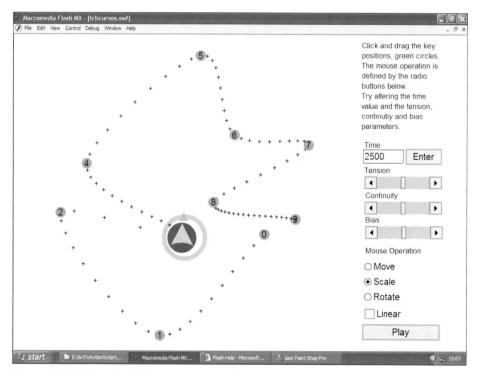

Figure 12.10 Using the TCB curves example.

For each key position you can set the time, tension, continuity and bias. The crosshairs give an indication of the curve used to move around the key positions; as you can see there is a smooth motion throughout. The crosshairs bunch up when the section duration is long and appear widely spaced when the section duration is short. The crosshairs are positioned with a call to the function 'updateCrossHairs'. This function is called whenever the user adjusts the curve.

```
function updateCrossHairs () {
        var i, name, interval, time = keys[0].millisecs;

        interval = (keys[keys.length-1].millisecs – keys[0].↵
           millisecs)/100.0;

        for (i=0; i<100; i++) {
                name = "cross" + i;
                time += interval;
                tween_keyframe(name, 2, time);
        }
}
```

Both *http://www.robertpenner.com/* and *http://www.gizma.com/easing/* provide more information on tweening from ActionScript.

Summary

Using ActionScript to tween your Movie Clips will give you a smoother movement and gives smaller file sizes. Although the maths can be intimidating at first, it is well worth understanding enough to be able to cut and paste the code into your own games. You should have enough ActionScript background now to start programming your own games. There is no substitute for actually writing your own code and in the next chapters we will start to create some fun games.

Section 3
Putting it into practice

You know your stuff, so how about using this knowledge to make some games.

13 Small games to keep them loading

If your game is over a meg and most users access this via dial-up, then you will have lost your audience before they have even seen it. Another game site is just a click away. Your job is to entertain the user; one useful way to keep the interest of your players while your latest one-meg epic loads is to provide a small game as a pre-loader that they can play while the main game loads. In this chapter we look at creating games that use 20 K or less; for the bandwidth of a small gif, we have a game to entertain and sustain their interest.

How to keep a game small

There are a few golden rules for keeping games small:

Minimize the use of bitmaps

ActionScript code is usually only a few 'K'. But a single bitmap image can easily add 50 K to the game's download size. When producing small games, you can effectively rule out the use of bitmaps.

Use Movie Clip symbols for anything that gets reused

There are several ways to group things in Flash. You can use a 'Group'; the problem with this is that it is not a symbol from the library. Everything about the graphic is stored for each use of the 'Group'. It is always preferable to use a symbol, since then you are only storing the complex object once. 'Tweens' make a huge impact on a file and should be used sparingly in small games. If you can duplicate a clip in code then the impact on the file size is negligible.

Minimize the use of sound

Even poor quality sound at '16 kbps' adds 20 K to the file size for each 10 seconds. If we are going to fit the entire game in under 20 K, then you will need to limit the audio to 4 K at the most. This will give 4 seconds of '8 kbps' audio, suitable for impacts and clicks only.

Don't embed a font

Another common requirement is the use of embedded fonts. If you are only using the numbers for a score, for example, then only embed the numbers.

To select the font outlines that you intend to embed, open the 'Character' dialog by selecting the 'Character . . .' button from the Properties panel for the text. To embed an entire font, click the AllCharacters' radio button. For select font sets select 'Only' and use the check boxes to choose from upper case, lower case, numbers or punctuation. To select specific outlines enter them in the edit text box underneath the punctuation check box.

If you need to embed an entire font then the game will be too big. A single font can easily be 20 K. Just the numbers are usually around 1–2 K, so can easily be justified. If you need the odd word then select this using specific outlines or if the text is static then let Flash select just the outlines needed.

Figure 13.1 Embedding selected font outlines.

Working out where the size goes using a Publish report

Flash has several tools to help the developer determine how the size of their 'swf' files relates to the projects content. The most detailed option is to generate a size report. The 'Publish Settings' dialog box contains the check box necessary to tell Flash to create a report. The 'Publish Settings' dialog box is accessed using the menu option 'File/Publish Settings . . .'

Figure 13.2 Using the Publish Settings dialog box to generate a size report.

To see how this works, open the Flash project file 'Examples/ Chapter13/random.fla'. This is a very simple game, where you watch a random number generator and click a button when the displayed number is less than 100 000. Basically it is a reaction time tester. The displayed output shows the total number of times the random number generator created a number less than 100 000, the number of times the user pressed the stop button correctly and the number of times the user pressed the stop button incorrectly.

There is a considerable use of text in this game, but despite this the minimum total size for the game is just 4112 bytes or 4.02 K. Let's look at how this size can be affected by the incorrect use of fonts.

In the game the greatest single use of fonts involves the numbers displayed. For this reason the outlines for the numbers of the chosen font, 'Arial Narrow', are embedded. The text box settings for the 'Dynamic Text boxes' that show the main 'randomnumber', 'total', 'right' and 'wrong' answers are all set to include just the number outlines. The word 'TOTAL'

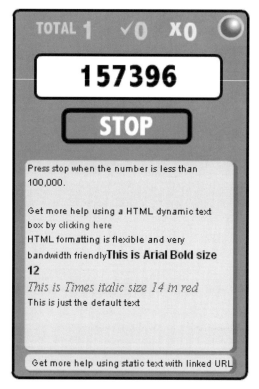

Figure 13.3 A simple reaction time tester.

is a static text box using the same font and the label on the button 'STOP' is also static.

Flash can use either *embedded fonts* or *device font*; an embedded font is included in the 'swf' file while a device font is assumed to be available on the target computer. The large text area is set to be a device font by selecting '_sans' as the font. Flash includes three device fonts: '_sans', '_serif' and '_typewriter'. On a Windows machine these will default to use 'Arial', 'Times' and 'Courier'.

The large text area is set to be a Dynamic Text box. Because it is dynamic, the only way to put multiple font formatting into the box is to use the HTML option. This is set in the 'Text Options' dialog box.

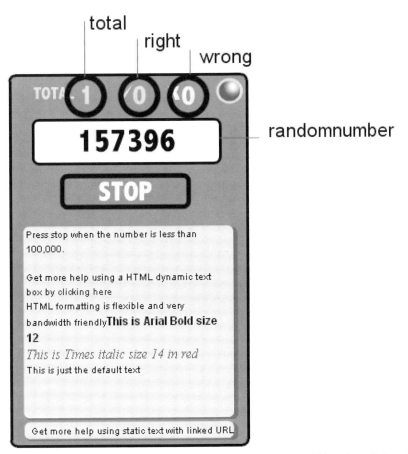

Figure 13.4 Dynamic Text boxes used in the 'Examples/Chapter13/random.fla' project.

When using HTML formatting you can set the font face, colour and size. You can include Bold, Underline and Italic formatting. You can add a Hyperlink and you can set the paragraph splits. In this example, the formatting was all done in the action for frame 1 using the following ActionScript.

Figure 13.5 Setting a Dynamic Text box to use HTML formatting.

```
html text = "<P><FONT FACE='Arial' SIZE='10'>Press stop when the ↵
         number is less than 100,000. </P><P></P>";
html text += "<P>Get more help using a HTML dynamic text box by ↵
         </FONT>";
html text += "<FONT COLOR='#0000FF'><A HREF='randomhelp.html' ↵
         >clicking here</A></FONT></P>";
html text += "<P><FONT FACE='Arial' SIZE='10' COLOR='#000000'>HTML↵
         formatting is flexible and very bandwidth friendly↵
         </FONT>"
html text += "<P><FONT FACE='Arial'SIZE='12'><B>This is Arial Bold ↵
         size 12</B></FONT></P>";
html text += "<P><FONT FACE= 'Times' SIZE='14'COLOR='#FF0000'><I>↵
         This is Times italic size 14 in red</I></FONT></P>";
html text += "<P><FONT FACE='Arial' SIZE='10' COLOR='#000000'>This↵
         is just the default text</FONT>"
```

HTML text formatting adds nothing to the size of your game, but it is a very flexible way to put up instructions or text that can change very dynamically. All this text is formatted within the game, or it could be loaded into the game using 'loadVariables'.

The tags you can use are

<A>
Used to create a Hyperlink,

```
<A HREF='mylink.html'>This is the words you see on the page</A>
```

<P>
Used to set a paragraph break,

```
<P>This is new paragraph</P>
```


Used to set Bold text

```
This is ordinary text and <B>this is Bold text</B>
```

<U>
Used to set underlined text

```
This is ordinary text and <U>this is underlined text</U>
```

<I>
Used to set Italic text

```
This is ordinary text and <I>this is Italic text</I>
```


Used to set a fonts face, colour and size.

```
This is ordinary text and <FONT FACE='Arial' COLOR='#FF0000'
SIZE='12'>this is 12 point Arial in Red </FONT>
FACE='. . .' takes a font name.
COLOR='. . .' takes a hexadecimal colour value see chapter 11
for an explanation of hexadecimal use
SIZE='. . .' the point size for the font.
```

When using HTML text formatting, remember that all HTML tags expect a closing tag that is the same as the opening tag but includes a forward slash character. To create a paragraph you would use:

```
<P>This is the first paragraph and will automatically word wrap to ↵
the size of the text box.</P>
<P>This is the second paragraph and is guaranteed to start on a ↵
newline.</P>
```

Once you set a tag, it remains active until the closing tag. So with:

```
<P><FONT FACE='Arial' SIZE='10' COLOR='#000000'><B>HTML ↵
   formattingis flexible and very bandwidth friendly</FONT>
<P><FONT FACE=' Arial' SIZE=' 12'>This is a bigger font but it is ↵
   still set to be bold</B></FONT></P>";
```

all type is bold because of the positioning of the and tags.
Here is the Publish report for the game:

```
Movie Report
-----------
```

FrameFrame #	Frame Bytes	Total Bytes	Page
1	4192	4192	Scene 1
2	92	4284	2
3	2	4286	3
4	2	4288	4

5	2	4290	5
6	2	4292	6
7	2	4294	7
8	2	4296	8
9	2	4298	9
10	2	4300	10
11	2	4302	11
12	2	4304	12
13	2	4306	13
14	2	4308	14
15	15	4323	15

Page	Shape Bytes	Text Bytes
Scene 1	434	553

Page	Symbol Bytes	Text Bytes
ResetButton	164	0
StopButton	77	117
RandomNumbers	0	65

Font name	Bytes	Format
_sans	20	
Arial Narrow	1585	0123456789ALOPST

Pay particular attention to the Font section. Here there are two fonts mentioned; 'Arial' uses just 20 bytes. This is because the small text area at the bottom of the game is a static font that is set to be a 'Device Font' using the 'Text Option' panel.

See what happens if this box is not checked.

Font Name	Bytes	Characters
Arial	2125	GLRUacdeghiklmnoprstuwx
Arial Narrow	1396	0123456789ALOPST

Every font outline is needed to display the line 'Get more help using static text with linked URL'. Rather than this using just 20 bytes it uses 2125 bytes, over 100 times the size, just because one simple check box was overlooked. Notice also that the font outlines included for the 'Arial Narrow' font contain the numbers and 'ALOPST', just the outlines needed

Figure 13.6 Using device fonts.

to display 'STOP' and 'TOTAL' along with the number text boxes. When you are trying to keep the game small, device fonts make a huge difference to the file size.

Pong, one of our favourites

Before we look at how to code the game, let's look at how the use of fonts can influence the size. You can see from the Movie Report for Pong that the game uses just 7470 bytes or around 7 K. But look where the bytes came from: 5367 of the 7470 come from the numbers in the 'Cooper Black Bold' font. If you are really strapped for bandwidth you could use a device font here. As you know, device fonts use just 20 bytes so the total size would come down from 7470 to 2123. See what an impact fonts can make on the file size of a small game. If we had chosen to embed the entire font,

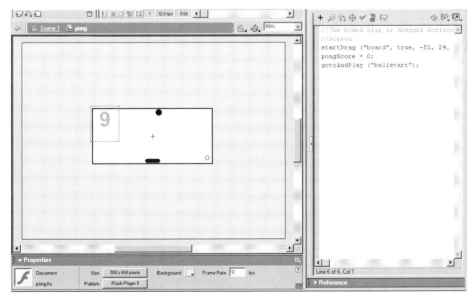

Figure 13.7 Developing the Pong game.

instead of just the numbers, then the game would have used 42 131 bytes, nearly 40 K more than we could have used for a device font. My recommendation is to use device fonts unless you really have to for these small loader games.

```
Movie Report
----------

Frame #           Frame Bytes     Total Bytes     Page
----------        ----------      ----------      ----------
1                      7470           7470         Scene 1

Page                              Shape Bytes     Text Bytes
----------------------            ----------      ----------
Scene 1                                0               0

Symbol                            Shape Bytes     Text Bytes
----------------------            ----------      ----------
pong                                  85              46
pongboard                             29               0
pongball                              54               0
pongSFX                                0               0

Event sounds: 11 KHz Mono 16 kbps MP3

Sound Name                    Bytes           Format
------------------------      ----------      --------
Pulselec.wav                     639          11KHz Mono 16 kbps MP3

Font Name                     Bytes           Characters
------------------------      ----------      ----------
Cooper Black Bold               5367          0123456789
```

Another thing to notice in the Movie Report is the use of a small sound file. At under 1 K the 'bip' sound when the ball hits the bat is well worth including.

When you are creating small loader games you want to be able to easily port them to another game. For this reason they should be a self contained Movie Clip. It is best not to access any '_root' level variable because then you can place this game anywhere. If the game uses Movie Clips within itself then access variables at another level using the '_parent' syntax rather than the '_root' syntax. Most of these games are fairly simple so you should find it easy to work within this limitation.

Pong uses seven layers:

sound: Used for the single sound effect, this is embedded inside the Movie Clip, sfx. This way it can be triggered easily from code. An alternative method would be to use a 'Sound' object, but Movie Clips work fine.

score: The score is just a Dynamic Text box that tracks the variable 'pongScore'.

mask: Used to contain the ball within the frame.

ball: Containing the 'ball', Movie Clip.

board: Containing the 'board', the bat, Movie Clip.

bg: Containing the background design.

control: Containing all the ActionScript that controls the game.

Graphically the game could not be simpler, but the design can easily be changed to reflect the main game that 'Pong' is just an entertaining loader for. The main interest then is in the coding. For this game all the code is contained in the main timeline. There are no 'onClipEvent's or nested Movie Clips that contain code. The code is set in four frame actions.

Frame 1: actionScript

```
//The board clip is dragged horizontally across the base of the
//screen
startDrag ("board", true, -51, 24, 52, 24);
gotoAndPlay ("ballstart");
```

The purpose of the script on frame 1 is simply to allow the user to drag the 'board' using the mouse. Flash contains a very useful command 'startDrag'; this command takes up to six parameters:

```
startDrag(movieClip, [lockMouse], [left, top, right, bottom]);

movieClip:
```

The name of a Movie Clip instance

```
lockMouse:
```

Whether the Movie Clip is locked to the centre of the mouse position (true) or where the user first clicks (false)

```
left, top, right, bottom:
```

Coordinates relative to the Movie Clip's parent that specify a constraining rectangle.

In the script we set the drag to be locked to the mouse centre and the constraining rectangle to allow no vertical movement by setting the values for top and bottom to be the same.

Then the playback jumps to the frame 'ballstart'.

Frame 'ballstart' – ActionScript

```
//Initialise the variables for a new ball and score
//The ball always starts at the top going directly down
ballY = -23;
ballX = random(100) -50;
ball._y = ballY;
ball._x = ballX;
moveX = 0;
moveY = 3;
pongScore = 0;
gotoAndPlay ("ballplay");
```

Again, a very simple initialization script. The variables 'ballX' and 'ballY' store the 'ball' location. Initially these are set to −23, the top of the play area and a random location across the play width. Using these variables the location of the Movie Clip, 'ball', is set using the Movie Clip parameters '_x' and '_y'. The game uses a movement in the 'x' direction set to 0 and a movement in the 'y' direction which is initially set to 3. The two variables define the amount of horizontal and vertical movement of the ball in a single frame. Finally, the score is set to 0 and play jumps to the frame 'ballplay'.

Frame 'ballplay' – ActionScript

```
ballX += moveX;
ballY += moveY;
```

```
//Bounce off the sides
if ((ballX>57 && moveX>0) || (ballX< -57 && moveX<0)) {
    ballX = ballX - moveX;
    moveX = -moveX;
}

//Bounce off top
if (moveY<0 && ballY <= -26) {
    ballY = ballY - moveY;
    moveY = 3;
}

ball._x = ballX;
ball._y = ballY;

//Bounce off bat or miss
if (moveY>0 && ballY == 19) {
    boardTest = ballX - board._x;
    if (boardTest>-8 && boardTest<8) {
        pongScore++;
        moveY = -3;
        moveX += (boardTest * 0.625);
        sfx.gotoAndPlay (2);
    }
}

//If we are going down and the y>31 then we've missed
if (moveY>0 && ballY >= 31) {
    gotoAndPlay ("ballstart");
} else {
    prevFrame ();
}
```

Here is the 'meat' of the game. First, we update the 'ballX' and 'ballY' variables by adding the values for 'moveX' and 'moveY'. Then we test to see if the ball has hit the side. This happens if the *x* value for the ball is greater than or less than 57. If we only test for the ball location then we could end up trapping the ball. What we need to do is detect for a collision with the side only when the ball is heading towards that side. This ensures that when the ball bounces off the wall it does not immediately set itself up to hit the wall, then bounce off, then hit in an infinite loop. If we test for the right side, when the 'ballX' variable is

greater than 57 and only react if the 'moveX', the ball's direction, is greater than zero and we only react to the collision when the ball is heading right. The code that is contained within the 'if' statement flips the 'moveX' variable and updates the value for 'ballX' so that it is at the position of the previous frame. It is possible that the next time this code is run the value for 'ballX' is still greater than 57, in which case if we had not added the further condition that 'moveX' has to be greater than zero then the code within the 'if' statement would be executed again, flipping 'moveX' a second time, so the ball would stick to the wall. But the test for 'moveX' ensures that the ball will bounce freely from the wall.

The next 'if' statement tests for a collision with the top wall and behaves identically to the test for the sides; this time we test for the value of 'ballY' only when the direction is up, 'moveY' is less than zero. At this point we update the ball. Then we test for a collision with the 'board' clip. This can only happen when the ball is moving down, 'moveX>0' and the *y* value of the ball is 19. The use of an exact value like this means that you cannot change the direction value or the initial start position without adjusting this value. I point this out because it is a coding technique to discourage. Because the initial *y* position for the ball is −23, and the increments are in threes, the ball will eventually hit the value 19.

$$-23 + 14 * 3 = 19$$

But if you change anything it won't. Yuck! Much better to make 19 the goal value. If we want to make sure the test only occurs once then add in another test to make

```
if (moveX>0 && ballY>=19 && ballY<22) {
```

But there is still a problem here; we are embedding into the code the increment in the '*y*'. Because we 'know' that the movement in the '*y*' is always three we have used this to test for the 'ballY' value being equal to or greater than 19, while also less than 19 + 3 = 22. What if we want to scale the game play as the player gets a higher score by making the '*y*' increment four. The code would not work. It is a much better coding technique to use a variable for the *y* increment, 'incY'. Then wherever we have used the value '3' we can use 'incY' instead. Now the ball hitting the board test should be:

```
if (moveX>0 && ballY>=19 && ballY<(19 + incY)) {
```

Wherever possible, avoid the use of numerical equality in a conditional; they are prone to errors. A test for zero is about the only one worth using.

If the condition for the y position of the ball passes the above test, then the code within the 'if' statement executes. Firstly, a convenience variable 'boardTest' is set to the position of the ball relative to the 'board'. If this is between plus and minus eight, then the player has successfully hit the ball and so the score is incremented and a new deflection value is set. The y movement is simply going to be the y increment negated, but the value for moveX reflects how central the bat is in relation to the board, along with the current movement in the x. Finally, the sound effect for a hit is triggered by moving the playback of the sound effect Movie Clip 'sfx' to the second frame, where the sound is played.

A simple game, about an hour's work and under 3 K, it may not be the latest hot game for the PlayStation, but it should keep them occupied for the seconds it takes to load your game.

Tetris: simple concept, terrific game play

The game of 'Tetris' uses five layers:

Code:	Containing all the ActionScript.
Debug:	Used to display useful debugging information.
Pieces:	Containing the playing pieces.
Board & Game Over:	Displays the board and information boxes.
Score & Time:	Containing the text boxes that display the score and time.

The coding for the game makes extensive use of arrays of game data. The game is initialized by duplicating Movie Clips containing a single tile and placing these all over the game board. The displayed frame for each of these Movie Clips is controlled by the game logic and the value is stored in the arrays. Collision detection is all done by reading these arrays. For more details on the coding strategy for this game read Chapter 9, where the concepts are discussed in detail. The game uses just 14 K and can be placed inside any Flash timeline.

Here is a small section from the main game loop that can be found on frame 22 ('MainLoop') of the 'tetris' clip in the project 'Examples/Chapter13/tetris.fla'.

Figure 13.8 Developing Tetris.

We will just look at how the current time and level are set using the following code:

```
// Update time
milliSecs = getTimer () - startTime;

//Increment the speed as the time increases
if (milliSecs>30000) {
    //At 30 secs set to level 1
    level = 1;
} else if (milliSecs>60000) {
    //At 60 secs set to level 1
    level = 2;
} else if (milliSecs>90000) {
    //At 90 secs set to level 1
    level = 3;
}
```

```
secs = int(milliSecs/1000);
mins = int(secs/60);
secs -= (mins * 60);
if (secs<10) {
    Time = mins + ":0" + secs;
} else {
    Time = mins + ":" + secs;
}
```

The Flash command 'getTimer' returns a time in milliseconds. Since we initialized a variable called 'startTime', using 'getTimer', when the game was launched, the time since the game began is simply the current timer value minus the starting value. This value is used to set the game level, so that the game scales as the player gets further into the game. Finally, the on-screen display for time is set by first getting the number of elapsed seconds, by dividing the millisecond value by 1000. Then the number of minutes in this value is determined by dividing the seconds' value by 60. The 'int ()' command converts the number within the brackets into an integer value. Having determined the number of minutes, then seconds can be reduced by this value times 60. The on-screen display for 'Time' is in a Dynamic Text box; we want to ensure that the seconds' part of the box always shows two characters, '01' not '1'. Consequently, if 'secs' is less than 10 then we need to insert a '0' into the string. The string handling is placed within the 'if' conditional to allow for this.

The remainder of the 'MainLoop' frame action involves fairly complex checking of the game state and collision testing; try reviewing it now and see if you can analyse how the game works.

Crosswords: make them read the instructions!

One popular technique for loaders is to place the instructions in the loading screens. But who reads instructions? In our experience almost no one. Simple low-file-size animated instructions certainly help. But you could have a quiz, or a crossword that makes the users read the instructions. Without reading the instructions they cannot do the crossword or quiz. An interactive experience is the reason the user has visited your site, so they are willing and eager to get involved. Here is a simple crossword puzzle that could contain questions relating to the instructions for the game. For the example here the questions all relate to Flash programming, so you should know all the answers. The layout is very simple: the crossword is on the left and the clues on the right. To avoid using too much screen space the clues are split into 'Across' and 'Down', which can be flipped using the button on

Figure 13.9 Testing the crossword project.

the bottom right. If you are stuck then click the 'Answer' button. This reverts to a 'Clear' button when clicked. The crossword layout and questions are all loaded in from a text file using 'loadVariables', so the game is very easily adapted. The project file for this example can be found at 'Examples/ Chapter13/crossword.fla'.

The 'crossword.txt' file contains variables of the form:

rows: An integer giving the total number of rows.

rowx: Where *x* is an integer between 1 and 'rows'. Each of these is a string giving the letters for the row. To show a black square, enter a '0' at the appropriate place in the string.

 row1=variable00a0 would show as eight blank squares, two black, a blank and a black.

cluetotal:	The total number of clues.
cluex:	Where *x* is an integer between 1 and cluetotal. Each of these indicates the square on which a clue starts.
cluesacross:	A string in HTML format.
cluesdown:	A string in HTML format.
loaded:	Set to 1 to indicate that loading of the file is complete.

The number of columns, 'cols', is determined by getting the length of the first row string. Then the on-screen clue display 'cluetext' is set to show the 'cluesacross' clues. The crossword is made up of duplicated Movie Clips to keep the formatting flexible and to maintain a small file size. Each square on crossword contains a single Movie Clip that contains just two frames: the first frame is a Black square and the second frame includes an Input text box connected to the variable 'letter' and a Dynamic Text box connected to the variable 'clueNum'. Using a little string parsing the appropriate frame is chosen. If the current row string contains a '0' at the current column, then the black square frame, 1, is shown, if not then frame 2 is shown.

```
count=0;
cols = length(row1);
cluetext = cluesacross;

orgX = 27;
orgY = 24;

for(row=0; row<rows; row++) {
    for (col=0; col<cols; col++) {
        name = "cell" + row + "_" + col;

        if (count>0) {
            duplicateMovieClip("cell0_0", name, count);
            eval(name)._x = orgX + col * 20;
            eval(name)._y = orgY + row * 20;
        }

        str = new String(eval("row" + (row + 1)));
        if (str.charAt(col)=='0') {
            eval(name).gotoAndStop(1);
        }else{
            eval(name).gotoAndStop(2);
        }
```

```
eval(name).letter = "";
eval(name).clueNum = "";
count++;
        }
    }
```

The remainder of the script sets the clue numbers in the crossword. The cell number is calculated from the value for the 'cluex' variables. Because these think of the top left cell as one, the value is decremented. To get the column we need the remainder after dividing by the number of columns. We get this using (cell % cols); this will give the integer value remaining after division by 'cols'. To get the 'row' we need to find the integer portion of division by 'cols'; 'int(cell/cols)' does just that. Then we can build up the name of this cell as one of the duplicated Movie Clips from the earlier part of the script. At this point we can assign the current loop value to the variable 'clueNum' inside the clip.

```
for (i=1; i<=cluetotal; i++) {
    cell = eval("clue" + i);
    cell--;
    col = (cell % cols);
    row = int(cell/cols);
    name = "cell" + row + "_" + col;
    eval(name).clueNum = i;
}
```

That sets up the game, and then the player can enter the values as they wish. There is no checking involved in the game; I leave you to do this enhancing. But there is an answer button that populates the crossword with the correct answer. After doing this the button becomes a clear button so that the player can try again. The code for the answer button is fairly straightforward:

```
on (release) {
    if (answerbuttontext == "Answers") {
        for (row=0; row<rows; row++) {
            str = eval("row" + (row + 1));
            for (col=0; col<cols; col++) {
                name = "cell" + row + "_" + col;
                if (str.charAt(col)!='0') {
                    eval(name).letter = str.charAt(col);
                }
            }
        }
```

```
            extra.letter = "v";
            answerbuttontext = "Clear";
    }else{
            for (row=0; row<rows; row++) {
                    for (col=0; col<cols; col++) {
                            name = "cell" + row + "_" + col;
                                    eval(name).letter = "";
                    }
            }
            extra.letter = "";
            answerbuttontext = "Answers";
    }
  }
```

If the displayed text on the button is 'Answers', then the values in the 'rowx' variables are parsed to get the current letter for the current cell and this is then assigned to the Movie Clip variable 'letter'. If the displayed value is not 'Answers', then the Movie Clip variable 'letter' is set to a blank string for each cell.

Summary

Small games while the main game loads are an important consideration for users on a dial-up connection. A 56 K modem connection means 56 kbps (56 000 bits per second), a byte uses 8 bits, so you can immediately divide the value by 8; 56/8=7, so 7 K is the theoretical maximum throughput with no error checking of a 56 K modem. In practice, a 56 K modem usual delivers around 4 k per second. If you can get the player involved in a game within 5 seconds of viewing the page by introducing a simple game that is under 20 K, then they are much more likely to stay while the 500 K game loads in around 500/4 = 125 seconds or just over 2 minutes. When another site is only a click away 2 minutes is an eternity. On TV, the broadcasters worry about losing their audience as the credits roll and regularly put trailers for the programmes that are coming later on the same screen as the credits to avoid losing audience share. Your users do not know how marvellous your game is until it loads. How many will you lose that get to the page and don't stay the distance? Your aim must be to minimize this haemorrhaging of users. In this chapter we covered some ideas about how you can 'keep 'em watching'.

14 Quizzes

Quizzes are a very popular form of entertainment on TV. In the UK, where I live, a quiz show called *Who Wants to be a Millionaire?* became one of the highest rated programmes on TV. Quizzes are very simple to create but are fairly demanding to maintain. In this chapter we will look at creating a database of questions using an SQL Server database. Because the questions are categorized by difficulty and topic we can use this database to access questions in a variety of ways. This chapter builds on some of the concepts presented in Chapter 11.

Multiple choice or free text?

The easiest way to write a quiz program is to use questions that have a multiple choice answer. The advantage of using multiple choice is that any answer the user gives is either definitely wrong or definitely right. There is no ambiguity. Computer programs hate ambiguity. The problem is that the quiz compilers are required to create the alternative different answers, which adds to their work. Free-text input is prone to errors. A quiz that allows free-text input for the answers must have answers that are very easy to input. Numerical answers are the least prone to error. If the answer is '3', how do you respond to an answer of 'three'? Both answers are correct but if the code is checking for '3' and finds 'three' then the player could easily be marked wrong. Free-text input is very demanding to code; you must mark as correct many answers that are incorrectly spelt. But how do you allow for that? One way is to compare the player's answer with the correct answer using a table of allowed, wrongly spelt answers. However you approach it, the problem is complex and can result in 'obvious' wrong answers being marked correct and vice versa. In this chapter we are therefore only going to consider the multiple choice option. In the database of quiz questions we will keep the correct answer and three incorrect ones.

Creating a database

Databases come in many shapes and forms. In this chapter we will concentrate on using SQL Server. This is a relational database management system for Windows NT servers. If you intend to do much work using SQL Server then you will need to get a copy of the developer edition. Unfortunately, this costs about the same as a copy of

Figure 14.1 SQL Server Enterprise Manager.

Flash, although a trial evaluation version is available. A simpler alternative is to use an Access-based database and much of the material in this chapter applies to both databases. The major difference between the two options is in the way the server implements the database access. The SQL Server route is much more flexible and results in a smoother experience for the users. In the end, the cost difference is more than outweighed by the benefits.

Figure 14.2 Creating the database, stage 1.

Because most of this chapter involves the use of server-based techniques, the examples do not run direct from the CD. They are on the CD so that you can examine the code, but to use them in a live way you will need to be running the database on an SQL Server and the ASP code needs to be running on an IIS (Internet Information Server). If you are using a Windows platform then it is easy to set up your own machine to operate as an IIS. Check out the documentation that comes with your version of Windows to learn how to do this. (Unfortunately, the Home Edition of Windows XP does not allow you to set up your machine as an IIS.) If you are unable to set up your machine as an IIS either because your version of Windows is unsuitable or because you are developing on a Mac, then you will need to upload the ASP stuff to an ISP and run the samples across the Internet.

Having installed your version of SQL Server, run the option called 'Enterprise Manager'. This is an application that allows you to create and manipulate databases.

Firstly, we will create a database. Connect to a database by clicking on one of the available servers. You can use SQL Server to connect to a remote database, assuming you have the access privileges. For now we will assume that the server is local to your machine and that you are logged on as administrator. Right-click on the 'Database' folder and choose 'New Database'. For the examples in this chapter I created a database called 'a2a'.

By default, the files for the database are stored in the 'C:\Program Files\Microsoft SQL Server\MSSQL\Data' folder. Each database uses two files, the data file and the transaction log. You can change the path to

Figure 14.3 Creating the database, stage 2.

Figure 14.4 Creating the database, stage 3.

these files using the Database properties dialog that is opened when you create a database.

Creating a user for the database

Having created the database we will now create a user. In this example the user is called 'quiz' and has access via SQL Server Authentication using a password. To create a new user expand the database folder and select the newly created database 'a2a' if you are following the example. Expand the 'a2a' folder and right-click on Users; select 'New Database User . . .' from the context menu. This brings up the dialog box that you can see in Figure 14.5.

Figure 14.5 Creating a user.

Type in the name 'quiz' and the password you intend to use. Now set up the type of database access this user can have using the 'Database Access' tab. Check the 'db_datareader' and the 'db_datawriter' boxes as shown in Figure 14.6.

Creating a table

A database can contain several tables. For this example we will create a single table called 'Quiz'. To create a table right-click 'Table' in the 'a2a' drop-down and select 'New Table . . .'. This brings up the table designer tool. For this example the table contains nine columns. Each column has a data type suitable for the information that will be stored in the column. Database design is a complex subject and if you intend to use a lot of

database access then you are strongly advised to get a good SQL book; the bibliography lists a few of the ones we have used.

Finally, we set the permissions for the user, quiz, we have created, in this table. The user 'quiz' can 'SELECT, INSERT and UPDATE' but cannot 'DELETE'. Right-click on user 'quiz' and select properties, then click the 'Permissions' button.

You now have a database that the user 'quiz' can access to select rows from the table 'quiz'; they can update the data stored there and they can insert new rows.

Inputting the data

To make the inputting of data easy, we will create a Flash-based input tool. Open 'Examples\Chapter14\createquiz.fla'. This project uses the

Figure 14.6 Allocating the user's roles.

Figure 14.7 Creating a table.

new Flash components to create a tool that allows the developer to read and update the database. Access to the database is via ASP pages. ASP pages can run on your local machine if it is set up as an IIS (Internet Information Server) or you can run them on a remote server. Before we look at how the 'createquiz.fla' project works, we will look at the ASP pages it uses.

Connecting to the database using ASP

The first thing we must do if using a database is connect to it. Because all our pages will use this we will put this code in a file that can be included in all the other files. As well as creating the connection to the

Figure 14.8 Setting user permissions.

database the code snippet includes the definitions of a few constants that will be used by other pages. 'adCmdText, adCmdTable' and 'adCmdStoredProc' are just useful constants to make the code more readable. To create a connection we declare several variables, 'db-UserID', which in this example is the user we have created to access the database, 'quiz'. The password is included; this must be exactly as entered into the SQL Authentication box when creating the user 'quiz'. We also include the database name that we are going to link to, in this case 'a2a', and the server on which the data reside. This can be a remote server. Once these details are provided we can create a connection string, simply a string containing all the information a database connection will require. Finally, we can use the 'Server' object to create an 'ADODB.Connection', using the 'CreateObject' method. Although by this time we have a connection object it is not connected; to actually connect we must use the 'Open' method of the connection object passing the connection string as a parameter. Here is the code; it can be found as 'Examples\Chapter14\scriptsJS\dbconnect.asp'.

```
<%
//-----------------------------------------------------------
//Connects to database
//-----------------------------------------------------------

//************DB connection************
var dbUserID, dbPassword, dbDatabaseName, dbServerName,
dbConnectStr, conn;
var adCmdText = 1;
var adCmdTable = 2;
var adCmdStoredProc = 4;

dbUserID = "quiz";
dbPassword = "A2a!quiz";
dbDatabaseName = "a2a";
dbServerName = "NiksDell2";
dbConnectStr =      "Provider=SQLOLEDB.1;" +
                        "Password=" + dbPassword + ";" +
                        "Persist Security Info=True;" +
                        "User ID=" + dbUserID + ";" +
                        "Initial Catalog=" + dbDatabaseName + ";" +
                        "Data Source=" + dbServerName;

conn = Server.CreateObject("ADODB.Connection")
conn.Open(dbConnectStr);
%>
```

Creating a new row

Now we have the script to create a connection we can use it to create a new entry in the database or to update an existing entry. The details for the new entry are passed in via a query string. Remember that a query string takes the form:

```
varName1=varValue1& varName2=varValue2& varName3=varValue3&
varName4=varValue4& . . .
```

Each variable name and value are linked using the ampersand character. To turn the string into variable data you can use the 'Request' command. The first section of the script turns the query string into the variables 'category', 'difficulty', 'question', and 'A, B, C, D'.

An ASP page is cached by the browser so it is best to include the command 'Response.Expires = 0;' at the beginning of the file to ensure that this caching does not take place, otherwise the page can only be used once.

Having parsed the string into usable variables the 'dbconnect.asp' file is included in the file. The effect of an include is as though the code in the file is actually part of this page. So if everything has worked at this stage in the file you will have the variables to define a record in the database and an open connection. Because the same ASP page is used for both updating and adding we must first find out whether this question appears in the database. To do this we will need another object, an 'ADOD-B.recordset', which is created in the same way as the connection. Having created a recordset we use the 'Open' method passing a string and the open connection. This time the string is an SQL query. To discover whether the record exists we simply ask for a list of records containing this question using the SQL query 'SELECT * FROM quiz WHERE question=' the current question. Here the table is 'quiz' and the only test is for the single parameter 'question'. The database engine then looks through all the records in the 'quiz' table for a match for the current question. Each time it finds a match it is added as a new record to the object 'rs'. We can move between records in the 'rs' object until we reach the end, when rs.EOF (End Of File) evaluates to true. If rs.EOF is false after the SQL query then the question was not found. To allow us to use this information later in the code the variable 'found' is set to true or false based on the return value of the query, true if the question exists and false if not.

Part of the information stored in the database is the date the record was added. To do this we need to get the current date. Creating a variable using 'new Date ()' initializes the variable to a 'Date' object containing the current date. To use this with an SQL query we must convert the format into a string. The string should be of the form

```
Month/Date/Year
```

where 'Month' is a number between 1 and 12, 'Date' is a number between 1 and 31 depending on the month, and the year is in the four-number form. The 'Date' object has methods for returning this information, although the month is returned as a number between 0 and 11, so 1 must be added to achieve the SQL formatting.

We are nearly ready to update or add to the database. First, we must format a query string using the information we have discovered. If we are updating then we use the SQL command 'UPDATE'. The format is to follow 'UPDATE' with the table name, then use 'SET' and a list of

values to set, separated by commas. So that SQL knows which record to update the query is completed by adding 'WHERE' with the column name 'question' being equal to the current variable 'question'. If instead we are adding a new record, then we use the SQL command 'INSERT INTO' followed by the table name and a list of column names separated by commas inside round brackets. The value of the column names follows the word 'VALUES' and is a list of values separated by commas inside round brackets in the same way as the column names. To actually send this information to the database we create the string then pass it to the 'Execute' method of the open connection. Finally, we close the open connection and pass some data to Flash, either 'questionAdded=true' or 'questionUpdated=true', using the 'Response.Write' method. Inside Flash the values of these variables will be set directly as a result of the write. The code for this script is in the file 'Examples\Chapter14\scriptsJS\addQuestion.asp'.

```
<%@Language=JavaScript %>

<%
//-------------------------------------------------------------
//Script writes a new question to the database from a querystring
//-------------------------------------------------------------
//Strip data from the query string
Response.Expires = 0;
var category = Request("category");
var difficulty = Request("difficulty");
var question = Request("question");
var A = Request("A");
var B = Request("B");
var C = Request("C");
var D = Request("D");
//--------------DATABASE STUFF--------------------
%>
<!- -#include file="dbconnect.asp"- ->
<%
var rs=Server.CreateObject("ADODB.recordset");
var found = false;

rs.Open("SELECT * FROM quiz WHERE question=\'" + question + "\'", ↵
    conn);
if (!rs.EOF) found = true;
rs.Close ();
```

```
var sqlStr, date;
var d = new Date ();
var dateStr = new String((d.getMonth () +1) + "/" + d.getDate () + ↵
    "/" + d.getYear ());

if (found) {
    // The entry exists so we will amend it
    sqlStr = "UPDATE quiz SET category=\'" + category + "\', ↵
        difficulty=" +
                difficulty + ", A=\'" + A + "\', B=\'" + B + ↵
                "\', C=\'" + C +
                "\', D=\'" + D + "\' WHERE question=\'" + ↵
                question + "\'";
    Response.Write("questionUpdated=true&");
}else{
    //No entry so add it
    sqlStr = "INSERT INTO quiz " +
                "(category, difficulty, question, A, B, C, D, ↵
                createdate) " +
                "VALUES (\'" + category + "\'," + difficulty + ↵
                ", \'" +
                question + "\', \'" + A + "\', \'" + B + "\', ↵
                \'" + C + "\', \'" + D + "\', \'" + dateStr + ↵
                "\')";
    Response.Write("questionAdded=true&");
}

conn.Execute(sqlStr);
conn.Close ();

%>
```

Deleting a row

Sometimes we will need to delete a row. Here the method is similar to above. First, we parse the query string to find the current question. Then we make a connection by including the 'dbconnect.asp' file. Then we build a query, this time using 'DELETE FROM' and the table name 'WHERE question=' the current value of the variable question. We can execute this directly on the database without the need for any recordsets. The code for this is in the file 'Examples\Chapter14\scriptsJS\deleteQuestion.asp'.

```
<%@Language=JavaScript %>

<%
//-----------------------------------------------------------
//Script writes a new question to the database from a querystring
//-----------------------------------------------------------
//Strip data from the query string
Response.Expires = 0;
var question = Request("question");

//--------------DATABASE STUFF--------------------
%>
<!--#include file="dbconnect.asp"-->
<%
var sqlStr = "DELETE FROM quiz WHERE question=\'" + question + "\'";

conn.Execute(sqlStr);
conn.Close ();

Response.Write("questionDeleted = true");
%>
```

Deleting an entire category

For convenience, another ASP page deletes an entire category.
In the same way as deleting a single question, only multiple
records can be deleted. The code for this is in the file
'Examples\Chapter14\scriptsJS\deleteCategory.asp'.

```
<%@Language=JavaScript %>

<%
//-----------------------------------------------------------
//Script writes a new question to the database from a querystring
//-----------------------------------------------------------
//Strip data from the query string
Response.Expires = 0;
var category = Request("category");

//--------------DATABASE STUFF--------------------
%>
```

```
<!--#include file="dbconnect.asp"-->
<%
var sqlStr = "DELETE FROM quiz WHERE category=\'" + category + "\'";

conn.Execute(sqlStr);
conn.Close ();

Response.Write("questionDeleted = true");
%>
```

Accessing a category

The input engine will require data from the records in a category. So that the user can access an entire category, the script 'Examples\Chapter14\scriptsJS\getCategory.asp' was included. Here a connection is made to the database in the usual way and the variable 'category' is tripped from the query string. The recordset is made using the SQL query 'SELECT * FROM' the table 'Quiz' 'WHERE category=' the value of the variable category. Then we create a string from the records to pass back to Flash. The value of the columns in a record can be accessed using 'Fields.Item(x)', where 'x' is the number of the column. To set up the string suitable for Flash, the variable data must be in the MIME-encoded form of variable name equals variable value connecting each assignment pair with the ampersand character. To move through the records in the recordset object use the 'moveNext' method. So that Flash knows how many records have been sent, the value of the variable 'questionTotal' is added to the string and a 'loaded=1' value so that Flash knows that the data have been passed. An alternative method for passing data is to use the 'LoadVars' object; this has something called a callback function so that the program is informed when the data have been correctly received. You will learn more about the 'LoadVars' object in Chapter 19.

```
<%@ Language=JavaScript%>

<%
//----------------------------------------------------------
//Script writes card data to db and sends ecards
//----------------------------------------------------------
Response.Expires = 0;
var category;
```

```
//Strip data from the query string
category = Request("category");

//---------------DATABASE STUFF---------------------
%>
<!--#include file="dbconnect.asp"-->
<%
var rs = Server.CreateObject("ADODB.Recordset");
var str = "SELECT * FROM Quiz WHERE category =\'" + category + "\'";

rs.Open(str, conn);

var i=0;
str = "";

while (!rs.EOF) {
    //Set string
    str += ("question" + i + "=" + rs.Fields.Item(2).Value + "&");
    str += ("difficulty" + i + "=" + rs.Fields.Item(1).Value + "&");
    str += ("A" + i + "=" + rs.Fields.Item(3).Value + "&");
    str += ("B" + i + "=" + rs.Fields.Item(4).Value + "&");
    str += ("C" + i + "=" + rs.Fields.Item(5).Value + "&");
    str += ("D" + i + "=" + rs.Fields.Item(6).Value + "&");
    rs.moveNext ();
    i++;
}
str += ("questionTotal=" + i + "&loaded=1&");
Response.Write(str);

rs.Close ();
conn.Close ();

%>
```

Getting a list of all categories

The last script we will look at returns all the categories in the database; this will be useful for creating the input engine. Much of the methodology will be familiar. The new feature is the use of the term 'DISTINCT'. This ensures that only one record for each instance is returned; if there are 25 records in the 'sport' category, only a single record 'sport' is returned to

the recordset. The data are passed back to Flash using the MIME-encoded string method.

```javascript
<%@Language=JavaScript %>

<%
//-------------------------------------------------------------
//Script gets all the distinct category names from the database
//-------------------------------------------------------------
//--------------DATABASE STUFF---------------------
%>
<!--#include file="dbconnect.asp"-->
<%
Response.Expires = 0;
var rs = Server.CreateObject("ADODB.Recordset");
var str = "SELECT DISTINCT(category) FROM Quiz";

rs.Open(str, conn);

var i=0;
str = "";

while(!rs.EOF) {
        str += ("category" + i + "=" + rs.Fields.Item(0).Value + "&");
        rs.moveNext ();
        i++;
}
str += ("categoryTotal=" + i + "&loaded=1&");

rs.Close ();
conn.Close ();

Response.Write(str);

%>
```

Creating the front end

Now we have the ASP scripts we can use them with a front end for inputting the data. In this example we will make use of the UI components that come with Flash MX. The input screen has a combo box in the top left

Figure 14.9 Creating an input application.

corner to select the category; buttons to move through the questions in a category are placed to the right of the category combo. There are four buttons, 'Delete category', 'Delete question', 'Reset' and 'Enter question'. There are five radio buttons to select the level of difficulty and finally five text boxes to enter and display the question, correct answer and three alternative answers. To initialize the data, the script 'scriptsJS/getCategories.asp' is called using the 'LoadVariables' method. This occurs on ActionScript for frame 1. Then the movie goes into a mini loop waiting for the value of 'loaded' to be set to 1 by the ASP script.

```
loaded = 0;
count = 0;
resetQuestion ();
loadVariables("scriptsJS/getCategories.asp", "");
status = "Loading category list";

function resetQuestion () {
        categoryCombo.setValue("");
        question = "";
```

```
        difficulty = "";
        correctAnswer = "";
        option1 = "";
        option2 = "";
        option3 = "";
        questionInfo = "";
    }
```

Once the categories are loaded we can load them into the combo box using the 'addItem' method. Remember to clear the combo box first using 'removeAll'. Because the data are passed in as 'category0', 'category1', 'category2' etc., we access the values of these variables using the 'eval' command. The second parameter passed to the 'addItem' method is a data value for this entry. In this example we do not use this, so the second parameter is always zero. Once the combo box is populated we load the questions for the first category in the list using the 'getCategory.asp' script, with the value for category set to the value of the variable 'category0'.

```
for (i=0; i<categoryTotal; i++) {
        categoryCombo.addItem(eval("category" + i), 0);
}
loaded = 0;
loadVariables("scriptsJS/getCategory.asp?category=" + ↵
    category0, "");
status = "Loading category " + category0;
nextFrame ();
```

Again, the engine enters a waiting loop until the value for 'loaded' is set to 1 by the ASP script. Finally, the first question can be displayed using the 'setQuestion' function. This function is passed the index of the required question and the values of the displayed variables are updated using the variables set by the ASP page.

```
function setQuestion(i) {
        questionIndex = i;
        question = eval("question" + i);
        difficulty = eval("difficulty" + i);
        eval("diff" + difficulty).setState(true);
        correctAnswer = eval("A" + i);
        option1 = eval("B" + i);
        option2 = eval("C" + i);
```

```
option3 = eval("D" + i);
questionInfo = (i+1) + "\\" + questionTotal;
prevBtn.setEnabled((i!=0));
nextBtn.setEnabled((i!=(questionTotal-1)));
debug = question + chr(13) + correctAnswer + chr(13) +
                option1 + chr(13) + option2 + chr(13) + ↵
                    option3 + chr(13);
}
```

Whenever there is a change of category, the following script is run, which makes a call to the 'getCategory.asp' script.

```
function changeCategory () {
    category = categoryCombo.getSelectedItem ().label;
    loaded = 0;
    loadVariables("scriptsJS/getCategory.asp?category=" + ↵
        category, "");
    status = "Loading " + category;
    gotoAndPlay("loadCategory");
}
```

Whenever the enter button is pressed, the following script is used. Here the current value of the category is accessed using the combo box method 'getValue'. If a combo box is editable then this value is the text string that is entered by the user and displayed in the combo box when the drop-down options are not shown. If this is a new entry then we should place it in the combo box drop-down list. To check this we look through every entry in the combo box list to see if it is the same as the current category value. If it is, then we do not need to update the combo box; if not, then an update is required using the 'addItem' method.

To get the difficulty level we need to go through each radio button in turn; they have been given the instance names 'diff1' to 'diff5'. As soon as we find the one that is set we can set the difficulty level to the index for that button and jump out of the repeat loop. It just remains to create the MIME-encoded query string, by combining all the elements needed to add or update a question and call the 'addQuestion.asp' script. Then playback jumps to a loop that is waiting for the variables, either 'questionAdded' or 'questionUpdate', to be set to true.

```
function enterQuestion () {
    category = categoryCombo.getValue ();
    //Update the combo box if this is a new category
```

```
found = false;
for (i=0; i<categoryCombo.getLength (); i++) {
        if (category==categoryCombo.getItemAt(i).label) {
                found = true;
                break;
        }
}
if (!found) categoryCombo.addItem(category, 0);
str = "category=" + category;
//Get the difficulty level from the radio buttons
for (i=1; i<=5; i++) {
        if (eval("diff" + i).getState ()) {
                difficulty = i;
                break;
        }
}
str += "&difficulty=" + difficulty;
str += "&question=" + question;
str += "&A=" + correctAnswer;
str += "&B=" + option1;
str += "&C=" + option2;
str += "&D=" + option3;
questionAdded = false;
questionUpdated = false;
loadVariables("scriptsJS/addQuestion.asp?" + str, "");
resetQuestion ();
status = "Adding or updating question";
gotoAndPlay("addQuestion");
}
```

When deleting a question, it was found necessary to add a random variable to avoid the caching issue. That is the purpose of 'killcache=' + random(100000); it simply makes each call to the page unique. If any readers know of a better way to avoid the caching problem then please get in touch via the web page for this book, www.toon3d.com/flash

```
function deleteQuestion () {
        loadVariables("scriptsJS/deleteQuestion.asp?question=" ↵
            + question + "&killcache=" + random(100000), "");
        resetQuestion ();
        status = "Question deleted";
}
```

Deleting a category involves updating the combo box, by first finding the category that is currently displayed and then using the combo box method 'removeItemAt'.

```
function deleteCategory () {
      category = categoryCombo.getValue ();
      //Update the combo box
      for (i=0; i<categoryCombo.getLength (); i++) {
            if (categoryCombo.getItemAt(i).label==category) {
                  categoryCombo.removeItemAt(i);
                  break;
            }
      }
      loadVariables("scriptsJS/deleteCategory.asp?category=" ↵
         + category, "");
      status = "Category deleted";
      resetQuestion ();
}
```

Moving through the questions is easily achieved using these two simple functions that are called by the forward and back buttons.

```
function previousQuestion () {
      if (questionIndex>0) {
            setQuestion(questionIndex - 1);
      }
}
function nextQuestion () {
      if (questionIndex<(questionTotal-1)) {
            setQuestion(questionIndex + 1);
      }
}
```

Ideas for the implementation

At this stage you have an engine to enter and update quiz questions. The actual implementation of the quiz is left to the developer. You can access the questions based on category and difficulty. An interactive quiz should

Figure 14.10 Using the input application.

include some scaling of the difficulty and certain hurdles that the player must get over in order to move on to an extra life. Maybe you can offer some useful lifelines initially by reducing the number of possible answers, or making suggestions that are often but not always correct. The quiz could be made funny by including a cartoon character that responds to correct and incorrect answers in an amusing way. The quiz could use a high score table that offers prizes on a daily, weekly or monthly basis. Maybe the quiz could be part of an email program, where players could send 10 questions to a pal. However it is implemented, quizzes are a popular form of entertainment and easily updated. Because we have included the input date in the database, we could easily offer the player just to select from the new questions. This breathes new life into a website and encourages more visits.

Summary

Most of this chapter dealt with database access. This is a very important subject, because on even the simplest site you probably want to collect some data from the users even if it is only email address and current high scores. ASP (Active Server Pages) is one of the simplest and most effective methods for communicating between Flash and a database management system. In this chapter you have learnt some basics about ASP and data access.

15 Mazes

Mazes form the basis of many games. The maze structure may be obvious as in the example in this chapter or subtler, like the movement from room to room in a first person shooter. In this chapter we are going to look at creating a first person maze. Graphically, the imagery will be computer generated using Lightwave 3D. The process is a three-stage one. First, we will create a program using Flash to generate the data that a maze game will need. Then we will create the graphics using Lightwave, but any CGI application will suffice. Finally, we will learn how to import the data and how to move around the maze using the constraints implied by the maze data.

Storing a maze in a computer readable form

People like pictures, computers like numbers. The imagery we will show to the player of our maze game will be pictorial, but internally the computer will only understand numbers. To store the maze in a computer-readable form, we will first ensure that the maze is effectively a grid. Each cell in the grid can have an entrance to the North, South, East or West, or any combination of these. There are 16 possible combinations of four elements.

 The strategy used to store the paths is to assign a number to each exit: North will be 1, South 2, East is 4 and West is 8. If a cell has no paths then the value stored for this cell will be zero. If a cell has four paths then the value stored will be 15. Table 15.1 shows all the possible values. Because a path can either be on or off, choosing powers of two to provide the value for a column ensures that we have enough information to store every possible value. If a cell is the entrance then we will add 16 to the value and if the cell is an exit we will add 32. To create a maze we need to generate the values for each cell and store this in a MIME-encoded form so that we can easily load the variable values into Flash. To do this we will create a maze maker program.

Table 15.1 Storing the paths into a cell

North (1)	South (2)	East (4)	West (8)	Total
0	0	0	0	0
1	0	0	0	1
0	2	0	0	2
1	2	0	0	3
0	0	4	0	4
1	0	4	0	5
0	2	4	0	6
1	2	4	0	7
0	0	0	8	8
1	0	0	8	9
0	2	0	8	10
1	2	0	8	11
0	0	4	8	12
1	0	4	8	13
0	2	4	8	14
1	2	4	8	15

Maze maker

The maze maker program, 'Examples\Chapter15\mazeMaker.fla', contains a Movie Clip called 'cell'. This has 13 frames to represent the 12 different possible values for the paths coming into a cell and an extra frame to allow for looping back to frame 1. The clip contains a transparent button, a button with only a hit area, no graphics. The one release action for the button is to step to the next frame; on frame 13 the playback head is set to frame 1. The maze maker program also contains input boxes to set up the number of rows and columns in the maze. There are three command buttons and a Dynamic Text area.

When the movie starts, a new LoadVars object is created with the onLoad callback for this object set to 'mazeLoaded'. Recall that a 'LoadVars' object can be used to input data from a text file or other remote source file. A callback function happens whenever the relevant event takes place; in this instance the code in the function 'mazeLoaded' will execute when the 'LoadVars' object 'lv' has newly loaded some variables. The use of callbacks makes the execution of the program much easier to handle. Previously a waiting loop would have been necessary after a call to 'loadVariables'. Now the program can continue and will be informed about a successful or non-successful load at the earliest opportunity. The

Figure 15.1 Creating the maze generator program.

'LoadVars' object even has facilities for estimating the length that a download will take so that you can inform the player with a progress bar. This code is placed on frame 1 of the main timeline.

```
ENTRANCE = 16;
EXIT = 32;
cellH = 0;
cellV = 0;
val2Frame = new Array(1,1,1,7,1,3,2,9,1,4,5,11,6,10,12,8);
lv = new LoadVars ();
lv.onLoad = mazeLoaded;
createMaze ();
stop ();
```

Notice that the frame 1 code contains a call to a function called 'createMaze'. The purpose of this function is to dynamically create the duplicated movie clips that show a maze grid. To ensure that a previous maze grid is deleted the function calls 'clearCells'. The number of

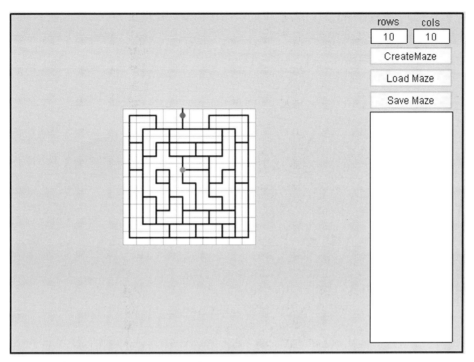

Figure 15.2 Using the maze generator program.

duplicated Movie Clips in the vertical direction is stored in the variable 'cellV' and the number in the horizontal direction in the variable 'cellH'. These two variables are used by the 'clearCells' function in the two loops, for 'row' and 'col'. Having duplicated a clip it is positioned based on a grid centred around the middle of the movie. To centre something you can use the code snippet

```
left = (movieWidth - clipWidth)/2;
top = (movieHeight - clipHeight)/2;
```

The 'orgX' and 'orgY' variables are set in similar way, only rather than using the value for a clip's width and height we take the value of the number of rows and columns multiplied by a cell width and height; this gives the total width of the maze on screen.

```
function createMaze () {
        var name, row, col, count = 1, orgX, orgY;

        if (cellH>0 || cellV>0) clearCells ();
```

```
        orgX = (450 - cols * 16)/2;
        orgY = (400 - rows * 16)/2;

        for (row=0; row<rows; row++) {
                for (col=0; col<cols; col++) {
                        name = "cell" + row + "_" + col;
                        duplicateMovieClip("cell", name, count++);
                        eval(name)._x = col * 16 + orgX;
                        eval(name)._y = row * 16 + orgY;
                }
        }
        cellH = cols;
        cellV = rows;
}

function clearCells () {
        var row, col;

        for (row=0; row<cellV; row++) {
                for (col=0; col<cellH; col++) {
                        removeMovieClip("cell" + row + "_" + col);
                }
        }
        cellH = 0;
        cellV = 0;
}
```

When the 'Load Maze' button is pressed, the movie uses the 'LoadVars' object 'lv' to load the variables contained in the text file 'maze.txt'. Because we set the callback for the 'lv' object to 'mazeLoaded', this function is called when the variables are loaded or have failed to load. If the load was successful the variable 'success' will be set to true. This is used in the function. Then the function 'createMaze' is used to create a new maze set to the size indicated by the 'maze.txt' file. Then the frame for each cell is set using the values in the file. Finally, for each cell the nested Movie Clip 'Entrance' is set to a frame to indicate whether this is an entrance or exit frame or whether it is an ordinary cell. The value for a cell is stored as in Table 15.1. To get the cell value, however, we must strip out the effect of the addition of a possible value for EXIT or ENTRANCE. This is achieved using the bitwise And operator, &. In the code snippet

```
low4bits = (src & 0xF);
```

0xF refers to the hexadecimal value 'F'. Hexidecimal has 16 symbols for each column. The symbol 9 is followed by A, B, C, D, E and F. F is the same as 15. The binary value for 15 is 1111. That is, the lowest four bits are all set to 1. By Anding in this way we ensure that any higher bits are excluded.

```
next4bits = (src & 0xF0);
```

The effect of Anding with 0xF0 is to test the next four bits. That is, the bits that represent 16, 32, 64 and 128 and exclude the effect of lower bits. Using this method we can easily extract just the value we want from a variable that may contain multiple bits of information. For example, because we know that the information for the South path is stored in the second bit, we can use

```
southPath = (src & 0x2)
```

to access just this bit.

```
function loadMaze () {
      lv.load("maze.txt");
}

function mazeLoaded(success) {
      var row, col, cellname, valname, val;

      if (success) {
          rows = lv.rows;
          cols = lv.cols;
          createMaze ();
          for(row=0; row<rows; row++) {
              for(col=0; col<cols; col++) {
                  cellname = "cell" + row + "_" + col;
                  valname = "lv.val" + row + "_" + col;
                  val = (eval(valname) & 0xF);
                  eval(cellname).gotoAndStop(val);
                  val = (eval(valname) & 0xF0);
                  switch(val) {
                      case ENTRANCE:
                      eval(cellname).Entrance.gotoAndStop(2);
                      break;
                      case EXIT:
                      eval(cellname).Entrance.gotoAndStop(3);
```

```
                              break;
                              default:
                              eval(cellname).Entrance.gotoAndStop(1);
                       }
                }
           }
      }
 }
```

Because of security implications across the Internet, Flash does not contain any code for saving a file. But a user can select the characters in a Dynamic Text box. In this example we use a text box in this way. After pressing the 'Save Maze' button, the text box is populated. To save the text, select and copy it and paste it into a text editor. The text is simply a MIME-encoded file. The value for each cell is stored in the file as 'valx_y', where x is the row and y the column.

```
function saveMaze () {
       var row, col, cellname, valname, val;

       mazeStr = "rows=" + rows + "&cols=" + cols;
       for (row=0; row<rows; row++) {
            for (col=0; col<cols; col++) {
                 cellname = "cell" + row + "_" + col;
                 valname = "val" + row + "_" + col;
                 val = eval(cellname).value;
                 if (eval(cellname).Entrance._currentframe == 2) {
                       val += ENTRANCE;
                 }else if (eval(cellname).Entrance._currentframe⤶
                    == 3) {
                       val += EXIT;
                 }
                 mazeStr += ("&" + valname + "=" + val);
            }
       }
 }
```

Creating the graphics

In the example 'Examples\Chapter15\maze.fla', we use a first person view of the maze. This is created using the 3D application program

Lightwave. This is not a real-time 3D program; all the images are pre-rendered. Every cell has an animation that takes you into the cell in 10 frames and then a left, forward, right and spin action that is dependent on the current cell type. A cell with four paths would have each action, while a straight will have just a forward and spin action. Every animation sequence has a common frame at the beginning of the 'Into' animation. This is achieved using fogging, so that the path in the distance is hidden from the viewer as it disappears into darkness. There are 18 different

Figure 15.3 Creating the tunnel model.

animations pre-rendered in 10 frame sequences, making a total of 180 bitmap images. The total would be greater if it were not for symmetry. This ensures that the corners and T junctions to the right can be flipped to give the corners and T junctions to the left. Because the mid position of the animations needs to be common across all animations, the modelling and animating must be done using numerical values.

The basic model used is a cross. This allows for every possible path. Each exit from the central cross can be blocked using an extra polygon,

whose surface can be set to 100 per cent transparent. The distance fogging is set so that the end of the tunnel disappears.

The camera motion is set to move the camera exactly three cells forward and rotate right if necessary. The end of the motion matches the beginning exactly, so that each animation sequence can be joined with any other.

Figure 15.4 Setting camera paths for the tunnel.

Creating the maze game

At this stage we have 18 ten-frame animation sequences. These are used in several different Movie Clips. There is a 'T_Both', 'T_Right', 'T_Left', 'Cross', 'Straight', 'CornerR', 'CornerL', 'End', 'Block' and 'Exit'. The allowed paths from the different cells are given in Table 15.2.

Open 'Examples\Chapter15\maze.fla' and double-click the tunnel to see the embedded Movie Clips.

Figure 15.5 Developing the maze game.

Table 15.2 Exit paths from cells

Clip	moveForward	turnLeft	turnRight	SpinAround	Value
T_Both		✓	✓	✓	14
T_Right			✓	✓	7
T_Left		✓		✓	11
Cross	✓	✓	✓	✓	15
Straight	✓			✓	3
CornerR			✓	✓	6
CornerL		✓		✓	10
Exit				✓	8

In addition to the images in the 'Tunnel' clip, there is an overview of the maze which is created in a way identical to that used in the 'mazeMaker' project and a 'Start Again' button.

The ActionScript for frame 1 simply defines a few constants and loads in the maze using a 'LoadVars' object.

```
NORTH = 1;
SOUTH = 2;
EAST = 4;
WEST = 8;
ENTRANCE = 16;
EXIT = 32;
lv = new LoadVars ();
lv.onLoad = mazeLoaded;
lv.load("maze.txt");
stop ();
```

When the data for the maze are loaded the 'mazeLoaded' function is called where the values for the entrance and exit are extracted and the

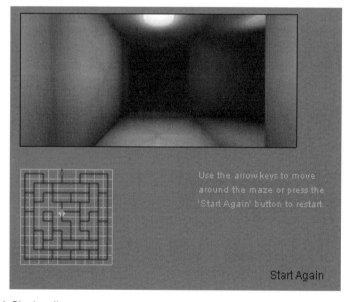

Figure 15.6 Playing the maze game.

overview map is created, in much the same way as the mazeMaker project and the current cell is entered.

```
function mazeLoaded(success) {
      var found = false, exitRow, exitCol, name;

      //trace("Maze loaded: ("+ lv.rows + "," + lv.cols + ") "+ ↵
          success);
```

```
for (row=0; row<lv.rows; row++) {
       for (col=0; col<lv.cols; col++) {
              if (eval ("lv.val" + row + "_" + col) & EXIT) {
                     exitRow = row;
                     exitCol = col;
                     found = true;
                     break;
              }
       }
}

if (!found) {
       //Create default exit
       name = "lv.val" + (lv.rows - 1) + "_" + (lv.cols - 1);
       //eval(name) = eval(name) + EXIT;
}
found = false;

for (row=0; row<lv.rows; row++) {
       for (col=0; col<lv.cols; col++) {
              if (eval ("lv.val" + row + "_" + col) & ↵
                 ENTRANCE) {
                     found = true;
                     break;
              }
       }
       if (found) break;
}

if (!found) {
       //Create default entrance
       row = 0;
       col = 0;
}

entranceRow = row;
entranceCol = col;

dir = NORTH;
showMap ();
enterCell ();
}
```

The purpose of the 'enterCell' function is to set up the correct images' sequence to show. A player's direction influences the behaviour. If a player is pointing in a northerly direction then the current value of the cell gives the information necessary to show the current image sequence. If, however, the player is facing South, then the images we should show are different. The images' sequence to show is based on the values of the paths from that cell. For example, if we have a 'T_Right' junction when facing North, the value for this cell would be 7, made up of North (1), South (2) and East (4). If we faced South at the same cell, then the image sequence should be 'T_Left'. Facing East we should show 'Straight' and facing west we should show 'T_Both'. What we need is a mapping for each direction. When facing South, North maps to South and South maps to North, while West maps to East and East maps to West. So the value changes as shown in Table 15.3.

Table 15.3 How mapping from a North to a South direction affects the value

	North	South	East	West	Total
Original	1	2	4	0	7
Mapped	1	2	0	8	11

This maps a T_Right to a T_Left, as you can see from the values displayed in Table 15.2.

It is important that the program knows when an animation is playing and when to wait for user input. The Movie Clip 'Tunnel' contains a 'mode' variable that can take the values 'STATIONARY', 'EXITING', 'EXITED', 'ENTERING' or 'NOTLOADED'. These constants are declared on frame 1 of the Tunnel clip.

```
function enterCell () {
    var val, tmp, exitcell, name, path = new Array(4);

    name = "lv.val" + row + "_" + col;
    val = eval(name) & 0xF;
    exitcell = eval(name) & 0x20;
```

```
name = "cell" + row + "_" + col;
Location._x = eval(name)._x;
Location._y = eval(name)._y;

switch(dir) {
        case NORTH:
        //Already correct value
        Location.gotoAndStop(1);
        break;
        case SOUTH:
        tmp = 0;
        if (val & SOUTH) tmp += NORTH;
        if (val & NORTH) tmp += SOUTH;
        if (val & WEST) tmp += EAST;
        if (val & EAST) tmp += WEST;
        val = tmp;
        Location.gotoAndStop (2);
        break;
        case EAST:
        tmp = 0;
        if (val & EAST) tmp += NORTH;
        if (val & WEST) tmp += SOUTH;
        if (val & NORTH) tmp += WEST;
        if (val & SOUTH) tmp += EAST;
        val = tmp;
        Location.gotoAndStop (3);
        break;
        case WEST:
        if (val & EAST) tmp += SOUTH;
        if (val & WEST) tmp += NORTH;
        if (val & SOUTH) tmp += WEST;
        if (val & NORTH) tmp += EAST;
        val = tmp;
        Location.gotoAndStop (4);
        break
}

trace("enterCell: (" + row + "," + col + ") =" + val);

Tunnel.gotoAndStop(1);
//Store the current direction rotated path value
paths = val;
if (exitcell == EXIT) val = 1;
```

```
    switch (val) {
        case 1:
                Tunnel.gotoAndPlay("exit");
                break;
        case 3:
                Tunnel.gotoAndPlay("straight");
                break;
        case 6:
                Tunnel.gotoAndPlay("cornerR");
                break;
        case 7:
                Tunnel.gotoAndPlay("T_Right");
                break;
        case 10:
                Tunnel.gotoAndPlay("cornerL");
                break;
        case 11:
                Tunnel.gotoAndPlay("T_Left");
                break;
        case 14:
                Tunnel.gotoAndPlay("T_Both");
                break;
        case 15:
                Tunnel.gotoAndPlay("cross");
                break;
    }
    Tunnel.mode = Tunnel.ENTERING;
}
```

Responding to user input

If the mode for the 'Tunnel' clip is STATIONARY, then in the 'onClipEvent', enterFrame for this clip we read the keyboard. The arrow keys all call a different function declared on frame 1 of the main timeline. The same clip event is used to trigger the change over from an exiting animation to an entering animation. Exiting animations are triggered using user input, but entering events are called from this event alone.

```
onClipEvent(enterFrame) {
    switch(mode) {
        case EXITED:
        _root.enterCell ();
        break;
        case STATIONARY:
```

```
if (Key.isDown(Key.UP)) {
        _root.moveForward ();
}else if (Key.isDown(Key.LEFT)) {
        _root.turnLeft ();
}else if (Key.isDown(Key.RIGHT)) {
        _root.turnRight ();
}else if (Key.isDown(Key.DOWN)) {
        _root.spinAround ();
}
break;
        }
    }
```

Each of the functions called from a keyboard press test for a suitable exit in the required direction. The variable 'paths' is the user rotated view of the maze. If you are pointing East and there is a path to the East then this will have been mapped to a North direction using the enterCell function. The purpose of each of these functions is to move the player around the maze, legally. Each function updates the 'row' and 'col' variables and adjusts the direction variable 'dir' if a turn is involved. Each function completes by setting the 'mode' variable and playing the appropriate animation to exit a cell.

```
function moveForward () {
    if (paths & NORTH) {
        //Only allowed if a NORTH movement is available
        switch (dir) {
            case NORTH:
            row--;
            break;
            case SOUTH:
            row++;
            break;
            case EAST:
            col++;
            break;
            case WEST:
            col--;
            break;
        }
        Tunnel.mode = Tunnel.EXITING;
        Tunnel.anim.gotoAndPlay("Forward");
    }
}
```

```
function turnLeft () {
    if (paths & WEST) {
        //Only allowed if a WEST movement is available
        switch (dir) {
            case NORTH:
            dir = WEST;
            col--;
            break;
            case SOUTH:
            dir = EAST;
            col++;
            break;
            case EAST:
            dir = NORTH;
            row--;
            break;
            case WEST:
            dir = SOUTH
            row++;
            break;
        }
        Tunnel.mode = Tunnel.EXITING;
        Tunnel.anim.gotoAndPlay("Left");
    }
}

function turnRight () {
    if (paths & EAST) {
        //Only allowed if an EAST movement is available
        switch (dir) {
            case NORTH:
            dir = EAST;
            col++;
            break;
            case SOUTH:
            dir = WEST;
            col--;
            break;
            case EAST:
            dir = SOUTH;
            row++;
            break;
```

```
                        case WEST:
                        dir = NORTH
                        row--;
                        break;
                }
                Tunnel.mode = Tunnel.EXITING;
                Tunnel.anim.gotoAndPlay("Right");
        }
}

function spinAround () {
        if (paths & SOUTH) {
                //Only allowed if a SOUTH movement is available
                switch (dir) {
                        case NORTH:
                        dir = SOUTH;
                        row++;
                        break;
                        case SOUTH:
                        dir = NORTH;
                        row--;
                        break;
                        case EAST:
                        dir = WEST;
                        col--;
                        break;
                        case WEST:
                        dir = EAST;
                        col++;
                        break;
                }
                Tunnel.mode = Tunnel.EXITING;
                Tunnel.anim.gotoAndPlay("Spin");
        }
}
```

Each exit sequence completes by setting the mode variable to 'EXITED'; this is used by the onClipEvent to trigger an 'Into' sequence. This in turn completes by setting the mode variable to STATIONARY. Using this code you can move around any maze at will. Try creating a new maze using the mazeMaker and then saving this as 'maze.txt' in the same folder as 'maze.swf'. Running the 'maze.swf' movie will load the new maze.

Suggestions for enhancement

The example is only the basis for a program; you can improve it by randomly blocking an exit, or having a timer so that the user must move quickly. Maybe the map is usually hidden with just a quick glance every now and then. Maybe you are being chased and have to avoid the cells that contain baddies. You could work out a value for every cell as a distance to exit value. By comparing this with the previous cell you could provide a 'getting warmer' or 'getting colder' bar to help find the way out of the maze without a map. There are so many additions to the basic idea that I leave it to the interested reader to add some excitement to the basic game.

Summary

In common with many computer-programming exercises, creating a maze is all about data structures and navigating them. In this chapter we looked at using Flash to create a tool to help produce the raw data that a game needs. We also showed that Flash games don't always have to have a cartoon look. Flash is quite capable of displaying bitmap images and does a reasonable job of keeping their sizes within Internet-friendly constraints. Just look at the fact that the project file is over 11 mB in size while the published game is just 273 K!

16 Board games

There are many two-player board games that convert readily to being played by a solo player and a computer. Chess programming particularly played a significant role in the history of computer programming. In this chapter I hope to introduce some of the ideas necessary to create a two-player strategy game that involves some programmed intelligence on the part of the computer.

Two-player board games

The simplest game is noughts and crosses. Even this game presents several challenges but with only a 3×3 playing grid it can be thought of as a game that could be analysed to a finish. Connect 4 is a variation on noughts and crosses limiting the player's possible moves to filled columns only, and the game is made more difficult since a line of four is required. The classic two-player board game is chess, but programming a full chess implementation is beyond a one chapter tutorial. The game of Go is such an easy game to learn and such a difficult one to master. The game we are going to concentrate on is a simple game to learn and again quite tricky to play well, but it does have some very useful ground rules that make it easier to teach a computer to play at least reasonably well.

The game of Reversi

The traditional game of Reversi is sold today as the game 'Othello'. It has very simple rules, yet the game has all the hallmarks of a game of skill, namely that a good player will always beat a poor player; luck does not play any role. Each player uses the same counters, that are coloured differently on both sides, black and white being two obvious choices; one player always places their counters down with one side facing up and the other player uses the opposite side. The board is a grid of 64 squares.

Figure 16.1 The traditional game Reversi.

The game starts by each player taking it in turn to fill the four central squares. After these first four pieces are placed, the player must sandwich their opponent between their own coloured pieces in a line. A line can be vertical or diagonal. Any opponent piece that is sandwiched between the player's new piece and any existing player pieces are flipped over.

Figure 16.2 Placing a new piece.

Figure 16.2 shows how placing a white piece at the lower right corner has the effect of flipping two of black's pieces. A line of opposing pieces can be of any length. The game is completed when either all the squares on the board are filled or a player cannot go. So that's the game, where do we begin in programming this game as a solo player against the computer game?

Methods for board games

First, we need to reduce the problem into manageable chunks. How are we going to play the game?

1 Build and display the board.
2 Check for user input.
3 If the user places a piece legally, update the placed square and then update the board.
4 Scan the board for legal computer moves.
5 Work out the best move for the computer.
6 Place the computer piece in the best calculated square and then update the board.
7 Repeat steps 2–6 until the game ends.
8 Show the number of player pieces and computer pieces and declare a winner.

So we will need an initialization function to build a clear board, a legal move generator and an evaluation function to determine the best computer move. By far the hardest part of this is the evaluation function. Such a function could in fact look ahead to the end of the game and work out which move from the current position gave the computer the best result. We are only going to look ahead two moves; the idea for the two moves is to maximize the computer's result and minimize the player's. If you are interested in the technical background to these type of games then try a search for 'Combinatorial Game Theory' in your favourite web search engine; http://www.ics.uci.edu/~eppstein/cgt/ is a good starting point.

Building and initializing the board

Without question this is the easiest part of the programming. The game is a simple 8 × 8 grid; the images that can appear in this grid are limited

Figure 16.3 Three frames are used to display the pieces.

to just three possibilities: a blank square, a white piece or a black piece. Figure 16.3 shows the images needed. To achieve this we will create a three-frame Movie Clip that is duplicated to form the 8 × 8 grid. The Movie Clip contains a blank button that has an event that responds to the user's input.

Here is the simple code used on frame 1 of the main timeline. Take a look at 'Examples\Chapter16\reversi.fla' to examine the code.

```
PLAYER = 3;
COMPUTER = 2;
makeBoard ();
initGame ();
flip = new Array(8);
board = new Array(64);
cBoard = new Array(64);
pBoard = new Array(64);
stop ();
```

The arrays are used throughout the program to store the data needed. The array 'flip' stores which directions from a given square have a line that can be flipped after executing a legal move; 'board' contains the current view of the board in a computer-friendly manner. 'cBoard' stores the temporary board after the computer has made a possible move and is used in the code for evaluating the computer's best option. 'pBoard' stores the player's move following the computer's move and is used for evaluating the player's least best move after the computer has made a temporary move. We will look at the use of these arrays in more detail later in the chapter. Then we have a call to a simple function that duplicates and positions the single Movie Clip 'piece'.

```
function makeBoard () {
      var row, col, name, count=1;

      for(row=0; row<8; row++) {
            for(col=0; col<8; col++) {
                  name = "board" + row + "_" + col;
                  duplicateMovieClip("piece", name, count++);
                  eval(name)._x = col * 45 + 36;
                  eval(name)._y = row * 45 + 36;
                  eval(name).row = row;
                  eval(name).col = col;
            }
      }
}
```

The code on the first frame of the main timeline also initializes a first game with a call to the function 'initGame'.

```
function initGame () {
      var row, col, name, count=1;
      for(row=0; row<8; row++) {
            for(col=0; col<8; col++) {
                  name = "board" + row + "_" + col;
                  eval(name).gotoAndStop(1);
            }
      }
      curGo = 0;
      playersMove ();
}
```

The initialization function makes use of one of two functions that swap the current player and update the move counter 'curGo'.

```
function playersMove () {
      computerHL.gotoAndStop(1);
      playerHL.gotoAndStop(2);
      whoseGo = PLAYER;
      curGo++;
}

function computerMove () {
      computerHL.gotoAndStop(2);
```

```
        playerHL.gotoAndStop(1);
        whoseGo = COMPUTER;
        curGo++;
    }
```

The variable 'whoseGo' is used by two Movie Clips that check for the next player; they are visually the lozenges behind the words 'Computer' and 'Player'.

Tracking the player's move

A player's move is legal if the square they clicked is empty, in one of eight directions stemming from this square there is an opponent's piece and continuing in the same direction there is a player's piece. This checking is all done using the 'checkBoard' function. This function can be called by either the player or the computer; the caller is contained in the variable 'piece'. The function calls a further function 'scanBoard' a total of eight times. For each call the direction that is being scanned is contained in the fifth and sixth parameters. Parameters 1 and 2 contain the starting square and parameters 3 and 4 the current player and opponent. For each direction the array 'flip' is set to either true or false, and a variable 'legal' dictates whether this is an acceptable square.

```
function checkBoard(row, col, piece) {
    var legal = false, opponent;

    if (piece==PLAYER) {
        opponent = COMPUTER;
    }else {
        opponent = PLAYER;
    }

    if (scanBoard(row, col, piece, opponent, 1, 0)) {
        legal = true;
        flip[0] = true;
    }else {
        flip[0] = false;
    }
    if (scanBoard(row, col, piece, opponent, 0, 1)) {
        legal = true;
        flip[1] = true;
```

```
    }else {
        flip[1] = false;
    }
    if (scanBoard(row, col, piece, opponent, -1, 0)) {
        legal = true;
        flip[2] = true;
    }else {
        flip[2] = false;
    }
    if (scanBoard(row, col, piece, opponent, 0, -1)) {
        legal = true;
        flip[3] = true;
    }else {
        flip[3] = false;
    }
    if (scanBoard(row, col, piece, opponent, -1, -1)) {
        legal = true;
        flip[4] = true;
    }else {
        flip[4] = false;
    }
    if (scanBoard(row, col, piece, opponent, 1, -1)) {
        legal = true;
        flip[5] = true;
    }else {
        flip[5] = false;
    }
    if (scanBoard(row, col, piece, opponent, 1, 1)) {
        legal = true;
        flip[6] = true;
    }else {
        flip[6] = false;
    }
    if (scanBoard(row, col, piece, opponent, -1, 1)) {
        legal = true;
        flip[7] = true;
    }else {
        flip[7] = false;
    }

    return legal;
}
```

Flash MX Games

Here is the 'scanBoard' function. Notice how parameters 5 and 6, incX and incY, are used in a repeat loop checking for the existence of an opponent's piece. There must be at least one piece, so if none is found the function returns false. If there is an opponent's piece then the values for 'incX' and 'incY' are added repeatedly until the condition fails. At this point we check that the end of the line contains a player's piece; if this is true then this direction contains a line that is suitable.

```
function scanBoard(row, col, piece, opponent, incX, incY) {
        var x, y, name;

        x = col + incX;
        y = row + incY;
        name = "board" + y + "_" + x;

        //Must be at least one
        if (eval(name)._currentframe != opponent) return false;

        while(eval(name)._currentframe==opponent) {
            x += incX;
            y += incY;
            name = "board" + y + "_" + x;
        }

        //Next piece must be a piece frame
        if (eval(name)._currentframe == piece) return true;

        return false;
    }
```

Once the chosen player's square has been checked and found to be legal, we need to update the display. The function 'adjustBoard' does that. The start location and current player are passed to the function and then the values stored in the 'flip' array are used. Again, we use eight calls to another function with the direction passed to each call.

```
function adjustBoard(row, col, piece) {
        var opponent;

        if (piece==PLAYER) {
                opponent = COMPUTER;
        }else {
                opponent = PLAYER;
        }
```

```
        if (flip[0]) flipLine(row, col, piece, opponent, 1, 0);
        if (flip[1]) flipLine(row, col, piece, opponent, 0, 1);
        if (flip[2]) flipLine(row, col, piece, opponent, -1, 0);
        if (flip[3]) flipLine(row, col, piece, opponent, 0, -1);
        if (flip[4]) flipLine(row, col, piece, opponent, -1, -1);
        if (flip[5]) flipLine(row, col, piece, opponent, 1, -1);
        if (flip[6]) flipLine(row, col, piece, opponent, 1, 1);
        if (flip[7]) flipLine(row, col, piece, opponent, -1, 1);
    }
```

The function 'flipLine' does the actual work of manipulating the display.

```
function flipLine(row, col, piece, opponent, incX, incY) {
    var x, y, name;

    x = col + incX;
    y = row + incY;
    name = "board" + y + "_" + x;

    while(eval(name)._currentframe==opponent) {
        eval(name).gotoAndStop(piece);
        x += incX;
        y += incY;
        name = "board" + y + "_" + x;
    }
}
```

Evaluating the computer's best move

The evaluation function for the computer's best move is the most complex part of the game to code efficiently. The aim of the function is to derive the computer's best move based on a look-ahead of two moves. Because we do not want to affect the display, we first copy the on-screen board into a one-dimensional array called 'board'. This array starts in the top left corner and scans the board one row at a time; index 8 is therefore row 1 column 0.

After storing the board position in a format that is easily readable by the computer, we then process every square of the board looking for a legal move. The function used is 'computerScore'; this function returns –1 if the position is an illegal move and a score for the computer if the square is a legal move. We will look a little later at how this score is derived. If the

Flash MX Games

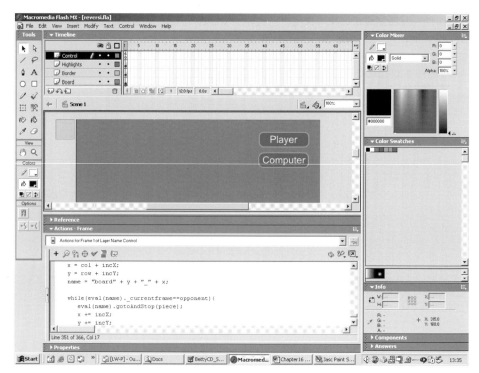

Figure 16.4 Developing the Reversi game.

move is legal then we use the position following this move that is stored in the single dimension array 'cBoard' in a further function 'playerScore'; the purpose of this function is to calculate the player's best score from the board position stored in the array 'cBoard'. Then we subtract the player's best score from the computer's best score and work out the move that will give the computer the best advantage. Finally, having discovered the best move on the basis of this simple algorithm, we calculate the row and column that the move implies. Because the arrays are single dimensional, to map to row and column we use the code snippet:

```
row = int(best/8);
    col = best % 8;
```

Here, row is the integer value after dividing the index 'best' by 8; this will place 'row' between 0 and 7. The value of 'col' is determined using the modulus operator '%'. This operator returns the remainder, after the left of the operator is divided by the right. Again, this will return a value between 0 and 7. We update the 'flip' array by calling 'legalMove' again and set the

current square directly; it only then remains to update the on-screen display using the 'adjustBoard' function we looked at earlier.

```
function doComputerMove() {
      var diff=-100000, c, p, i, row, col, best=-1, count=0, name;

      //Get current board
      for (row=0; row<8; row++) {
            for (col=0; col<8; col++) {
                  name = "board" + row + "_" + col;
                  board[count++] = eval(name)._currentframe;
            }
      }

      count = 0;

      for (i=0; i<64; i++) {
            c = computerScore(i);
            if (c > -1) {
                  p = playerScore ();
                  if (diff < (c - p) || best==-1) {
                        diff = c - p;
                        best = i;
                  }
            }
      }

      row = int(best/8);
      col = best % 8;

      legalMove(best, COMPUTER);
      name = "board" + row + "_" + col;
      eval(name).gotoAndStop(COMPUTER);

      adjustBoard(row, col, COMPUTER);

      playersMove ();
}
```

The above function calls several functions which we will look at in detail. The first function to consider is the 'computerScore' function. This function uses the 'legalMove' generator to test whether the current square is

legitimate for the current board and player. If it is, then we set the array 'cBoard', to be a duplicate of 'board', which you will recall is simply the current displayed board. Then we update the current board using the function 'adjustArray'. Finally, we count how many COMPUTER pieces are on the new board, stored in the array 'cBoard'.

```
function computerScore(i) {
        var n, count = 0;

        if (!legalMove(i, COMPUTER)) return -1;

        for (n=0; n<64; n++) cBoard[n] = board[n];
        cBoard[i] = COMPUTER;
        adjustArray(i, COMPUTER);

        count = 0;
        for (n=0; n<64; n++) {
                if (cBoard[n]==COMPUTER) count++;
        }
        return count;
}
```

The 'legalMove' function works in much the same way as the function 'checkBoard,' only this function operates on the single dimensional arrays rather than using the frame values of the Movie Clips in the on-screen display. The function in turn calls the 'scanArray' function, which is a mirror of 'scanBoard', operating on arrays.

```
function legalMove(i, piece) {
        var legal = false;

        if (scanArray(i, piece, 1, 0)) {
                legal = true;
                flip[0] = true;
        }else {
                flip[0] = false;
        }
        if (scanArray(i, piece, 0, 1)) {
                legal = true;
                flip[1] = true;
        }else {
                flip[1] = false;
        }
```

```
if (scanArray(i, piece, -1, 0)) {
      legal = true;
      flip[2] = true;
}else {
      flip[2] = false;
}
if (scanArray(i, piece, 0, -1)) {
      legal = true;
      flip[3] = true;
}else {
      flip[3] = false;
}
if (scanArray(i, piece, -1, -1)) {
      legal = true;
      flip[4] = true;
}else {
      flip[4] = false;
}
if (scanArray(i, piece, 1, -1)) {
      legal = true;
      flip[5] = true;
}else {
      flip[5] = false;
}
if (scanArray(i, piece, 1, 1)) {
      legal = true;
      flip[6] = true;
}else {
      flip[6] = false;
}
if (scanArray(i, piece, -1, 1)) {
      legal = true;
      flip[7] = true;
}else {
      flip[7] = false;
}

return legal;
}
```

To calculate the index based on the values for 'incX' and 'incY' in a single dimensional array requires the use of a new increment value.

```
inc = incY*8 + incX;
```

The function can operate either on the 'board' array if the value for piece is COMPUTER, or the 'cBoard' array if the value for 'piece' is PLAYER. Again, when scanning a row the first square must be empty, the next must contain an opponent piece and the final must be a player piece. If all the conditions are passed then true is returned, otherwise false is returned.

```
function scanArray(i, piece, incX, incY) {
        var name, n, inc;

        inc = incY*8 + incX;
        n = i + inc;

        //Must be at least one
        switch (piece) {
                case PLAYER:
                if (cBoard[i]!=1||cBoard[n]!=COMPUTER) return false;
                do {
                        n += inc;
                }while(cBoard[n] == COMPUTER);
                //Next piece must be a PLAYER piece
                if (cBoard[n] == PLAYER) return true;
                break;

                case COMPUTER:
                if (board[i]!=1||board[n]!=PLAYER) return false;
                do {
                        n += inc;
                }while(board[n] == PLAYER);
                //Next piece must be a COMPUTER piece
                if (board[n] == COMPUTER) return true;
                break;
        }

        return false;
}
```

Once the best computer score is evaluated, the function 'adjustArray' is called.

```
function adjustArray(i, piece) {
      if (flip[0]) flipArrayLine(i, piece, 1, 0);
      if (flip[1]) flipArrayLine(i, piece, 0, 1);
      if (flip[2]) flipArrayLine(i, piece, -1, 0);
      if (flip[3]) flipArrayLine(i, piece, 0, -1);
      if (flip[4]) flipArrayLine(i, piece, -1, -1);
      if (flip[5]) flipArrayLine(i, piece, 1, -1);
      if (flip[6]) flipArrayLine(i, piece, 1, 1);
      if (flip[7]) flipArrayLine(i, piece, -1, 1);
}
```

which uses the function 'flipArrayLine'.

```
function flipArrayLine(i, piece, incX, incY) {
      var n, inc;

      inc = 8*incY + incX;
      n = i + inc;

      switch (piece) {
            case PLAYER:
            while(pBoard[n]==COMPUTER) {
                  pBoard[n] = PLAYER;
                  n += inc;
            }
            break;

            case COMPUTER:
            while(cBoard[n]==PLAYER) {
                  cBoard[n] = COMPUTER;
                  n += inc;
            }
            break;
      }
}
```

This leaves just the 'playerScore' function to consider from the main function 'doComputerMove'. This works in much the same way as calculating the computer's best move. Each square in the board stored in the array 'cBoard' is tested for a legal PLAYER move. Subject to this test evaluating to true, we update the 'pBoard' array and count the number of PLAYER squares; if this is a higher value than the stored value for 'score',

Flash MX Games

then the variable 'score' is updated. After considering every square the final value for 'score' is returned.

```
function playerScore () {
        var i, n, score-0, count;

        for (i=0; i<64; i++) {
                if (legalMove(i, PLAYER)) {
                        for(n=0; n<64; n++) pBoard[n] = cBoard[n];
                        adjustArray (i, PLAYER);
                        pBoard[i] = PLAYER;
                        count = 0;
                        for(n=0; n<64; n++) {
                                if (pBoard[n]==PLAYER) count++;
                        }
                        if (count>score) score = count;
                }
        }

        return score;
}
```

Using this code gives a reasonable game. Problems do occur, stemming from the evaluation function using array values out of range. This is an important point. Whenever you use arrays in this way, it is always best to ensure that the bounds are within the constraints of the array. A call to an array with an index below zero or above the length of the array minus one returns an undefined value. It is easy to mistake this for useful data and so it always best to check that the index for an array is within the bounds of the array.

Improving the evaluation function

The score derived in this function is all about the pieces on the board after two look-ahead moves. Although this gives some semblance of intelligence, a good Reversi player knows that certain rules improve their play. In the early game, controlling the centre four squares is a useful extra so you could add to your evaluation function by scoring these squares higher in the return value for a position. Also, a border square means that your opponent cannot get a piece to the other side of you, so they are more valuable; again, using this positional information you could add to the score in these circum-stances. The three squares that surround a corner are very poor squares to

Figure 16.5 Debugging the game.

play in because your opponent will almost certainly then get a corner and corner pieces can never be flipped. You could improve the evaluation function greatly by scoring these squares very low regardless of the short-term gain they may achieve. Finally, getting a corner is the strongest move you can play and should be given a very high score. These improvements in the evaluation function will make a huge difference to the chances of a poor player ever beating the computer. When creating these types of games the method is always to look for ways to improve the evaluation function while not performing an exhaustive search. In many games an exhaustive search is well beyond the power of present-day computers. The number of possible game options from a single game position is enormous and working through the game to the end for each of these is not a realistic possibility.

The presentation

Although the presentation of the game in this chapter was quite traditional, it doesn't have to be that way. The game of Reversi could be

presented using a cat and mouse theme, you place a cat and all the mice in a line run off and a cat takes their place. A cartoon effect on the changeover would make the game strikingly different while the game play remains the same.

Summary

One surprise about the example in this chapter is that the final game is only 3 K. I could have included the game in Chapter 13. In this chapter you were given an overview of the techniques required to create a two-player board game where the computer is a reasonable opponent. The techniques we learnt were board initialization, legal move generation and evaluation function. The final technique is where your skills as a programmer and all your creativity will be used. After the mind games in this chapter you will find the manual dexterity of the next a welcome break.

17 Platformers

Creating a platform-based game is quite a challenge, but by this stage in the book you should have all the necessary skills. In this chapter we are going to look at the problems of controlling the behaviour of a sprite in a platform world. First, we will look at an example where we move the sprite and the background remains stationary and then we will look at using a multi-layered scrolling background. Platform games often use dynamically created sprites; we will look at creating sprites on the fly and removing them when they are no longer in use.

The basics of platform games

Platform games involve two fundamental concepts. Firstly, user control of a sprite character. This character can usually perform several actions: walk, run, jump, fall, etc. Secondly, collision detection to ensure that the character remains anchored to the world that is presented to the player. Both parts of creating a platform game need careful coding to ensure success. You may prefer to start with the collision testing or with the user control; either way, they are two separate problems and should be tested and debugged separately as far as possible. We will start with the problem of user control.

Responding to user input

Usually, the only control the user has over the game play will be via a few keypresses or using the mouse. Often the control is context sensitive. For example, if a character is falling then the player cannot set a new direction until the character has landed and the player regains

control. For this reason always use a control flag. If the character is under player control then set the flag to 'true' and if the character is being controlled by the computer then set the control flag to 'false'. Because, wherever possible, we want to keep the data pertaining to a 'Movie Clip' within that 'Movie Clip', place this flag as a variable inside the clip. The actions a sprite can perform are often limited both by its placement on screen and the action that is currently being performed; for this reason use a variable that stores the current action. Responding

Figure 17.1 Developing 'Example/ Chapter 17/FatCat01.fla.

to keyboard input is easier to handle than mouse input for a platform game. Usually keyboard control will mean reading the arrow keys, space bar and possibly the control and shift keys. Reading the keyboard is easy using the 'Key.isDown ()' construct. To clarify the principles, let's look at an example. Open 'Examples/Chapter17/FatCat01.fla'. Try running the program by pressing 'Ctrl + Enter'. Using the arrow keys you can move the cat around the screen, jumping and landing on the various platforms that you can see on the screen.

A simple example

The code for this example is mainly located in three places. An initialization script on frame 1 of the main timeline contains the following code:

```
//Set initial parameters
DEBUG_GAME = true;
Cat.orgX = Cat._x;
Cat.orgy = Cat._y;
Cat.tracemotion = false;
stop ();
```

Notice that here we are just setting some initial values and some debug parameters. As you will know from the chapter on debugging, getting feedback information as your game plays is vital to creating a stable game. By setting a simple Boolean value to true or false, we can quickly set the debugging level of a game.

The second main code location is a clip event for the 'Cat' movie clip.

```
onClipEvent(enterFrame) {
    if (_root.DEBUG_GAME) {
      if (Key.isDown(Key.SHIFT)) {
        moveY = 1;
      }else if (Key.isDown(Key.CONTROL)) {
        moveY = -1;
      }else if (Key.isDown(Key.SPACE)) {
        moveY = 0;
      }else if (Key.isDown(Key.TAB)) {
        initAction(STOPRIGHT);
        userControl = true;
      }
      if (Key.isDown(Key.CAPSLOCK)) {
        tracemotion = true;
      }else {
        tracemotion = false;
      }
      dump ();
    }
```

```
if (usercontrol) {
   if (Key.isDown(Key.RIGHT)) {
      userKey = "Right";
      userAction(WALKRIGHT);
   }else if (Key.isDown(Key.LEFT)) {
      userKey = "Left";
      userAction(WALKLEFT);
   }else if (Key.isDown(Key.UP)) {
      userKey = "Up";
      userAction(JUMP);
   }else {
      userKey = "none";
      userAction(HALT);
   }
}
move ();
}
```

Notice that the first section of this code is conditional on the flag 'DEBUG_ GAME'; this allows you to quickly turn off features that are unsuitable to the finished game but make debugging the game much easier. When in debug mode several extra keys are used. The shift key causes the sprite to move up the screen by one pixel for each screen redraw. The control key works in the opposite direction. The space bar fixes the up and down movement set by the shift and control keys. The tab key forces the character into a distinct mode and reactivates 'usercontrol', a variable that is used to activate and deactivate keyboard input. If the caps lock key is down then the variable 'tracemotion' is set to true. This causes dump of the location of the sprite to be sent to the output window. The value of the variable is used within another function that we will examine later that actually does this work.

The bulk of the code is inside the 'Cat' clip on frame 1. Before we look at that, take a look at the timeline for the 'Cat' Movie Clip. There are 14 labels, each one indicating the first frame of an animation. Within the 'Control' layer there are a few small 'ActionScripts'; these set variables specific to certain actions or reset the action, we will examine these later. The labels used are:

WalkRight, FallRight, JumpRight, LandRight, StopRight, StartRight, TurnRight

WalkLeft, FallLeft, JumpLeft, LandLeft, StopLeft, StartLeft, TurnLeft

The code on frame 1 starts with some simple initialization, but most of the code defines functions that are used to control the character. Both 'userAction' and 'move' are called by the 'onClipEvent' ActionScript.

```
//Init variables
JUMP = 1;
TURNLEFT = 2;
STARTRIGHT = 3;
WALKRIGHT = 4;
FALLRIGHT = 5;
JUMPRIGHT = 6;
LANDRIGHT = 7;
STOPRIGHT = 8;
TURNRIGHT = 9;
STARTLEFT = 10;
WALKLEFT = 11;
FALLLEFT = 12;
JUMPLEFT = 13;
LANDLEFT = 14;
STOPLEFT = 15;
HALT = 16;
actionNames = new Array("No action", "Jump", "TurnLeft", "StartRight",
            "WalkRight", "FallRight", "JumpRight", "LandRight",
            "StopRight", "TurnRight", "StartLeft", "WalkLeft",
            "FallLeft", "JumpLeft", "LandLeft", "StopLeft",
            "Halt");
x = 0;
y = 0;
jumping = false;
platform = "";
initAction(STOPRIGHT);
```

In the initialization section, the values of certain constants are defined so that we can write 'WALKLEFT' in the code rather than '11'. When you are reading through the code it is much easier to understand if you use names in this way rather than numbers. To facilitate easier debugging, the initialization also creates a string array that contains the names of the possible actions. Using this array we can get the name of an action using the code:

```
actionNames[action];
actionNames[WALKRIGHT]
```
would return 'WalkRight'.

Now we will look at the functions defined on frame 1.

'userAction' is called by the keyboard reader in the onClipEvent for the Cat. A 'switch' statement is used to select which code to run.

```
//===============userAction=================================
//This is called by the onClipEvent of the Cat instance
//parameters=================================================
//index Possible values WALKRIGHT, WALKLEFT and JUMP
//===========================================================
function userAction(index) {
    switch (index) {
    case WALKRIGHT :
        userWalkRight ();
        break;
    case WALKLEFT :
        userWalkLeft ();
        break;
    case JUMP :
        userJump ();
        break;
    case HALT :
        if (action == WALKLEFT) {
            initAction(STOPLEFT);
        } else if (action == WALKRIGHT) {
            initAction(STOPRIGHT);
        }
        break;
    }
}
```

If the Cat calls 'userRight' then we need to decide what to do based on the current action. The 'Cat' action could be 'STOPRIGHT', 'STOPLEFT' or 'WALKLEFT'. The current action dicates what the Cat action should be set to.

```
//===============userWalkRight=================================
//This is called by the userAction function
//parameters=================================================
//none
//===========================================================
function userWalkRight () {
    switch (action) {
    case STOPRIGHT :
        initAction(STARTRIGHT);
        break;
```

```
            case STOPLEFT :
                initAction(STARTLEFT);
                break;
            case WALKLEFT :
                initAction(TURNRIGHT);
                break;
        }
    }
```

'userLeft' works in a similar way with the directions reversed.

```
    //===============userWalkLeft==================================
    //This is called by the userAction function
    //parameters==================================================
    //none
    //============================================================
    function userWalkLeft () {
        switch (action) {
        case STOPLEFT :
            initAction(STARTLEFT);
            break;
        case STOPRIGHT :
            initAction(STARTRIGHT);
            break;
        case WALKRIGHT :
            initAction(TURNLEFT);
            break;
        }
    }
```

'userJump' is called if the 'Cat' is under user control and the UP arrow is pressed.

```
    //===============userJump=====================================
    //This is called by the userAction function
    //parameters==================================================
    //none
    //============================================================
    function userJump () {
        //Only possible if we are walking or stopped
        switch (action) {
        case STOPLEFT :
            initAction(JUMPLEFT);
            break;
```

```
    case STOPRIGHT :
        initAction(JUMPRIGHT);
        break;
    case WALKLEFT :
        initAction(JUMPLEFT);
        break;
    case WALKRIGHT :
        initAction(JUMPRIGHT);
        break;
    }
}
```

All three of the above functions use 'initAction' to set the actual action to show and set up variables specific to that action. Notice that this function uses another debug technique; the variable 'TRACE_ACTIONS' is set to false, causing the current action 'trace' statements to be ignored. If, when debugging, you wanted to quickly see the order of action assignment then by setting 'TRACE_ACTIONS' to true the 'trace' statements are all used.

```
function initAction(index) {
    TRACE_ACTIONS = false;
    switch (index) {
    case WALKRIGHT :
        if (TRACE_ACTIONS) trace("initAction WalkRight");
        action = index;
        usercontrol = true;
        moveX = -5;
        moveY = 0;
        gotoAndPlay("WalkRight");
        break;
    case FALLRIGHT:
        if (TRACE_ACTIONS) trace("initAction FallRight");
        action = index;
        usercontrol = false;
        moveY = -2;
        gotoAndPlay("FallRight");
        break;
    case JUMPRIGHT :
        if (TRACE_ACTIONS) trace("initAction JumpRight");
        action = index;
        usercontrol = false;
        moveY = 0;
        moveX = 0;
        gotoAndPlay("JumpRight");
        break;
```

```
case LANDRIGHT :
    if (TRACE_ACTIONS) trace("initAction LandRight");
    action = index;
    usercontrol = false;
    moveX = 0;
    moveY = 0;
    gotoAndPlay("LandRight");
    break;
case STOPRIGHT :
    if (TRACE_ACTIONS) trace("initAction StopRight");
    action = index;
    usercontrol = false;
    moveX = 0;
    moveY = 0;
    gotoAndPlay("StopRight");
    break;
case STARTRIGHT :
    if (TRACE_ACTIONS) trace("initAction StartRight");
    action = index;
    usercontrol = false;
    moveX = 0;
    moveY = 0;
    gotoAndPlay("StartRight");
    break;
case TURNRIGHT :
    if (TRACE_ACTIONS) trace("initAction TurnRight");
    action = index;
    usercontrol = false;
    moveX = 0;
    moveY = 0;
    gotoAndPlay("TurnRight");
    break;
case WALKLEFT :
    if (TRACE_ACTIONS) trace("initAction WalkLeft");
    action = index;
    usercontrol = true;
    moveX = 5;
    moveY = 0;
    gotoAndPlay("WalkLeft");
    break;
```

```
case FALLLEFT:
    if (TRACE_ACTIONS) trace("initAction FallLeft");
    action = index;
    usercontrol = false;
    moveY = -2;
    gotoAndPlay("FallLeft");
    break,
case JUMPLEFT :
    if (TRACE_ACTIONS) trace("initAction JumpLeft");
    action = index;
    usercontrol = false;
    moveX = 0;
    moveY = 0;
    gotoAndPlay("JumpLeft");
    break;
case LANDLEFT :
    if (TRACE_ACTIONS) trace("initAction LandLeft");
    action = index;
    usercontrol = false;
    moveX = 0;
    moveY = 0;
    gotoAndPlay("LandLeft");
    break;
case STOPLEFT :
    if (TRACE_ACTIONS) trace("initAction StopLeft");
    action = index;
    usercontrol = false;
    moveX = 0;
    moveY = 0;
    gotoAndPlay("StopLeft");
    break;
case STARTLEFT:
    if (TRACE_ACTIONS) trace("initAction StartLeft");
    action = index;
    usercontrol = false;
    moveX = 0;
    moveY = 0;
    gotoAndPlay("StartLeft");
    break;
```

```
        case TURNLEFT:
            if (TRACE_ACTIONS) trace("initAction TurnLeft");
            action = index;
            usercontrol = false;
            moveX = 0;
            moveY = 0;
            gotoAndPlay("TurnLeft");
            break;
    }
}
```

For each call to the 'Cat' onClipEvent the function 'move' is called. The purpose of move is to set the on-screen position of the sprite. The position is based on the values of *x* and *y*, which in turn are updated using the values of moveX and moveY; 'move' must test based on the current action to ensure that the position is legal. As the game starts the value of the variable 'platform' is set to an empty string. If this is the case then the 'Cat' is on the floor. The switch statement uses the value for 'platform' if the 'Cat' action is currently WALKRIGHT, STOPRIGHT, STARTRIGHT, WALKLEFT, STOPLEFT or STARTLEFT. The variable 'platform' contains the name of the platform that the 'Cat' is standing or walking on. The variable is set by the 'land' function that we will examine next. If this is set then we need to know whether we have reached the limit of the platform; the limits are reached when the '_*x*' position of the platform minus the current value for '*x*' is less than 60 or greater than 120. If this is the case then a fall is initialized using the 'initAction' function. The other special case occurs if the Cat is jumping. When a jump is occurring we need to constantly update the moveY value. Initially, this is set to 23, a value that was found simply by trying the action out. For each call the value is reduced by multiplying the current value by 0.7. When the current value is less than 4 and greater than −4, the value is reduced by subtracting 2 from the value. Finally, the negative value is increased by multiplying by 1.3. The effect of this curve is to create a curved motion of sorts. If your maths can cope with it, however, I recommend following the physics calculations in the box.

Instead of using lots of 'if' conditions, we can use a simple physics calculation. The *y* value for a projectile motion is defined as:

$$y = ut + gt^2$$

where u is the launch value, t is the time in seconds and g is the acceleration due to gravity. If time, t, is less than 1 second, the value for t^2 will be less than t, but above 1 second, t^2 will overtake. If 'g' operates in the opposite direction to 'u' then the increase in the values for y will decrease and eventually reverse. But this sounds all very hit and miss. Actually it is easy to calculate. Suppose that you want a jump to occur over 1 second and the starting and ending values for y are zero, then you want:

$$ut = -gt^2$$

when $t = 0$ and $t = 1$. To do this you need to solve a quadratic equation. Whoops, that sounds like maths to me! Believe me it's not that hard. You want

$$ut + gt^2 = 0$$

But we also want to control the maximum height of the jump. This occurs when the derivative of the curve has a value of zero. The derivative of the curve is

$$u + 2gt$$

OK, so let's fiddle with the figures. If we want a maximum height for the curve of 150 and if the total jump takes 1 second, then the maximum height is going to be at 0.5 seconds. Half way through in other words. At $t = 0.5$, we want

$$u + 2gt = 0 \text{ and } ut + gt^2 = 150$$

Replacing t with 0.5 gives

$$u + g = 0 \text{ and } 0.5u + 0.25g = 150$$

Two equations with two unknowns can be solved

$u = -g$ from the first equation; therefore, we can substitute u for $-g$ in the second equation, giving

$$-0.5g + 0.25g = 150 \text{ or } -0.25g = 150$$

Which means that

$g = -600$ and $u = 600$.

If you are working in metres rather than pixels, then the usual value for g is $-9.81 \, ms^2$; for convenience we will say $-10 \, ms^2$. Imagine that the cat is about 1 metre high and can jump slightly more than its own height. Therefore,

$u - 20t = 0$ and $ut - 10t^2 = 1$

From the first equation, we know that $u = 20t$, we can pump this into the second equation and see that

$$20t^2 - 10t^2 = 1 \text{ or } t^2 = \frac{1}{10}$$

or t is approximately 0.32 seconds. So the peak of the curve will occur at around about one third of a second.

If you are able to follow this, then it is without doubt the best way to get the curved motions that you want. But if it is all totally baffling then just try changing the values until you get the result you want. Trial and error never hurt. Physics can, however, be a very useful way of creating very smooth animations and it is well worth trying to get your head around some simple manipulation of equations. You are unlikely to need more than some simple trigonometry, a little basic algebra and enough calculus to understand how to work out the derivative of a curve when working with Flash games.

To work out the derivative of a polynomial, you simply multiply the coefficient by the power and reduce the power by one. Therefore, x^2 becomes $2x$, $4x^3$ becomes $(3) * 4x^{(3-1)} = 12x^2$, $5x$ becomes just 5 and a constant drops out to zero. Consequently, the derivative of:

$4x^3 + x^2 + 5x + 3$ is $12x^2 + 2x + 5$

The derivative gives the slope of a curve. The maximum or minimum of a quadratic curve (a curve where the highest power is 2) occurs when the derivative has the value zero because this indicates that the slope of the curve at this point is horizontal.

Lecture over, let's make some games!!

Flash MX Games

```
function move () {
    var i, name, dx;

    x -= moveX;
    y -= moveY;

    switch (action) {
    case WALKRIGHT:
    case STOPRIGHT:
    case STARTRIGHT:
        if (platform!="") {
            dx = eval(platform)._x - x;
            if (dx<60 || dx>120) {
                platform = "";
                initAction(FALLRIGHT);
            }
        }
        break;
    case WALKLEFT:
    case STOPLEFT:
    case STARTLEFT:
        if (platform!="") {
            dx = eval(platform)._x - x;
            if (dx<60 || dx>120) {
                platform = "";
                initAction(FALLLEFT);
            }
        }
        break;
    case FALLRIGHT:
    case JUMPRIGHT:
        if (jumping) {
            if (moveX>0) moveX-=0.5;
            if (land ()) {
                initAction(LANDRIGHT);
            }else {
                if (moveY > 4) {
                    moveY *= 0.7;
                }else if (moveY<=4 && moveY>-4) {
                    moveY -= 2;
                }else if (moveY < 0) {
                    moveY *= 1.3;
                }
            }
        }
        break;
```

```
    case FALLLEFT:
    case JUMPLEFT:
        if (jumping) {
            if (moveX<0) moveX+=0.5;
            if (land ()) {
                initAction(LANDLEFT);
            }else {
                if (moveY > 4) {
                    moveY *= 0.7;
                }else if (moveY<=4 && moveY>-4) {
                    moveY -= 2;
                }else if (moveY < 0) {
                    moveY *= 1.3;
                }
            }
        }
        break;
    }
    _x = x + orgX;
    _y = y + orgY;
}
```

One of the most important parts of the code in this example is the collision detection involved in the 'land' function. There are two possible

Figure 17.2 Legal area for a landing.

landings, either on the floor, at *y*>0, or on a platform. To decide if the cat has landed on a platform we must go through each platform in turn. There are 11 boxes and three bins; each of these must be tested. To achieve a landing the cat must be in a legal position both horizontally and vertically. We determine this position using the debug box. On screen for debugging purposes you can see a multi-line dynamic text box. The box tracks the value of the variable '_root.debug'. A considerable quantity of debugging values are displayed using string functions. To work out the values you need to land on a platform, simply move the cat using the control keys and the debug keys and work out the values for the upper left and lower right of the rectangle that defines a legal landing area.

The vertical range must use the current value for moveY to ensure that the platform is not missed. It is remarkably easy when checking for a collision with a platform to check on one frame where the sprite will be above the platform and the check on the following frame where the sprite is below the platform. A collision must have occurred between the two frames, but if the movement in the vertical direction is not part of the calculation then this collision can be missed.

```
function dump () {
    var dx, dy;

    _root.debug = actionNames[action] + chr(13);
    _root.debug += "(x,y): (" + int(x) + "," + int(y) + ")" + chr(13);
    _root.debug += "(mX,mY): (" + int(moveX) + "," + int(moveY) + ↵
        ")" + chr(13);
    _root.debug += "userControl: " + usercontrol + chr(13);
    _root.debug += "jumping: " + jumping + chr(13);
    _root.debug += "Platform: " + platform + chr(13);
    _root.debug += "userKey: " + userKey + chr(13);
    name = "_root.Box1";
    dx = eval(name)._x - x;
    dy = eval(name)._y - y;
    if (tracemotion) trace("moveY, dy: " + moveY + ", " + int(dy));
    _root.debug += "Box1: (" + int(dx) + "," + int(dy) + ")" + ↵
        chr(13);
    //_root.debug += "landing: " + landing + chr(13);
}
```

In the calculations, we first calculate a delta distance from the current platform to the current value for *x*; if this is in the range 60–120 then the platform is in a possible collision location. Next, we test the *y* location again using a delta distance. The condition must conform to two tests, one

that includes the current movement in the *y* direction. If each of the four tests evaluates to true, then the cat has landed on a platform. The cat is set to an exact fit in the *y* direction, otherwise the cat could seem too low in relation to the platform and the name of the platform is stored in the platform variable.

```
function land () {
    var i, name, dx, dy;

    if (moveY>0) return false; //Must be going down to land
    //Main floor
    if (y>0) {
        y = 0;
        return true;
    }
    //Check platforms
    for (i=1; i<12; i++) {
        if (i<=3) {
            name = "_root.Bin" + i;
            dx = eval(name)._x - x;
            if (dx>60 && dx<120) {
                dy = eval(name)._y - y;
                if (dy<475 && dy>(475+moveY)) {
                    //Align to exact fit
                    y = eval(name)._y - 475;
                    platform = name;
                    return true;
                }
            }
        }
        name = "_root.Box" + i;
        dx = eval(name)._x - x;
        if (dx>60 && dx<120) {
            dy = eval(name)._y - y;
            if (dy<460 && dy>(460+moveY)) {
                //Align to exact fit
                y = eval(name)._y - 460;
                platform = name;
                return true;
            }
        }
    }
    return false;
}
```

Although there are a great number of conditions to test when creating a platform game, keeping the code as modular as possible and carefully considering every possible location and action makes the exercise possible.

Using a scrolling background

Most players expect a platform game to scroll. Unfortunately, scrolling games are not a strength of Flash and the software can often struggle to maintain frame rate when using a scrolling environment. On a fast machine the second example should maintain a reasonable frame rate, but on a slow machine it will probably be dire. As machines get generally faster, Flash scrollers will become more acceptable, so with a nod to the future let's look at some of the problems. On a scroller the main character stays central, everything else moves. We can use most of the code from the previous example, with a few exceptions. Open 'Examples/Chapter17/FatCat02.fla'. Take a look at the game first, so you can see how it behaves.

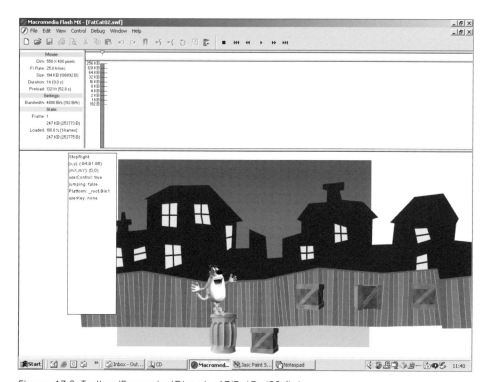

Figure 17.3 Testing 'Examples/Chapter17/FatCat02.fla'.

Notice that we have what is called parallax scrolling, that is things further away scroll less than things nearer to the camera. To achieve this, the initial parameters are set in frame 1 of the main timeline.

```
//Set initial parameters
DEBUG_GAME = true;
for (i=1; i<12; i++) {
    if (i<=3) {
        name = "Bin" + i;
        eval(name).orgX = eval(name)._x;
        eval(name).orgY = eval(name)._y;
        eval(name).scale = 1.0;
    }

    name = "Box" + i;
    eval(name).orgX = eval(name)._x;
    eval(name).orgY = eval(name)._y;
    eval(name).scale = 1.0;
}

House.orgX = House._x;
House.orgY = House._y;
House.scale = 0.6;

Fence.orgX = Fence._x;
Fence.orgY = Fence._y;
Fence.scale = 0.8;

stop ();
```

Notice that in addition to storing a starting location (orgX, orgY), we also store a scale for each Movie Clip. In this example, even the fence and the houses are Movie Clips. The scale value does not relate to the standard Movie Clip parameter '_scale'; we do not use it to resize the clip, we use it to work out how far it should move. Take a look at the revised 'move' function.

```
function move () {
    var i, name, dx;

    x += moveX;
    y += moveY;
```

```
switch (action) {
case WALKRIGHT:
case STOPRIGHT:
case STARTRIGHT:
    if (platform!="") {
        dx = eval(platform)._x - _x;
        if (dx<-30 || dx>30) {
            platform = "";
            initAction(FALLRIGHT);
        }
    }
    break;
case WALKLEFT:
case STOPLEFT:
case STARTLEFT:
    if (platform!="") {
        dx = eval(platform)._x - _x;
        if (dx<-30 || dx>30) {
            platform = "";
            initAction(FALLLEFT);
        }
    }
    break;
case FALLRIGHT:
case JUMPRIGHT:
    if (y<0) {
        y = 0;
        initAction(LANDRIGHT);
        break;
    }
    if (jumping) {
        if (moveX>0) moveX-=0.5;
        if (land ()) {
            initAction(LANDRIGHT);
        }else {
            if (moveY > 4) {
                moveY *= 0.7;
            }else if (moveY<=4 && moveY>-4) {
                moveY -= 2;
            }else if (moveY < 0) {
                moveY *= 1.3;
            }
        }
    }
    break;
```

```
case FALLLEFT:
case JUMPLEFT:
    if (y<0) {
        y = 0;
        initAction(LANDLEFT);
        break;
    }
    if (jumping) {
        if (moveX<0) moveX+=0.5;
        if (land()) {
            initAction(LANDLEFT);
        }else {
            if (moveY > 2) {
                moveY *= 0.7;
            }else if (moveY<=2 && moveY>-2) {
                moveY--;
            }else if (moveY < 0) {
                moveY *= 1.3;
            }
        }
    }
    break;
}
for (i=1; i<12; i++) {
    if (i<=3) {
        name = "_root.Bin" + i;
        eval(name)._x = x*eval(name).scale + eval(name).orgX;
        eval(name)._y = y*eval(name).scale + eval(name).orgY;
    }
    name = "_root.Box"+i;
    eval(name)._x = x*eval(name).scale + eval(name).orgX;
    eval(name)._y = y*eval(name).scale + eval(name).orgY;
}
_root.House._x = x*_root.House.scale + _root.House.orgX;
_root.House._y = y*_root.House.scale + _root.House.orgY;
_root.Fence._x = x*_root.Fence.scale + _root.Fence.orgX;
_root.Fence._y = y*_root.Fence.scale + _root.Fence.orgY;
}
```

The only real difference is the end of the function where all the clips are moved. Each clip is moved using the value of *x* or *y* that is in turn scaled by the scale value for the clip and then the original location is added to the result. This simple code gives perfect parallax scaling and the elements

retain their original relationship because every element is moved using the same code. The 'land' code must take into consideration the value of scale, because this affects the on-screen location.

```
function land () {
    var i, name, dx, dy;

    if (moveY>0) return false; //Must be going down to land
    //Main floor
    if (y<0) {
        y = 0;
        return true;
    }
    //Check platforms
    for (i=1; i<12; i++) {
        if (i<=3) {
            name = "_root.Bin" + i;
            dx = eval(name)._x - _x;
            if (dx>-30 && dx<30) {
                dy = eval(name)._y - _y;
                if (dy>67 && (67-dy)>moveY) {
                    //Align to exact fit
                    y = (67 - eval(name).orgY + _y)/eval(name).scale;
                    platform = name;
                    return true;
                }
            }
        }
        name = "_root.Box" + i;
        dx = eval(name)._x - _x;
        if (dx>-30 && dx<30) {
            dy = eval(name)._y - _y;
            if (dy>55 && (55-dy)>moveY) {
                //Align to exact fit
                y = (55 - eval(name).orgY + _y)/eval(name).scale;
                platform = name;
                return true;
            }
        }
    }
    return false;
}
```

Creating sprites dynamically

Often a platform game will involve a central character jumping on elements or head-butting them to get power up sprites or tokens. This means that you must be prepared to create sprites dynamically during the course of the game. This could not be easier in Flash. Simply use the ActionScript command

```
duplicateMovieClip(target, name, level);
```

where *target* is the Movie Clip that is being duplicated, *name* is the name that will be used for the new clip and *level* is a unique number that indicates where the clip will be located, rather like the layers on the timeline. When you create a new clip, store the name of the clip in a global level array, 'dynamicClips', so that at a later stage you will be able to remove it. To add a new element to an array simply use 'push'.

```
dynamicClips.push(newclip); //newclip is the name that will be stored
```

Suppose that when the cat lands on a certain box you want to set off an animation that includes a fish power up token. First, you create the graphics and animation and store this in a clip that is off screen. Make sure that the animation in the clip stops at the end rather than loops back and have it set a flag at the start, something like 'clipFinished = false', which is set to true at the end of the animation. On the main ticking loop for the game, either a clip event or a main timeline loop, run through every clip in the dynamicClips array. If you find that the variable 'clipFinished' is true, then remove the clip using:

```
removeMovieClip(clipname);
```

Then update the array so that it is not removed again. A single element can be removed from an array using the 'splice' method. The method takes the starting index in the array and then a parameter that defines how many elements to delete. The same method can take a third and subsequent parameters; these subsequent parameters define elements that are added to the array. These parameters are optional and when missing the method operates just by removing elements rather than removing and replacing. If the second parameter is missing then the array is deleted from the number index indicated by the first parameter up to the end of the array.

```
for (i=0; i<dynamicClips.length; i++) {
    if (eval(dynamicClips[i]).clipFinished) {
            removeMovieClip(dynamicClips[i]);
            dynamicClips.splice(i, 1);
    }
}
```

Summary

Platform games can be quite difficult to code, but if you are methodical and prepared to rigorously test each part of your script then they can be great fun to produce and certainly great fun to play. The two examples in this chapter give you the basis for a game. Hopefully you will create a functional game using these as a template; if you do then please send a URL of the game to me, nik@toon3d.com. I look forward to seeing the results. I hope to create a page of reader's examples at toon3d.com/flash.

18 Sports simulations

Some of the most successful commercial games are sports simulations. Golf has been a popular game on computer since the beginning of the computer games industry and tennis sometimes makes the bestsellers. Downhill skiing and snowboarding are popular in the retail games arena and in the arcades. But one of the bestsellers worldwide is football. In this chapter we are going to look at how to create a football game. One of the central problems is in gathering user input when potentially there can be 11 players to control. Another feature of the game is the use of a roving camera to simulate TV coverage. Although a 3D game would certainly give a more realistic view of the game, the Flash presentation can still be very involving.

An overview of the game

Essentially the aim of the game from a programming perspective is to keep the game as object orientated as possible. We want the players to move themselves because most of them will be under computer control. Only a single player will be under user control; this player will be moved using the arrow keys and space bar to kick the ball. For each step of the game the computer will move all the other players and decide on which opposing player is nearest the ball, making this player the one with ball focus. If the ball has been kicked by the user's team then the computer calculates the nearest team player and they become the new player under user control. The ball is hit using simple physics calculations and the camera tracks the players from both teams with the ball focus and the ball, centring the display in the middle of this triangle. If this means that one or other of the elements of the triangle, player team A, player team B and ball, are out of shot then the scale of the view switches to wide, so that an

Figure 18.1 Developing the football game.

overview of the game is shown. Each team has just five players and the game is played in the manner of five-a-side football, where the players can bounce the ball off the walls.

Initializing the game

As usual, the first code section we will review is game initialization. Each instance of a player uses the same Movie Clip, 'Blue0'. The Movie Clip contains just two frames, all the actions for the blue player are stored in a Movie Clip on frame 1 and all the actions for the red player on frame 2; in all other respects the players perform identically, so the purpose of this initialization is just to duplicate the clips, set their index value, set the appropriate colour for the team by moving to either frame 1 or 2 and to tell the clip which team they belong to. At this stage we are ready to call the root level function 'startGame', which is defined on frame 1 of the movie, which is the 'Loader' scene.

```
count = 1;
for (i=0; i<5; i++) {
        name = "Blue" + i;
        if (i>0) duplicateMovieClip ("Blue0", name, count++);
        eval(name).index = i;
        eval(name).Team.gotoAndStop(1);
        eval(name).teamno = _root.BLUE;

        name = "Red" + I;
        duplicateMovieClip ("Blue0", name, count++);
        eval(name).index = i;
        eval(name).Team.gotoAndStop(2);
        eval(name).teamno = _root.RED;
}
_root.startGame ();
stop ();
```

Frame 1 of the loader is also used to define several constants that will be used throughout the program. As usual, I define all the constants using upper case; they stand out then in the source code. Because Flash doesn't have a constant definition they are in actual fact just variables.

```
//Constants
BALLDIAMETER = 16;
BALLDIAMETER2 = BALLDIAMETER * 2;
BALLDIAMETER3 = BALLDIAMETER * 3;
BALLDIAMETER4 = BALLDIAMETER * 4;
BALLDIAMETER5 = BALLDIAMETER * 5;
PI = Math.PI;
ROTATIONFRAMES = 64;
PLAYERFRAMES = 16;
PLAYERROTATESTEP = ROTATIONFRAMES/PLAYERFRAMES;
FRAMETORADIANS = (2 * PI)/ROTATIONFRAMES;
PANFRAMES = 20;
RED = 0;
BLUE = 1;
MINSPEED = 0.2;
MAXSPEED = 10;
STARTSPEED = 2.5;
ACCELERATION = 0.05;
MAXSPEEDB = 6;
ACCELERATIONB = 0.03;
```

```
PASS = 0;
SHOOT = 1;
SHOOTDISTANCE = 150;
MAXKICKSTRENGTH = 80;
BALLFRAMES = 100;
TARGETMIN = 10;
PLAYERSIZESQ = 2 * BALLDIAMETER * BALLDIAMETER;
```

The 'startGame' function initializes the scores for each team and defines which team is the computer and which the player. The direction in which the team is playing is defined using the Movie Clip variable 'playleft'. This allows a half-time break, when the players' direction will change. The movie clip function 'enableuser' is called to define which of the players is controlled from the keyboard.

```
function startGame () {
        starttime = getTimer ();

        ScoreA = 0;
        ScoreB = 0;
        playerTeam = RED;
        for (i=0; i<5; i++) {
                eval("Blue" + i).playleft = false;
                eval("Red" + i).playleft = true;
        }
        eval("Pitch.Red0").enableuser ();
        kickoff ();
}
```

The 'startGame' function completes by calling the function 'kickOff'. The purpose of this function is to reposition the players to the kick off locations and enable and disable keyboard control. Notice how each and every team member is in position and set a target.

```
function kickoff () {
        Pitch.Ball._x = 0;
        Pitch.Ball._y = 10;

        Pitch.Blue0._x = -32;
        Pitch.Blue0._y = 0;
        if (playerTeam!=BLUE) {
                Pitch.Blue0.disableuser ();
        }
```

```
Pitch.Red0._x = 34;
Pitch.Red0._y = 0;
if (playerTeam!=RED) {
      Pitch.Red0.disableuser ();
}

for (i=1; i<4; i++) {
      name = "Pitch.Blue" + i;
      eval(name)._y = Pitch.Blue0._y - 40 + (i-1)*40;
      eval(name)._x = Pitch.Blue0._x - 40;
      eval(name).disableuser ();
      name = "Pitch.Red" + i;
      eval(name)._y = Pitch.Red0._y - 40 + (i-1)*40;
      eval(name)._x = Pitch.Red0._x + 40;
      eval(name).disableuser ();
}

//Goalies
Pitch.Blue4._x = -199;
Pitch.Blue4._y = 0;
Pitch.Blue4.disableuser ();
Pitch.Red4._x = 190;
Pitch.Red4._y = 0;
Pitch.Red4.disableuser ();

Pitch.Blue0.targetx = -135;
Pitch.Blue0.targety = -108;
Pitch.Blue1.targetx = 41;
Pitch.Blue1.targety = 105;
Pitch.Blue2.targetx = 96;
Pitch.Blue2.targety = -120;
Pitch.Blue3.targetx = 151;
Pitch.Blue3.targety = 83;
Pitch.Blue4.targetx = -192;
Pitch.Blue4.targety = 0;
Pitch.Red0.targetx = 135;
Pitch.Red0.targety = 108;
Pitch.Red1.targetx = -41;
Pitch.Red1.targety = -105;
Pitch.Red2.targetx = -96;
Pitch.Red2.targety = 120;
Pitch.Red3.targetx = -151;
```

```
        Pitch.Red3.targety = -83;
        Pitch.Red4.targetx = 192;
        Pitch.Red4.targety = 0;
  }
```

The main game loop

The main game loop is in the clip event for the 'Pitch' Movie Clip. Step 1 is to update the timer. The purpose of storing the 'startTime' is that it can be used to calculate the elapsed time using

```
  secs = int((getTimer () - startTime)/1000);
```

The 'getTimer' returns the system time in milliseconds, by subtracting the start time and dividing by 1000, the elapsed seconds can easily be calculated. Then this can be stripped into minutes and seconds using the integer value after division by 60 and the remainder after division by 60,

Figure 18.2 Player animation frames.

the modulus operator '%'. The values for these two numbers are then converted in strings of two characters and then built into a string to display the time.

```
function SetTimeStr () {
        secs = int((getTimer() - startTime)/1000);
        mins = int(secs/60);
        secs %= 60;

        secstr = String(secs);

        while (length(secstr)<2) {
                secstr = "0" + secstr;
        }

        minstr = String(mins);

        while (length(minstr)<2) {
                minstr = "0" + minstr;
        }

        TimeStr = minstr + ":" + secstr;
}
```

The next step in the main game loop is to determine the player for each team that is nearest to the ball. This is done using the function 'nearestPlayer'. The function sets up the team name using the passed in team number. Then, for each of the five players in the team, the *x* and *y* distance to the ball is calculated. The actual distance to the ball is then the square root of the *x* distance square plus the *y* distance square. This is just Pythagoras's theorem about the sides of a triangle. The square root function is actually quite a slow function to calculate and you could improve this code by just calculating the squared distance, because we are only interested in the nearest not the actual distance. If the loop is being run for the first time, namely *i* = 0, then the variables 'player' and 'dist' are set to the current values of 'i' and 'balldist' respectively. If the loop is in the second or higher passes then the values for 'player' and 'dist' are only set if the 'dist' value is greater than the value for 'balldist' in the current pass. Finally, the 'Direction' clip inside the player's clip is set if the current team is not the player's team. The direction clip is an arrow indicator showing the player's direction and indicating to the player that this player has the ball focus.

```
function nearestplayer(teamno) {
        var i, dist, dx, dy, name, player;

        if (teamno==BLUE) {
                teamname = "Pitch.Blue";
        }else {
                teamname = "Pitch.Red";
        }

        for (i=0; i<5; i++) {
                name = teamname + i;
                if (teamno != playerTeam) eval(name).disableuser ();
                dx = eval(name)._x - Pitch.Ball._x;
                dy = eval(name)._y - Pitch.Ball._y;
                eval(name).balldist = Math.sqrt(dx*dx + dy*dy);
                if (i==0) {
                        player = i;
                        dist = eval(name).balldist;
                }else if (eval(name).balldist<dist) {
                        player = i;
                        dist = eval(name).balldist;
                }
        }

        if (teamno != playerTeam) {
                name = teamname + player;
                eval(name).Direction.gotoAndStop(2);
        }

        return player;
}
```

Having calculated the nearest players to the ball for both teams these are stored in the variables 'a' and 'b'. The code is designed so that a player can choose which team to use; the choice is stored in the variable 'playersTeam'. If the opponent closest to the ball has changed after calling the 'nearestPlayer' function, then root level variables 'opponentNo' and 'movecount' are updated, the function 'opponent-Move' is executed on the opponent nearest to the ball and the current team member nearest to the ball is stored in the root level variable 'closestplayer'.

The opponentMove function

This function is quite complex and needs some careful study. The basic idea is the player wants to move towards the ball in a direction so that they can have a direct kick towards their own goal. The function starts by creating a vector from the goal to the ball. This vector needs to be of length 1. To convert an arbitrary vector to a vector of length 1 in the same direction we must normalize the vector; that is, we must divide both the values by the same number, so it is then still in the same direction, in such a way that if we draw the diagonal vector connecting the start of the vector to the end the length will be 1. First, we find out what the current length is using the famous Pythagoras theorem. This value is stored in the variable 'mag'. Now we divide both the elements in the vector by this value, and hey presto we have a unit length vector. Next we move along this vector three times the ball's diameter and create a new target stored in the variables 'gx' and 'gy', which will be the perfect spot for our player to run and hit the ball to get a terrific goal kick. Now we create two ramp values 'a' and 'b'. 'a' is how much we want our player to run towards our perfect spot to kick the ball, 'b' is

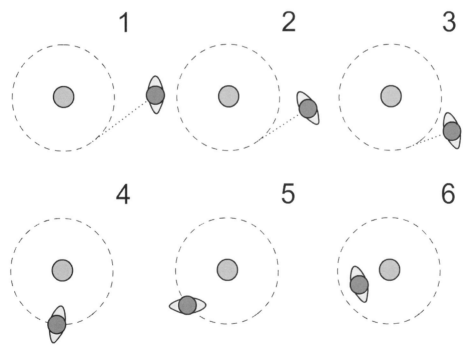

Figure 18.3 The effect of ramping between moving the player to the ball and to three times the ball's diameter.

how much we want our player to just run at the ball. If we are within three times the ball's diameter then we want the player to be more targeted at hitting the ball the nearer they are. To make sure we show the appropriate images of the player, we must calculate the angle that the player will be running now that we have the information needed. The player graphics contain 32 separate two-frame run cycles, rotating around a full 360 degrees. We can decide which to show on the basis of this angle. The angle is calculated using the 'atan' function; this function takes two sides of a triangle and returns an angle. This angle can be converted to the frame to show using a division by the constant FRAMETORADIANS.

The player must avoid kicking the ball towards their own goal, so if they are positioned in a line player–ball–own goal then they must run around the outside of the ball. This is done by adjusting their angle if this is the case, aiming towards the outside of a circle that is three times the player's diameter.

```
function opponentmove () {
        //Create a vector from the goal to the ball
        x = _root.Pitch.Ball._x - 260;
        y = _root.Pitch.Ball._y - 0;
        //Normalise this vector
        //mag is the distance from the ball to the goal
        mag = Math.sqrt(x*x + y*y);
        x /= mag;
        y /= mag;
        //Move out by 3 times ball diameter
        x *= _root.BALLDIAMETER3;
        y *= _root.BALLDIAMETER3;
        gx = x + _root.Pitch.Ball._x;
        gy = y + _root.Pitch.Ball._y;
        //Create a ramp between the outer target and the ball
        //a is target proportion
        //b is ball proportion
        if (balldist>_root.BALLDIAMETER3) {
                a = 1;
                b = 0;
        }else {
                a = (balldist - _root.BALLDIAMETER)/_root.↵
                   BALLDIAMETER3;
                b = 1 - a;
        }
```

```
c = _root.ROTATIONFRAMES/3;
x = a * (_x - gx) + b * (_x - _root.Pitch.Ball._x);
y = a * (_y - gy) + b * (_y - _root.Pitch.Ball._y);
angle = Math.atan2(y, x) + _root.PI;
frame = int(angle/_root.FRAMETORADIANS) + 1;

if (balldist<_root.BALLDIAMETER) {
        if (frame > c && frame < (_root.ROTATIONFRAMES - c)) {
                //Test whether the player is running back
                //If so and the balldist less than the ball
                //diameter then kick ball
                kickball(_root.PASS);
        }else if (a<b && mag<_root.SHOOTDISTANCE) {
                //Test for shoot
                //Condition is goal distance is less than
                //SHOOTDISTANCE and direction is based on a<b
                //kickball(_root.SHOOT);
        }
}else {
        if (frame > c && frame < (_root.ROTATIONFRAMES - c)) {

                //Try to run around outside of ball
                //First set b equal to the ball angle
                x = _x - _root.Pitch.Ball._x;
                y = _y - _root.Pitch.Ball._y;
                b = Math.atan2(y, x) + _root.PI;
                //Get deflection angle
                if (balldist < _root.BALLDIAMETER3) {
                        y = balldist;
                }else {
                        y = _root.BALLDIAMETER3;
                }
                x = Math.sqrt(balldist * balldist - y * y);
                a = Math.atan2(y, x);
                //Move towards the closest deflection angle
                //to the target
                i = angle - (b - a);
                j = angle - (b + a);
                i *= i;
                j *= j;
                if (i<j) {
                        angle = b - a;
```

```
                        }else {
                                angle = b + a;
                        }
                        frame = int(angle/_root.FRAMETORADIANS) + 1;
                }
        }

        setframe(frame);
        if (speed<0.2) {
                speed=1;
        }else {
                speed += ((_root.MAXSPEEDB - speed)*_root.↵
                    ACCELERATIONB);
        }
    }
```

Reading the keyboard

The 'checkKeys' function is used to both read the keyboard and set up
Movie Clip parameters that are affected by user input. The name of the
Movie Clip under user control is calculated and stored in variable 'name'.
If the left key is pressed then the player is rotated anticlockwise; similarly
the right key rotates the clip clockwise. The rotation is virtual, in that the
Movie Clip itself is never rotated, it is simply the display frame that
suggests the rotation. The 'setFrame' function does the work of setting the
appropriate frame. The up arrow adjusts the speed for the clip and the
space bar kicks the ball if the ball is close enough to the player.

```
function checkKeys () {
        var name;

        if (_root.playerTeam == _root.BLUE) {
                name = "Blue" + _root.playerNo;
        }else {
                name = "Red" + _root.playerNo;
        }

        if (Key.isDown(Key.LEFT)) {
                //Left arrow
                if (rotateleft<3) rotateleft *= 1.4;
                frame = int(eval(name)._currentframe - rotateleft);
```

```
        if (frame<1) { frame += _root.ROTATIONFRAMES; }
        eval(name).setFrame(frame);
}else {
        rotateleft = 1;
}

if (Key.isDown(Key.UP)) {
        //Up arrow
        eval(name).uparrow = true;
        if (eval(name).speed < _root.MINSPEED) {
                eval(name).speed = _root.STARTSPEED;
        }else {
                eval(name).speed += ((_root.MAXSPEED-
                        eval(name.speed))*_root.ACCELERATION);
        }
}

if (Key.isDown(Key.RIGHT)) {
        //Right arrow
        if (rotateright<3) {
                rotateright *= 1.4;
        }
        frame = int(eval(name)._currentframe + rotateright);
        if (frame>_root.ROTATIONFRAMES) {
                frame -= _root.ROTATIONFRAMES;
        }
        eval(name).setFrame(frame);
}else {
        rotateright = 1;
}

if (Key.isDown(Key.SPACE)) {
        //Space Bar
        if (eval(name).balldist<_root.BALLDIAMETER) {
                eval(name).kickBall(_root.SHOOT);
        }
        eval(name).disableUser ();
        if (_root.playerTeam == _root.BLUE) {
                name = "Blue" + _root.closestplayer;
        }else {
                name = "Red" + _root.closestplayer;
        }
```

```
                    eval(name).enableUser ();
                    if (_root.closestplayer != _root.playerNo) {
                            if (_xscale>100) {
                                    movecount = _root.PANFRAMES;
                            }else {
                                    movecount = 0;
                            }
                    }
            }
    }
```

The 'setFrame' function determines whether the player is actually already on the best frame to display the current angle, because in this example we only have 32 different display angles but the clip can be set to any angle. We only need to update the frame when we move into a new angle display. By finding the integer of the current frame after division by the step value and comparing this with the requested frame divided in the same way, we can see whether we have stepped into a new display block. Then we test for the current speed and set the player's display frame to either a stationary rotate frame or a running display frame.

```
function setFrame(frame) {
        a = int(_currentframe/_root.PLAYERROTATESTEP);
        b = int(frame/_root.PLAYERROTATESTEP);
        if (a!=b) {
                //Need to rotate our player
                b++;
                if (speed<1) {
                        Team.Player.gotoAndStop(b);
                }else {
                        Team.Player.gotoAndPlay("Rotate" + b);
                }
        }
        gotoAndStop(frame);
}
```

The other function called by the keyboard reader is 'kickBall'. Firstly, the strength of the kick is calculated based on the player's current distance from the ball's centre. The ball in turn is informed that a kick has occurred and is required to start bouncing, using the ball function 'startKick'.

```
function kickBall(type) {
    //Calculate the strength of the kick based on
    //players distance from the ball
    //balldist = BALLDIAMETER max strength
    //balldist = BALLDIAMETER*2 min strength

    a = (1 - balldist/_root.BALLDIAMETER)*5;
    //Calculate players movement vectors
    x = Math.cos(angle) * speed;
    y = Math.sin(angle) * speed;
    _root.Pitch.Ball.startKick(a, x, y);
}
```

The 'startKick' function is very simple; using the parameters passed from the 'kickBall' function, the movement vector and power are calculated.

```
function startKick(strength, x, y) {
    strength /= 10;
    moveX = x * strength;
    moveY = y * strength;
    if (strength>1) strength = 1;
    power = int(strength * _root.BALLFRAMES)/2.5;
    bouncing = true;
    bouncestart = getTimer ();
}
```

Updating the players

By the time the 'update' function is called for the players, all user input has been gathered and the nearest player to the ball has been stored. There are two different update methods: either the player is under keyboard control, in which case the movement has taken place, or the player is the computer player nearest the ball, in which case the function 'opponentMove' has already been called to update their position. If neither of these possibilities apply to the current player, then the function 'moveToTarget' is used. Each player has a target position they are aiming at; this is a simple mechanism to get the players to work as a team, rather than every player heading towards the ball. The function works by first creating a vector from the current position of the player to the target position. If the target has been achieved then the square of this vector will

be less than the constant 'TARGETMIN'. If this is the case then a new target is calculated. Some players are set to be attacking players, the others are defenders. The new target is calculated taking into consideration an arbitrary location on the pitch and the current ball position; attacking players use more of the ball position in deciding a new target, defenders tend to stay inside their own half. The function closes with a call to 'setDirection'.

```
function moveToTarget () {
        x = _x - targetx;
        y = _y - targety;
        if ((x*x + y*y)<_root.TARGETMIN) {
                //At target so run towards the ball
                a = random(100)/100;
                b = 1 - a;
                if (index<3) {
                        //Attacking players
                        b = -b;
                }
                x = random(100) + 140;
                if (playleft) {
                        x = -x;
                }
                y = 75 - random(100);
                targetx = a * _root.Pitch.Ball._x + b * x;
                targety = a * _root.Pitch.Ball._y + b * y;

        }
        setDirection(targetx, targety);
}
```

In the 'setDirection' code, a vector from the current position to the target is used to calculate the current direction and then the 'setFrame' function is called to update the current frame for the player.

```
function setDirection(x1, y1) {
        x = _x - x1;
        y = _y - y1;
        angle = Math.atan2(y, x) + _root.PI;
        frame = int(angle/_root.FRAMETORADIANS) + 1;
        setFrame(frame);
```

```
    if (speed<0.2) {
        speed=1;
    }else {
        speed += ((_root.MAXSPEEDB - speed)*_root.↵
            ACCELERATIONB);
    }
}
```

Having executed either a keyboard-controlled move, a computer-controlled move or a move to target move, we need to then test for any collisions with other players. The 'update' function uses the functions, 'playerCollide' and 'collision' to do just this.

```
function update () {
    if (_root.playerTeam == teamno) {
        if (_root.playerNo!=index) {
            //Move player using location tactics
            moveToTarget ();
        }
    }else {
        if (_root.opponentNo!=index) {
            //Move player using location tactics
            movetotarget ();
        }
    }
    angle = getAngle ();
    if (!Key.isDown(38)) {
        speed *= 0.95;
    }
    vecx = Math.cos(angle) * speed;
    vecy = Math.sin(angle) * speed;

    //Test for collisions with other players
    for (i=0; i<5; i++) {
        if (i!=index) {
            name = "_root.Pitch.Blue" + i;
            if (playerCollide(name)) {
                clearCollision(name);
                break;
            }
        }
```

```
                                   name = "_root.Pitch.Red" + i;
                                   if (playerCollide(name)) {
                                           clearCollision(name);
                                           break;
                                   }
                           }
                   }
```

Testing for collisions

A collision occurs if the squared value of the vector between the two players is greater than the constant PLAYERSIZESQ. The 'playerCollide' returns true if a collision occurs and false otherwise.

```
function playerCollide(name) {
        x = (_x + vecx) - (eval(name)._x + eval(name).vecx);
        y = (_y + vecy) - (eval(name)._y + eval(name).vecy);
        if ((x*x + y*y)<_root.PLAYERSIZESQ) {
                return true;
        }
        return false;
}
```

Clearing the collision is much more complex. The aim of the function is to calculate a vector in the direction of the collision, then bounce the player off like a snooker ball. The normal for the collision is the direction vector of the current object minus the direction vector of the collision object plus the current object's location minus the collision object's location. These values are stored in the two variables 'cnx' and 'cny'. This vector is then normalized. The relative velocity of the two objects is found by subtracting the collison object's movement vector 'vecx, vecy' from the current object's movement vector. The relative velocity is stored in the two variables 'vabx' and 'vaby'. The dot product of the two vectors is the sum of the products of the components of the vector.

$$\mathbf{a}{\cdot}\mathbf{b} = a.x * b.x + a.y * b.y$$

if **a** and **b** are both vectors containing two components x and y. The function 'dotproduct' is designed to return this value.

```
function dotproduct(x1, y1, x2, y2) {
        return (x1 * x2 + y1 * y2);
}
```

But the dot product of two vectors has another definition:

$$\mathbf{a \cdot b} = |\mathbf{a}||\mathbf{b}|\cos \theta$$

This means that the dot product is the magnitude of one vector times the magnitude of the other times the cosine of the angle between them. If each has magnitude 1, they are unit vectors, then the dot product is the cosine of the angle between the two vectors. If this value is less than or equal to zero, then we can calculate the new velocities for the objects involved in the collision. If the value is positive, then the collision has occurred with the opposite side of the object, that is the objects totally overlap; if we allow such a collision, then the effect will be to bounce in the opposite direction to the desired result.

```
function collision(name) {
        //Get the normal of the collision
        cnx = (_x + vecx) - (eval(name)._x + eval(name).vecx);
        cny = (_y + vecy) - (eval(name)._y + eval(name).vecy);
        //Get magnitude of normal and normalise
        mag = Math.sqrt(cnx * cnx + cny * cny);
        cnx /= mag;
        cny /= mag;
        //Set masses for collision objects
        ma = 20;
        mb = 20;
        //Coefficient of restitution value,
        //how much force is lost in collision
        e = -(1 + 0.8);
        //Components of players velocity are already known
        vax = vecx;
        vay = vecy;
        //Calculate components of player b velocity
        if (eval(name).speed!=0) {
                vbx = eval(name).vecx;
                vby = eval(name).vecy;
        }else {
                vbx = 0;
                vby = 0;
        }
```

```
//Calculate relative velocity
vabx = vax - vbx;
vaby = vay - vby;
//Get magnitude of relative velocity and normalise
mag = Math.sqrt(cnx * cnx + cny * cny);
vabx /= mag;
vaby /= mag;

//Check collision direction
vdotn = _root.dotproduct(vabx, vaby, cnx, cny);

if (vdotn<=0) {
        //Only react to a collision if negative
        //relative normal velocity
        a = _root.dotproduct(vabx*e, vaby*e, cnx, cny);
        b = _root.dotproduct(cnx, cny, cnx, cny);
        b *= (1/ma + 1/mb);
        j = a/b;
        a = j/ma;
        vecx += a*cnx;
        vecy += a*cny;
        //At this point we can calculate the deflection for ↵
            player b
        //using vb' = vb - (j/mb)n
        eval(name).vecx -= a*cnx;
        eval(name).vecy -= a*cny;
    }
}
```

It's time to move the players and the ball

The main game loop is now ready to move the players and the ball by
calling the 'move' functions of of the Movie Clips. Moving the players is
easy; the new location for the clip is calculated by adding 'vecx' and 'vecy'
to the current position as long as the player stays within the room. If the
player goes beyond the room boundaries, then the speed for the player is
set to zero and the position is not updated.

```
function move () {
        i = _x + vecx;
        if (i > -271 && i<256) {
                _x = i;
```

```
}else {
        speed = 0;
}
i = _y + vecy;
if (i > -171 && i<154) {
        _y = i;
}else {
        speed = 0;
}
}
```

Moving the ball is much more complex and involves testing for collisions with any of the players or the walls. Step 1 is to slow the ball down, by multiplying the movement vector by 0.95. Then we test for a goal subject to the *x* value exceeding ±230 and the *y* position being within acceptable bounds. If a goal is scored then the score is updated and the root level function 'kickOff' is called to reposition all the players at their starting positions. If the '_currentframe' for the ball is greater than 1, then the ball must be bouncing. If the '_currentframe' is greater than 5 then the ball is considered too high to be played by any player and so only collisions with walls are considered. If the ball is on the ground, then we test for and respond to collisions with all players in the same way as we responded to collisions between players. The ball Movie Clip contains a bounce animation that takes place over 100 frames. If the ball is bouncing because of a kick then the 'bounce' function is called. This uses a simple physics function; the displayed frame is calculated using the time since the bounce began and the current power. If the value calculated is less than 1, then a new bounce is initialized subject to a new power calculation staying above 1.

```
function bounce () {
        time = (getTimer () - bouncestart)/150;
        frame = time * (power - 5 * time) + 1;
        if (frame<1) {
                power *= 0.8;
                if (power<1) {
                        bouncing = false;
                        gotoAndStop(1);
                }else {
                        bouncestart = getTimer ();
                }
        }else {
                gotoAndStop(int(frame));
        }
}
```

The final step in the 'move' function is to update the current position for the ball by adding the final value for 'movex' and 'movey' to the current position.

```
function move () {
        movex *= 0.95;
        movey *= 0.95;
        //Test for collisions with goal posts
        if (x < -230) {
                //Blue team goal
                if ((_y<-53 && y>-53) || (_y > 43 && y < 43)) {
                        //Hit top or bottom side
                        movey *= -0.8;
                }else if (y > -53 && y < 43) {
                        //Red team have scored
                        _root.ScoreB++;
                        _root.kickOff ();
                }
        }else if (x > 230) {
                //Red team goal
                if ((_y<-53 && y>-53) || (_y > 43 && y < 43)) {
                        //Hit top or bottom side
                        movey *= -0.8;
                }else if (y > -53 && y < 43) {
                        //Blue team have scored
                        _root.ScoreA++;
                        _root.kickOff ();
                }
        }

        if (_currentframe<5) {
                //Test for collisions with other players
                for (i=0; i<5; i++) {
                        name = "_root.Pitch.Blue" + i;
                        if (eval(name).balldist<_root.BALLDIAMETER) {
                                collision(name);
                                if (_root.playerTeam == _root.BLUE) {
                                        break;
                                }
                        }
                        name = "_root.Pitch.Red" + i;
```

```
            if (eval(name).balldist<_root.BALLDIAMETER) {
                collision(name);
                if (_root.playerTeam == _root.RED) {
                    break;
                }
            }
        }
    }

    //Test for collisions with the room
    x = _x + movex;
    y = _y + movey;
    if (x<-250 || x>250) {
        movex *= -0.6;
        x = _x + movex;
    }
    if (y<-140 || y>140) {
        movey *= -0.6;
        y = _y + movey;
    }

    if (bouncing) bounce ();

    _x += movex;
    _y += movey;
}
```

Adjusting the camera location and scale

For much of the time the camera is scaled as in Figure 18.4 with the centre located in the middle of a triangle that includes the two players with focus and the ball. This movement is achieved using the 'move' function for the 'Pitch' clip. All the players and the ball are children of the 'Pitch' clip. Because the players with focus change regularly and yet we don't want the camera view to jump, we calculate a ramp between the positions using the 'movecount' variable. Whenever the player with focus changes, the 'movecount' variable is set to the value of the constant PANFRAMES. A first call to the 'move' function with 'movecount' equal to PANFRAMES gives a value for '*a*' of 1 and a value for '*b*' of 0. The *x* and *y* values are calculated using the ramp value.

Figure 18.4 Testing the game.

```
function move () {
        //Position the pitch so that it is centred around
        //the ball and the nearest player and opponent
        if (_root.playerTeam==_root.RED) {
                x = eval("Red" + _root.playerNo)._x;
                x += eval("Blue" + _root.opponentNo)._x;
                y = eval("Red" + _root.playerNo)._y;
                y += eval("Blue" + _root.opponentNo)._y;
        }else {
                x = eval("Red" + _root.playerNo)._x;
                x += eval("Blue" + _root.opponentNo)._x;
                y = eval("Red" + _root.playerNo)._y;
                y += eval("Blue" + _root.opponentNo)._y;
        }

        scale = _xscale/100;

        x = (x + Ball._x)/3;
        x = 270 - x *scale;
```

```
if (movecount>0) {
        a = movecount/_root.PANFRAMES;
        b = 1 - a;
        x = b * x + a * _x;
}

if (x>-247 && x<795) {
        _x = x;
}

y = (y + Ball._y)/3;
y = 220 - y * scale;

if (movecount>0) {
        y = b * y + a * _y;
        movecount--;
}

if (y>-104 && y<537) {
        _y = y;
}
}
```

The onClipEvent(enterFrame) function for the Pitch Movie Clip

That completes the analysis of the main game loop. Here is the function which operates:

1 Find the nearest player to the ball for both teams.
2 Update the stored values if step 1 was a change of player.
3 Read the keyboard.
4 Update the players if any have collided.
5 Move the players now their final position has been determined.
6 Move the ball by responding to the new player locations.
7 Position the camera to centre on the players with focus and the ball, or show full pitch.

```
onClipEvent (enterFrame) {
        _root.SetTimeStr ();
        frametime = getTimer () - frametime;
```

```
//Find closest player and calculate ball distances
a = _root.nearestPlayer(_root.RED);
b = _root.nearestPlayer(_root.BLUE);

if (_root.playerTeam==_root.RED) {
        if (_root.opponentNo!=b) {
                movecount = _root.PANFRAMES;
                _root.opponentNo = b;
        }
        eval("Blue" + b).opponentMove ();
        _root.closestplayer = a;
}else {
        if (_root.opponentNo!=a) {
                movecount = _root.PANFRAMES;
                _root.opponentNo = a;
        }
        eval("Red" + a).opponentMove ();
        _root.closestplayer = b;
}

checkkeys ();

//Update players
for (i=0; i<5; i++) {
        name = "Blue" + i;
        eval(name).update ();
        name = "Red" + i;
        eval(name).update ();
}

//Move players
for (i=0; i<5; i++) {
        name = "Blue" + i;
        eval(name).move ();
        name = "Red" + i;
        eval(name).move ();
}

//Move ball
Ball.move ();
```

```
if (_root.playerTeam == _root.BLUE) {
        name = "Blue" + _root.playerNo;
}else {
        name = "Red" + _root.playerNo;
}

//Move camera
if (eval(name).balldist>100) {
        //If ball is getting near to out of shot
        //then track back
        _xscale = 90;
        _yscale = 90;
        _x = 273.5;
        _y = 225;
}else {
        _xscale = 200;
        _yscale = 200;
        move ();
}

frametime = getTimer ();
}
```

Enhancements

As 'Examples\Chapter 18\Football.fla' stands, the player can't choose a team. The game needs a team strip chooser. There is no end to the game; there should be a change of ends at half time and a final whistle. Running into an opponent could be regarded as a foul and a free kick is given. The game needs crowd noises and music.

The collision code is all the code necessary to create a snooker game; the balls can be made to bounce off each other using the collision function in the ball object. It is left to the interested reader to create a snooker, pool or pinball game based on this collision code.

Summary

The code in this chapter presents the greatest challenge to the reader. Some of the tests involved in the collision detection use vector math results that are likely to push many readers' maths to the limit. By all

means just strip out the code and get it working for you without worrying unduly how the code achieves its results. If you are interested in the methods then read up more on vector maths, because there is a lot of interesting stuff out there for you to make use of in your games. That completes the practical section of the book; we now move on to the 'Flash for boffins' section. Many of the ideas in the next chapter have been introduced in the rest of the book, so don't think it will be beyond you.

Section 4
Flash for boffins

Sometimes you will need to extend what you can do in Flash using external methods. In previous chapters we have looked at using external files. The last two chapters introduce you to other things you should be thinking about.

19 High score tables

High score tables encourage users to stay online in order to see their name appear in the high score list or to win a prize if they are the highest scorer for a prize winning game. The high score tables are usually stored in a database and then loaded into Flash when a call to a high score table is required. This chapter explores the options. The information extends what you have learnt in Chapters 11 and 14. In contrast to Chapter 14, where we concentrated on using an SQL Server database, in this chapter we will use an Access database. Access is part of the Office package and can be accessed from all Windows servers. To make high score tables work you will need a registration and log-in form and you will need to keep track of information as you move from page to page; Session variables provide this vehicle or Cookies if you want the information to persist even after the user has logged off the site. We will look at using Session variables and Cookies to store information as we navigate a multi-page site. On a big site the Webmaster will need tools to examine traffic and users; we will look at creating pages in Flash to review the database, update and delete records.

Creating a registration page

If a user has never visited a site, then the first thing we want them to do is register. You probably want them to have some access to find out what the site has to offer, but you will constantly remind them that they should register. Registered users bring a database to help you promote the site as new features and games are added. Some users will gladly register and are happy to receive information via email; others will deliberately give a fake address in order to remain anonymous. High score tables are the most effective encouragement to register particularly when linked to a prize-winning game. There will be no point winning a prize-winning game if the player has given a fake email address!

Figure 19.1 Creating a registration page.

On the registration page we are going to create we will collect the name, password, email, company, address, telephone number and fax number of the user. Only the name, password and email will be made mandatory. When you are creating form-based web pages it is recommended that you set the focus to the first field that you want the user to enter, and ensure that the users can tab through the different fields. Flash MX introduced a new property of an instance, 'tabIndex'. If you set the tabIndex property then automatic tab ordering is disabled and only the instances with a specifically set tabIndex are included in the tab ordering. A text field can be given an instance name in the properties box for a text field and then this instance can be given a tabIndex in code. In 'Example\Chapter19\Register.fla', the focus is set to the variable with the name 'name'. Assuming this variable is an input box and that this box is visible, the caret, the flashing line that indicates where text input will be directed, will be set to that field and will flash. Be warned that Flash does not allow the caret colour to be set to any colour other than black, so if your input box has a black background it will not be visible, this can be very confusing for the user.

 The first few frames of the 'register.fla' project are all loading frames. By frame 5 we know that the form and all its resources are loaded. Take a look at the frame action on the main timeline for frame 5.

```
//Frame 5 main timeline
A.tabIndex = 1;
B.tabIndex = 2;
C.tabIndex = 3;
D.tabIndex = 4;
E.tabIndex = 5;
F.tabIndex = 6;
G.tabIndex = 7;
Selection.setFocus("name");
stop ();
```

Notice here that the 'tabIndex' is set for each of the Input Box text fields and the focus is set to 'name'.

 The functionality for the form is basically handled by Flash. A text field input box allows for keyboard input, character deletion, copying and pasting without a single line of code. The place where some ActionScript is required is for the 'register' button. This has a simple 'on (release)' method.

```
//Register button action
on (release) {
        if (emailcheck(email) && name!="" && password!="") {
                loadVariables("scripts/register.asp","","POST");
                nextFrame ();
        } else {
                warning.gotoAndPlay(2);
        {
}
```

First, we make a check for a legitimate email using a function call; assuming this is OK we check for a name and password entry. If everything is in order, then we can send all the variables in the current Flash movie to an ASP page using the POST action and then move to the next frame. If the data entered are invalid, however, then we display a warning message that is embedded in the Movie Clip 'warning'.

 The 'emailcheck' function works by testing for the presence of both the '@' symbol and a dot character, ultimately returning true only if they are both present in the email string passed to the function.

```
function emailcheck (str) {
        at = false;
        dot = false;
        for (i=0; i<str.length; i++) {
                if (str.charAt(i) == '@') { }
                        at = true;
                }
                if (str.charAt(i) == '.') {
                        dot = true;
                }
        }
        return (at && dot);
}
```

Most of the work in the register.fla project will be handled by the ASP page, 'register.asp'. We will look at how this works later in the chapter.

Creating a log-in page

A user may have already registered and simply wishes to log in. To allow for this we create a log-in page, 'Examples\Chapter19\login.fla'. This is a

Figure 19.2 The log-in page.

very simple project; the log-in button calls the 'login.asp' scipt and either moves on to the 'highscore.html' page if log-in is successful or to the 'register.html' if the user cannot be found in the database.

Creating an Access database to store the data

The program Access comes with a complete Office package. To create a new database simply run the program and select 'File/New'. Before you can make use of the database you will need to create two tables. Access does not have the same level of security as an SQL Server database so you will not need to create users and permissions. In some respects this makes life easier, but at the expense of lower security. The speed with which records can be retrieved from the database is also noticeably slower than SQL Server, but sometimes, and particularly if your server does not have a version of SQL Server running, Access provides a good second best alternative.

To create a table just use the 'Create a table in Design view' or one of the two other table creation tools.

Figure 19.3 Creating an Access database.

Figure 19.4 Creating a table in Access using the Design view.

To create a table in Design view, just give the field a name and a data type. In the sample database 'Examples\Chapter19\Site\scripts\register.mdb', there are two tables, 'Scores' and 'Users'. *Scores* contains *gameID*, *playerID* and *score* fields. *Users* contains *name*, *password*, *email*, *company*, *address*, *telephone number* and *fax number* fields. In the example there are 10 users entered and 30 scores, one for each user for three different games.

Using Cookies for persistent data

When a user arrives at our site the first thing we will do is see if they have registered already by checking to see if a Cookie exists. Cookies are a persistent form of data that can be saved on our computer by a web page. Reading and writing to the Cookie is restricted to the domain from which the Cookie originated. The existence or otherwise of the Cookie is handled by the ASP page 'cookies.asp', which is stored in the 'scripts' sub-folder of the folder 'Site'. To get a Cookie we use the 'Request' object.

```
var name = Request.Cookies ("name");
```

This code snippet will set the variable 'name' to the value of the Cookie 'name' for this domain if it exists. If it does exist then we set two Session variables 'loggedIn' and 'playerID' to true and the player's name respectively. A Session variable exists only while a user is connected to a particular site; when they disconnect the variable is deleted. The final task if the Cookie exists is to update the expiry data by setting the 'Expires' property to a string that is formatted `month dd, yyyy`, where *month* is the full month name, *dd* is the date using two characters, so the fourth would be 04, and *yyyy* is the year using four characters. The function 'getExpireString' formats the string by first getting the current time using the Date object, then adding 10 days in milliseconds to the millisecond value of the current time. This time is converted into another Date object 'expdate'. The 'expdate' object is used to build the expiry string.

If the Cookie turns out to be empty, then the Session variable 'loggedIn' is set to false and the playerID is set to an empty string. The calling program can use the value for 'playerID' to choose how to behave. A 'playerID' of 'nocookie' will force the log-in or register screen to appear. In the example this is all handled by the 'index.fla' project.

```
Cookies.asp

<%@Language=JavaScript %>

<%

Response.Expires = -1;

var name = Request.Cookies ("name");

if (name!="") {
   Response.Write("playerID=" + name);
   Session("loggedIn") = true;
   Session("playerID") = String(name);
   Response.Cookies ("name").Expires = getExpireString ();
}else {
   Session("loggedIn") = false;
   Session("playerID") = "";
   Response.Write("playerID=nocookie");
}
```

```
function getExpireString () {
    var nowdate = new Date ();
    var ms = nowdate.getTime () + (10 * 24 * 60 * 60 * 1000);
    var expdate = new Date(ms);
    var str, m, d, y, tmp;

    m = expdate.getMonth ();

    switch(m) {
    case 0:
        str = "January ";
        break;
    case 1:
        str = "February ";
        break;
    case 2:
        str = "March ";
        break;
    case 3:
        str = "April ";
        break;
    case 4:
        str = "May ";
        break;
    case 5:
        str = "June ";
        break;
    case 6:
        str = "July ";
        break;
    case 7:
        str = "August ";
        break;
    case 8:
        str = "September ";
        break;
    case 9:
        str = "October ";
        break;
    case 10:
        str = "November ";
        break;
```

```
case 11:
    str = "December ";
    break;
}

d = expdate.getDate ();

if (d<10) str += "0";
str += String(d) + ", " + expdate.getYear ();

return str;
}
%>
```

Shared objects for persistent data

A new feature in Flash MX is the object 'SharedObject'. This operates in a very similar way to Cookies and can be used without any external scripting. To use the SharedObject you first create an object from the 'getLocal' method of the SharedObject. This takes a single string parameter, which is the name to use for the shared data file. Unless you want to read this file from another program then you don't need to know where the data are actually stored; on a PC it is in the Documents and Settings folder, C:\Documents and Settings\[User Name]\Application Data\Macromedia-\Flash Player\[path to swf]\swfname.swf. In the file the data for each stored element are saved as a string. Having created a shared object from this file, the object contains the data in the file. If the file does not exist, then the object is essentially empty. To use the object you can use the 'data' property and the 'flush' method. The data property contains any data that you want to store up to the file limit which is settable, but should be fairly small. In this short snippet, we create a shared object called 'so' then trace the value of the data property 'favoriteColor'; this could be any name that you find useful. Then we assign to this property the value 'orange'. If the property does not exist then it is created by an assignment. Then we access the data property 'possibleColors'. If this exists then the data will be listed in the output window, if it does not then 'undefined' will be displayed. If the array is missing then we create it as a new Array and assign values to it, then assign this array to the data property 'possibleColors'. Finally we ensure that the data are written to the file using SharedObject method 'flush'. If 'flush' returns false then writing to the file is prohibited by security limits or file size.

```
so = SharedObject.getLocal("myInfo");
trace(so.data.favoriteColor);
so.data.favoriteColor = "orange";
trace(so.data.possibleColors);
if (so.data.possibleColors==NULL) {
        colors = new Array("red", "blue", "green", "blue");
        so.data.possibleColors = colors;
}
if (!so.flush ()) {
        //Did not work
}
stop();
```

Shared objects are a useful and quick way to guarantee persistence between one run of the page and another for the user.

Logging in via ASP

The first job of the log-in ASP page is to strip out the elements of the query string, 'name' and 'pw' (password could not be used as a column name in the database because it is a keyword). Then we make a connection to the database using the connection string shown in the listing. Connection strings are very unforgiving; get them wrong and you will get nowhere. Once we have a connection we create a record set object 'rs' and an SQL string. We are looking for a record in the database of the current user. To do this we look in the 'Users' table for a record where the 'name' field matches the value of the variable 'name' and the 'pw' field matches the value of the variable 'pw'. If a record is found then the 'rs' object will not be at the end of the file, EOF. Using this condition we set a string to write back to Flash, set the Session variables 'loggedIn' and 'playerID', and write the name as a Cookie just in case it has been deleted. The expire date for the Cookie is set using the same 'getExpireString' function we looked at earlier.

If the player cannot be found then we write a message back to Flash to indicate this fact and set the Session variables to indicate that we have not yet logged in.

```
login.asp

<%@Language=JavaScript %>

<%
```

```
Response.Expires = -1;

var name = Request("name");
var pw = Request("pw");

//Connect to the database
var conn = Server.CreateObject("ADODB.Connection");
var connStr = "PROVIDER=Microsoft.Jet.OLEDB.4.0; DATA SOURCE=" +
        Server.Mappath("register.mdb") + ";" + "Password=;";
conn.Open(connStr);

var rs = Server.CreateObject("ADODB.Recordset");
var sqlStr = "SELECT * FROM Users WHERE name=\'" + name +
        "\' AND pw=\'" + pw + "\'";

rs.Open(sqlStr, conn);

var str;

if (!rs.EOF) {
   str = ("loggedIn=true&message=Welcome back " + name);
   Session("loggedIn") = true;
   Session("playerID") = String(name);
   Response.Cookies("name") = name;
   Response.Cookies("name").Expires = getExpireString ();
}else {
   str = "loggedIn=false&message=Can't find you in our database";
   Session("loggedIn") = false;
   Session("playerID") = "";
}

Response.Write(str);

rs.Close ();
conn.Close ();
```

Registering via ASP

First, we parse all the data sent to the page and store them in several variables. Then we connect to the database and build an SQL string. This time the string is an INSERT string, which takes the form

```
INSERT INTO table (field1, ...) VALUES(val1, ...)
```

This is executed on the current connection. To make a full registration application we should really check for the existence of a user with the same name, because the 'name' field is required to be unique. We can find out whether a user with the same name exists simply by creating a record set from the Users table based on the name value being the same;

Figure 19.5 Registering.

if this record set has any entries then the name has already been used and so we can write back a message to indicate this and the Flash application can require the user to choose a different name. The function 'getExpireString' is again used to set the Expires property of the 'name' Cookie if registration was successful.

```
register.asp

<%@Language=JavaScript %>

<%
```

```
Response.Expires = -1;

var name, password, email, company, address, tel, fax;

name = Request("name");
password = Request("password");
email = Request("email");
company = Request("company");
address = Request("address");
tel = Request("tel");
fax = Request("fax");

//Connect to the database
var conn = Server.CreateObject("ADODB.Connection");
var connStr = "PROVIDER=Microsoft.Jet.OLEDB.4.0; DATA SOURCE=" +
        Server.Mappath("register.mdb") + ";" + "Password=;";
conn.Open(connStr);

var sqlStr = "INSERT INTO Users (name, pw, email, company, address,
tel, fax)" + " VALUES (\'" + name + "\',\'" + password + "\', \'" +
email + "\',\'" + company + "\',\'" + address + "\', \'" + tel +
"\',\'"+ fax + "\')";

conn.Execute(sqlStr);
conn.Close ();

Session("loggedIn") = true;
Session("playerID") = String(name);
Response.Cookies("name") = name;
Response.Cookies("name").Expires = getExpireString ();
Response.Write("loggedIn=true");
```

Saving the user's score

Assuming the player is successfully logged in, either via an existing Cookie, the log-in page or registration, then the page is set to 'highscores.html', which contains the swf from the project 'Examples\Chapter19\highscores.fla'. When this loads it shows a menu screen from where you can select one of three games, 'Car Chase', 'Cat Splatt' and 'Ninga Rhino'. This screen also contains two buttons, 'Set Score' and 'View Scores'. The message displayed also shows the user's name because this is known by the time the screen is displayed.

Figure 19.6 Running the high scores page.

The action for the 'Set Score' button first works out which game is selected by getting the state of the three radio buttons. Only one button in a radio button group can be active. This value is used to choose the name of the game from an array of game names. The score is arbitrarily set to a random value between 0 and 9999, then these data are sent to the ASP page 'setscore' via a query string. The playback head is set to the 'wait' frame, where playback loops until either 'setscore' or 'viewscores' is set to 'true'.

```
on (release) {
    var i, game=0, score;

    for (i=1; i<=3; i++) {
        if (eval("game" + i).getState ()) {
            game = games[i-1];
            break;
        }
    }
    score = random(10000);
    loadVariables("scripts/setscore.asp?gameID=" + game + ↵
        "&score=" + score, "");
    gotoAndPlay("wait");
}
```

The ASP page works by stripping the query string into variables, connecting to the database in the usual way and creating an SQL string. The SQL string is a 'SELECT' statement, seeking to find a record from the Scores table for the current player and game. If this record exists then it is updated with the new score. We should really check to see if the existing score is higher than the score we are going to use to overwrite; I leave this to the interested reader. If the record does not exist then it is inserted. Recall that the INSERT statement takes the form:

```
INSERT INTO table (fieldname1, ...) VALUES (value1, ...)
```

When an existing entry is updated you use the form:

```
UPDATE table SET fieldname1=value1 [AND ...] ↵
WHERE fieldName2=value2 [AND ...]
```

This method can be used to update several records simultaneously. Notice that Flash is informed that the page has completed successfully using the Response.Write method. Anything in brackets will be sent back to Flash, using a MIME-encoded string format; multiple variables can be returned in the form:

```
variable1=value1&variable2=value2 etc.
```

Each variable value pair is connected to the rest using an ampersand character.

```
<%@Language=JavaScript %>

<%

Response.Expires = -1;

var gameID = Request("gameID");
var playerID = Session("playerID");
var score = Number(Request("score"));

//Connect to the database
var conn = Server.CreateObject("ADODB.Connection");
connStr = "PROVIDER=Microsoft.Jet.OLEDB.4.0; DATA SOURCE=" +
        Server.Mappath("register.mdb") + ";" + "Password=;";
conn.Open(connStr);
```

```
var sqlStr = "SELECT * FROM Scores WHERE playerID=\'" +
        String(playerID) + "\' AND gameID=\'" + gameID +"\'";
var rs = Server.CreateObject("ADODB.recordset");

rs.Open(sqlStr, conn);

if (!rs.EOF) {
   //No entry so add it
   sqlStr = "INSERT INTO Scores " + "(gameID, playerID, score) " +
        "VALUES (\'" + gameID + "\', \'" + playerID + "\', " + ↵
            score + ")";
}else{
   // The entry exists so we will amend
   sqlStr = "UPDATE Scores SET score=" + Number(score) +
        " WHERE gameID=\'" + gameID + "\' AND playerID=\'" +
        playerID +"\'";
}

conn.Execute(sqlStr);
Response.Write("setscore=true&message=Your score for " + gameID +
   " has been set to " + score);
rs.Close ();
conn.Close ();

%>
```

Accessing the high score table

When the 'View Scores' button is pressed in the 'highscores.fla' project, the following code is executed. The game name is derived from the selected radio button and this is sent to the ASP page 'gethighscores.asp'.

```
on (release) {
    var i, game=0, score;

    for (i=1; i<=3; i++) {
        if (eval("game" + i).getState ()) {
            game = games[i-1];
            break;
        }
    }
    loadVariables("scripts/gethighscores.asp?gameID=" + ↵
        game, "");
    gotoAndPlay("wait");
}
```

Figure 19.7 The high score table.

The ASP page operates by first getting a total of all the scores for the current game. Then, using this value, we ask for a maximum of 10 scores. But we want the top 10. To do this we must ask for only 10 records and we must sort the record set using the score value.

```
SELECT TOP x fieldName1, . . . FROM table
WHERE fieldNamex=value ORDER BY fieldNamex DESC
```

Using the condition TOP x, we can set how many records we want returning. ORDER BY lets us set the field to use for any sorting and DESC means that the highest values go first. Having got the data out of the database, they are passed to Flash using the familiar MIME-encoded string formatting. In this instance the Flash variables 'hs1', 'hs2', . . ., 'hs10' are set to the players name and score strings.

```
Gethighscores.asp

<%@Language=JavaScript %>

<%

Response.Expires = -1;

function getScoreCount (gameID, conn)
{
    var rs=Server.CreateObject ("ADODB.recordset");
    var scoreCount = 0;

    rs.Open ("SELECT COUNT(gameID) FROM Scores WHERE gameID=\'"
            + gameID + "\' ", conn);
    scoreCount = rs.Fields.Item(0).value;
    rs.Close ();
    return scoreCount;
}

function getScore (playerID, gameID, conn)
{
    var rs=Server.CreateObject("ADODB.recordset");
    var score = 0;

    rs.Open ("SELECT score FROM Scores WHERE playerID=\' " + ↵
        playerID +
            "\' AND gameID=\'" + gameID + "\'", conn);

    if (!rs.EOF) score = rs.Fields.Item(0).value;
    rs.Close ();
    return score;
}

var gameID = Request("gameID");
var playerID = Session("playerID");
var scoreCount = 0;

//Connect to the database
var conn = Server.CreateObject("ADODB.Connection");
connStr = "PROVIDER=Microsoft.Jet.OLEDB.4.0; DATA SOURCE=" +
            Server.Mappath("register.mdb") + ";" + "Password=;";
conn.Open(connStr);
```

```
scoreCount = getScoreCount(gameID, conn);
//We may have to return less than they ask.
if (scoreCount > 10) scoreCount = 10;

var rs = Server.CreateObject("ADODB.recordset");
rs.Open ("SELECT TOP" + scoreCount +
        " playerID, score FROM Scores WHERE gameID=\'" + gameID +
        "\' ORDER BY score DESC", conn);

var count = 1, str;

while (!rs.EOF) {
   str = "hs" + String(count++) + "=" + rs.Fields.Item(0).↵
      value + " " +
         rs.Fields.Item(1).value + "&";
   Response.Write(str);
   rs.moveNext ();
}
rs.Close ();

score = getScore(playerID, gameID, conn);
str = "message=Your best score for " + gameID + " is " +
        String(score) + "&viewscores=true";
Response.Write(str);

conn.Close ();

%>
```

ASP pages are an easy way to link between Flash and a database. Because you can write ASP pages in JavaScript and that is the syntax used for ActionScript, you are already well on your way to becoming a JavaScript expert.

Creating administrative pages

The administrator for your site will want to be able to read and manipulate the database. SQL Server is very good for maintaining a remote database, Access is more limited. Sometimes the best way to create an easy-to-maintain site is to create admin pages. Such pages are designed to allow the administrator to check such features as traffic and users. We

have found that cunning players often find ways to fake a high score, sometimes by sending a score directly to the database using the ASP pages that Flash uses. This happens particularly on prize-winning games. To avoid this happening, we have taken to using encryption techniques for most data that we send by ASP. The Webmaster can often spot someone cheating simply by checking their records in a database. Flash is a good tool for creating user-friendly front ends to allow a Webmaster to check out the database. The 'admin.fla' project shows how you can tie a Flash application to a database. The 'Grid' component has three parameters, rowCount, colCount and colNames – an array of strings. These can be set directly at design time or you could create ASP pages to get the total number of columns and the names from a table in the database. Having accessed this information, you can use it to initialize the grid to the appropriate column headers and the appropriate data in the cells. You could create a button that allows users to delete or update records. You could even let users write their own SQL strings and then use these to update the database. By linking Flash and ASP pages in this way, you can provide all the functionality a Webmaster could ever need.

Summary

Flash MX is a great tool for linking to server-side scripts. Because we can get data out of Flash using a query string or the POST method, we can easily send this to a server-side script. On the server we can use the data to manipulate a database, then send this information back to Flash using a MIME-encoded string. We can send as many variables in this way as are needed for a particular task. There are many books on ASP; many of these books use VBScript as the scripting language and so you may find them unfamiliar at first, but a lot of the detail will be the same if you use JavaScript as your scripting language.

In this chapter we explored more fully some of the features of ASP and SQL. If you are manipulating databases then it well worth learning more about SQL. The language offers you a great many tools for selecting records from databases and linking together tables. Check out the Bibliography for some interesting SQL books.

20 Multi-player games using sockets

Although multi-player games are possible using ASP pages or another server-based script engine, the best technique to use is a server-side listening program that exploits the use of sockets. From Flash five sockets have been supported and provide the fastest and most reliable way to pass and process real-time data. In this chapter we are going to look at creating the server-side program using MFC, Microsoft Foundation Classes, on a Windows server. For many readers this will be unfamiliar territory, but we are in the 'Flash for boffins' section! The first part of this chapter assumes a reasonable knowledge of C++. There are lots of good C++ books available, a few of which are listed in the Bibliography. To use a server-based socket listener the developer will need to have the ability to run an executable program on a server with a static IP address. Finally, we will implement a very simple multi-player game across the Internet.

Moving boxes on a remote computer

The example we are going to study in this chapter is deliberately kept very simple. There is a lot to learn when understanding sockets and so your time is better spent understanding the principles rather than be bogged down in the intricacies of the game design. In the example there are up to eight boxes. A user can click and drag any unused box. When a box is being dragged, every other computer connected to the site will see the box move on their own screens. If a user has entered their name in the box at the top, then their name will be displayed in the box. Very simple maybe, but it illustrates the concept of multiple users receiving and passing data in real-time across a remote network. Before we can create the Flash application we need a program to be running on the server. This program acts as the conductor for all the connected computers. We are going to create this program using Visual C++.

Figure 20.1 Moving boxes on a remote computer.

Sockets on a Windows server

This section is going to use C++ code. The syntax for C++ is very similar to the JavaScript syntax you are familiar with from using Flash ActionScript. We are going to use something called Microsoft Foundation Classes. These are a library of C++ classes (another word for objects) that make programming Windows Applications easier and more robust. To make use of the example on the CD, you will need a copy of Visual C++ on a PC. If you can, open the file 'Examples\Chapter20\SockListener\SockListener.dsw'. This file is a Visual C++ project file. A C++ project uses several files to store the source code and other information the IDE (Integrated Development Environment) requires to compile the program. The source we will examine is in the file 'SockListenerDlg.cpp'; this is simply a text file, so if you don't have Visual C++ then just open this in a text viewer. MFC applications come in several flavours; this one uses a dialog box as the main window. Figure 20.1 shows the application running. Visually, the program is just a list box where we can add text information that makes understanding the

Figure 20.2 The SockListener application.

program's operation easier. The purpose of the program is to open a server socket on a defined port on a computer with a static IP address and listen for users across the Internet who want to connect to this socket. Whenever there is a new connection it is stored in a list and the program sees to it that all the current listeners to this socket get fed with information. The example program allows remote users to move boxes on another user's computer and vice versa.

Initializing the dialog box

Whenever a new dialog box is created, MFC calls the function 'OnInitDialog' in the dialog box class. Most of this is standard to all dialog boxes; a menu is created and the icon for the application is set. For the SockListener application we want to initialize a server socket. The dialog will only ever contain one of these, but first we need the IP address of the server. To get this we create a function called 'GetServerIP'. This uses the API, Application Programming Interface, function, 'gethostname'. The purpose of this function is to return the host name in string format. Notice that, unlike Flash, every variable has to be of a specified type, and every variable must be declared before use.

After getting the name of the server, a structure HOSTEENT is returned using the function 'gethostbyname' passing the host name as a parameter. The HOSTENT structure contains details about the server, including the IP address, which is stored in the member 'h_addr'. The host name is stored in the member variable, 'm_cshostname', for future use.

```
BOOL CSockListenerDlg::GetServerIP ()
{

        HOSTENT *hs;
        UCHAR ch[4] = { 0 };
        CString csInfo;

        ::gethostname((LPSTR)(LPCTSTR)m_cshostname, 50);
        hs = gethostbyname((LPSTR)(LPCTSTR)m_cshostname);

        memcpy(ch, hs->h_addr, 4);
        csInfo.Format("%s %d.%d.%d.%d", m_cshostname,
                ch[0], ch[1], ch[2], ch[3]);
        GetDlgItem(IDC_TEXT)->SetWindowText(csInfo);
        return TRUE;
}
```

Assuming that the IP address was successfully found, the server socket is created, using the PORT defined by the constant PORT; in this example this is set to 5001 and the fact that the type of socket is a stream. The value of the PORT is set in file 'stdafx.h', which is part of this application; the value for the constant SOCK_STREAM is defined in the file 'winsock.h', which is a standard file included with Visual C++. Having created the server socket, it is set to listening mode using the member function 'Listen'.

```
//////////////////////////////////////////////////////////////
/
// CSockListenerDlg message handlers

BOOL CSockListenerDlg::OnInitDialog ()
{

        CDialog::OnInitDialog ();
        ASSERT((IDM_ABOUTBOX & 0xFFF0) == IDM_ABOUTBOX);
        ASSERT(IDM_ABOUTBOX < 0xF000);
```

```
CMenu* pSysMenu = GetSystemMenu(FALSE);
if (pSysMenu != NULL)
{
      CString strAboutMenu;
      strAboutMenu.LoadString(IDS_ABOUTBOX);
      if (!strAboutMenu.IsEmpty ())
      {
            pSysMenu->AppendMenu(MF_SEPARATOR);
            pSysMenu->AppendMenu(MF_STRING,
                        IDM_ABOUTBOX, strAboutMenu);
      }
}

//Set the icon for this dialog. The framework does this
//automatically
// when the application's main window is not a dialog
SetIcon(m_hIcon, TRUE);                // Set big icon
SetIcon(m_hIcon, FALSE);         // Set small icon

if(!GetServerIP ()) {
      AfxMessageBox("Unable to get IP", MB_OK|MB_ICON↵
          ERROR);
}
else {
      m_ServerSocket.m_ptrDlg = this;
      m_ServerSocket.Create(PORT, SOCK_STREAM);
      m_ServerSocket.Listen();
}
return TRUE;
}
```

Establishing a connection

Everytime a new connection needs to be made, the server socket calls the dialog box function 'ProcessPendingAccept'. This function creates a new client socket and then calls the server function 'Accept' using a pointer to this new client socket. If you are new to pointers then think of it as a variable that points to the position in memory where the actual data that you are interested in reside. If the server function 'Accept' returns true then this socket is added to the list of sockets being handled by the server socket, if not then the client socket is deleted and no connection is made.

```
void CSockListenerDlg::ProcessPendingAccept ()
{
    TRACE("CSockListenerDlg::ProcessPendingAccept\n");
    CString csSockAddr;
    CString csInfo;
    UINT nSockPort;

    CClientSocket *pSocket = new CClientSocket(this);

    if (m_ServerSocket.Accept(*pSocket))
    {
        if(pSocket->GetSockName(csSockAddr, nSockPort)) {
            csInfo.Format("%s : %u - Connected", ↵
                csSockAddr, nSockPort);
            m_list1.InsertString(-1, csInfo);
        }
        m_connectionList.AddTail(pSocket);
    }
    else
        delete pSocket;
}
```

Closing a connection

When a client socket is ready to close down, the socket calls the dialog box function 'OnCloseConnection'; this function prints a message to the dialogs list box and builds an XML message string.

> XML, eXtensible Mark-up Language, is called extensible because it is not a fixed format like HTML (a single, pre-defined mark-up language). Instead, XML is actually a 'meta-language' – a language for describing other languages – which lets you design your own customized mark-up languages for limitless different types of documents. XML can do this because it's written in SGML, the international standard meta-language for text mark-up systems (ISO 8879).

The format for Flash XML tag is a 'less than' symbol, name, data, forward slash and a 'greater than' symbol. The OnCloseConnection function sends the message

```
<DROPBOX ID=x/>
```

where *x* is the index value for the box being controlled.

All sockets being controlled by this server socket are sent the message that a box has been dropped using the XML form and the client socket is removed from the list of sockets being handled by the server socket. Finally, the socket is closed and deleted.

```
BOOL CSockListenerDlg::OnCloseConnection(CClientSocket *pSocket)
{
    CString csSockAddr;
    CString csInfo;
    static int nIndex = 0;
    char xmlmsg[1000];
    UINT nSockPort;

    if(pSocket->GetSockName(csSockAddr, nSockPort)) {
        csInfo.Format("%s : %u - DisConnected", csSockAddr, ↵
            nSockPort);
        m_list1.InsertString(-1, csInfo);
    }

    sprintf(xmlmsg, "<DROPBOX ID=\"%i\"\>", pSocket->boxid);
    POSITION pos,temp;

    for(pos = m_connectionList.GetHeadPosition (); pos != NULL;) {
        temp = pos;
        CClientSocket* pSock =
                (CClientSocket*)m_connectionList.GetNext(pos);
        if (pSock == pSocket) {
                m_connectionList.RemoveAt(temp);
                break;
        }else {
                pSock->Send(xmlmsg, strlen(xmlmsg)+1);
        }
    }

    pSocket->Close ();
    delete pSocket;

    return TRUE;
}
```

What happens when a client socket requests information?

A client socket calls the dialog box function 'ProcessPendingRead' whenever a socket wants information. First we read the information requested. XML syntax is used to pass information. The possible tags in this example are:

QUERYBOXES – used to find out which boxes are currently under remote user control.

No parameters are passed. For each connection in the connection list the ID of the connection is stored in the array 'userids'. This array is initially set to eight zeros. If a connection is being used then the array for this index is set to 1. Then we build a string using the XML tag QUERYBOXES and the value of each of the eight members of the 'userid' array are passed to it. This message is then sent back to the socket who asked for it.

PICKBOX – used to tell the server which box this connection is controlling and the name to use.

The name and ID are stripped out of the string that is passed. This information is then passed on to each connection in the server's connection list.

MOVEBOX – informs the server that the box has moved, who passes the details on to each connection.

The ID, XPOS and YPOS of the box are stripped from the passed message and passed on to every connection.

DROPBOX – A user has stopped dragging the box. This information is passed to each connection.

The ID of the dropped box is stripped from the string and passed on to each connection in the server's connection list.

```
void CSockListenerDlg::ProcessPendingRead(CClientSocket *pSocket)
{
    char msg[1000], xmlmsg[1000], *cp;
    int id, xpos, ypos, usedids[]= {0,0,0,0,0,0,0 };
    POSITION pos = m_connectionList.GetHeadPosition ();
    CClientSocket *socket;
```

```
memset(msg, 0, 1000);
pSocket->Receive(msg, 1000);

if (strncmp(msg, "QUERYBOXES", 5)==0) {
      while(pos) {
            socket = (CClientSocket*)m_connectionList.↵
                GetNext(pos);
            if (socket->boxid) usedids[socket->boxid-1] = 1;
      }
sprintf(xmlmsg, "<QUERYBOXES ID1=\" %i\" ID2=\"%i\" ↵
   ID3=\"%i\" ID4=\"%i\" ID5=\"%i\" ID6=\"%i\" ID7=\"%i\"/>",
            usedids[0], usedids[1], usedids[2], usedids[3],
            usedids[4], usedids[5], usedids[6]);

      pSocket->Send(xmlmsg, strlen(xmlmsg)+1);

      return;
}

if (strncmp(msg, "PICKBOX", 4)==0) {
      cp = strstr(msg, "ID=");
      if (!cp) return;
      cp+=3;
      pSocket->boxid = atoi(cp);

      cp = strstr(msg, "NAME=");
      if (!cp) return;
      cp+=5;
      pSocket->name = cp;

      sprintf(xmlmsg, "<PICKBOX ID=\"%i\" NAME=\"%s\"/>",
            pSocket->boxid, pSocket->name);

      while(pos) {
            socket = (CClientSocket*)m_connectionList.↵
                GetNext(pos);
            if (socket!=pSocket)
                  socket->Send(xmlmsg, strlen(xmlmsg)+1);
      }

      return;
}
```

```
if (strncmp(msg, "MOVEBOX", 4)==0) {
     cp = strstr(msg, "ID=");
     if (!cp) return;
     cp+=3;
     id = atoi(cp);

     cp = strstr(msg, "XPOS=");
     if (!cp) return;
     cp+=5;
     xpos = atoi(cp);

     cp = strstr(msg, "YPOS=");
     if (!cp) return;
     cp+=5;
     ypos = atoi(cp);

     //Pass it on
     sprintf(xmlmsg, "<MOVEBOX ID=\"%i\" XPOS=\"%i\" ↵
        YPOS=\"%i\"\>",
           id, xpos, ypos);

     while(pos) {
           socket = (CClientSocket*)m_connectionList.↵
              GetNext(pos);
           if (socket!=pSocket)
                 socket->Send(xmlmsg, strlen(xmlmsg)+1);
     }

     return;
}

if (strncmp(msg, "DROPBOX", 4)==0) {
     sprintf(xmlmsg, "<DROPBOX ID=\"%i\"\>", pSocket->↵
        boxid);
     pSocket->boxid = 0;

     while(pos) {
           socket = (CClientSocket*)m_connectionList.↵
              GetNext(pos);
           if (socket!=pSocket)
                 socket->Send(xmlmsg, strlen(xmlmsg)+1);
     }

     return;
}

}
```

Now we have a program that is going to handle the connections and pass the data around each connected user.

Creating the Flash application

Open the project 'Examples\Chapter20\MoveBox.fla'. The code in frame 1 is as follows:

```
sock = new XMLSocket ();
sock.onXML = gotMessage;
sock.onConnect = onSockConnect;
usedids = new Array(0, 0, 0, 0, 0, 0, 0, 0);
dragbox = 0;
sock.connect("192.168.0.1", 5001)
stop ();
```

The root level variable 'sock' is set as a new XML Socket object and the two callback functions for this object 'onXML' and 'onConnect' are set to

Figure 20.3 Creating the MoveBox.fla.

'gotMessage' and 'onSockConnect' respectively. The 'onSockConnect' function gets called when a connection is made and is passed a Boolean variable that indicates whether the connection was successfully made. The XML Socket member function 'connect' is called using the static IP address of the computer that is running the listening program. This is why the program must be running on a server that is available on the web and that uses a static IP address; the second parameter in the function call 'connect' is the port to connect to. In the MFC application this was set to 5001. If the connection is made successfully, then we create a new XML message that contains just the tag QUERYBOXES. Recall that the listening program handles this function by passing a message to all the connected computers that indicates which boxes are currently being moved.

```
function onSockConnect (success) {
        if (success) {
                connected = true;
                xmlmsg = new XML("QUERYBOXES");
                sock.send(xmlmsg);
                gotoAndPlay("MainLoop");
        } else {
                connected = false;
        }
}
```

Whenever Flash receives a message via the connected socket it calls the function 'gotMessage'. This function handles any XML data that are passed by the server program. Firstly, we create a variable out of the first child of the document object that is the only parameter of the function and then search for a node name of QUERYBOXES, PICKBOX, MOVEBOX or DROPBOX. If we find QUERYBOX then we search for the attributes ID1–8 that are passed from the SockListener application. In this simple case there is only ever one node to parse, so we don't need to loop through multiple layers. But an XML object in Flash has all the methods necessary to process a very complex document with multiple layers of embedded data. Each node can have an unlimited number of attributes that are accessed using the name used.

```
function gotMessage (doc) {
        var name;

        xmlObj = doc.firstChild;
```

```
if (xmlObj.nodeName == "QUERYBOXES") {
        msg = xmlObj.attributes.USEDIDS;
        usedids[1] = xmlObj.attributes.ID1;
        usedids[2] = xmlObj.attributes.ID2;
        usedids[3] = xmlObj.attributes.ID3;
        usedids[4] = xmlObj.attributes.ID4;
        usedids[5] = xmlObj.attributes.ID5;
        usedids[6] = xmlObj.attributes.ID6;
        usedids[7] = xmlObj.attributes.ID7;
}

if (xmlObj.nodeName == "PICKBOX") {
        id = Number(xmlObj.attributes.ID);
        clientname = xmlObj.attributes.NAME;
        eval("Box"+id).Name = clientname;
        usedids[id] = 1;
        Debug = "Pickbox " + id + " " + clientname;
}

if (xmlObj.nodeName == "MOVEBOX") {
        id = Number(xmlObj.attributes.ID);
        xpos = xmlObj.attributes.XPOS;
        ypos = xmlObj.attributes.YPOS;
        if (usedids[id]!=0) {
                name = "Box" + id;
                eval(name)._x = xpos;
                eval(name)._y = ypos;
        }
}

if (xmlObj.nodeName == "DROPBOX") {
        id = Number(xmlObj.attributes.ID);
        usedids[id] = 0;
        name = "Box" + id;
        eval(name)._x = id * 50 - 15;
        eval(name)._y = 364);
        eval(name).Name = "None";
        Debug = "Dropbox " + id;
}
}
```

Figure 20.4 The application running on the server.

The main loop

All that is necessary in the main loop is to pass the current on-screen location and ID of the box that is being dragged.

```
if (dragbox!=0) {
    msg = "MOVEBOX ID=" + dragbox + "XPOS=" + _xmouse + "YPOS=" ↵
        + _ymouse;
    sock.send(msg);
}
```

Whatever game you create, you can pass and handle data in this way. You will simply change the way you handle requests from clients in the SockListener and the way you handle messages in Flash; most of the other details will be the same whatever the application.

Summary

Sockets provide a great way to handle multiple users if you have the ability to run server-side programs. The details can be a little tedious and never expect data to arrive in a pre-defined order. If you do an analysis of the way messages are passed, you will regularly be surprised to find that messages sent one after another are received in the opposite order.

You've reached the end of the book. The Appendices that follow give advice on some specific and common problems for Flash game developers.

Appendix A:
Integrating Flash with C++

In the last chapter of the book we looked at creating a socket listener in C++. In this Appendix we look at how experienced programmers can add Flash to their executable programs. By creating a specialized wrapper we can get all the dynamic animation facilities that Flash can provide, together with the excellent development environment, and we can extend it to use operating system features such as the file system and purpose-made non-rectangular skins. Flash operates as an ActiveX control in the Windows environment and as such is fairly easily embedded into a C++ executable. We also look at communication between the parent program and Flash.

Figure A.1 Creating a new Visual C++ project.

Figure A.2 *Selecting a dialog-based project.*

Figure A.3 *Choosing the source file names.*

Creating a new workspace

Step 1 is to run Visual C++ and choose 'File/New'. Click the 'Projects' tab in the dialog box that opens and select 'MFC AppWizard (exe)' as the project type. You must also select a location and name for the project.

In the next dialog choose 'Dialog based' for the type of application you want to create.

The default file names for the source files will probably suffice, but you have the option to change them if you wish. Then click 'Finish'; all the project files are automatically created and you are ready to add the Flash object.

Inserting a Flash ActiveX control

To add the Flash object click on the 'ResourceView' tab in the workspace panel. If the dialog template is not open then expand the Dialog folder and click on the single template that is in the folder. You should see a dialog template that is the same as that shown in Figure A.4. Right-click on the template and select 'Insert ActiveX Control . . .' from the context menu.

Figure A.4 Inserting an ActiveX control.

Ficsh MX Games

Figure A.5 Select Shockwave Flash Object from the list.

Figure A.6 Drag and size on the dialog box template.

Figure A.7 Inserting a member variable for the dialog box.

Figure A.8 Visual C++ creates a source file wrapper.

Figure A.9 Choosing the source file names for the wrapper.

Figure A.10 Selecting the name of the Flash member variable.

A dialog box opens offering a list of ActiveX controls that appear on your PC. Scroll down to 'Shockwave Flash Object'. If you haven't got Flash installed then it will not appear in the list, but this book wouldn't be much use to you either!

A black box appears; this is the Flash Object without a movie embedded. You can drag and position this if you wish or you can do this in code.

To use the Flash Object in your source code open Class Wizard and select the 'Member Variables' tab. Click on the ID name you have chosen for the Flash Object. Press the 'Add Variable . . .' button.

Figure A.11 The source file in Visual C++.

Visual C++ warns you that the object does not have a source file in the current project and automatically generates one from the information found inside the ActiveX control.

The source files created can be renamed from the defaults if you choose.

Give the member variable a name that you will use to manipulate the Flash Object.

You now have a project that contains a Flash ActiveX control.

Embedding the Flash Movie as a resource

At this stage the Flash Movie is empty. In this example we want to create a single exe file, so we need to embed the swf file in the exe. To do this you need to add a custom resource. In the ResourceView panel right-click and choose 'Import . . .'; in the import dialog select 'Custom' as the import type and select an swf file. In the Custom Resource Type dialog type in FLASH as the resource type. A new folder will appear in the Resource-View panel labelled 'FLASH'. Inside this folder will be the new resource. Give this a useful name by right-clicking and choosing 'Properties'.

Turning the resource into a temporary swf file

Before you can assign the custom resource to Flash you need to open it and store it as a temporary file. The function 'CreateTmpSwf' does this work for you. If you are interested in how this function works, then you will need to get several books on the Windows platform to better understand the memory management and API calls.

```
BOOL CFlashAXExeDlg::CreateTmpSwf ()
{
    HINSTANCE hInst = AfxGetResourceHandle ();
    HRSRC hrsrc = ::FindResource(hInst, MAKEINTRESOURCE(IDR_↵
      GAME), "FLASH");
    if (!hrsrc) {
      TRACE("BINARY resource not found");
      return FALSE;
    }
    HGLOBAL hg = LoadResource(hInst, hrsrc);
    if (!hg) {
      TRACE("Failed to load BINARY resource");
      return FALSE;
    }
    BYTE* pRes = (BYTE*) LockResource(hg);
    ASSERT(pRes);
    int iSize = ::SizeofResource(hInst, hrsrc);

    // Mark the resource pages as read/write so the mmioOpen
    // won't fail
    DWORD dwOldProt;
```

```
    BOOL b = ::VirtualProtect(pRes,
                              iSize,
                              PAGE_READWRITE,
                              &dwOldProt);
    ASSERT(b);

      CFile file("C://tmp.swf",CFile::modeWrite|CFile::mode⏎
        Create);
      file.Write(pRes,iSize);
      file.Close ();
      return TRUE;
  }
```

Initializing the Flash control

Having called 'CreateTmpSwf', if the function was successful a movie exists at the root of the C drive called 'tmp.swf'. We can set this as the movie for the Flash Object using the 'SetMovie' method of the ActiveX control. The 'OnInitDialog' function is called to initialize the dialog box and is also used to set the shape of the dialog box to a round rectangle using the 'SetWindowRgn' method for a window.

```
BOOL CFlashAXExeDlg::OnInitDialog ()
{
    CDialog::OnInitDialog ();

    SetIcon(m_hIcon, TRUE); // Set big icon
    SetWindowPos(&wndTopMost,0,0,WIDTH,HEIGHT+10,SWP_NOMOVE);

    CRgn rgn;
    rgn.CreateRoundRectRgn(0,0,WIDTH,HEIGHT+10,100,100);
    SetWindowRgn(HRGN(rgn),TRUE);
    CRect rect;
    CWnd *wnd=GetDlgItem(IDC_EXIT);
    if (wnd) wnd->SetWindowPos(NULL,
                WIDTH-70,0,0,0,SWP_NOZORDER|SWP_NOSIZE);
    GetClientRect(&rect);
    rect.top+=10;
```

```
        m_flash.Create("Flash",WS_CHILD|WS_VISIBLE,rect,this,↵
            IDD_FLASH);
        if (CreateTmpSwf ()) m_flash.SetMovie("C:\\tmp.swf");

        return TRUE;
    }
```

Responding to mouse events

Because this is a custom window we need to let the users close the window and move the dialog box. To do this we override the 'OnMouse-Move' method and the 'OnLButtonUp'. If the user clicks in the upper left corner then we use the 'PostQuitMessage' function to close the dialog box.

```
void CFlashAXExeDlg::OnMouseMove(UINT nFlags, CPoint point)
{
    if ((nFlags & MK_LBUTTON)) {
        if (point.y<10) {
            if (point.x>(WIDTH-50)) {
                PostQuitMessage(0);
            }else {
                ReleaseCapture ();
                int ret = this->SendMessage(WM_NCLBUTTON↵
                    DOWN,
HTCAPTION, 0);

                return;
            }
        }
    }
    CDialog::OnMouseMove(nFlags, point);
}

void CFlashAXExeDlg::OnLButtonUp(UINT nFlags, CPoint point)
{
    if (point.y<16) {
        CRect rect;
        CWnd *wnd=GetDlgItem(IDC_EXIT);
```

```
            if (wnd) {
                  wnd->GetClientRect(&rect);
                  wnd->MapWindowPoints(this,&rect);
                  if (PtInRect(rect,point)) PostQuitMessage(0);
            }
      }
      CDialog::OnLButtonUp(nFlags, point);
}
```

Removing the temporary swf

Remember whenever a temporary file is saved to the file system to remove it when the application closes. The API call 'DeleteFile' does this for you.

```
void CFlashAXExeDlg::OnDestroy ()
{
      m_flash.DestroyWindow ();
      CDialog::OnDestroy ();
      DeleteFile("C:\\tmp.swf");
}
```

Figure A.12 The final exe.

If you have ever done any Windows programming then much of the information in this Appendix would be familiar and you may be pleasantly surprised how easy it is to incorporate Flash into your application. If you have never done any Windows programming then the whole lot probably seemed totally confusing. You can actually use the source code without understanding it, if you wish, but if you do intend to create a wrapper for a Flash movie then I recommend getting to grips with at least the basics of Windows programming.

Communicating between the Flash Object and the wrapper

If you are doing anything more than just creating an exe wrapper then you will probably want to respond to events that take place inside Flash. To do this you need to respond to fscommand events. Flash sends an fscommand using this syntax:

```
fscommand("click", "");
```

The first parameter is the command name and the second any arguments you want to send at the same time. You can send an 'fscommand' at any time in your ActionScript. The command name can be any string that is useful for the context. To respond to all fscommand events we need to add a member function to the main window of our wrapper.

```
void CFlashTalkDlg::OnFSCommandFlash(LPCTSTR command, LPCTSTR ↵
    args)
{
    if (_stricmp(command, "click")==0) {
        AfxMessageBox("Flash passed click fscommand");
    }
}
```

You test for the command string using the function 'strcmp' for a case-sensitive comparison or '_stricmp' if you want it to be case insensitive. If the strings are the same then the string comparison function is set to zero. In this way you can send any message from Flash. Having sent a message your wrapper may want to query the current state of variables in Flash.

If you need to get the value of a variable in Flash then use:

```
m_flash.getVariable(variablename)
```

Regardless of the type of the variable this function returns a string.
 If you want to set a variable in Flash then use:

```
m_flash.setVariable(variablename, variablevalue)
```

Where both 'variablename' and 'variablevalue' are passed as strings.
 You will be able to see from the list of exposed methods in the Flash ActiveX control that there are a considerable number of other ways that you can communicate between the wrapper and Flash. The wrapper can control the playback by setting the frame and the play mode for both the main timeline and any Movie Clips, but the principal methods you will use are 'setMovie', 'setVariable', 'getVariable' and the event callback 'OnFSCommand'.

Summary

Using the Flash ActiveX control in this way allows you as a developer to create desktop characters, email virals and screensavers. It is certainly worth looking into how the control can be used to extend your applications.

Appendix B: Integrating Flash with Director

Director is starting to make a more significant impact on the Internet with the addition of Shockwave 3D. As an experienced Flash developer you will probably find it easier to control the 3D worlds using a Flash interface. In this Appendix you will find an introduction to controlling a 3D world using Flash.

As I write, Director 8.5 is the latest version, although by the time you read this it will probably have moved on. Director 8.5 can import Flash 5 or below movies, not Flash MX, so make sure that you export your movies in the Flash 5 format. This Appendix will use two examples. The first is available at 'Examples\AppendixB\boxes.fla' on the CD. This simple example uses just two buttons. One button is labelled 'Add box' and the other 'Remove Box'. Each has a very simple ActionScript attached to the release event.

```
on (release) {
        getURL("event:addBox");
}
```

To communicate between Flash and Director we use the Flash 'getURL' method. For each link we use the 'event:*myeventName*', where 'myeventName' can be any name you like that is not a keyword in Director. On the Flash side that is all you need to do; the action is similar to passing an *fscommand* to a parent window.

In Director you can import the Flash interface that you have created. The Director project 'Examples\AppendixB\boxes.dir' is a working example. In this example we use the terrific 3D physics engine Havok to add and remove boxes to a 3D world. You can pick up the boxes with the

Figure B.1 Developing the Boxes interface.

mouse and throw them around. The boxes all interact with each other, bounce off one another and react to the collisions. If you are interested then study the code. For now, though, we are only interested in the way that Flash can be used to initiate the actions. For each 'event: myeventName' you need to add a function to a Movie Script in Director. The script must be a Movie Script, not a Behaviour script or a Parent Script. The form for the code will be

```
on myeventName
--Code that will run when called
end
```

If you place a 'put' in the code you will see that each time that Flash sends a 'getURL("event:myeventName")', Director catches the event within the function; 'put' is the Director equivalent to 'trace'. In the current example, the function 'addBox' is used to create a new box and initiate the physical behaviour; 'removeBox' is used to delete the last box that has been added.

Figure B.2 Importing the Flash interface.

The movie can be published suitable for the Internet by setting the appropriate values in the Publish Settings dialog box. Director creates a compressed file with a 'dcr' extension. This file contains the Flash interface; you do not need to have a version of the 'swf' file available on the site.

Sometimes you will want to pass on the 'event' to the 3D world. Director uses the same layered design as Flash and in the next example 'Examples\AppendixB\road.dir' you will find that the 3D world is on layer 2. In this example the arrows are Flash buttons; each button sends a different event to Director. In addition, Director sets two variables in Flash that display the current position and orientation. Each event is handled in the same way:

```
on turnleft
    sendsprite(2, #turnleft)
end
```

The first parameter in the 'sendsprite' method is the layer number for the sprite; the second parameter is the name of a function for an

Figure B.3 Running the project in a browser.

attached behaviour for the sprite. Director uses a syntax that prefixes the name of a function with the '#' character to denote a symbol. The 3D world has a script behaviour attached that contains the code that will be called:

```
on stopmotion
    moveZ = 0
    rotY = 0
end
```

In this example, the code is used to set the value of two variables that are used to update the position of the camera in the 3D world for each step of the timer. Director uses the 'enterFrame' event for each beat of the timer:

```
on enterFrame
   vec = cam.transform.position
   x = integer(vec.x/10)
   y = integer(vec.y/10)
   z = integer(vec.z/10)
   str = string(x) & ":" & y & ":" & z
   sprite(1).setVariable("position", str)
   vec = cam.transform.rotation
   x = integer(vec.x)
   y = integer(vec.y)
   z = integer(vec.z)
   str = string(x) & ":" & y & ":" & z
   sprite(1).setVariable("orientation", str)

   cam.rotate(0, rotY, 0)
   cam.translate(0, 0, moveZ)
end
```

The 'enterFrame' event is used to update the value of a string containing information about the camera position and orientation. This is sent to Flash using the syntax:

```
sprite(n).setVariable(variableName, variableValue)
```

where *n* is the layer where the Flash sprite resides, variableName is the name of the Flash variable and variableValue is the string value to set. If you have a variable within a Movie Clip that you need to set then you can use the following syntax:

```
sprite(n).telltarget(clipName)
       sprite(n).setVariable(variableName, variableValue)
sprite(n).endtelltarget()
```

where 'clipName' is the name of the Movie Clip instance from the '_root' level. You can use the same technique to move the frame within a Flash clip:

```
sprite(n).telltarget(clipName)
       sprite(n).gotoFrame(5)
sprite(n).endtelltarget()
```

You can set the properties of a clip using:

```
sprite(n).setFlashProperty(clipName, #propertyName, value)
```

Figure B.4 Developing the road example in Director 8.5.

For example:

```
sprite(2).setFlashProperty("Cat", #x, 180)
```

To retrieve the value of a property use:

```
value = sprite(n).getFlashProperty(clipName, #propertyName)
```

For example:

```
CatX = sprite(2).getFlashProperty("Cat", #x)
```

Using these simple methods you can create a complex interface in Flash for controlling a 3D world.

Appendix C:
Creating Flash screensavers

Having worked through Chapter 20 and Appendix A, in this section you can extend your knowledge of C++ to create Flash-based screensavers for the Windows platform. Screensavers are simply executable applications that respond to certain defined command line messages, mouse movement and keyboard input. As such, they can be created by starting a new workspace and selecting 'MFC AppWizard (exe)' as the project type. The source code for the current example is in the folder 'Examples\AppendixC'.

Figure C.1 Creating the swf file.

Creating the Flash content

There are no limitations on creating the Flash movie except that you should not require any mouse or keyboard input. Export the movie as an 'swf' file. If you have used the installer for the CD then you should find a file in your system folder called 'FlashSS.swf'; if you are not sure where your system folder is then try doing a search for this file. Just replacing this file with your own swf file will instantly create a screensaver using your own Flash content. If this is enough for you then that is fine. If you want to know how it all works then read on.

The screensaver window class

To make things as easy as possible the source code includes a special C++ class source file for a screensaver window. The class name is 'CSaveWnd'

Figure C.2 Selecting the screensaver.

and it builds upon the 'CWnd' class, which is an integral feature of MFC (Microsoft Foundation Classes), for its base class. This means that all the functionality of the CWnd class is available to the new class, plus the developer has the ability to include additional features. In our application we will take the CSaveWnd class, embed a Flash ActiveX control into it, set the movie we want to use for the screensaver and show the result either full screen or within a preview pane. To make the window fully functional, we need two 'Create' functions, one to use when this is the main full screen window and one to use when the window is a preview pane. The Display Properties dialog, where any screensaver is selected, can be accessed by right-clicking the desktop. We want to be able to display the Flash screensaver in the small preview pane so that the user can see at a glance how it behaves. Flash is ideal for this because it is resolution independent and can easily be scaled from full screen to miniature viewing.

Space is too short to go into detail about Windows creation and manipulation; you can take it on trust that the code works. The aim with the two 'Create' functions is to create and size the window. The child window is sized based on the rectangle passed by the parent. The main window version gets the screen size using the API call 'GetSystem-Metrics' and sizes the window to fill the screen.

```
BOOL CSaveWnd::Create ()
{
    // Register a class with no cursor
    const char* pszClassName
        = AfxRegisterWndClass(CS_HREDRAW|CS_VREDRAW|CS_SAVEBITS|↵
            CS_DBLCLKS,
                            ::LoadCursor(AfxGetResourceHandle (),

MAKEINTRESOURCE(IDC_NULL_CURSOR)));
        BOOL res = CWnd::CreateEx(WS_EX_TOPMOST,
                        pszClassName,
                        "Flash ScreenSaver",
                        WS_POPUP | WS_VISIBLE,
                        CRect(0,
0,::GetSystemMetrics(SM_CXSCREEN),::GetSystemMetrics(SM_↵
    CYSCREEN)),
                            NULL,NULL);
        if (!res) return FALSE;
        m_mode=SCREENSAVER;
        return TRUE;
}
```

```
BOOL CSaveWnd::Create(CWnd *parent)
{
    // Register a child class
    const char* pszClassName
        = AfxRegisterWndClass(CS_HREDRAW|CS_VREDRAW|CS_PARENTDC);

        CRect rect;
        parent->GetWindowRect(&rect);
    // Create the window
    BOOL res = CWnd::CreateEx(0,
                        pszClassName,
                        "Flash Preview",
                        WS_CHILD | WS_VISIBLE,
                        CRect(0,0,rect.Width(),rect.Height()),
                        parent,
                        NULL);
    if (!res) return FALSE;
    m_mode=PREVIEW;
    return TRUE;
}
```

Any window created in this way must also look after its own destruction.

```
void CSaveWnd::PostNcDestroy()
{
    // We must delete the window object ourselves since the
    // app framework doesn't do this.
    delete this;
}
```

Windows sends messages to its windows constantly. A screensaver window must respond to several of these messages. If a WM_SYSCOMMAND message is sent containing the information SC_SCREENSAVE or SC_CLOSE then the window returns false. If a WM_DESTROY message is sent then the window sends a 'PostQuitMessage'. A WM_SETCURSOR message is used to remove the cursor by setting it to NULL. Mouse move messages must first check whether the mouse has really moved by testing the current mouse positions and comparing them with a previous position. The reason for this is that Windows sends a mouse move message every 2 minutes, even if the mouse has not moved, just to force the application to repaint. If we don't check for an

Flash MX Games

actual movement then we could end up terminating the screensaver even though the mouse has not been moved.

Finally, in the list of messages that we must respond to is any keyboard input which will force a quit.

```
LRESULT CSaveWnd::WindowProc(UINT nMsg, WPARAM wParam, LPARAM ↵
   lParam)
{
    static BOOL      fHere = FALSE;
    static POINT     ptLast;
    POINT            ptCursor, ptCheck;

    switch (nMsg) {
    case WM_SYSCOMMAND:
        if ((wParam == SC_SCREENSAVE) || (wParam == SC_CLOSE)) {
            return FALSE;
        }
        break;

    case WM_DESTROY:
        PostQuitMessage(0);
        break;

    case WM_SETCURSOR:
        SetCursor(NULL);
        break;

    case WM_NCACTIVATE:
        if (wParam == FALSE) {
            return FALSE;
        }
        break;

    case WM_ACTIVATE:
    case WM_ACTIVATEAPP:
        if(wParam != FALSE) break;
        // only fall through if we are losing the focus...

    case WM_MOUSEMOVE:
            if (m_mode==SCREENSAVER) {
                if(!fHere) {
                    GetCursorPos(&ptLast);
                    fHere = TRUE;
```

```
                } else {
                        GetCursorPos(&ptCheck);
                        if(ptCursor.x = ptCheck.x - ptLast.x) {
                                if(ptCursor.x < 0) ptCursor.x *= -1;
                        }
                                if(ptCursor.y = ptCheck.y - ⏎
                                    ptLast.y) {
                                if(ptCursor.y < 0) ptCursor.y *= -1;
                        }
                        if((ptCursor.x + ptCursor.y) > ⏎
                            THRESHOLD) {
                                PostMessage(WM_CLOSE, 0, 01);
                        }
                }
        }
    break;

    case WM_LBUTTONDOWN:
    case WM_MBUTTONDOWN:
    case WM_RBUTTONDOWN:
        GetCursorPos(&ptCursor);
        ptCursor.x ++;
        ptCursor.y ++;
        SetCursorPos(ptCursor.x, ptCursor.y);
        GetCursorPos(&ptCheck);
        if(ptCheck.x != ptCursor.x && ptCheck.y != ptCursor.y)
        ptCursor.x -= 2;
        ptCursor.y -= 2;
        SetCursorPos(ptCursor.x,ptCursor.y);

    case WM_KEYDOWN:
    case WM_SYSKEYDOWN:
        if (m_mode==SCREENSAVER) PostMessage(WM_CLOSE, 0, 01);
        break;
    }
    return CWnd3drWindowProc(nMsg, wParam, lParam);
}
```

This general-purpose file can be used for any screensaver. If the functionality needs extending then you should derive a new class using this as the base class. In the example we do this using the class 'CMyWnd'. Two additional function calls are created in this class:

'CreateScreenSaver' and 'CreatePreview'. The purpose of each of these is to initialize the Flash ActiveX control that is embedded as a member variable. 'CreateScreenSaver' is used for full screen use and 'CreatePreview' when viewed as a minature.

```
BOOL CMyWnd::CreateScreenSaver(CString &movie)
{
    if (!Create ()) return FALSE;
    CRect rect;
    GetClientRect(&rect);
    m_flash.Create("Flash",WS_CHILD|WS_VISIBLE,rect,this,↵
        IDD_FLASH);
    m_flash.SetMovie(LPCTSTR(movie));
    SetCapture ();
    ShowCursor(FALSE);
    return TRUE;
}

BOOL CMyWnd::CreatePreview(CWnd *parent, CString &movie)
{
    if (!Create(parent)) return FALSE;
    CRect rect;
    GetClientRect(&rect);
    m_flash.Create("Flash",WS_CHILD|WS_VISIBLE,rect,this,↵
        IDD_FLASH);
    m_flash.SetMovie(LPCTSTR(movie));
    return TRUE;
}
```

The main application class

As usual, in any MFC application the executable is derived from a CWinApp class. The initialization is all handled in the 'InitInstance' function. First, we must parse the command line looking for an 's', 'c' or 'p'. If an 's' is found then the screensaver should be run as normal, a 'p' indicates that it should be run in preview mode and a 'c' means show the configuration dialog. If we are displaying the full screensaver then we have the option to resize the display if required.

A screensaver is launched each time the Wait parameter is exceeded even if the screensaver is currently running. If the 'Wait' parameter set in the Display Properties dialog is set to 5 minutes then in just half an hour

we could end up with six versions of the screensaver running at the same time; the computer would quickly grind to a halt under this sustained processor use. To avoid multiple versions of screensaver running simultaneously we check for a currently running version using:

```
previnst = CWnd::FindWindow(NULL, "Flash Screensaver");
```

The string 'Flash Screensaver' is a window name and is set in the Create function of the CSaveWnd class. If the instance is a preview then this string was set to 'Flash Preview'. The 'FindWindow' function returns NULL if no window with this property exists.

```
BOOL CFlashSSApp::InitInstance ()
{
        AfxEnableControlContainer ();

        int mode=NOMODE;
        CWnd *previnst,*parent;
        BOOL dispmode;
        int i=0;
        DEVMODE dm;

        CString str=m_lpCmdLine,movie;
        str.TrimLeft ();
        str.TrimRight ();
        str.MakeLower ();
        if (str.Find('s')!=-1) mode=SCREENSAVER;
        if (str.Find('c')!=-1) mode=CONFIG;
        if (str.Find('p')!=-1) {
                int pos=str.Find(' ');
                if (pos!=-1) {
                        str = str.Right(str.GetLength () -pos);
                        parent = CWnd::FromHandle((HWND)atoi(LPCTSTR↵
                           (str)));
                        str.Format("Preview parent %i", parent);
                        mode=PREVIEW;
                }
        }

        movie = m_pszHelpFilePath;
        i = movie.ReverseFind('\\');
```

```
if (i==-1) {
        CFileDialog dlg(TRUE, "swf", NULL, OFN_HIDEREADONLY,
            "Flash Files (*.swf)|*.swf||");
        dlg.m_ofn.lpstrTitle="Please select a Flash file";
        if (dlg.DoModal () ==IDCANCEL) return FALSE;
        movie=dlg.GetPathName ();
}else {
        movie = movie.Left(i) + "\\FlashSS.swf";
}

switch (mode) {
case 1:// Run as screen saver
        previnst=CWnd::FindWindow(NULL,"Flash Screensaver");
        if (previnst) return FALSE;
        m_resize=GetProfileInt("FlashSS","Resize",0);
        if (m_resize) {
            while(1) {
                    m_resize=0;
                    dispmode=EnumDisplaySettings↵
                        (NULL,i,&dm);
                    if (!dispmode) break;
                    if ((dm.dmBitsPerPel==24||dm.↵
                        dmBitsPerPel==32)
                    && dm.dmPelsWidth==640 && dm.↵
                        dmPelsHeight==480) {
                    dm.dmFields =
                     DM_BITSPERPEL|DM_PELSWIDTH|DM_↵
                        PELSHEIGHT;
                            if (ChangeDisplaySettings(&dm,
                                CDS_FULLSCREEN) ==
                            DISP_CHANGE_SUCCESSFUL) ↵
                                m_resize=1;
                            break;
                    }
                    i++;
            }
        }
        if (!wnd->CreateScreenSaver(movie)) {
            if (wnd) delete wnd;
            return FALSE;
        }
        m_pMainWnd = wnd;
        return TRUE;
        break;
```

```
case 2:// Run the configuration dialog
    DoConfig(CWnd::GetActiveWindow ());
        if (wnd) delete wnd;
        break;
case 3:// Run preview
        previnst=CWnd::FindWindow(NULL,"Flash Preview");
        if (previnst||!parent) {
            if (wnd) delete wnd;
            return FALSE;
        }
        if (!wnd->CreatePreview(parent,movie)) {
            if (wnd) delete wnd;
            return FALSE;
        }
        m_pMainWnd = wnd;
        return TRUE;
        break;
    }
    // Now just terminate
    return FALSE;
}
```

The screensaver can be used as is, simply by replacing the 'FlashSS.swf' file. Screensavers should be saved to the 'Windows\System' folder, which on Windows 2000 machines is usually 'WinNT\System32'. If you do a

Figure C.3 Running the screensaver.

search for files that end '.scr' then you will find where they are stored on your machine. You will need to put both the file 'FlashSS.scr' and 'FlashSS.swf' in this folder in order to select this screensaver. You can change the name of the 'FlashSS.scr' file as long as you also change the name of the swf file.

FlashSS.scr → MyFancyNewName.scr
FlashSS.swf → MyFancyNewName.swf

Summary

Flash screensavers are a great way of quickly creating dynamic content. The enclosed source files allow you to simply cut and copy or to get into the detail of how they work so that you can alter the behaviour to better suit your purpose.

Bibliography

Art

The Illusion of Life, Frank Thomas and Ollie Johnston, ISBN 0-89659-232-4, Abbeville, 1981. Written by two of the nine old men of Disney, this book contains a wealth of information for anyone interested in animation.

The Animator's Survival Kit, Richard Williams, ISBN 0-57120-228-4, Faber & Faber, 2001. The best practical guide to creating great animation ever written by one of the best in the business.

Storyboards: Motion in Art, Second Edition, Mark Simon, ISBN 0 240 80374 4, Focal Press, 2000. A comprehensive look at the art and the business of storyboarding.

Interactive Design for New Media and the Web, Nicholas V. Iuppa, ISBN 0 240 80414 7, Focal Press, 2001. A hands-on practical guide to interactive design.

Paint Shop Pro: The Guide to Creating Professional Images, Robin Nichols, ISBN 0 240 51698 2, Focal Press, due for publication 2003. A complete and easy to follow introduction to the popular picture editor.

Photoshop 7.0 A to Z: The Essential Visual Reference Guide, Peter Bargh, ISBN 0 240 51912 4, Focal Press, 2002. A great guide to getting the best out of the world's standard bitmap editor.

Code

Code Complete: A Practical Handbook of Software Construction, Steve C. McConnell, ISBN 1 556 15484 4, Microsoft Press, 1993. A modern-day classic on software engineering, *Code Complete* focuses on specific practices you can use to improve your code and your ability to debug it – and ultimately deliver better, more efficient programs in less time.

The Practice of Programming, Brian W. Kernighan, Rob Pike, ISBN 0 201 61586 X, Addison-Wesley, 1999. Co-authored by one of the pioneers of

Flash MX Games

the C programming language, *The Practice of Programming* is a manual of good programming style that will help any developer create faster, more maintainable code.

Beginning Programming for Dummies, Wallace Wang, ISBN 0 764 50835 0, Hungry Minds, 2001. This book focuses on introducing you to the basics of programming and guides you step-by-step through the basic tools and software, explaining the advantages and disadvantages of each one.

Advanced

Programming Windows with MFC2, Jeff Prosise, ISBN 1 572 31685 0, Microsoft Press, 1999. The best MFC book available, if you want to get into writing native Windows code.

Programming Microsoft Visual InterDev 6.0, Evans, Miller and Spencer, ISBN 1 572 31814 7, Microsoft Press, 1999. A useful guide to the development environment.

ASP in a Nutshell, A. Keyton, Weissinger, ISBN 1 565 92843 1, O'Reilly, 2000. *ASP in a Nutshell*, gives Microsoft Active Server Pages' developers a quick reference guide for looking up object usage. This guide is geared towards working ASP programmers who need to get their answers quickly, without wading through long examples.

Database Design and Programming with Access, SQL and Visual Basic, John Carter, ISBN 0 077 09585 5, McGraw-Hill Education, 2000. The book is designed as a comprehensive introductory textbook on all aspects of the database process, from analysis and design to programming.

Internet and World Wide Web How to Program, Dietel, ISBN 0 130 30897 8, Prentice-Hall, 2001. An introductory programming course (replacing traditional programming languages like C, C++ and Java) for schools wanting to integrate the Internet and World Wide Web into their curricula.

Web

www.catalystpics.co.uk
Home page of the author's company.

mohsye.com
After hours site created by Catalyst staff Christian Holland and Paul Barnes.

www.toon3d.com/flash
Home page for the book; check it out for useful bug fixes and links.

chattyfig.figleaf.com/flashcoders-wiki/
A community-run information database for the FlashCoders mailing list.

http://radio.weblogs.com/0102755/
All the Flash MX news that's fit to print!

http://www.flashkit.com/
A Flash developers resource site.

http://www.flashwizards.com/
A source for Flash inspiration.

http://www.flashcomponents.net/index.cfm?nav=1
Useful information about Flash MX components.

http://www.flashthief.com/
More Flash information than you could shake a stick at.

http://www.moock.org/webdesign/flash/
Loads of useful stuff.

http://www.waxpraxis.org/
This is the personal website of Branden J. Hall (bhall@waxpraxis.org), with a heavy focus on Macromedia Flash and other web technologies.

Index

Focal Press

www.focalpress.com

Join Focal Press on-line
As a member you will enjoy the following benefits:

- an email bulletin with **information on new books**

- a regular **Focal Press Newsletter**:
 - featuring a selection of new titles
 - keeps you informed of **special offers, discounts and freebies**
 - alerts you to **Focal Press news and events** such as author signings and seminars

- complete access to **free content** and reference material on the focalpress site, such as the focalXtra articles and commentary from our authors

- a **Sneak Preview** of selected titles (sample chapters) *before* they publish

- a chance to have your say on our **discussion boards** and **review books** for other Focal readers

Focal Club Members are invited to give us feedback on our products and services.
Email: worldmarketing@focalpress.com – we want to hear your views!

Membership is **FREE**. To join, visit our website and register. If you require any further information regarding the on-line club please contact:

Lucy Lomas-Walker
Email: l.lomas@elsevier.com
Tel: +44 (0) 1865 314438
Fax: +44 (0)1865 314572
Address: Focal Press, Linacre House,
Jordan Hill, Oxford, UK, OX2 8DP

Catalogue

For information on all Focal Press titles, our full catalogue is available online at www.focalpress.com and all titles can be purchased here via secure online ordering, or contact us for a free printed version:

USA
Email: christine.degon@bhusa.com
Tel: +1 781 904 2607 T

Europe and rest of world
Email: j.blackford@elsevier.com
el: +44 (0)1865 314220

Potential authors

If you have an idea for a book, please get in touch:

USA
editors@focalpress.com

Europe and rest of world
focal.press@repp.co.uk

128088

Installing the *CorelDRAW! 6 Expert's Edition Bonus CD*

Included on the *CorelDRAW! 6 Expert's Edition Bonus CD* are the following online documents in Adobe Acrobat 2.1 format:

- ✔ What's on the *CorelDRAW! 6 Expert's Edition Bonus CD*

- ✔ *CorelDRAW! 6 Expert's Edition Resource Guide*

- ✔ *CorelDRAW! 6 Expert's Edition Online Glossary*

- ✔ Installation and other readme information for the various demo programs, shareware, and freeware on the CD

To view, copy, or print these documents, you must first install the Acrobat Reader. Acrobat Reader, version 2.1, is found on the *CorelDRAW! 6 Expert's Edition* in the ACROREAD folder.

Installing the Acrobat Reader for Windows

To install the Acrobat Reader, you need to exit any DOS windows you may have open, close any applications you have running, and insert the CD.

1. From the Win95 Start menu, choose **S**ettings, **C**ontrol Panel, then double-click on Add/Remove Programs.

2. On the Install/Uninstall tabbed menu, click on **I**nstall to display Install Program From Floppy Disk or CD-ROM. Click on Next.

3. In the next dialog box, click on B<u>r</u>owse to locate the CD-ROM drive.

4. Click on the Acroread.exe icon in the Folders window, then click on <u>O</u>pen. This takes you to the Run Installation Program dialog box. Click on Finish to begin the installation.

5. After a moment or two, the Electronic End User License Agreement dialog box appears. Click on <u>A</u>ccept to accept the terms.

6. The Acrobat Reader Installer then displays a dialog box where you can choose the location on your hard disk, and the name of the folder for Acrobat Reader 2.1. Make your selections, then click on Install.

7. You're prompted to fill out the electronic registration card, which isn't on your hard disk until after you've installed the Reader utility. Click on OK, and don't forget!

8. Enter your name and the name of your organization in the Acrobat Installer dialog box, then click on OK.

9. The Acrobat Reader installation should complete in less than a minute. When you click on OK, you're in business.

Now, when you click on Win95's Start menu button, you'll find a new program group, Acrobat Reader, with the Acrobat Reader 2.1 icon nested inside.

Using the *CorelDRAW! 6 Expert's Edition* Online Glossary

After the Acrobat Reader is installed, using the *Online Glossary* is simple. Click on the Acrobat Reader 2.1 icon in Windows Start menu to launch the Reader. In the Open dialog box, use the <u>F</u>olders and Dri<u>v</u>es fields to go to the ACRODOCS folder on the *CorelDRAW! 6 Expert's Edition Bonus CD.* Double-click on CEE6-GL.PDF in the box under the File <u>n</u>ame text entry box, and the *Online Glossary* will open.